TEXTUAL POACHERS

STUDIES IN CULTURE AND COMMUNICATION
in the same series

Advertising as Communication
Gillian Dyer

Case Studies and Projects in Communication
Neil McKeown

Film as Social Practice
Graeme Turner

Introduction to Communication Studies
John Fiske

An Introduction to Language and Society
Martin Montgomery

Key Concepts in Communication
Tim O'Sullivan, John Hartley, Danny Saunders and John Fiske

On Video
Roy Armes

Popular Culture: The Metropolitan Experience
Iain Chambers

A Primer For Daily Life
Susan Willis

Television Drama: Agency, Audience, and Myth
John Tulloch

Understanding News
John Hartley

Understanding Radio
Andrew Crisell

Understanding Television
Andrew Goodwin and Garry Whannel

The Ideological Octopus: An Exploration of Television
and its Audience
Justin Lewis

TEXTUAL POACHERS

TELEVISION FANS & PARTICIPATORY CULTURE

HENRY JENKINS

ROUTLEDGE
NEW YORK AND LONDON

Published in 1992 by

Routledge
An imprint of Routledge, Chapman and Hall, Inc.
29 West 35th Street
New York, NY 10001

Published in Great Britain by

Routledge
11 New Fetter Lane
London EC4P 4EE

Library of Congress Cataloging-in-Publication Data

Jenkins, Henry.
 Textual poachers : television fans and participatory culture /
Henry Jenkins.
 p. cm. — (Studies in culture and communications)
 Includes bibliographical references and index.
 ISBN 0-415-90571-0 (hb). — ISBN 0-415-90572-9 (pb)
 1. Fans (Persons)—Psychology. 2. Television viewers—Psychology.
3. Popular culture. I. Title. II. Series: Studies in culture and
communication.
HM291.J42 1992 92-19400
306'.1—dc20 CIP

British Library cataloguing in publication
data also available

Contents

Acknowledgments .. vii

Introduction... 1

1 "Get a Life!": Fans, Poachers, Nomads 9

2 How Texts become Real................................... 50

3 Fan Critics .. 86

4 "It's Not a Fairy Tale Anymore": Gender, Genre,
Beauty and the Beast ... 120

5 Scribbling in the Margins: Fan Readers/Fan Writers 152

6 "Welcome to Bisexuality, Captain Kirk": Slash and the
Fan-Writing Community .. 185

7 "Layers of Meaning": Fan Music Video and the
Poetics of Poaching.. 223

8 "Strangers No More, We Sing": Filk Music, Folk Culture, and
the Fan Community .. 250

Conclusion
"In My Weekend-Only World. . .":
Reconsidering Fandom... 277

Appendix
Fan Texts (Prepared by Meg Garrett) 288

Sources ... 307

Index ... 329

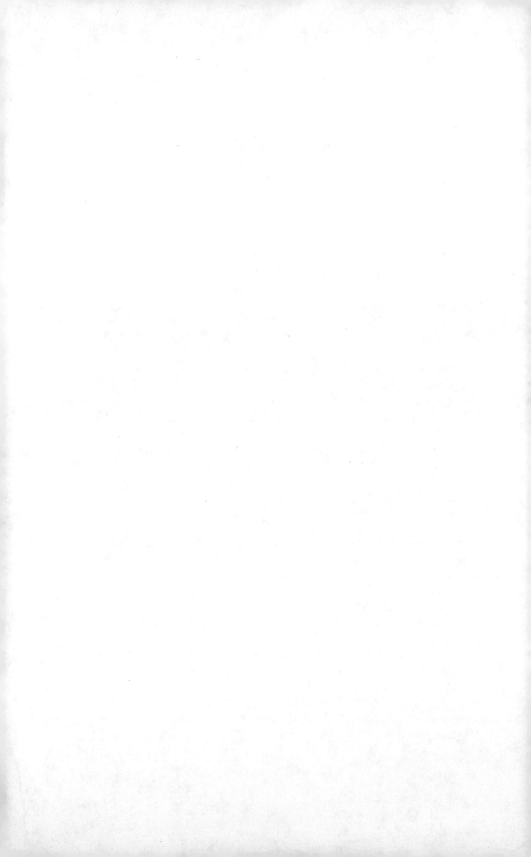

Acknowledgments

I could not have written this book without the assistance of countless fans, of whom I want particularly to thank Barbara Tennison, Signe Hovde, and her Madison friends, Ursula Boyle, Spencer Love, Emily McEwan, Mary Van Deusen, Vicki Burke, Lee Heller, Shoshanna Green, Joan Martin, the *Oblique* group, and the members of North of Shangri-La, who have shared with me their insights, their materials, their connections, and their experiences, and whose ideas can be found on almost every page of this book. I want to thank all of the fans who sent me personal letters, envelopes stuffed with photocopies of previous correspondence, copies of their publications, artwork, and who have demonstrated to me in the most material ways the sense of community that is a central concern of this book. I especially wish to thank Meg Garrett who has read and commented on every page, who has sent me hours of tapes and videos, who has engineered introductions and shared addresses with other fans, and who wrote the appendix to this book. I always greet another package from "The Court of Chaos" with excitement.

I would also like to take this opportunity to thank the academic readers and critics who have challenged my theoretical claims and helped me to clarify aspects of fan culture that might seem cryptic to mundane readers: David Thorburn, Lynn Spigel, Constance Penley, John Fiske, John Tulloch, Louis Galdieri, Lisa Rofel, Mary Fuller, Ruth Perry, Jane Shattuc, Ellen Draper, Susan Emanuel, Lisa Lewis, Peter Kramer, Nickianne Moody, Les Perelman, Briony Keith, and the members of the Narrative-Intelligence and Construction of Sexuality Reading Groups at MIT. I would also like to thank my students for their helpful input and strong support, especially those who came to my presentations of this material during the Independent Activity Period in early 1991. Portions of this manuscript have appeared previously in: *Critical Studies in Mass Communications, Journal of University Film and Video Association, Camera Obscura, and The Adoring Audience* (New York: Routledge, 1991).

vii

Most importantly, I want to thank Cynthia Jenkins, who helped me learn how to feel comfortable reading as a fan. She has influenced every word of this book; I can claim few of the ideas here as entirely my own because my thinking about fans has been completely shaped by some 12 years of conversations with her. She did a great deal of research on this book and deserves a great share of the credit for its success. Any errors that remain are probably the result of my hard-headedness in clinging to bad ideas even when she has so ably demonstrated their foolishness. This book belongs to her (except for tenure purposes) and part of the proceeds from its sale will send her to cons and buy her zines.

Introduction

Textual Poachers offers an ethnographic account of a particular group of media fans, its social institutions and cultural practices, and its troubled relationship to the mass media and consumer capitalism. There are, of course, many different types of fans—rock fans, sports fans, movie buffs, opera enthusiasts, etc.; "fans" have a much longer history, fitting more generally into longstanding debates about the popular consumption of fiction or audience response to popular entertainments. As Cultural Studies has directed more attention on the process of reception, and as researchers have begun to construct more precise accounts of both historical and contemporary audiences, we are beginning to develop a more sophisticated understanding of how these groups relate to the mass media and draw upon it as a resource in their everyday life. I focus on only one of these fan cultures here—an amorphous but still identifiable grouping of enthusiasts of film and television which calls itself "media fandom." This group embraces not a single text or even a single genre but many texts—American and British dramatic series, Hollywood genre films, comic books, Japanese animation, popular fiction (particularly science fiction, fantasy, and mystery)—and at the same time, it constructs boundaries that generally exclude other types of texts (notably soap opera and for the most part, commercial romance). This group is largely female, largely white, largely middle class, though it welcomes into its ranks many who would not fit this description. This subculture cuts across traditional geographic and generational boundaries and is defined through its particular styles of consumption and forms of cultural preference. The fans discussed here come from New England and the Northern Seaboard, the South, the Midwest, the West, and the Pacific coast as well as from England, Australia, New Zealand, Iceland, and Europe. Perhaps my most difficult claim will be that such a widespread and diverse group may still constitute a recognizable subculture.

Textual Poachers identifies at least five distinct (though often interconnected) dimensions of this culture: its relationship to a par-

1

ticular mode of reception; its role in encouraging viewer activism; its function as an interpretive community; its particular traditions of cultural production; its status as an alternative social community. Chapter one offers an overview of the complex social and cultural status of the fan, challenging conventional stereotypes and outlining recent work in cultural studies which provides the theoretical background for this study. Chapter two identifies characteristics of fandom's mode of reception, considering issues of textual proximity, rereading, and the translation of program materials into resources for conversation and gossip. Chapter three looks at the critical and interpretive practices of the fan community, including the processes of program selection, canon formation, evaluation, and interpretation as well as their relationship to gender-specific reading styles. Chapter four traces the reception history of a particular program, *Beauty and the Beast*, suggesting the role played by generic expectations in shaping fan response and ways that fan interpretive conventions provide the basis for activism against the producer's actions. Chapters five, six, and seven examine two forms of cultural production within the fan community—specifically fan writing and video-making—describing the texts produced, their generic traditions, and the aesthetic criteria by which they are judged. Chapter eight considers fandom's status as a new form of "community," one formed by relations of consumption and categories of taste, and discusses the role of folk music in creating a common identity for this geographically and socially dispersed group. The conclusion returns to the question of defining fandom and then suggests what this study can and *cannot* contribute to our larger understanding of media audiences. Such an approach recognizes that fan culture is a complex, multidimensional phenomenon, inviting many forms of participation and levels of engagement. Such an approach also traces a logical progression from the immediate reception of a broadcast toward the construction of alternative texts and alternative social identities. Much of what I say about this group applies to other fan cultures as well, some of what I say applies to popular reading more generally, yet, my claims are more modest, focusing on this one subculture and its traditions.

I use words like "culture" and "community" with some caution in this book, recognizing their increasingly problematic status within the social sciences. There, the move has been to deconstruct the unified notions of culture found in classic anthropological accounts and to focus on the contradictions within traditionally defined cul-

tural communities as well as "borderlines" or points of intersection between different cultural groups. As Renato Rosaldo (1989) notes in a recent overview of debates surrounding ethnography, anthropology now seems to emerging scholars less an "art museum" wherein cultures stand as "sacred images" whose "integrity and coherence" make them worthy objects of isolated contemplation than a "garage sale" where the focus shifts into understanding the complex "boundaries that crisscross over a field at once fluid and saturated with power" (page 44). Unlike classical ethnographies, my project is already concerned with a subculture that exists in the "borderlands" between mass culture and everyday life and that constructs its own identity and artifacts from resources borrowed from already circulating texts. From the outset, an account of fan culture necessarily signals its problematic status, its inescapable relations to other forms of cultural production and other social identities. Nobody functions entirely within the fan culture, nor does the fan culture maintain any claims to self-sufficiency. There is nothing timeless and unchanging about this culture; fandom originates in response to specific historical conditions (not only specific configurations of television programing, but also the development of feminism, the development of new technologies, the atomization and alienation of contemporary American culture, etc.) and remains constantly in flux. Such a culture also defies attempts to quantify it, because of its fluid boundaries, its geographic dispersement, and its underground status. My task here is not to signal the fluidity of cultural communities but rather to make a case for fandom as having any degree of coherence and stability at all. *Textual Poachers* describes a social group struggling to define its own culture and to construct its own community within the context of what many observers have described as a postmodern era; it documents a group insistent on making meaning from materials others have characterized as trivial and worthless. What this book offers is a necessarily partial account of that subcultural community as it appeared to me at the end of the 1980s and the early 1990s. Michel de Certeau (1988) suggests that readers' activities can only be theorized, not documented. I would disagree, pointing to the material signs of fan culture's productivity, yet it is true that such a culture can be glimpsed only through local details rather than measured in its entirety.

Equally problematic for contemporary social science has been the question of ethnographic authority. Writers like Rosaldo (1989),

James Clifford, and others (Clifford, 1983; Clifford and Marcus, 1986) have questioned a tradition of abstracted, objective, disinterested ethnography and urged a greater attention to the situated knowledge of the ethnographer and the power relations between researcher and community. Anthropology and sociology have entered a period of experimentation as ethnographers seek new methods ranging from autobiographical accounts of fieldwork to various forms of dialogic writing. Central to this move has been the recognition that there is no privileged position from which to survey a culture. Rather, each vantage point brings with it both advantages and limitations, facilitating some types of understanding while blinding us to others. The result is a shift from totalizing accounts of social and cultural processes toward partial, particularized, and contingent accounts of specific encounters within and between cultures. This newer conception of ethnographic authority is central to women's studies, gay studies, and ethnic studies, where newer forms of ethnography contribute to the reconstruction of social images for their communities (Strathern, 1987; Strathern, 1987; McRobbie, 1982; Chabram, 1990; Paredes, 1977; Goodwin, 1989). The newer ethnography offers accounts in which participation is often as important as observation, the boundary between ethnographer and community dissolves, and community members may actively challenge the account offered of their experience.

Textual Poachers draws inspiration from these movements within traditional social sciences. What follows grows not only from conventional forms of field research but also from my own active involvement as a fan within this subcultural community over the past decade and more. I suppose I have always been something of a fan, spending many hours of my childhood watching old movies on television, reading *Famous Monsters of Filmland*, and play-acting my favorite stories in the backyard with my friends. My earliest introduction to organized fandom came through my older cousin, George Jr., whose room with its monster magazines and models, comic books, *Mad* magazines, and hand-drawn copies of popular cartoon characters fascinated me as a young boy; my parents told me that he was active in Atlanta science fiction and comic book fandom, though I had only a vague sense at the time of what this meant. I rediscovered fandom as an undergraduate, attending my first convention amidst the excitement surrounding *Star Wars*. At the time, I had no thoughts of an academic career, let alone of writing a book on fan culture; rather, I was seeking a double major

in political science and journalism with aspirations of being a political reporter (a common enough ambition in the wake of Watergate). My commitment to fandom intensified when I met the woman who would become my lifelong partner and I discovered fanzines and fan criticism through her. I was, initially, dubious about fannish reading and writing practices, unable to break with my respect for authorial intention, unsure what to make of all of this time and effort put into amateur production; yet, gradually, I came to understand more fully the pleasures of fannish interpretation and to appreciate the merit of its cultural traditions. My interest in cinema, my work as a critic and entertainment editor for the campus paper, my academic interests in the social sciences (not to mention my budding romantic life) all came together for me one day with the realization that I should go to graduate school and study media. To no small degree, it was my fannish enthusiasm and not my academic curiosity that led me to consider an advanced degree in media studies and to spend all of the time required to gain competency in that discipline (though by that point, I would be hard pressed to separate the two).

I have found approaching popular culture as a fan gives me new insights into the media by releasing me from the narrowly circumscribed categories and assumptions of academic criticism and allowing me to play with textual materials. My exposure to fan culture challenged much of what I was being taught about the "ideological positioning of viewing subjects." That dissatisfaction led me to embrace cultural studies when I encountered it in a class taught by John Fiske at the University of Iowa some years ago.

When I write about fan culture, then, I write *both* as an academic (who has access to certain theories of popular culture, certain bodies of critical and ethnographic literature) and as a fan (who has access to the particular knowledge and traditions of that community). My account exists in a constant movement between these two levels of understanding which are not necessarily in conflict but are also not necessarily in perfect alignment. If this account is not overtly autobiographical in that it pulls back from recounting my own experiences in favor of speaking within and about a larger community of fans, it is nevertheless deeply personal. (For experiments in more overtly autobiographical writing about media audiences, see Walkerdine, 1986; Fiske, 1990; McRobbie, 1991.)

Does this color what I say about fandom? Almost certainly, which is why I am acknowledging it at the outset. In a recent critique

of ethnographic work on audience resistance, David Sholle (1991) warns of the dangers of overidentification with the research subject: "The stance of the ethnographer . . . must still to some extent retain a dimension of distance from the situation. There is a danger of taking up the standpoint of a fan and thus confusing one's own stance with that of the subject being studied" (84). While conceding that such a risk (media study's particular version of "going native") is present in writing an ethnography from within the fan community, I must note as well that this danger is not substantially lessened by adopting a more traditionally "objective" stance. In the past, scholars with little direct knowledge or emotional investment within the fan community have transformed fandom into a projection of their personal fears, anxieties, and fantasies about the dangers of mass culture. This more distanced perspective did not insure a better understanding of the complexity of the phenomenon so much as it enabled scholars to talk about a group presumed incapable of responding to their representation. This same danger recurs in more recent and substantially more sympathetic treatments of fan culture, such as Janice Radway's otherwise exemplary *Reading the Romance* (1984), which cast writers as vanguard intellectuals who might lead the fans toward a more overtly political relationship to popular culture. Academic distance has thus allowed scholars either to judge or to instruct but not to converse with the fan community, a process which requires greater proximity and the surrender of certain intellectual pretensions and institutional privileges.

Writing as a fan about fan culture poses certain potential risks for the academic critic, yet it also facilitates certain understandings and forms of access impossible through other positionings. Many of the fans I have contacted shared with me "horror stories" of previous accounts of fan culture, either in the popular press or in academic articles; many remained distrustful of how their culture might look under scholarly scrutiny and I was only able to gain their trust by demonstrating my own commitment to the fan community and my own background as a participant in those activities.

Claiming a common identity with fans does not erase other forms of power relations that color all ethnographic research, for if I am a fan, I am also a male fan within a predominantly female fan culture. Male media fans are less common than female fans, though certainly not remarkable within this culture; we have learned to play according to the interpretive conventions of that community, even if these subcultural traditions did not originate in response to

our particular interests or backgrounds. There are perhaps some corners of fandom or some fans who are closed to me as a male participant, though I have found fandom generally open and accepting of my involvement.

Writing as a fan means as well that I feel a high degree of responsibility and accountability to the groups being discussed here. I look at my fellow fans as active collaborators in the research process. My practice from the outset has been to share each chapter with all of the quoted fans and to encourage their criticism of its contents. I have received numerous letters from fans, offering their own insights into the issues raised here and I have learned much from their reactions. I have met with groups of fans in open discussions of the text and have incorporated their suggestions into its revision. In some cases, I have inserted their reactions into the text, yet, even where this has not occurred directly and explicitly, it must be understood that this text exists in active dialogue with the fan community. I have not always been successful in locating fans and they have not always responded to my inquiries. Many fan artifacts circulate anonymously, originating in the community at large, defeating easy efforts to pin down authorship. I have always made an effort (though I have a pile of returned envelopes on my desk) and beg forgiveness for any oversights that might have occurred in this lengthy and complicated process. I still welcome fan comments on my work and hope that this process will continue after this book has seen print.

My motivations for writing this book are complex and bound to my dual role as fan and academic. As a fan, I feel that most previous academic accounts of fan culture are sensationalistic and foster misunderstandings about this subculture. From talking to fans, I recognize that these misconceptions have material consequences in our lives and contribute to often hostile treatment from workmates, friends, and family members. I want to participate in the process of redefining the public identity of fandom, to use my institutional authority to challenge those stereotypes, and to encourage a greater awareness of the richness of fan culture. I also hope that my work will be part of the exchange of knowledge between different segments of the fan community and provide a record of the accomplishments of remarkable fan writers, artists, and performers. As an academic, I am dismayed by general theories of television spectatorship that gave little attention to the specificity and complexity of the practices I experience as a fan. I am equally

troubled by the inadequacy with which many academics write about popular culture and particularly our inability to link ideological criticism with an acknowledgement of the pleasures we find within popular texts. At this moment in the development of media studies, there is a great deal we as academics can learn about fan culture and perhaps even more we can learn *from* fan culture. Both sets of interests come together in this book which is written to, for, and about fans but also written in response to debates within the academic community.

1

"Get a Life!":
Fans, Poachers, Nomads

When *Star Trek* star William Shatner (Captain James T. Kirk) appeared as a guest host of *Saturday Night Live,* the program chose this opportunity to satirize the fans of his 1960s television series. The "Trekkies" were depicted as nerdy guys with glasses and rubber Vulcan ears, "I Grok Spock" T-shirts stretched over their bulging stomachs. One man laughs maliciously about a young fan he has just met who doesn't know Yeoman Rand's cabin number, while his friend mumbles about the great buy he got on a DeForest Kelly album. When Shatner arrives, he is bombarded with questions from fans who want to know about minor characters in individual epi-

1.1 "Get a Life": Two "Trekkies" on *Saturday Night Live*

sodes (which they cite by both title and sequence number), who seem to know more about his private life than he does, and who demand such trivial information as the combination to Kirk's safe. Finally, in incredulity and frustration, Shatner turns on the crowd: "Get a life, will you people? I mean, I mean, for crying out loud, it's just a TV show!" Shatner urges the fans to move out of their parent's basements and to proceed with adult experiences ("you, there, have you ever kissed a girl?"), to put their fannish interests behind them. The fans look confused at first, then, progressively more hurt and embarrassed. Finally, one desperate fan asks, "Are you saying we should pay more attention to the movies?" Enraged, Shatner storms off the stage, only to be confronted by an equally angry convention organizer. After a shoving match and a forced rereading of his contract, an embarrassed Shatner takes the stage again and tells the much-relieved fans that they have just watched a "recreation of the evil Captain Kirk from episode 27, 'The Enemy Within.' "

This much-discussed sketch distills many popular stereotypes about fans. Its "Trekkies":

a. are brainless consumers who will buy anything associated with the program or its cast (DeForest Kelly albums);

b. devote their lives to the cultivation of worthless knowledge (the combination to Kirk's safe, the number of Yeoman Rand's cabin, the numerical order of the program episodes);

c. place inappropriate importance on devalued cultural material ("It's just a television show");

d. are social misfits who have become so obsessed with the show that it forecloses other types of social experience ("Get a Life");

e. are feminized and/or desexualized through their intimate engagement with mass culture ("Have you ever kissed a girl?");

f. are infantile, emotionally and intellectually immature (the suggestion that they should move out of their parents' basement, their pouting and befuddled responses to Shatner's criticism, the mixture of small children and overweight adults);

g. are unable to separate fantasy from reality ("Are you saying we should pay more attention to the movies?").

Those in doubt about the "credibility" of this representation of fan culture need only flip to the cover story of the December 22, 1986 issue of *Newsweek* to see an essentially similar depiction of a fan convention, though in this case, one which claimed no comic exaggeration (Leerhsen, 1986). (Fans saw little comic exaggeration in the *Saturday Night Live* sketch, in any case, since Shatner had repeatedly expressed many of these same sentiments in public interviews and clearly meant what he said to his fans.) Where *Saturday Night Live* served its audience jokes, *Newsweek* interviewed "experts" who sought to explain "the enduring power of *Star Trek*"; where *Saturday Night Live* featured comic actors as stereotypical characters, *Newsweek* provided actual photographs of real *Star Trek* fans—a bearded man ("a Trekkie with a phaser") standing before an array of commercially produced *Star Trek* merchandise; three somewhat overweight, middle-aged "Trekkies" from Starbase Houston dressed in Federation uniforms and Vulcan garb; an older woman, identified as "Grandma Trek," proudly holding a model of the Enterprise. The article's opening sentences could easily be a description of the *Saturday Night Live* fan convention: "Hang on: You are being beamed to one of those *Star Trek* conventions, where grown-ups greet each other with the Vulcan salute and offer in reverent tones to pay $100 for the autobiography of Leonard Nimoy" (66). Fans are characterized as "kooks" obsessed with trivia, celebrities, and collectibles; as misfits and "crazies"; as "a lot of overweight women, a lot of divorced and single women" (68); as childish adults; in short, as people who have little or no "life" apart from their fascination with this particular program. Starbase Houston is "a group of about 100 adults who have their own flag, jackets and anthem" (68); Amherst's Shirley Maiewski ("Grandma Trek") "has a Klingon warship hanging from her rec-room ceiling and can help you find out what three combinations Captain Kirk used to open his safe" (68); one man was married in Disneyland wearing a Federation uniform and his "Trekkie" bride wore (what else), rubber Vulcan ears. Such details, while no doubt accurate, are selective, offering a distorted picture of their community, shaping the reality of its culture to conform to stereotypes already held by *Newsweek's* writers and readers. The text and captions draw their credibility from the seemingly "natural" facts offered by the photographs and quotes, yet actually play an important role fitting those "facts" into a larger "mythology" about fannish identity (Barthes, 1973). The smug and authoritative tone of the *Newsweek* article, especially

when coupled with countless other similar reports in local news-papers and on local newscasts, lends credibility to the only slightly more hyperbolic *Saturday Night Live* sketch, until "everyone knows" what "Trekkies" are like and how they would be likely to react to being chastised by William Shatner. These representations won widespread public acceptance and have often been quoted to me by students and colleagues who question my interest in fan culture; their recognition and circulation by non-fans reflects the degree to which these images fit comfortably within a much broader discourse about fans and their fanaticism.

FANS AND "FANATICS"

Many of these stereotypes seem to have been attached to the term "fan" from its very inception. "Fan" is an abbreviated form of the word "fanatic," which has its roots in the Latin word "fana-ticus." In its most literal sense, "fanaticus" simply meant "Of or belonging to the temple, a temple servant, a devotee" but it quickly assumed more negative connotations, "Of persons inspired by or-giastic rites and enthusiastic frenzy" (*Oxford Latin Dictionary*). As it evolved, the term "fanatic" moved from a reference to certain excessive forms of religious belief and worship to any "excessive and mistaken enthusiasm," often evoked in criticism to opposing political beliefs, and then, more generally, to madness "such as might result from possession by a deity or demon" (*Oxford English Dictionary*). Its abbreviated form, "fan," first appeared in the late 19th century in journalistic accounts describing followers of profes-sional sports teams (especially in baseball) at a time when the sport moved from a predominantly participant activity to a spectator event, but soon was expanded to incorporate any faithful "devotee" of sports or commercial entertainment. One of its earliest uses was in reference to women theater-goers, "Matinee Girls," who male critics claimed had come to admire the actors rather than the plays (Auster, 1989). If the term "fan" was originally evoked in a some-what playful fashion and was often used sympathetically by sports writers, it never fully escaped its earlier connotations of religious and political zealotry, false beliefs, orgiastic excess, possession, and madness, connotations that seem to be at the heart of many of the representations of fans in contemporary discourse.

Robert Jewett and John Shelton Lawrence (1977), for example, come close to the original meaning of the word, "fanaticus," in their absurdly literal account of the mythic aspects of *Star Trek* and of "Trekkie Religion." Drawing on the work of Joseph Campbell, Jewett and Lawrence claim that science fiction television and its fans constitute a kind of secular faith, "a strange, electronic religion . . . in the making" (24). The hyperbolic rhetoric of fan writing is read literally as "written in the spirit of . . . religious devotion" (26); Kirk and Spock are understood as "redeemers," fans as their "disciples," and fanzines as "apocryphal literature" forming the basis for a new "theology" (27–31). Jewett and Lawrence are particularly concerned with the program's female devotees, whose erotic fantasies about the characters are likened to the "temple rites" of vestal virgins. The writers both celebrate and distrust this zealous relationship to fictional texts, seeing it as evidence supporting their own claims about the mythic possibilities of *Star Trek*, yet also comparing it to the obsessiveness of the Manson family and the suicidal Werther cult of 19th-century Germany. In the end, Jewett and Lawrence are unable to understand how a television program could produce this extreme response, a confusion they pass onto the fans who are characterized as inarticulate about the series' popularity.

Building on the word's traditional links to madness and demonic possession, news reports frequently characterize fans as psychopaths whose frustrated fantasies of intimate relationships with stars or unsatisfied desires to achieve their own stardom take violent and antisocial forms. The murderous actions of Charles Manson (a Beatles fan), John Hinkley (a Jodie Foster fan), and Dwight Chapman (a John Lennon fan), as well as less-publicized incidents like the attack on *Cagney and Lacey*'s Sharon Gless by a "lesbian loony" as one tabloid described it, are explained according to a stereotypical conception of the fan as emotionally unstable, socially maladjusted, and dangerously out of sync with reality. Julie Burchill (1986) evokes this same myth of the "unbalanced" fan in her account of the destructive quality of celebrity culture:

A harmless crush can become a clinical obsession when held a beat too long. The fan has no power over the performer but to destroy. . . . The thin line between love and hate, between free will and fate, gradually disappears for the fan in the attic, lumping around his unacknowledged, unwanted love like an embarrassing erection all stressed

up with nowhere to go; and the love turns into a weapon
as he realizes he can never touch the one he wants, except
with a bullet. (143)

What Burchill describes as "the fan in the attic" is a stock figure
in suspense films, detective novels, and television cop shows, one
of the "usual suspects" for the commission of crimes and a source
of almost instantaneous threat. So powerful is this stereotype that
the opening of one recent film, *The Fan* (1981), provokes terror
simply by depicting a lone fan (Michael Biem) sitting in a darkened
room slowly typing a letter to his favorite Broadway actress (Lauren
Bacall): "Dear Ms. Ross, I am your greatest fan because unlike the
others, I want nothing from you." The camera's slow pan over a
room strewn with countless autographed photographs, playbills, and
posters and the relentless clatter of his keys already primes the
viewer for the horrible acts of violence which will follow. Unable
to get a personal response to his persistent letters, the fan slaughters
those closest to the star, breaks into and vandalizes her apartment,
sends her death threats, and finally kidnaps her and threatens rape
and murder. Similar images of dangerous fans can be found in films
such as *Fade to Black* (1980), *King of Comedy* (1983), and *Misery*
(1990), each of which represent fans as isolated, emotionally and
socially immature, unable to achieve a proper place for themselves
in society, and thus prone to replace grim realities with rich media
fantasies.

 If the psychopathic "fan in the attic" has become a stock char-
acter of suspense films, comic representations offer a more benign
but no less socially maladjusted figure: the star-struck projectionist
in Buster Keaton's *Sherlock Jr.* (1924), the escapist book publishers
in *The Seven Year Itch* (1955) and *The Secret Life of Walter Mitty*
(1947), the movie-mad extras in *Ali Baba Goes to Town* (1937) and
The Errand Boy (1951), the accident-prone comedy fiend in *Stooge-
mania* (1985), and the romantically frustrated film critic in *Play It
Again, Sam* (1972). Like their counterparts in more dramatic films,
these men live unrewarding lives, have few social ties, unsuccessful
or threatening romantic relationships, and hectic or demeaning jobs,
often at the periphery of show business. They are drawn inward
toward a rich and varied realm of personal fantasy that substitutes
for the decisive action they fail to display in their everyday lives.
Such figures can, no doubt, trace their roots back to earlier repre-
sentations of distracted or overidentified readers, such as *Don Quix-*

ote or *Madame Bovary*, and enjoy a place in centuries-old debates about the dangers of consuming fiction.

The myth of the "orgiastic" fan, the groupie, survives as a staple fantasy of rock music reporting and criticism, exemplified perhaps most vividly by the lurid promotion of Fred and Judy Vermorel's *Starlust* (1985). That book promises its readers "the secret fantasies of fans," fantasies largely erotic in nature (such as the confessions of a woman who thinks about Barry Manilow while making love to her husband). The book's editors claim their project was initiated by a desire to offer a sympathetic treatment of fans "not [as] passive victims of showbiz exploitation, but real and socially functioning people working through and acting out the consequences of fandom for all of us" (247). However, their presentation of this material, from the image of a screaming woman on the cover to chapters with titles like "Possession," "Obsession," "Ecstasy," and "Delirium," confirms traditional stereotypes. The Vermorels' fans speak endlessly of their desire to possess and be possessed by their favorite celebrities.

Significantly, if the comic fan and the psychotic fan are usually portrayed as masculine, although frequently as de-gendered, asexual, or impotent, the eroticized fan is almost always female (the shrieking woman on the cover of the Vermorels' book); the feminine side of fandom is manifested in the images of screaming teenage girls who try to tear the clothes off the Beatles or who faint at the touch of one of Elvis's sweat-drenched scarfs, or the groupie servicing the stars backstage after the concert in rockamentaries and porn videos. Not only are these women unable to maintain critical distance from the image, they want to take it inside themselves, to obtain "total intimacy" with it. Yet, these representations push this process one step further: the female spectator herself becomes an erotic spectacle for mundane male spectators while her abandonment of any distance from the image becomes an invitation for the viewer's own erotic fantasies.

As these examples suggest, the fan still constitutes a scandalous category in contemporary culture, one alternately the target of ridicule and anxiety, of dread and desire. Whether viewed as a religious fanatic, a psychopathic killer, a neurotic fantasist, or a lust-crazed groupie, the fan remains a "fanatic" or false worshiper, whose interests are fundamentally alien to the realm of "normal" cultural experience and whose mentality is dangerously out of touch with reality.

"A SCANDALOUS CATEGORY"

To understand the logic behind these particular discursive constructions of fans, we must reconsider what we mean by taste. Concepts of "good taste," appropriate conduct, or aesthetic merit are not natural or universal; rather, they are rooted in social experience and reflect particular class interests. As Pierre Bourdieu (1979) notes, these tastes often seem "natural" to those who share them precisely because they are shaped by our earliest experiences as members of a particular cultural group, reinforced by social exchanges, and rationalized through encounters with higher education and other basic institutions that reward appropriate conduct and proper tastes. Taste becomes one of the important means by which social distinctions are maintained and class identities are forged. Those who "naturally" possess appropriate tastes "deserve" a privileged position within the institutional hierarchy and reap the greatest benefits from the educational system, while the tastes of others are seen as "uncouth" and underdeveloped. Taste distinctions determine not only desirable and undesirable forms of culture but also desirable and undesirable ways of relating to cultural objects, desirable and undesirable strategies of interpretation and styles of consumption. Witness, for example, the ways that Shakespeare's plays have provoked alternative responses, demanded different levels of intellectual investment as they have moved from popular to elite culture (Levine, 1988).

Though the enculturation of particular tastes is so powerful that we are often inclined to describe our cultural preferences not simply as natural but as universal and eternal, taste is always in crisis; taste can never remain stable, because it is challenged by the existence of other tastes that often seem just as "natural" to their proponents. The boundaries of "good taste," then, must constantly be policed; proper tastes must be separated from improper tastes; those who possess the wrong tastes must be distinguished from those whose tastes conform more closely to our own expectations. Because one's taste is so interwoven with all other aspects of social and cultural experience, aesthetic distaste brings with it the full force of moral excommunication and social rejection. "Bad taste" is not simply undesirable; it is unacceptable. Debates about aesthetic choices or interpretive practices, then, necessarily have an important social dimension and often draw upon social or psychological categories as a source of justification. Materials viewed as undesirable within

a particular aesthetic are often accused of harmful social effects or negative influences upon their consumers. Aesthetic preferences are imposed through legislation and public pressure; for example, in the cause of protecting children from the "corrupting" influence of undesired cultural materials. Those who enjoy such texts are seen as intellectually debased, psychologically suspect, or emotionally immature.

The stereotypical conception of the fan, while not without a limited factual basis, amounts to a projection of anxieties about the violation of dominant cultural hierarchies. The fans' transgression of bourgeois taste and disruption of dominant cultural hierarchies insures that their preferences are seen as abnormal and threatening by those who have a vested interest in the maintenance of these standards (even by those who may share similar tastes but express them in fundamentally different ways). As Bourdieu (1980) suggests, "The most intolerable thing for those who regard themselves as the possessors of legitimate culture is the sacrilegious reuniting of tastes which taste dictates shall be separated" (253). Fan culture muddies those boundaries, treating popular texts as if they merited the same degree of attention and appreciation as canonical texts. Reading practices (close scrutiny, elaborate exegesis, repeated and prolonged rereading, etc.) acceptable in confronting a work of "serious merit" seem perversely misapplied to the more "disposable" texts of mass culture. Fans speak of "artists" where others can see only commercial hacks, of transcendent meanings where others find only banalities, of "quality and innovation" where others see only formula and convention. One *Beauty and the Beast* fan, for example, constructed a historical account of American broadcasting, echoing the traditional narrative of a '50s golden age followed by a '60s wasteland, yet, using it to point toward certain fan favorites (*Twilight Zone, Outer Limits, Star Trek, The Avengers, The Prisoner*) as representing turning points or landmarks. These series stand apart from the bulk of broadcast material because of their appeal to the intelligence and discrimination of their viewers, contrasting sharply with "mediocre series," such as *Lost in Space, Land of the Giants, The Invaders,* or *The Greatest American Hero,* which were characterized by their "poor writing, ridiculous conflicts offering no moral or ethical choices, predictable and cardboard characterizations, and a general lack of attention to creativity and chance-taking" (Formaini 1990, 9–11). His historical narrative ends, naturally enough, with the appearance of his favorite series, *Beauty and the*

Beast, which achieves the perfect melding of fantasy, science fiction, and classical literature that had been the goal of this "great tradition" of pop "masterpieces." Such an account requires not simply an acknowledgement of the superior qualities of a desired text but also a public rejection of the low standards of the "silly and childish offerings" that fall outside of the fan canon. The fan's claims for a favored text stand as the most direct and vocal affront to the legitimacy of traditional cultural hierarchies.

Yet the fans' resistance to the cultural hierarchy goes beyond simply the inappropriateness of their textual selections and often cuts to the very logic by which fans make sense of cultural experiences. Fan interpretive practice differs from that fostered by the educational system and preferred by bourgeois culture not simply in its object choices or in the degree of its intensity, but often in the types of reading skills it employs, in the ways that fans approach texts. From the perspective of dominant taste, fans appear to be frighteningly out of control, undisciplined and unrepentant, rogue readers. Rejecting the aesthetic distance Bourdieu suggests is a cornerstone of bourgeois aesthetics, fans enthusiastically embrace favored texts and attempt to integrate media representations into their own social experience. Unimpressed by institutional authority and expertise, the fans assert their own right to form interpretations, to offer evaluations, and to construct cultural canons. Undaunted by traditional conceptions of literary and intellectual property, fans raid mass culture, claiming its materials for their own use, reworking them as the basis for their own cultural creations and social interactions. Fans seemingly blur the boundaries between fact and fiction, speaking of characters as if they had an existence apart from their textual manifestations, entering into the realm of the fiction as if it were a tangible place they can inhabit and explore. Fan culture stands as an open challenge to the "naturalness" and desirability of dominant cultural hierarchies, a refusal of authorial authority and a violation of intellectual property. What may make all of this particularly damning is that fans cannot as a group be dismissed as intellectually inferior; they often are highly educated, articulate people who come from the middle classes, people who "should know better" than to spend their time constructing elaborate interpretations of television programs. The popular embrace of television can thus be read as a conscious repudiation of high culture or at least of the traditional boundaries between high culture and popular culture. What cannot easily be dismissed as ignorance must be read

as aesthetic perversion. It is telling, of course, that sports fans (who are mostly male and who attach great significance to "real" events rather than fictions) enjoy very different status than media fans (who are mostly female and who attach great interest in debased forms of fiction); the authority to sanction taste, then, does not rest exclusively on issues of class but also encompasses issues of gender, which may account for why popular publications like *Newsweek* or programs like *Saturday Night Live* find themselves aligned with the academy in their distaste for media fans as well as why stereotypes portray fans either as overweight women (see *Misery*) or nerdy, degendered men (see *Fade to Black*).

The fan, whose cultural preferences and interpretive practices seem so antithetical to dominant aesthetic logic, must be represented as "other," must be held at a distance so that fannish taste does not pollute sanctioned culture. Public attacks on media fans keep other viewers in line, making it uncomfortable for readers to adapt such "inappropriate" strategies of making sense of popular texts or to embrace so passionately materials of such dubious aesthetic merit. Such representations isolate potential fans from others who share common interests and reading practices, marginalize fan activities as beyond the mainstream. These representations make it highly uncomfortable to speak publicly as a fan or to identify yourself even privately with fan cultural practices.

Even within the fan community, these categories are evoked as a way of policing the ranks and justifying one's own pleasures as less "perverse" than those of others: a flier circulated at a recent science fiction convention categorized *Star Trek* fans as belonging to the "G.A.L." ("Get a Life") club, part of an ongoing struggle between literary science fiction fans and media fans; the advocate of an unpopular opinion in a *Twin Peaks* computer net discussion group was dismissed as a "Trekkie" and told to seek his company elsewhere; a critic for a commercial publication aimed at science fiction fans dismissed one professional *Star Trek* novel as "too fannish." There is always someone more extreme whose otherness can justify the relative normality of one's own cultural choices and practices. As C. E. Amesley (1989) notes, "I have yet to find a self-identified 'Hardcore Trekkie.' Whether fans watch the show every night, miss other events to come home to watch, go to conventions, participate in contests, collect all the novels or study Klingon, they always know others who, unlike them, are 'really hardcore.' The idea of a 'hardcore Trekkie' influences their beliefs concerning their

Are you a Star Trek fan? Do you dream at night that you're aboard the starship Enterprise, giving the orders to boldly go where no man has gone before? Do you dream about this **all the time**? If you answered yes, then you may be the sort of pellucid go-getter we've been looking for ! This may be your once-in-a-lifetime opportunity to join the elite ranks of the.......

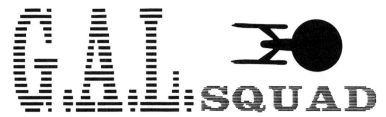

Yes, freind, the G.A.L. squad is looking for people just like yourself to partake in the exciting, glamourous life already enjoyed by members the world over.

* Attend conventions!

* Wear authentic costumes!

* Be heard at our never-ending technical infofmation debates!

* Enjoy our fast food buffets!

* Join in our monthly laundry excursions!

* Go on trips to exotic, distant lands and spend your time in the best mediocre hotel suites!

* See Jimmy Doohan ten, twenty, fifty times!

* Learn how to speak Klingon-our teachers will also help you understand and memorize every detail of the **Enterprise**!

No Club Gimmicks!

Sound too good to be true? Guess again! It's all happening even as you read this! Never again will you feel alone in your absolutely worthwhile devotion to the most celebrated cultural enigma in world history-**STAR TREK!** Join the proud members of the G.A.L. squad and you too will enjoy all the exciting hebetude!
If you're a thoroughly anserous, exacting person, then delay no longer! Just send $200.00 today! After you recieve your membership certificate, you automatically inherit all the benefits existing in the G.A.L. SQUAD! So what are you waiting for?
Join today!

Live it to the limit

YES! I WANT TO JOIN THE G.A.L. SQUAD! ENCLOSED IS TWO HUNDRED DOLLARS IN CRISP, UNMARKED BILLS. PLEASE RUSH ME MY MEMBERSHIP CERTIFICATE!

IMPROVE YOUR IMAGE

(Sign) _____

Name _____
Address _____ Apt. _____
City _____
State _____ Zip _____
P.S. You don't need to spend a fortune to get a good American Value.

Join the Adventure!

1.2 "G.A.L. Squad" (Get a Life Squad): Anti-*Star Trek* fan flier circulated by literary science fiction fans

own behavior, but does not, except in theory, exist" (338). Fans prefer to describe themselves as "Trekkers" rather than "Trekkies" (a term which has increasingly come to refer only to the media constructed stereotype)—or better still, to describe themselves simply as fans (a term which signifies their membership within a larger subculture of other fans and denies a fixed reader-text relationship).

Ien Ang (1985) confronted many of these issues in her interpretation of letters solicited by her from a group of Dutch viewers of *Dallas*. Her correspondents found it relatively easy to explain why they disliked the American soap opera, falling back on readily accessible categories from "the ideology of mass culture," gaining security from their commonsensical appeals to widely circulated discourses about cultural contamination. For those who found pleasure in *Dallas*, for those who might consider themselves fans of the program, defending their tastes proved a far more complex and difficult process. None of Ang's letter-writers could fully escape from the categories established by mass culture's critics, none could treat their pleasures as innocent or unproblematic. Critical discourse against mass culture, Ang concludes, had seemingly foreclosed any possibility for the *Dallas* fans to articulate their own social and cultural position or to "hit back" against their critics from a position of authority and strength.

Much like the *Dallas* fans Ang discusses, *Star Trek* fans often find themselves arguing from a position of weakness in attempting to defend their fascination with the program. For many, the only legitimate defense is to assert the "normality" of their lifestyle, professing their general conformity to middle-class culture as a way of creating common ground with nonfan friends. One fan wrote in response to the *Saturday Night Live* sketch:

> I resent having those assumptions made about me. I have 'got a life.' I have a husband and children. I do volunteer work and have opinions on a wide variety of matters, both political and religious. I do shopping, vote in elections and change diapers. I do live in a real world, with all of its tensions and stress. That is the reason I am a Trekker. A hobby is necessary for mental health. *Star Trek* helps me to keep from burning out in all the "important" things I do. It helps me relax. It helps me retain my perspective. It is fun. It is not my religion. I already have a perfectly good religion. (Well, I'm Catholic.) And I suspect that the

majority of fans are more like me than the stereotype. (Ku-
likauskas, 1988, 5)

Others justify the program's appeal in terms derived from tra-
ditional high culture: they cite scripts by renowned literary science
fiction writers such as Robert Bloch, Theodore Sturgeon, Norman
Spinrad, and Harlan Ellison; they note its confrontation of serious
social issues such as racism, terrorism, and drug abuse; they tout
its recognition by the industry and educational groups; they insist
upon its ability to "change lives" with its optimistic vision, all cat-
egories that appear with frequency in the pages of books like *Star
Trek Lives!* (Lichtenberg, Marshak, and Winston, 1975) or *The
World of Star Trek* (Gerrold, 1973), whose authors explain fandom
to mundane and neofan readers. Still others respond from a position
of "cultural populism," offering a negative identification of their
critics as close-minded and conformist ("know-it-alls" and "cynics")
while praising the program's fans for their open-mindedness and
communalism. Like Ang's *Dallas* viewers, these fans have inter-
nalized many aspects of dominant taste; they are struggling to un-
derstand their own relationship to the media within the terms pro-
vided by the ideology of mass culture. *Star Trek* can be defended
as a kind of ersatz high culture and judged according to its standards
(standards that are bound to judge it impoverished, if only because
it lacks the history of critical interpretation surrounding earlier pop-
ular works that have been absorbed into the official canon); there
seems to be no way of defending it as popular culture, as responsive
to consumer tastes, as satisfying audience desires and producing
immediate pleasures at the moment of its consumption, as "fun."

Yet there is an important difference between Ang's *Dallas* view-
ers and the *Star Trek* fans. The *Dallas* viewers wrote in isolation,
watching the program in their own homes with little or no acknowl-
edgement that others shared their enthusiasm for the series. What
led them to write to Ang in response to an advertisement soliciting
such letters might have been an attempt to overcome these feelings
of cultural isolation, to gain a larger identity as fans apart from the
alienation imposed on them by dominant discourse about mass
culture. Ang's respondents were *Dallas* fans only in the narrow sense
that they watched the program regularly but they lacked social con-
nections to a larger network of fans and did not participate in the
complex fan culture described here. The Trekkers, however, see
themselves as already participating in a larger social and cultural

community, as speaking not only for themselves but for *Star Trek* fans more generally. These fans often draw strength and courage from their ability to identify themselves as members of a group of other fans who shared common interests and confronted common problems. To speak as a fan is to accept what has been labeled a subordinated position within the cultural hierarchy, to accept an identity constantly belittled or criticized by institutional authorities. Yet it is also to speak from a position of collective identity, to forge an alliance with a community of others in defense of tastes which, as a result, cannot be read as totally aberrant or idiosyncratic. Indeed, one of the most often heard comments from new fans is their surprise in discovering how many people share their fascination with a particular series, their pleasure in discovering that they are not "alone."

This book is written on the assumption that speaking as a fan is a defensible position within the debates surrounding mass culture. Rejecting media-fostered stereotypes of fans as cultural dupes, social misfits, and mindless consumers, this book perceives fans as active producers and manipulators of meanings. Drawing on the work of Michel de Certeau, it proposes an alternative conception of fans as readers who appropriate popular texts and reread them in a fashion that serves different interests, as spectators who transform the experience of watching television into a rich and complex participatory culture. Viewed in this fashion, fans become a model of the type of textual "poaching" de Certeau associates with popular reading. Their activities pose important questions about the ability of media producers to constrain the creation and circulation of meanings. Fans construct their cultural and social identity through borrowing and inflecting mass culture images, articulating concerns which often go unvoiced within the dominant media.

The fans' response typically involves not simply fascination or adoration but also frustration and antagonism, and it is the combination of the two responses which motivates their active engagement with the media. Because popular narratives often fail to satisfy, fans must struggle with them, to try to articulate to themselves and others unrealized possibilities within the original works. Because the texts continue to fascinate, fans cannot dismiss them from their attention but rather must try to find ways to salvage them for their interests. Far from syncopathic, fans actively assert their mastery over the mass-produced texts which provide the raw materials for their own cultural productions and the basis for their social inter-

actions. In the process, fans cease to be simply an audience for popular texts; instead, they become active participants in the construction and circulation of textual meanings.

Fans recognize that their relationship to the text remains a tentative one, that their pleasures often exist on the margins of the original text and in the face of the producer's own efforts to regulate its meanings. While fans display a particularly strong attachment to popular narratives, act upon them in ways which make them their own property in some senses, they are also acutely and painfully aware that those fictions do not belong to them and that someone else has the power to do things to those characters that are in direct contradiction to the fans' own cultural interests. Sometimes, fans respond to this situation with a worshipful deference to media producers, yet, often they respond with hostility and anger against those who have the power to "retool" their narratives into something radically different from that which the audience desires.

TEXTUAL POACHERS

Michel de Certeau (1984) has characterized such active reading as "poaching," an impertinent raid on the literary preserve that takes away only those things that are useful or pleasurable to the reader: "Far from being writers . . . readers are travellers; they move across lands belonging to someone else, like nomads poaching their way across fields they did not write, despoiling the wealth of Egypt to enjoy it themselves" (174). De Certeau's "poaching" analogy characterizes the relationship between readers and writers as an ongoing struggle for possession of the text and for control over its meanings. De Certeau speaks of a "scriptural economy" dominated by textual producers and institutionally sanctioned interpreters and working to restrain the "multiple voices" of popular orality, to regulate the production and circulation of meanings. The "mastery of language" becomes, for de Certeau, emblematic of the cultural authority and social power exercised by the dominant classes within the social formation. School children are taught to read for authorial meaning, to consume the narrative without leaving their own marks upon it: "This fiction condemns consumers to subjection because they are always going to be guilty of infidelity or ignorance. . . . The text becomes a cultural weapon, a private hunting reserve" (171).

Under this familiar model, the reader is supposed to serve as the more-or-less passive recipient of authorial meaning while any deviation from meanings clearly marked forth within the text is viewed negatively, as a failure to successfully understand what the author was trying to say. The teacher's red pen rewards those who "correctly" decipher the text and penalizes those who "get it wrong," while the student's personal feelings and associations are rated "irrelevant" to the task of literary analysis (according to the "affective fallacy"). Such judgments, in turn, require proper respect for the expertise of specially trained and sanctioned interpreters over the street knowledge of the everyday reader; the teacher's authority becomes vitally linked to the authority which readers grant to textual producers. As popular texts have been adopted into the academy, similar claims about their "authorship" have been constructed to allow them to be studied and taught in essentially similar terms to traditional literary works; the price of being taken seriously as an academic subject has been the acceptance of certain assumptions common to other forms of scholarship, assumptions that link the interests of the academy with the interests of producers rather than with the interests of consumers. Both social and legal practice preserves the privilege of "socially authorized professionals and intellectuals" over the interests of popular readers and textual consumers. (Jane Gaines, 1990, for example, shows the ways that the primary focus of trademark law has shifted from protecting consumers from commercial fraud toward protecting the exclusive interests of capital for control over marketable images.) The expertise of the academy allows its members to determine which interpretive claims are consistent with authorial meaning (whether implicit or explicit), which fall beyond its scope. Since many segments of the population lack access to the means of cultural production and distribution, to the multiplexes, the broadcast airwaves or the chain bookstore shelves, this respect for the "integrity" of the produced message often has the effect of silencing or marginalizing oppositional voices. The exclusion of those voices at the moment of reception simply mirrors their exclusion at the moment of production; their cultural interests are delegitimized in favor of the commercial interests of authorized authors.

De Certeau's account of academic and economic practice is a highly polemical one; he offers a partial and certainly partisan version of certain traditional beliefs and attitudes. One does not have to abolish all reverence for authorial meaning in order to recognize

the potential benefits of alternative forms of interpretation and consumption. Yet de Certeau poses questions that we as scholars and teachers need to consider—the ways we justify our own positions as critics, the interests served by our expertise, the degree to which our instruction may hinder rather than encourage the development of popular criticism. Education can be a force for the democratization of cultural life. If it couldn't be, there would be no purpose in writing this book for an academic audience or committing oneself to a classroom. Often, however, education is too preoccupied with protecting its own status to successfully fulfill such a role. All too often, teachers promote their own authority at the expense of their students' ability to form alternative interpretations. De Certeau invites us to reconsider the place of popular response, of personal speculations and nonauthorized meanings in the reception of artworks and to overcome professional training that prepares us to reject meanings falling outside our frame of reference and interpretive practice.

De Certeau (1984) acknowledges the economic and social barriers that block popular access to the means of cultural production, speaking of a culture in which "marginality is becoming universal" and most segments of the population remain "unsigned, unreadable and unsymbolized" within dominant forms of representation (xvii). Yet de Certeau seeks to document not the strategies employed by this hegemonic power to restrict the circulation of popular meaning or to marginalize oppositional voices but rather to theorize the various tactics of popular resistance. De Certeau gives us terms for discussing ways that the subordinate classes elude or escape institutional control, for analyzing locations where popular meanings are produced outside of official interpretive practice. De Certeau perceives popular reading as a series of "advances and retreats, tactics and games played with the text," as a type of cultural bricolage through which readers fragment texts and reassemble the broken shards according to their own blueprints, salvaging bits and pieces of the found material in making sense of their own social experience (175).

Like the poachers of old, fans operate from a position of cultural marginality and social weakness. Like other popular readers, fans lack direct access to the means of commercial cultural production and have only the most limited resources with which to influence entertainment industry's decisions. Fans must beg with the net-

works to keep their favorite shows on the air, must lobby producers to provide desired plot developments or to protect the integrity of favorite characters. Within the cultural economy, fans are peasants, not proprietors, a recognition which must contextualize our celebration of strategies of popular resistance. As Michael Budd, Robert Entman, and Clay Steinman (1990) note, nomadic readers "may actually be powerless and dependent" rather than "uncontainable, restless and free." They continue, "People who are nomads cannot settle down; they are at the mercy of natural forces they cannot control" (176). As these writers are quick to note, controlling the means of cultural reception, while an important step, does not provide an adequate substitute for access to the means of cultural production and distribution. In one sense, then, that of economic control over the means of production, these nomadic viewers truly are "powerless and dependent" in their relationship to the culture industries. Yet, on another level, that of symbolic interpretation and appropriation, de Certeau would suggest they still retain a degree of autonomy. Their economic dependence may not be linked directly to notions of passive acceptance of ideological messages, as these critical writers might suggest; consumers are not governed by "a subjectivity that must, perforce, wander here, then wander there, as the media spotlight beckons," as these writers characterize them (Budd, Entman, Steinman 1990, 176). Rather, consumers are selective users of a vast media culture whose treasures, though corrupt, hold wealth that can be mined and refined for alternative uses. Some of the strategies fans adopt in response to this situation are open to all popular readers, others are specific to fandom as a particular subcultural community. What is significant about fans in relation to de Certeau's model is that they constitute a particularly active and vocal community of consumers whose activities direct attention onto this process of cultural appropriation. As such, they enjoy a contemporary status not unlike the members of the "pit" in 19th-century theatre who asserted their authority over the performance, not unlike the readers of Dickens and other serial writers who wrote their own suggestions for possible plot developments, not unlike the fans of Sherlock Holmes who demanded the character's return even when the author sought to retire him. Fans are not unique in their status as textual poachers, yet, they have developed poaching to an art form.

FANS AND PRODUCERS

The history of media fandom is at least in part the history of a series of organized efforts to influence programing decisions—some successful, most ending in failure. Many have traced the emergence of an organized media fan culture to late 1960s efforts to pressure NBC into returning *Star Trek* to the air, a movement which has provided a model for more recent attempts to reverse network decisions, such as the highly publicized efforts to save *Beauty and the Beast* or *Cagney and Lacey* (D'acci, 1988). Local *Blake's 7* clubs emerged in many American cities throughout the 1980s, with their early focus on convincing local PBS stations to buy the rights to this British science fiction program. American *Doctor Who* supporters volunteer their time at PBS stations across the country, trying to translate their passion for the program into pledge drive contributions that will ensure its continued airing. *War of the Worlds* devotees directed pressure against its producers trying to convince the studio not to kill some of their favorite characters, playfully suggesting that the only rationale for such a decision could be that "aliens have infiltrated Paramount studios!!!!!" (flier distributed at MediaWest, 1989). COOP, a national *Twin Peaks* fan organization, employed local rallies and computer networking to try to keep that doomed series on the air ("All we are saying is give *Peaks* a chance!") Chapter five will document a similar movement on behalf of *Beauty and the Beast*.

The television networks often help to publicize such audience campaigns, especially when they later decide to return programs from hiatus, as evidence of their responsiveness to their viewership. *Cagney and Lacey* producer Barney Rosenzweig actively solicited viewer support in his effort to convince CBS to give the series a second chance to attract higher ratings and publicizing the degree to which he had incorporated audience reactions directly into "the actual production process" (D'Acci, 1988). A recent commercial for *Quantum Leap* showed viewers swamping the network offices with their letters, forcing a reconsideration of its scheduling. Yet, just as often, fan campaigns produce little or no result. When ABC canceled the science fiction series, *Starman* (86–87), after less than a full season on the air, five of the program's fans organized Spotlight Starman to lobby for its return (Menefee, 1989). At its peak, the group maintained a mailing list of more than 5,000 names from across the United States and Canada and some 30 regional coor-

dinators maintained systematic contact among its various chapters. Since then, the group has hosted several national conventions of *Starman* fans, has sustained three different monthly publications focused on the movement, has worked closely with the PTA to publicize the family orientation of the program, and has continued to target both network executives and program producers with letters on behalf of the short-lived series. Despite such extensive efforts and some signs of receptiveness by the program's producer and stars, the network has so far not returned the series to the air nor has it released rights to broadcast the series in syndication. The fans have found themselves powerless to alter the program's fate.

While this grassroots campaign suggests extraordinary efforts by the program's audience and a remarkable success given how few viewers saw or even heard of the series during its initial airing, their numbers still amount to a small fraction of the ratings required to make such a series profitable for the networks. Moreover, even if the audience's ranks expanded dramatically, even if the campaign to save *Starman* was truly national in scope, it is doubtful that the viewers could force their will upon the network executives. As Eileen Meehan (1990) has suggested, despite the myth of popular choice that surrounds them, the *Nielsen* ratings reflect only a narrowly

Is your show in the top ten and in no danger of cancellation? Want to keep it that way? Use Dr. Decker's patented Reverse Psychology Method. You know that Network programming bigwigs are all scheming, conniving bastards. Well, this is your chance to enter the game and influence the men who make the decision on what millions of people will and will not watch.

"How?" You ask. Simple! Using the patented Reverse Psychology Method, write to those Network bigwigs and demand they take your favorite show off the air–cancel it immediately! Be neat, of course, write in crayon, state that you belong to a demographic group known to have almost no buying power (such as middle-aged spinning wheel repairmen), and tell them the reason you want the show off the air is because it isn't good for you or anyone else. What Network programming executive wouldn't be thrilled to find out one of their shows tuned out the people sponsers wouldn't want watching their program anyway. And everyone knows Americans spend the majority of their free time doing things that aren't good for them!

This is a letter campaign that actually works! Why try to save a show after it's hit the skids? Put your effort behind a show that is in no danger of hiatus and demand it be cancelled today!

1.3 Advice from a frustrated fan: from *(Not) The MediaWest Convention Program*

chosen segment of the television audience—a "commodity audi-
ence"—which can be sold to national advertisers and networks, but
which reflects neither mass taste nor the taste of an intellectual elite.
Meehan's history of the different rating systems employed by Amer-
ican network television suggests that shifts between different systems
reflect economic interests rather than attempts toward greater social
scientific accuracy; changing forms of data collection result in the
appearance of shifts in cultural preference that are the product of
the different "commodity audiences" constituted by the systems of
measurement. The ratings are not statistically sound, according to
standards of social science research, yet, they allow the networks to
dismiss popular movements or to justify otherwise questionable
programing decisions. The myth is, of course, that the American
public gets the programing it wants (and can thus blame no one but
itself for the banality of mass culture); the reality is that the Amer-
ican public gets programing that is calculated to attract the "com-
modity audience" with limited concern for what most viewers ac-
tually desire (see also Streeter, 1988).

 Many program producers are sympathetic to such campaigns
and have shrewdly employed them as a base of support in their
own power struggles with the network executives. Others, however,
have responded to such fan initiatives with contempt, suggesting
that fan efforts to protect favorite aspects of fictional texts infringe
upon the producer's creative freedom and restrict their ability to
negotiate for a larger audience. Confronted with a letter campaign
by *Batman* comic book fans angry about the casting of Michael
Keaton as the Dark Knight, *Batman* director Tim Burton re-
sponded: "There might be something that's sacrilege in the
movie. . . . But I can't care about it. . . . This is too big a budget
movie to worry about what a fan of a comic would say" (Uricchio
and Pearson 1991, 184). William Shatner adopts a similar position
in his characterization of *Star Trek* fans: "People read into it [the
series] things that were not intended. In *Star Trek*'s case, in many
instances, things were done just for entertainment purposes" (Spell-
ing, Lofficier, and Lofficier 1987, 40). Here, Shatner takes on himself
the right to judge what meanings can be legitimately linked to the
program and which are arbitrary and false.

 In extreme cases, producers try to bring fan activities under
their supervision. Lucasfilm initially sought to control *Star Wars*
fan publications, seeing them as rivals to their officially sponsored
and corporately run fan organization. Lucas later threatened to pros-

ecute editors who published works that violated the "family values" associated with the original films. A letter circulated by Maureen Garrett (1981), director of the official *Star Wars* fan club, summarized the corporation's position:

> Lucasfilm Ltd. does own all rights to the Star Wars characters and we are going to insist upon no pornography. This may mean no fanzines if that measure is what is necessary to stop the few from darkening the reputation our company is so proud of. . . . Since all of the *Star Wars* Saga is PG rated, any story those publishers print should also be PG. Lucasfilm does not produce any X-rated *Star Wars* episodes, so why should we be placed in a light where people think we do?. . . . You don't own these characters and can't *publish* anything about them without permission.

This scheme met considerable resistance from the fan-writing community, which generally regarded Lucas's actions as unwarranted interference in their own creative activity. Several fanzine editors continued to distribute adult-oriented *Star Wars* stories through an underground network of "special friends," even though such works were no longer publicly advertised or sold. A heated editorial in *Slaysu*, a fanzine that routinely published feminist-inflected erotica set in various media universes, reflects these writers' opinions:

> Lucasfilm is saying, "you must enjoy the characters of the *Star Wars* universe for male reasons. Your sexuality must be correct and proper by my (male) definition." I am not male. I do not want to be. I refuse to be a poor imitation, or worse, of someone's idiotic ideal of femininity. Lucasfilm has said, in essence, "This is what we see in the *Star Wars* films and we are telling you that this is what you will see." (Siebert, 1982, 44)

C. A. Siebert's editorial asserts the rights of fan writers to revise the character of the original films, to draw on elements from dominant culture in order to produce underground art that explicitly challenges patriarchal assumptions. Siebert and other editors deny the traditional property rights of producers in favor of a readers' right of free play with the program materials. As another *Star Wars* fan explained in response to this passage:

I still don't agree with the concept that property rights over fiction, such as *Star Wars*, include any rights of the author/producer to determine *how* readers or viewers understand the offering. In this sense, I don't believe fans can take from the producers anything which the producer owns. . . . Any producer or author who wants to ensure as a legal right that audiences experience the same feelings and thoughts s/he put into the work, has misread both the copyright law and probably the Declaration of Independence. . . . Fans' mental play is no business of producers and neither are their private communications, however lengthy." (Barbara Tennison, Personal Correspondence, 1991)

This conflict is one which has had to be actively fought or at least negotiated between fans and producers in almost every media fandom; it is one which threatens at any moment to disrupt the pleasure that fans find in creating and circulating their own texts based on someone else's fictional "universe"—though an underground culture like fandom has many ways to elude such authorities and to avoid legal restraint on their cultural practices.

The relationship between fan and producer, then, is not always a happy or comfortable one and is often charged with mutual suspicion, if not open conflict. Yet lacking access to the media, lacking a say in programing decisions, confronting hostility from industry insiders, fans have nevertheless found ways to turn the power of the media to their own advantage and to reclaim media imagery for their own purposes. Spotlight Starman may have failed to return its series to the air, but in the process of lobbying for its return, as the group notes, "an impressive body of 'fan art'—visual, literary and musical—has been created" which extends the body of the primary text in directions never predicted by the program's producers (Werkley, 1989). *Star Wars* fans continued to circulate erotic stories that expressed their desires and fantasies about the characters, even though such stories were forced even further underground by Lucas's opposition.

De Certeau's term, "poaching," forcefully reminds us of the potentially conflicting interests of producers and consumers, writers and readers. It recognizes the power differential between the "landowners" and the "poachers"; yet it also acknowledges ways fans may resist legal constraints on their pleasure and challenge attempts to regulate the production and circulation of popular meanings.

And, what is often missed, de Certeau's concept of "poaching" promises no easy victory for either party. Fans must actively struggle with and against the meanings imposed upon them by their borrowed materials; fans must confront media representations on an unequal terrain.

READING AND MISREADING

A few clarifications need to be introduced at this time. First, de Certeau's notion of "poaching" is a theory of appropriation, not of "misreading." The term "misreading" is necessarily evaluative and preserves the traditional hierarchy bestowing privileged status to authorial meanings over reader's meanings. A conception of "misreading" also implies that there are proper strategies of reading (i.e., those taught by the academy) which if followed produce legitimate meanings and that there are improper strategies (i.e., those of popular interpretation) which, even in the most charitable version of this formulation, produce less worthy results. Finally, a notion of "misreading" implies that the scholar, not the popular reader, is in the position to adjudicate claims about textual meanings and suggests that academic interpretation is somehow more "objective," made outside of a historical and social context that shapes our own sense of what a text means. (This problem remains, for example, in David Morley's *Nationwide* study (1980) which constructs a scholarly reading of the program against which to understand the deviations of various groups of popular readers.) De Certeau's model remains agnostic about the nature of textual meaning, allows for the validity of competing and contradictory interpretations. De Certeau's formulation does not necessarily reject the value of authorial meaning or academic interpretive strategies; such approaches offer their own pleasures and rewards which cannot easily be dismissed. A model of reading derived from de Certeau would simply include these interpretive goals and strategies within a broader range of more-or-less equally acceptable ways of making meaning and finding pleasure within popular texts; it questions the institutional power that values one type of meaning over all others.

Secondly, de Certeau's notion of "poaching" differs in important ways from Stuart Hall's more widely known "Encoding and Decoding" formulation (1980). First, as it has been applied, Hall's model of dominant, negotiated, and oppositional readings tends to

imply that each reader has a stable position from which to make
sense of a text rather than having access to multiple sets of discursive
competencies by virtue of more complex and contradictory place
within the social formation. Hall's model, at least as it has been
applied, suggests that popular meanings are fixed and classifiable,
while de Certeau's "poaching" model emphasizes the process of
making meaning and the fluidity of popular interpretation. To say
that fans promote their own meanings over those of producers is
not to suggest that the meanings fans produce are always opposi-
tional ones or that those meanings are made in isolation from other
social factors. Fans have chosen these media products from the total
range of available texts precisely because they seem to hold special
potential as vehicles for expressing the fans' pre-existing social com-
mitments and cultural interests; there is already some degree of
compatibility between the ideological construction of the text and
the ideological commitments of the fans and therefore, some degree
of affinity will exist between the meanings fans produce and those
which might be located through a critical analysis of the original
story. What one fan says about *Beauty and the Beast* holds for the
relationship many fans seek with favorite programs: "It was as if
someone had scanned our minds, searched our hearts, and presented
us with the images that were found there." (Elaine Landman, "The
Beauty and the Beast Experience," undated fan flier). Yet, as chapter
four will suggest, the *Beauty and the Beast* fans moved in and out
of harmony with the producers, came to feel progressively less sat-
isfied with the program narratives, and finally, many, though not
all, of them rejected certain plot developments in favor of their own
right to determine the outcome of the story.

Such a situation should warn us against absolute statements of
the type that appear all too frequently within the polemical rhetoric
of cultural studies. Readers are not *always* resistant; *all* resistant
readings are not necessarily progressive readings; the "people" do
not *always* recognize their conditions of alienation and subordi-
nation. As Stuart Hall (1981) has noted, popular culture is "neither
wholly corrupt [n]or wholly authentic" but rather "deeply contra-
dictory," characterized by "the double movement of containment
and resistance, which is always inevitably inside it" (228). Similarly,
Hall suggests, popular reception is also "full of very contradictory
elements—progressive elements and stone-age elements." Such
claims argue against a world of dominant, negotiating, and oppo-
sitional readers in favor of one where each reader is continuously

re-evaluating his or her relationship to the fiction and reconstructing its meanings according to more immediate interests.

In fact, much of the interest of fans and their texts for cultural studies lies precisely in the ways the ambiguities of popularly produced meanings mirror fault lines within the dominant ideology, as popular readers attempt to build their culture within the gaps and margins of commercially circulating texts. To cite only one example, Lynn Spigel and Henry Jenkins (1991) interviewed a number of "thirtysomethings" about their childhood memories of watching *Batman* on television. Our study sought not so much to reconstruct actual viewing conditions as to gain a better sense of the roles those memories played in the construction of their personal identities. The memories we gathered could not have been fit into ideologically pure categories, but rather suggested complex and contradictory attitudes towards childhood and children's culture. Remembering *Batman* evoked images of a personal past and also of the intertextual network of 1960s popular culture. Remembering the series provided a basis for a progressive critique of contemporary political apathy and cynicism, suggesting a time when social issues were more sharply defined and fiercely fought. Participants' memories also centered on moments when they resisted adult authority and asserted their right to their own cultural choices. For female fans, Catwoman became a way of exploring issues of feminine empowerment, of resistance to male constraints and to the requirement to be a "good little girl." Yet remembering *Batman* also evoked a more reactionary response—an attempt to police contemporary children's culture and to regulate popular pleasures. The adults, no longer nostalgic for childhood rebellion, used the 1960s series as the yardstick for what would constitute a more innocent style of entertainment. The same person would shift between these progressive and reactionary modes of thinking in the course of a single conversation, celebrating childhood resistance in one breath and demanding the regulation of childish pleasures in the next. These very mixed responses to the series content suggest the contradictory conceptions of childhood that circulate within popular discourse and mirror in interesting ways the competing discourses surrounding the television series when it was first aired.

As this study suggests, we must be careful to attend to the particularities of specific instances of critical reception, cultural appropriation, and popular pleasure—their precise historical context, their concrete social and cultural circumstances, for it is the specifics

of lived experience and not simply the abstractions of theory which illuminate the process of hegemonic struggle. For that reason, among others, this book is primarily a succession of specific case studies designed to document particular uses of the media within concrete social and historical contexts rather than a larger theoretical argument which would necessarily trade such specificity for abstraction and generalization. Having established in this chapter some general concepts regarding fan culture and its relationship to the dominant media, I want to illustrate these concepts in action, show how fan culture responds to actual historical and social contexts and trace some of the complex negotiations of meanings characterizing this cultural community's relationship to its favored texts.

NOMADIC READERS

De Certeau offers us another key insight into fan culture: readers are not simply poachers; they are also "nomads," always in movement, "not here or there," not constrained by permanent property ownership but rather constantly advancing upon another text, appropriating new materials, making new meanings (174). Drawing on de Certeau, Janice Radway (1988) has criticized the tendency of academies to regard audiences as constituted by a particular text or genre rather than as "free-floating" agents who "fashion narratives, stories, objects and practices from myriad bits and pieces of prior cultural productions" (363). While acknowledging the methodological advantages and institutional pressures that promote localized research, Radway wants to resist the urge to "cordon" viewers for study, to isolate one particular set of reader-text relationships from its larger cultural context. Instead, she calls for investigations of "the multitude of concrete connections which ever-changing, fluid subjects forge between ideological fragments, discourses, and practices" (365).

Both academic and popular discourse adopt labels for fans— "Trekkies," "Beastie Girls," "Deadheads"—that identify them through their association with particular programs or stars. Such identifications, while not totally inaccurate, are often highly misleading. Media fan culture, like other forms of popular reading, may be understood not in terms of an exclusive interest in any one series or genre; rather, media fans take pleasure in making intertextual connections across a broad range of media texts. The female *Star*

Trek fans discussed earlier understood the show not simply within its own terms but in relationship to a variety of other texts circulated at the time (*Lost in Space*, say, or NASA footage on television) and since (the feminist science fiction novels of Ursula LeGuin, Joanna Russ, Marion Zimmer Bradley, and others). Moreover, their participation within fandom often extends beyond an interest in any single text to encompass many others within the same genre—other science fiction texts, other stories of male bonding, other narratives which explore the relationship of the outsider to the community. The *Batman* fans Spigel and I interviewed likewise found that they could not remain focused on a single television series but persistently fit it within a broader intertextual grid, linking the Catwoman across program boundaries to figures like *The Avengers*' Emma Peel or the *Girl from UNCLE*, comparing the campy pop-art look of the series to *Mad* or *Laugh In*. Fans, like other consumers of popular culture, read intertextually as well as textually and their pleasure comes through the particular juxtapositions that they create between specific program content and other cultural materials.

On the wall of my office hangs a print by fan artist Jean Kluge—a pastiche of a pre-Raphaelite painting depicting characters from *Star Trek: The Next Generation:* Jean-Luc Picard, adopting a contemplative pose atop a throne, evokes the traditional image of King Arthur; Beverly Crusher, her red hair hanging long and flowing, substitutes for Queen Guinevere; while in the center panel, Data and Yar, clad as knights in armor, gallop off on a quest. Visitors to my literature department office often do a double-take in response to this picture, which offers a somewhat jarring mixture of elements from a contemporary science fiction series with those drawn from chivalric romance. Yet, this print suggests something about the ways in which *Star Trek* and other fan texts get embedded within a broader range of cultural interests, indicating a number of different interpretive strategies. The print could be read in relation to the primary series, recalling equally idiosyncratic juxtapositions during the holodeck sequences, as when Picard plays at being a tough-guy detective, when Data performs *Henry V* or studies borscht-belt comedy, or when the characters dash about as Musketeers in the midst of a crewmember's elaborate fantasy. Indeed, Kluge's "The Quest" was part of a series of "holodeck fantasies" which pictured various *Star Trek* characters at play. The combinations of characters foreground two sets of couples—Picard and Crusher, Yar and Data—which were suggested by program subplots and have formed the

focus for a great deal of fan speculation. Such an interpretation of the print would be grounded in the text and yet, at the same time, make selective use of the program materials to foreground aspects of particular interest to the fan community. Ironically, spokesmen for *Star Trek* have recently appeared at fan conventions seeking to deny that Data has emotions and that Picard and Crusher have a romantic history together, positions fans have rejected as inconsistent with the series events and incompatible with their own perceptions of the characters.

The image could also invite us to think of *Star Trek* transgenerically, reading the characters and situations in relation to tradition of quest stories and in relation to generic expectations formed through fannish readings of popular retellings of the Arthurian saga, such as Marion Zimmer Bradley's *Mists of Avalon* (1983), Mary Stewart's *The Crystal Cave* (1970), T. H. White's *The Once and Future King* (1939), or John Boorman's *Excalibur*. Such an interpretation evokes strong connections between the conventional formula of "space opera" and older quest myths and hero sagas.

The print can also be read extratextually, reminding us of actor Patrick Stewart's career as a Shakespearean actor and his previous screen roles in sword and sorcery adventures like *Excalibur, Beast Master*, and *Dune*. Fans often track favored performer's careers, adding to their video collections not simply series episodes but also other works featuring its stars, works which may draw into the primary text's orbit a wide range of generic traditions, including those of high culture.

A fan reader might also interpret the Kluge print subculturally, looking at it in relation to traditions within fan writing which situate series characters in alternate universes, including those set in the historical past or in the realm of fantasy, or which cross media universes to have characters from different television series interacting in the same narrative.

Finally, a fan reader might read this print in relation to Kluge's own ouevre as an artist; Kluge's works often juxtapose media materials and historical fantasies, and encompass not only her own fannish interests in *Star Trek* but a variety of other series popular with fans (*Blake's 7, Beauty and the Beast, Alien Nation*, among others).

Contemplating this one print, then, opens a range of intertextual networks within which its imagery might be understood. All available to *Trek* fans and active components of their cultural experience,

these networks link the original series both to other commercially produced works and to the cultural traditions of the fan community. Not every fan would make each of these sets of associations in reading the print, yet most fans would have access to more than one interpretive framework for positioning these specific images. Thinking of the print simply as an artifact of a *Star Trek*-fixated fan culture would blind us to these other potential interpretations that are central to the fans' pleasure in Kluge's art.

Approaching fans as cultural nomads would potentially draw scholars back toward some of the earliest work to emerge from the British cultural studies tradition. As Stuart Hall and Tony Jefferson's *Resistance through Rituals* (1976) or Dick Hebdidge's *Subculture: The Meaning of Style* (1979) document, British youth groups formed an alternative culture not simply through their relationship to specific musical texts but also through a broader range of goods appropriated from the dominant culture and assigned new meanings within this oppositional context. The essays assembled by Hall and Jefferson recorded ways symbolic objects—dress, appearance, language, ritual occasions, styles of interaction, music—formed a unified signifying system in which borrowed materials were made to reflect, express, and resonate aspects of group life. Examining the stylistic bricolage of punk culture, Hebdidge concluded that the meaning of appropriated symbols, such as the swastika or the safety pin, lay not in their inherent meanings but rather in the logic of their use, in the ways they expressed opposition to the dominant culture.

Feminist writers, such as Angela McRobbie (1980, 1976), Dorothy Hobson (1982, 1989), Charlotte Brunsdon (1981), and Mica Nava (1981), criticized these initial studies for their silence about the misogynistic quality of such youth cultures and their exclusive focus on the masculine public sphere rather than on the domestic sphere which was a primary locus for feminine cultural experience. Yet their own work continued to focus on subcultural appropriation and cultural use. Their research emphasized ways women define their identities through their association with a range of media texts. McRobbie's "Dance and Social Fantasy," (1984) for example, offers a far reaching analysis of the roles dance plays in the life of young women, discussing cultural materials ranging from a children's book about Anna Pavlova to films like *Fame* and *Flashdance* and fashion magazines. Like Hebdidge, McRobbie is less interested in individual texts than in the contexts in which they are inserted; McRobbie

shows how those texts are fit into the total social experience of their consumers, are discussed at work or consumed in the home, and provide models for social behavior and personal identity.

These British feminist writers provide useful models for recent work by younger feminists (on both sides of the Atlantic) who are attempting to understand the place of media texts in women's cultural experiences, (for useful overviews of this work, see Long, 1989; Rotman, Christian-Smith, and Ellsworth, 1988; Schwictenberg, 1989; Woman's Studies Group, 1978). Drawing on McRobbie's research, Lisa Lewis (1987), for example, has explored what she describes as "consumer girl culture," a culture which converges around the shopping mall as a specifically female sphere. Lewis links the "woman-identified" music videos of Cyndi Lauper and Madonna to the concerns of this "consumer girl culture," suggesting that these pop stars provide symbolic materials expressing the pleasure female adolescents take in entering male domains of activity. The young women, in turn, adapt these symbolic materials and weave them back into their everyday lives, imitating the performers' idiosyncratic styles, and postering their walls with their images. Images appropriated from MTV are linked to images drawn from elsewhere in consumer culture and form the basis for communication among female fans about topics common to their social experience as young women.

Following in this same tradition, I want to focus on media fandom as a discursive logic that knits together interests across textual and generic boundaries. While some fans remain exclusively committed to a single show or star, many others use individual series as points of entry into a broader fan community, linking to an intertextual network composed of many programs, films, books, comics, and other popular materials. Fans often find it difficult to discuss single programs except through references and comparisons to this broader network; fans may also drift from one series commitment to another through an extended period of involvement within "fandom." As longtime fan editor Susan M. Garrett explains: "A majority of fans don't simply burn out of one fandom and disappear. . . . In fact, I've found that after the initial break into fandom through a single series, fans tend to follow other people into various fandoms, rather than stumble upon programs themselves" (Personal correspondence, July 1991). Garrett describes how fans incorporate more and more programs into their interests in order to facilitate greater communication with friends who share common interests

or possess compatible tastes: "Well, if she likes what I like and she tends to like good shows, then I'll like this new show too" (Personal correspondence, July 1991). To focus on any one media product—be it *Star Trek* or "Material Girl"—is to miss the larger cultural context within which that material gets embedded as it is integrated back into the life of the individual fan.

Fans often form uneasy alliances with others who have related but superficially distinctive commitments, finding their overlapping interests in the media a basis for discussion and fellowship. Panels at MediaWest, an important media fan convention held each year in Lansing, Michigan, combine speakers from different fandoms to address topics of common interest, such as "series romances," "disguised romantic heroes," "heroes outside the law," or "Harrison Ford and his roles." Letterzines like *Comlink*, which publish letters from fans, and computer net interest groups such as Rec.Arts.TV, which offer electronic mail "conversation" between contributors, facilitate fan discussion and debate concerning a broad range of popular texts. Genzines (amateur publications aiming at a general fan interest rather than focused on a specific program or star) such as *The Sonic Screwdriver, Rerun, Everything But . . . The Kitchen Sink, Primetime,* or *What You Fancy* offer unusual configurations of fannish tastes that typically reflect the coalition of fandoms represented by their editors; these publications focus not on individual series but on a number of different and loosely connected texts. *Fireside Tales* "encompasses the genre of cops, spies and private eyes," running stories based on such series as *Hunter, I Spy, Adderly, Riptide,* and *Dempsey and Makepeace* while *Undercover* treats the same material with a homoerotic inflection. *Walkabout* centers around the film roles of Mel Gibson including stories based on his characters in *Lethal Weapon, Year of Living Dangerously, Tim, Tequila Sunrise,* and *The Road Warrior. Faded Roses* focuses on the unlikely combination of *Beauty and the Beast, Phantom of the Opera,* and *Amadeus,* "three of the most romantic universes of all time." *Animazine* centers on children's cartoons, *The Temporal Times* on time-travel series, *The Cannell Files* on the series of a particular producer, *Tuesday Night* on two shows (*Remington Steele* and *Riptide*) which were once part of NBC's Tuesday night line-up, and *Nightbeat* on stories in which the primary narrative action occurs at night, "anything from vampires to detectives."

This logic of cultural inclusion and incorporation is aptly expressed within the flier for one fan organization:

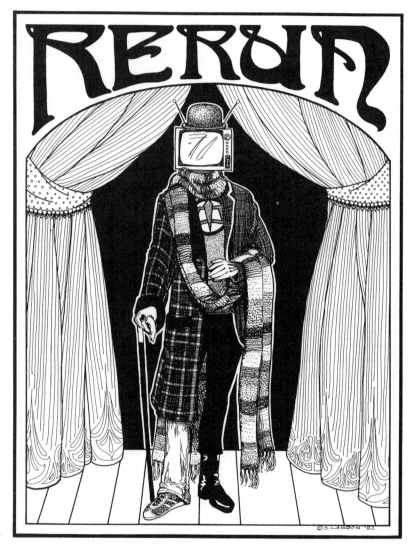

1.4 Signe Landon Danler, *Rerun*. This cover for a multi-media zine borrows iconography from a number of different series, including the Doctor's scarf, Barnabas Collins' cane and ring, John Steed's bowler, and Jim Kirk's pants.

DO YOU :

Have the urge to wear a 17-foot scarf?
Desire to be known as 'Madam President?'
Find it "Elementary, my dear Watson?"
Are you continually looking toward
 the sky for 'unwelcomed' visitors?

OR

Do you just want to visit "Fawlty Towers?" or
Join CI-5 to become a true 'Professional?'
Then you need search no further!
Set your time/space/relative dimention coordinates

FOR:

Anglofans Unlimited
(A British Media/Doctor Who/Blake's 7, etc. club)

Begun by a merry troup of loonies and ex-Federation convicts in February of 1987. Our boundries encompass the entire colonies of Britain (U.S., Canada & Australia). Among the benifits we offer are:

- A bi-monthly newsletter, "PLAIN ENGLISH," filled with club news, articles, fanzine reviews, convention reports, trivia and more.

- Round Robins--a way to make friends while participating in lively discussions about your favorite subjects.

- A Writing Department for those interested in creating fan fiction.

- Meetings for local members.

- And much, much more!

1.5 Nomadic Poaching: AngloFans Unlimited (A British Media/Doctor Who/Blake's 7, etc. Club)

DO YOU:
> Have the urge to wear a 17-foot scarf?
> Desire to be known as "Madame President?"
> Find it "Elementary, my dear Watson?"
> Are you continually looking toward the sky for
> "Unwelcome" visitors?

OR

> Do you just want to visit "Fawlty Towers?" Or
> Join CI-5 to become a true "Professional?"
> Then you need search no further!
> Set your time/space/relative dimension coordinates

FOR:
ANGLOFANS UNLIMITED
(A British media/Doctor Who/Blake's 7, etc. club).

Members of this club share not simply or even primarily a strong attachment to any given series but a broader configuration of cultural interests and a particularly intimate relationship to media content. The "etc." in the club's description foregrounds the group's constant and "unlimited" ability to accommodate new texts.

WHAT DO POACHERS KEEP?

If I find de Certeau's notions of textual poaching and nomadic reading particularly useful concepts for thinking about media consumption and fan culture, I want to identify at least one important way in which my position differs from his. (Other differences will surface throughout the discussion). De Certeau draws a sharp separation between writers and readers: "Writing accumulates, stocks up, resists time by the establishment of a place and multiplies its production through the expansionism of reproduction. Reading takes no measures against the erosion of time (one forgets oneself *and* also forgets), it does not keep what it acquires, or it does so poorly" (174). Writing, for de Certeau, has a materiality and permanence which the poached culture of the reader is unable to match; the reader's meaning-production remains temporary and transient, made on the run, as the reader moves nomadically from place to place; the reader's meanings originate in response to immediate concerns and are discarded when they are no longer useful. De Certeau draws a useful distinction between strategies and tactics:

strategies are operations performed from a position of strength, employing the property and authority that belong exclusively to literary "landowners," while tactics belong to the mobile population of the dispossessed and the powerless, gaining in speed and mobility what they lack in stability. The tactical strength and the strategic vulnerability of reading, he contends, lies in its inability to form the basis for a stable or permanent culture; readers maintain a freedom of movement at the expense of acquiring resources which might allow them to fight from a position of power and authority. Tactics can never fully overcome strategy; yet, the strategist cannot prevent the tactician from striking again.

While this claim may be broadly applicable to the transient meaning-production which generally characterizes popular reading, it seems false to the specific phenomenon of media fandom for two reasons. First, de Certeau describes readers who are essentially isolated from each other; the meanings they "poach" from the primary text serve only their own interests and are the object of only limited intellectual investment. They are meanings made for the moment and discarded as soon as they are no longer desirable or useful. Fan reading, however, is a social process through which individual interpretations are shaped and reinforced through ongoing discussions with other readers. Such discussions expand the experience of the text beyond its initial consumption. The produced meanings are thus more fully integrated into the readers' lives and are of a fundamentally different character from meanings generated through a casual and fleeting encounter with an otherwise unremarkable (and unremarked upon) text. For the fan, these previously "poached" meanings provide a foundation for future encounters with the fiction, shaping how it will be perceived, defining how it will be used.

Second, fandom does not preserve a radical separation between readers and writers. Fans do not simply consume preproduced stories; they manufacture their own fanzine stories and novels, art prints, songs, videos, performances, etc. In fan writer Jean Lorrah's words (1984), "Trekfandom. . . . is friends and letters and crafts and fanzines and trivia and costumes and artwork and filksongs and buttons and film clips and conventions—something for everybody who has in common the inspiration of a television show which grew far beyond its TV and film incarnations to become a living part of world culture." (N.P.) Lorrah's description blurs the boundaries between producers and consumers, spectators and participants, the commercial and the homecrafted, to construct an image of fandom

as a cultural and social network that spans the globe. Fandom here becomes a participatory culture which transforms the experience of media consumption into the production of new texts, indeed of a new culture and a new community.

Howard Becker (1982) has adopted the term "Art World" to describe "an established network of cooperative links" (34) between institutions of artistic production, distribution, consumption, interpretation, and evaluation: "Art Worlds produce works and also give them aesthetic values" (39). An expansive term, "Art World" refers to systems of aesthetic norms and generic conventions, systems of professional training and reputation building, systems for the circulation, exhibition, sale, and critical evaluation of artworks. In one sense, fandom constitutes one component of the mass media Art World, something like the "serious audience" which Becker locates around the symphony, the ballet, or the art gallery. Not only do "serious audience members" provide a stable base of support for artistic creation, Becker suggests, they also function as arbiters of potential change and development. Their knowledge of and commitment to the art insures that they "can collaborate more fully with artists in the joint effort which produces the work" (48). Historically, science fiction fandom may be traced back to the letter columns of Hugo Gernsbeck's *Amazing Stories*, which provided a public forum by which fans could communicate with each other and with the writers their reactions to published stories; critics suggest that it was the rich interplay of writers, editors, and fans which allowed science fiction to emerge as a distinctive literary genre in the 1930s and 1940s (Ross, 1991; Del Rey, 1979; Warner, 1969; Moskowitz, 1954; Carter, 1977). Since Gernsbeck and other editors also included addresses for all correspondents, the pulps provided a means by which fans could contact each other, enabling a small but dedicated community of loyal science fiction readers to emerge. Fans, under the approving eye of Gernsbeck and the other pulp editors, organized local clubs and later, regional science fiction conventions to provide an arena where they could exchange their ideas about their favorite genre. By 1939, fandom had grown to such a scale that it could ambitiously host a world science fiction convention, a tradition which has continued to the present day.

So, from its initiation, science fiction fandom has maintained close ties to the professional science fiction writing community and has provided intelligent user criticism of published narratives. Fan conventions play a central role in the distribution of knowledge

about new releases and in the promotion of comic books, science fiction novels, and new media productions. They offer a space where writers and producers may speak directly with readers and develop a firmer sense of audience expectations. Fan awards, such as the Hugo, presented each year at the World Science Fiction Convention, play a key role in building the reputations of emerging writers and in recognizing outstanding accomplishment by established figures. Fan publishing has represented an important training ground for professional writers and editors, a nurturing space in which to develop skills, styles, themes, and perhaps most importantly, self confidence before entering the commercial marketplace. Marion Zimmer Bradley (1985) has noted the especially importance of fandom in the development of female science fiction writers at a time when professional science fiction was still male-dominated and male-oriented; fanzines, she suggests, were a supportive environment within which women writers could establish and polish their skills.

Yet media fandom constitutes as well its own distinctive Art World, operating beyond direct control by media producers, founded less upon the consumption of pre-existing texts than on the production of fan texts. Much as science fiction conventions provide a market for commercially produced goods associated with media stories and as a showcase for professional writers, illustrators, and performers, the conventions are also a marketplace for fan-produced artworks and a showcase for fan artists. Fan paintings are auctioned, zines are sold, performances staged, videos screened, and awards are given in recognition of outstanding accomplishments. Semiprofessional companies are emerging to assist in the production and distribution of fan goods—song tapes, zines, etc.—and publications are appearing whose primary function is to provide technical information and commentary on fan art (*Apa-Filk* for fan music, *Art Forum* for fan artists, *Treklink* and *On the Double* for fan writers, etc.) or to publicize and market fan writing (*Datazine*). Convention panels discuss zine publishing, art materials, or costume design, focusing entirely on information needed by fan artists rather than by fan consumers. MediaWest, in particular, has prided itself on being fan-run and fan-centered with no celebrity guests and programing; its activities range from fan video screenings and fanzine reading rooms to workshops with noted fan artists, focused around providing support for the emergence of fan culture. These institutions are the infrastructure for a self-sufficient fan culture.

From its initiation in the 1960s in the wake of excitement about *Star Trek*, media fandom has developed a more distant relationship to textual producers than that traditionally enjoyed within literary science fiction fandom. If literary fans constituted, especially in the early years, a sizeable segment of the potential market for science fiction books, active media fans represent a small and insignificant segment of the audience required to sustain a network television series or to support a blockbuster movie. Media producers and stars have, thus, looked upon organized fandom less as a source of feedback than as, at best, an ancillary market for specialized spin-off goods. The long autograph lines that surround media stars often prohibit the close interaction that fans maintain with science fiction writers and editors.

Indeed, the largely female composition of media fandom reflects a historical split within the science fiction fan community between the traditionally male-dominated literary fans and the newer, more feminine style of media fandom. Women, drawn to the genre in the 1960s, discovered that the close ties between male fans and male writers created barriers to female fans and this fandom's traditions resisted inflection or redefinition. The emergence of media fandom can be seen, at least in part, as an effort to create a fan culture more open to women, within which female fans could make a contribution without encountering the entrenched power of long-time male fans; these fans bought freedom at the expense of proximity to writers and editors. Where this closeness has developed, as in the early years of American *Blake's 7* fandom, it has proven short-lived, since too many institutional pressures separate media professionals and fans.

Moreover, since copyright laws prohibit the commercial distribution of media fan materials and only a small but growing number of fans have gone on to become professional writers of media texts, these fan artists have a more limited chance of gaining entry into the professional media art world and thus have come to regard fandom less as a training ground than as a permanent outlet for their creative expression. (A growing number of media fans have "turned pro," writing professional *Trek* novels, contributing to commercial publications, pursuing careers as science fiction writers, or submitting scripts to television programs, a fact that offers inspiration to many current fan writers who have similar aspirations, yet, I would argue that the importance of media fan cultural production far exceeds its role as a training ground for professional

publishing.) Some fanzine stories and novels, such as the writing of Jean Lorrah, Jacqueline Lichtenberg, Leslie Fish, and Alexis Fagin Black, have remained in print since the late 1960s while others continue to circulate in mangled second-hand editions or faded photocopies. Works by some respected fan artists, such as Jean Kluge, Karen River, Suzan Lovett, and Barbara Fister-Liltz, may fetch several hundred dollars in convention auctions. There are a sizeable number of people who have been active in fandom for most or all of their adult lives and who are now raising children who are active fans. (Perhaps even a few have grandchildren in fandom.)

Media fandom gives every sign of becoming a permanent culture, one which has survived and evolved for more than twenty-five years and has produced material artifacts of enduring interest to that community. Unlike the readers de Certeau describes, fans get to keep what they produce from the materials they "poach" from mass culture, and these materials sometimes become a limited source of economic profit for them as well. Few fans earn enough through the sale of their artworks to see fandom as a primary source of personal income, yet, many earn enough to pay for their expenses and to finance their fan activities. This materiality makes fan culture a fruitful site for studying the tactics of popular appropriation and textual poaching. Yet, it must be acknowledged that the material goods produced by fans are not simply the tangible traces of transient meanings produced by other reading practices. To read them in such a fashion is to offer an impoverished account of fan cultural production. Fan texts, be they fan writing, art, song, or video, are shaped through the social norms, aesthetic conventions, interpretive protocols, technological resources, and technical competence of the larger fan community. Fans possess not simply borrowed remnants snatched from mass culture, but their own culture built from the semiotic raw materials the media provides.

2
How Texts become Real

"What are the requirements for transforming a book or a movie into a cult object? The work must be loved, obviously, but this is not enough. It must provide a completely furnished world so that its fans can quote characters and episodes as if they were aspects of the fan's private sectarian world. . . . I think that in order to transform a work into a cult object one must be able to break, dislocate, unhinge it so that one can remember only parts of it, irrespective of their original relationship with the whole." (Umberto Eco 1986, 197–198)

In an oft-quoted passage from a classic children's story, the old Skin Horse offers the Velveteen Rabbit a Christmas Eve lecture on the practice of textual poaching. The value of a new toy lies not in its material qualities (not "having things that buzz inside you and a stick-out handle"), the Skin Horse explains, but rather in how the toy is used, how it is integrated into the child's imaginative experience: "Real isn't how you are made. It's a thing that happens to you. When a child loves you for a long, long time, not just to play with, but REALLY loves you, then you become real" (Bianco 1983, 4). The Rabbit is fearful of this process, recognizing that consumer goods do not become "real" without being actively reworked: "Does it hurt? . . . Does it happen all at once, like being wound up or bit by bit?" (Bianco, 1983, 4–5) Reassuring him, the Skin Horse emphasizes not the deterioration of the original but rather the new meanings that get attached to it and the relationship into which it is inserted:

It doesn't happen all at once. You become. It takes a long time. That's why it doesn't often happen to people who break easily, or have sharp edges, or who have to be carefully kept. Generally, by the time you are Real, most of your hair has been loved off, and your eyes drop out and you get loose in the joints and very shabby. But these things

don't matter at all, because once you are Real, you can't
be ugly, except to people who don't understand. (Bianco
1983, 5–6)

The boy's investment in the toy will give it a meaning that was
unanticipated by the toymaker, a meaning that comes not from its
intrinsic merits or economic value but rather from the significance
the child bestows upon the commodity through its use. The boy in
Margery Williams Bianco's beloved story did not manufacture the
Velveteen Rabbit nor did he choose it as a gift; yet, only the boy
has the power to bring the toy to life and only the boy grieves its
loss. Only the boy can make it "Real." Bianco's story predates
Michel de Certeau, yet "The Velveteen Rabbit" seemingly reduces
his complex formulations into a simple (if sentimental) fable about
popular consumption.

Seen from the perspective of the toymaker, who has an interest
in preserving the stuffed animal just as it was made, the Velveteen
Rabbit's loose joints and missing eyes represent vandalism, the signs
of misuse and rough treatment; yet for the boy, they are traces of
fondly remembered experiences, evidence of his having held the toy
too close and pet it too often, in short, marks of its loving use.
Theodore Adorno (1978) takes the toymaker's perspective when he
describes how prized cultural texts are "disintegrated" through ov-
erconsumption as they are transformed from sacred artifacts into
"cultural goods": "irrelevant consumption destroys them. Not
merely do the few things played again and again wear out, like the
Sistine Madonna in the bedroom, but reification affects their inter-
nal structure. . . . The romanticizing of particulars eats away the
body of the whole" (281). Adorno suggests that musical texts become
mere "background," lose their fascination and coherence, when they
are played too often or in inappropriate contexts, while popular
texts are made simply to disintegrate upon first use and therefore
have little intrinsic worth. What Adorno's account of repeated con-
sumption misses is the degree to which songs, like other texts, as-
sume increased significance as they are fragmented and reworked
to accommodate the particular interests of the individual listener.

Recent work in cultural studies directs attention to the mean-
ings texts accumulate through their use. The reader's activity is no
longer seen simply as the task of recovering the author's meanings
but also as reworking borrowed materials to fit them into the context
of lived experience. As Michel de Certeau (1984) writes, "Every

reading modifies its object. . . . The reader takes neither the position of the author nor an author's position. He invents in the text something different from what they intended. He detaches them from their (lost or accessory) origin. He combines their fragments and creates something unknown" (169). This modification need not be understood as textual "disintegration" but rather as home improvements that refit prefabricated materials to consumer desires. The text becomes something more than what it was before, not something less.

Long-time science fiction fan P. L. Caruthers-Montgomery (1987) captures many aspects of this process in describing her initiation as an adolescent into *Star Trek* fandom:

> I met one girl who liked some of the TV shows I liked. . . .
> But I was otherwise a bookworm, no friends, working in
> the school library. Then my friend and I met some other
> girls a grade ahead of us but ga-ga over *ST*. From the be-
> ginning, we met each Friday night at one of the two homes
> that had a color TV to watch *Star Trek* together. I had a
> reel-to-reel tape recorder. Silence was mandatory except
> during commercials, and, afterwards, we "discussed" each
> episode. We re-wrote each story and corrected the wrongs
> done to "Our Guys" by the writers. We memorized bits of
> dialog. We even started to write our own adventures. One
> of us liked Spock, one liked Kirk, one liked Scotty, and
> two of us were enamored of McCoy (Yes, I was a McCoy
> fan). To this day, I can identify each episode by name
> within the first few seconds of the teaser. I amaze my hus-
> band by reciting lines along with the characters. (I had
> listened to those tapes again and again, visualizing the ep-
> isodes.) (8)

Such intense interaction eventually leads many fans toward the creation of new texts, the writing of original stories. Viewing the program became a springboard for conversation and debate as the fans evaluated the episodes and "rewrote" them. Much like the Velveteen Rabbit, *Star Trek* was transformed by these young women's interaction with it. Perhaps, the newness of the individual stories were worn away, the aura of the unique text was eroded, yet, the program gained resonance, accrued significance, through their social interactions and their creative reworkings.

Understanding this process seems central to understanding the often complex reconstructions of program materials I will discuss in later chapters. Here, I focus on three central aspects of fans' characteristic mode of reception: ways fans draw texts close to the realm of their lived experience; the role played by rereading within fan culture; and the process by which program information gets inserted into ongoing social interactions.

Two sets of objections are likely to be raised by this discussion. First, some readers may feel that the behaviors described in this chapter are excessive or trivial, that they can be understood within the stereotypes I have previously dismissed. Such a response isolates the moment of reception from its larger context within fan culture. While some of these activities are not necessarily "important" in themselves, they are the enabling conditions for fan cultural productions and for the construction of fandom as a social community. The "Trekkie" stereotype misassigns meanings to these activities, focusing on means as if they were ends and ignoring the results of this intensive commitment to popular fictions. Fannish reading will be understood in this book as a process, a movement from the initial reception of a broadcast toward the gradual elaboration of the episodes and their remaking in alternative terms. These reception practices are so intrinsic to this process that they must be carefully understood before moving to more material forms of fan productivity, even if doing so risks seeing them reinscribed into the circulating stereotypes about fannish obsession.

As for the "excessiveness" of these behaviors, much of this "scandal" stems from the perceived merits and cultural status of these particular works rather than anything intrinsic to the fans' behavior. Would these same practices (close attention, careful rereading, intense discussion, even the decipherment of texts in foreign or archaic languages) be read as extreme if they were applied to Shakespeare instead of *Star Trek*, Italian opera instead of Japanese animation, or Balzac instead of *Beauty and the Beast*? In other times and places, Shakespeare, opera, and Balzac, after all, have been part of popular rather than elite culture and were appreciated by a mass audience rather than institutionally sanctioned and professionally trained critics. I am not necessarily proposing all of these television programs for inclusion in the high art canon. Fans would be the first to acknowledge their flaws and shortcomings, though fans would respond by reworking promising works rather than categorically dismissing them. I would, however, argue that

there is value to these cultural experiences apart from the specific merits of the chosen texts. In truth, it may be the limitations of these individual works that encourage collective forms of creativity less often found in response to works that seem more complete and satisfying in their own terms.

A second likely objection seemingly contradicts but often accompanies the first sets of reservations. Some readers may charge that my descriptions of fannish reception practices would apply equally well to other classes of media consumers. This is at least partially true. There is no sharp division between fans and other readers. Rather, I would insist upon continuities between fan readers and a more general audience. In fact, a major concern of this chapter is to use these fan practices to question how television spectatorship has been conceptualized within contemporary media studies. Yet at the same time, I would stress the degree to which these practices have been institutionalized within fandom and provide a basis for other activities. My goal, then, is neither to see fans as totally outside the mainstream nor as emblematic of all popular reading. I want to document the particularity of fan reception as a specific (though not entirely unique) response to popular works.

FROM BYSTANDERS TO FANS

Recent theories of television spectatorship insist on a sharp contrast between the scopophilic experience of watching a film in a darkened movie theatre and the more causal experience of watching a television program in a cluttered living room. John Ellis (1982), for example, asserts that broadcasting constructs a spectator seeking only to absorb television's "continuous variety" without being fully absorbed into the narrative, a "bystander." He writes, "The viewer is cast as someone who has the TV switched on, but is giving it very little attention: a casual viewer relaxing in the midst of the family group" (162). Lawrence Grossberg (1987) essentially repeats Ellis's assertion in his postmodernist account of "TV's affective economy," claiming that television's constant effacement of distinctions between programs and commercials is mirrored in its reception by "indifferent" television viewers: "It is absurd to think that anyone watches a single television show, or even a single series. . . . There is, in fact, a significant difference between watching a particular program (which we all do sometimes) and watching TV

(which we all do most of the time). That is to say, the specifics of the episode are often less important than the fact of the TV's being on" (34-35). Writers within this paradigm cite a variety of evidence—the fragmented form of the morning news programs (Feuer, 1983), the narrative redundancy of soaps (Modleski, 1983), the particular quality of television sound which signals narratively important events before they occur (Altman, 1986), the seamless "flow" of the television signal itself (Williams, 1974)—to suggest ways television recognizes and encourages distracted and intermittent viewing.

While offering a useful corrective to the images of hypnotic absorbtion in earlier critical accounts of television spectatorship, such approaches have little or no way to explain the fan activities which concern us here. Indeed, having theorized a casual and emotionally distanced spectator, Ellis (1982) concludes that television fans are a theoretical impossibility, contrasting the alleged absence of "telephiles" to the prevalence of cinephiles. Grossberg (1987) suggests that the "in-difference" of television "makes the very idea of a television fan seem strange," since the medium's transience discourages affective alliances with particular programs: "Viewers rarely make plans to watch TV. . . . Its taken-for-grantedness makes it appear trivial, an unimportant moment of our lives, one in which we certainly invest no great energy" (34-45).

Ethnographic accounts of television use argue against totalizing theories: television is watched for many reasons and with different degrees of attentiveness as it is inserted into a range of viewing contexts. As Ann Gray (1987) writes, "the relationship between the viewer and television, the reader and the text, is often a relationship which has to be negotiated, struggled for, won or lost, in the dynamic and often chaotic process of family life" (40-41). The glancing or "indifferent" style of viewing Ellis and Grossberg describe is, thus, no more essential to television consumption than the hypnotic passivity sometimes ascribed to viewers by older critics. Both modes of reception reflect not innate qualities of television but rather the very different social relationships maintained by specific groups of viewers in the context of domestic consumption: for some, mostly men, the home is a place of leisure; for others, mostly women, it is a place of labor. Men often have the freedom to give the television broadcast their full attention while women often face expectations that draw their interests elsewhere (Morley, 1986; Fiske, 1987). For children (Palmer, 1986; Hodge and Tripp, 1986; Jenkins, 1988),

television becomes simply one more toy in the cluttered playroom and is watched only so long as it holds their fascination.

Moreover, the same person may watch television with different degrees of attentiveness and selectivity at different points in the day or according to the relevance of a particular program. Ann Gray (1987), for example, suggests that women watch different shows and with different degrees of interest when they watch videos with their families at night than with their female friends during the daytime. Often, she finds, evening viewing choices reflect the husband's tastes while the wife simply watches to maintain some social contact with her spouse; the wife watches in the evening only intermittingly, disrupted by the other expectations of the household. The women in Gray's study, however, also set aside time to view tapes they specifically chose to watch and that reflect their own tastes; these videos are enjoyed with concentration impossible in the evening hours. Even in women-only contexts, Gray claims, the women talk through shows that fail to hold their interests while watching others with a much higher degree of emotional involvement. As Stuart Hall (1986) writes, "We are all, in our heads, several different audiences at once, and can be constituted as such by different programs. We have the capacity to deploy different levels and modes of attention, to mobilize different competencies in our viewing" (10).

Fans also draw distinctions between regularly viewing a program and becoming fans of a series. Many watch a series, off and on, for an extended period of time before deciding to make a regular commitment to it. An *Alien Nation* fan (Cox, 1990), for example, recalled that she became interested in the series long after her husband started watching it and after she had half-heartedly viewed several episodes: "I did my distracted routine for a while ('yes, dear; nice show, but I'd rather read a book.') I think it all started when I started taping the show and I really started paying attention. Hey, I LIKE this show" (6). As many fans suggested to me, the difference between watching a series and becoming a fan lies in the intensity of their emotional and intellectual involvement. Watching television as a fan involves different levels of attentiveness and evokes different viewing competencies than more casual viewing of the same material. Another *Alien Nation* fan recalls:

> I've got to be honest here. I never thought I'd feel as strongly about a TV show as I did about the original *Star*

Trek series. Oh, there are other shows I've liked, a few I've bothered (or currently bother) to tape, one or two that have pushed me into fan activity. But after a certain number of years had passed, without a repeat of my experience with *Star Trek*, I was forced to the conclusion that being truly excited about a TV show was going to be a once-in-this-lifetime occurrence for me. . . . And then along came *Alien Nation*. Sneaky, sneaky *Alien Nation*. (Huff 1990, 13)

The fan describes the process by which she was drawn from casual interest toward a recognition of her strong emotional investment in the series and its characters:

I saw the listing for the television premiere movie in the *TV GUIDE* and decided it was definitely worth following up, since it was science fiction with a premise we'd enjoyed [in the theatrical film]. We [she and her husband] even, being optimistic sorts, stuck a tape in the VCR. We liked what we saw immediately. And the more episodes we watched, the more we liked the show. Pretty soon we were watching *AN* tapes instead of CNN at dinner time because a week was too long to wait between episodes. Then it was *AN* in-jokes, trading bits of dialogue, and discussing plotlines. (Huff 1990, 13)

Far from indifferent, this viewer, like other fans, makes a commitment to the series, draws it close and interweaves its materials into her daily interactions with her husband. Here, the details of particular stories matter greatly. She is not simply "watching television"; she is watching *Alien Nation*; no other text could possibly substitute for the pleasures she takes in this particular program. (And, for that matter, the individual episodes are far from interchangeable within her reception of the series, as we will see in chapter three.)

While Grossberg's "indifferent" viewer watches a popular series when it is convenient, when there are no other plans for the evening or nothing better on a competing channel, fans, as committed viewers, organize their schedules to insure that they will be able to see their favorite program. Confessions of missing an episode are almost automatically met with sympathetic offers from other fans willing to "clone" tapes to remedy this gap. The series becomes the object of anticipation: previews are scrutinized in fine detail, each frame

stopped and examined for suggestions of potential plot develop-
ments; fans race to buy *TV Guide* as soon as it hits the newsstands
so that they may gather new material for speculation from its pro-
gram descriptions. Secondary materials about the stars or producers
are collected and exchanged within the fan network.

While my description might make such practices sound fetish-
istic, these activities provide the fan with the information needed
to participate fully in the critical debates of the fan community; a
missed episode means a loss of information shared by others, mak-
ing it harder to participate in discussions of the program and weak-
ening their mastery over the series. Advanced information provides
resources for speculation, creating opportunities for additional de-
bates about the likely outcomes of a sketchily described future event.

If television often competes with other household activities and
therefore does not receive the viewers' full interest, fans watch their
favorite show with rapt attention, unplugging the telephone or put-
ting the kids to bed to insure that they will not be interrupted. I
asked Boston-area *Beauty and the Beast* fan club members to de-
scribe the context within which they normally watched the series.
One woman wrote in all capitals, "ALONE—WITHOUT DIS-
TRACTIONS OF *ANY* KIND," a theme repeated with somewhat
less emphasis in most of the other responses. One woman preferred
to watch in a room lit only by candles, another late at night when
her family was away; the majority watch it by themselves or with
other fans, since they feared others would not understand the pro-
tocols of viewing. Several described not the physical or social con-
text where viewing occurred, but rather the emotions that motivated
the experience. One watches her *Beauty and Beast* tapes "whenever
I'm depressed or upset"; another said she watched it "alone, with
a box of hankies nearby—(sniff)."

At one of the club meetings, the women took turns recounting
the precise moment when they first realized they had become fans
of the series; the women described the experience with the same
pleasure with which one might recount the progression of a ro-
mance. Each personal narrative was met with applause and sym-
pathetic laughter; there were frequent interruptions as the women
shared similar experiences and it was through this process that the
group reaffirmed its commonality and community: "I was sitting
there and I didn't get any work done. My chin was on the ground!
I couldn't believe what I was seeing." "I sat there and I sat there
and I'm like this and my kids come in and I remember them going

For those media fans who think 'The Big Three' newtorks are BCC1, BBC2, and ITV, we proudly present:

THE BRITISH EDITION OF

THE ACME STORY PLOTTING DICE

Give yourself the benefits of years of Anglophilia. By cutting and folding these dice as per the instuction and with one piece of tape for each, you, too can plot a BBC approved story for your favorite British television series, not matter what the genre!

*Situation Comedies *Westerns *Medical Programs
* Police or Detective Dramas *Science Fiction, Fantasy, or even Horror!

Television that starts at 3 PM and ends at 11 PM every night...what a concept! And, for the bold, adventurous soul, why not use the original **ACME STORY PLOTTING DICE** in conjunction with the **REVENGE** and **BRITISH** editions? Try a plot so complicated even Alistair Cooke would think twice about trying to explain it!

WARNING: May be harmful if swallowed whole or taken seriously. Offer void in Gibralter, certain parts of Wales, and wherever quality literature is sold.

2.1 Acme Story Plotting Dice, Author unknown. This parody suggests how fans play with the narrative conventions of popular television.

past me vaguely but I didn't let it distract me at all." The language of fans, like that of other enthusiasts, is exaggerated for comic effect as they speak of "addictions," "infections," and "seductions," descriptions accepted gleefully by the other members of the group. Yet this language also captures something of the closeness they feel to this program and the intense emotions they experience as they watch it. The fans may just be "sitting there" watching television but they are so emotionally engaged by the on-screen action that they seem oblivious to other household activities and actively ignore other family members' demands for their attention. Janice Radway (1984) has suggested that much of the pleasure for readers of romances may lie in creating time for themselves outside of the demands of other family members; the same can be said for female fans of programs like *Alien Nation* and *Beauty and the Beast*, though describing reading (and by extension, viewing) as a release from domestic demands only gives part of the picture. One still has to understand what these women find, what types of pleasures they gain from getting so absorbed in the series narratives, what interpretive strategies they employ in making meaning of their contents.

SITTING TOO CLOSE?

Recent formulations of critical distance and intellectual engagement leave us uncomfortable with such viewing practices. Surely, it can't be healthy (morally, socially, ideologically, aesthetically, depending on your frame of reference) to give oneself over so totally to a television broadcast! As Pierre Bourdieu (1980) suggests, contemporary "bourgeois aesthetics" consistently values "detachment, disinterestedness, indifference" over the affective immediacy and proximity of the popular aesthetic (237–239). The popular, Bourdieu claims, is often characterized by the "desire to enter into the game, identifying with the characters' joys and sufferings, worrying about their fate, espousing their hopes and ideals, living their lives" (237–239). The "bourgeois" aesthetic Bourdieu identifies often distrusts strong feelings and fears the loss of rational control suggested by such intense and close engagement with the popular. Even when such critics accept some popular culture as worthy of serious attention, they typically read popular works as if they were materials of elite culture, introducing "a distance, a gap"

between themselves and the text; the intellectual reader of popular texts focuses less on their emotional qualities or narrative interests than upon those aspects which "are only appreciated rationally through a comparison with other works," (upon evaluative notions of authorship, for example). Bourdieu finds this approach "incompatible with immersion in the singularity of the work immediately given" (239). These viewers, Bourdieu suggests, consistently deny the pleasures of affective immediacy in favor of the insights gained by contemplative distance. It is important to recognize that Bourdieu is describing a specific moment in the history of aesthetics, one often claiming the weight of a long tradition but actually a rejection of broader currents in aesthetics which embraced rather than rejected strong emotions (such as the aesthetic theories of Aristotle or of the romantics); Bourdieu is careful to specify the historical and social context where this ideal of distanced observation originated, though his followers have not always done so.

Since Brecht, this discomfort with proximity has assumed a specifically political dimension within ideological criticism: the naive spectator, drawn too close to the text emotionally, loses the ability to resist or criticize its ideological construction; critical distance, conversely, bestows a certain degree of freedom from the ideological complicitness demanded by the text as a precondition for its enjoyment. Within this formulation, distance empowers, proximity dominates. Mary Ann Doane (1987) suggests that the traits most often ascribed to the experience of mass culture, "proximity rather than distance, passivity, overinvolvement and overidentification" (2), are those traditionally ascribed to femininity. If traditional masculinity provides spectators with some critical distance from media texts, Doane argues, the female spectator is often represented as drawn so close to the text that she is unable to view it with critical distance and hence as less capable of resisting its meanings. Such identification, Doane suggests, cannot be "a mechanism by means of which mastery is assured," but rather "can only be seen as reinforcing her submission" to textual authority (16).

Michel de Certeau (1984) adopts a similar logic in his attempt to trace popular reading practices, falling prey to larger currents within European modernism that run directly counter to his larger argument. De Certeau constructs a dubious historical argument, positing a movement within Western culture from orality towards literacy which has worked to free the reader from textually imposed ideologies: "In earlier times, the reader interiorized the text; he made

his voice the body of the other; he was its actor. Today, the text no longer imposes its own rhythm on the subject, it no longer manifests itself through the reader's voice. This withdrawal of the body, which is the condition for its autonomy, is a distancing of the text. It is the reader's *habeas corpus*" (176). If earlier readers linked the comprehension of the printed word with "uttering the words aloud or at least mumbling them," modern readers comprehend the text without moving their lips, without engaging their bodies. The result, de Certeau suggests, is that modern readers are able to hold the text at a greater distance and to gain mastery over its meanings, free of its physical hold on them: "The autonomy of the eye suspends the body's complicities with the text; it unmoors it from the scriptural place; it makes the written text an object and it increases the reader's possibilities of moving about" (176). The separation of speech from reading frees the reader to engage in the nomadic poaching that de Certeau ascribes to popular reading practices.

De Certeau's endorsement of critical distance disappoints in its refusal to recognize the most profound aspects of his own argument: poachers do not observe from the distance (be it physical, emotional, or cognitive); they trespass upon others' property; they grab it and hold onto it; they internalize its meanings and remake these borrowed terms. The easy fit between Bourdieu's "bourgeois" aesthetic of bodily distance and Brecht's political ideal of critical distance should make us suspicious: perhaps, rather than empowering or enlightening, distance is simply one of the means by which the "scriptural economy" works to keep readers' hands off its texts. For the distanced observer, the text remains something out there, untouched and often untouchable, whose materials are not available for appropriation precisely because they can never fully become one's own property. Proximity seems a necessary precondition for the reworkings and reappropriations de Certeau's theory suggests. The text is drawn close not so that the fan can be possessed by it but rather so that the fan may more fully possess it. Only by integrating media content back into their everyday lives, only by close engagement with its meanings and materials, can fans fully consume the fiction and make it an active resource.

Agency is an important variable in this discussion: contemporary accounts of proximity and distance, particularly those from post-1968 ideological critics, treat them as if spectator "positions" were effects of the textual structure, something that happens to readers in the course of consuming the narrative. The reader is "posi-

tioned" ideologically; certain textual features "determine" how the reader will respond to the represented events or the depicted characters; viewers have no choice but to accept the ideological "demands" of the narrative system. Such a reductive model ascribes little or no agency to the reader while attributing tremendous power and authority to authorial discourse. De Certeau's notion of textual poaching focuses attention on the social agency of readers. The reader is drawn not into the preconstituted world of the fiction but rather into a world she has created from the textual materials. Here, the reader's pre-established values are at least as important as those preferred by the narrative system. Proximity and distance are different approaches readers adopt in making sense of the constructed narrative: "Sometimes, in fact, like a hunter in the forest, he spots the written quarry, follows a trail, laughs, plays tricks, or else like a gambler, lets himself be taken in by it" (173).

The raw materials of the original story play a crucial role in this process, providing instructions for a preferred reading, but they do not necessarily overpower and subdue the reader. The same narratives (*Dragnet*, say) can be read literally by one group and as camp by another. Some groups' pleasure comes not in celebrating the values of their chosen works but rather in "reading them against the grain," in expressing their opposition to rather than acceptance of textual ideology. Perhaps the most extreme example of resistive reading involves what Jeff Sconce (1989) has described as "the cult of 'Bad' cinema," fans who celebrate the most dubious aspects of the Hollywood cinema and who are drawn toward low-budget exploitation films such as *Glen or Glenda*, *Robot Monster*, and *Blood-Orgy of the She-Devils*. Sconce documents this movement's aesthetics ("It isn't enough that a movie be campy and mediocre. It must show incomparably flawed craftsmanship in every detail. It must be so stupefyingly [sic] artless that it IS ART, albeit of the most accidental kind" [pp. 9–10]) and social mission ["The search for BADTRUTH.... To resist temptations of REFINEMENT, TASTE, and ESCAPISM"]). These fans celebrate the technical incompetence and flawed conceptions of what they identify as some of the worst movies ever made, finding there a repudiation of respectable taste and middle-class values. The directors of "BAD-FILMS" are treated as undiscovered stylists in a travesty of conventional auteurism and fans read with perverse pleasure accounts of the filmmakers' failed careers and struggles against spartan production circumstances. Sconce suggests as well that these fans un-

2.2 Fan cartoonist Leah Rosenthal often plays with the border between television characters as real and as constructed, as in this spoof of the final episode of *Blake's 7*.

derstand their relationship to the dominant cinema in explicitly political terms, seeing a rejection of conventional aesthetics as simultaneously a rejection of conventional politics. Here, the fans' pleasure lies in distancing themselves from the text, in holding it at arm's length and laughing in its face. Such an approach combines both a begrudging respect for these films, albeit within an inverted framework of evaluations, as well as a gleeful disrespect for their bad plotting, clumsy acting, and pretentious conceptions.

Here, as elsewhere in popular reading, proximity and distance are not fixed "positions," established at the outset of the viewing experience and unaltered by changes in the reception context or narrative information. Rather, these relationships between readers and texts are continually negotiated and viewers may move fluidly between different attitudes toward the material. As several accounts of fan culture suggest, a sense of proximity and possession coexists quite comfortably with a sense of ironic distance (Amesley, 1989; Ang, 1985; Buckingham, 1987). In fact, fans often display a desire to take the program apart and see how it works, to learn how it was made and why it looks the way it does. Commercial publications feed the fan's desire for "insider information" about make-up and special effects techniques, casting decisions and scripting problems, performer and producer backgrounds, and network programing policies that impact a favorite show's chances for renewal. If the classical Hollywood cinema and its counterpart, the realist television text, have often been accused of masking the mechanisms of their own production, one needs to reconsider the role(s) played by these extratextual discourses in the viewers' experience.

Christian Metz (1977) has written of special effects (or rather, what he calls *trucage*) as an "avowed machination." The creation of these illusions is announced both within the film itself, through their formal presentation, and "in the periphery of the film, in its publicity, in the awaited commentaries which will emphasize the technical skill to which the imperceptible trucage owes its imperceptibility" (670). Thus, one experiences these effects by "dividing one's credibility," enjoying the mechanics of these illusions while still losing oneself in their narrative implications. Metz's commitment to psychoanalytic models of subject positioning requires him to see this divided credibility as an effect of the text's structure, while his own account invites us to see it as a way that extratextually informed readers negotiate between different levels of discourse and different modes of viewing. A *Starlog* article on the making of *Teen-*

age Mutant Ninja Turtles, for example, provides an account of the "remarkable" Turtle suits manufactured by Jim Henson's Creature Shop for use in the film and of the "challenges" faced by the actress who must play opposite the Turtles: "The eye contact she would normally maintain with a fellow actor was severed by the false orbs in the Turtle masks. Nearly every simple exchange of dialogue she shared with her costars brought a barrage of voices down upon her, from the players giving their lines as well as from the technicians who were busily articulating their handiwork's expressions" (Dickholtz 1990, 19). The viewer, armed with this behind-the-scenes information, has the choice of watching such scenes with suspended disbelief (treating the rubber-masked characters as Turtles, sutured into their reptilian gaze) or with a renewed respect for the craftsmanship and technical expertise that made this illusion possible. One approach allows the viewer to be absorbed into the realm of the fiction, the other holds the fiction at a distance in order to better appreciate how it was constructed, but both approaches are central to the fans' experience.

Analyzing the oral comments fans make during public consumption of *Star Trek* episodes, Cassandra Amesley (1989) finds evidence that fans see the fictional characters and their actions as simultaneously "real" and "constructed", adopting a strategy of "double viewing" that treats the show with both suspended disbelief and ironic distance. The characters are understood as "real" people with psychologies and histories that can be explored and as fictional constructions whose shortcomings may be attributed to bad writing or the suspect motivations of the producers. One reading privileges the fictional universe, the other the extratextual information the viewer has acquired. Amesley (1989) suggests that this dual interpretive stance may be a necessary precondition for fans' creative reworking of the media content: "Recognizing *Star Trek* as constructed makes it possible to intervene in the construction; to take an active role in appropriating new texts or commenting on old ones" (337–338). This distance from the fiction helps to explain how fans can pull the program close to them and still remain partially free of its ideological positioning. Yet, paradoxically, the closeness the fans feel toward narratives and characters motivates their extensive reworking and reappropriation of those materials.

VCRs, RERUNS AND REREADING

In an oft-quoted and little analyzed passage, Roland Barthes (1975) suggests that rereading runs counter to "commercial and ideological habits of our society" and thus books are constructed to sustain our interests only on a first reading "so that we can then move on to another story, buy another book" (15–16). Rereading is tolerated, Barthes claims with characteristic irony, only for certain classes of readers ("children, old people and professors"). His own account of the experience of reading Balzac's "Sarrasine" systematically privileges a first reading, driven by the desire to resolve the enigmas surrounding the central character's identity, an urge satisfied by the story's conclusion.

Barthes nevertheless offers several useful suggestions about the process of rereading: first, since narratives build heavily upon intertextual knowledge, all reading is essentially rereading as we draw upon cultural codes and social assumptions acquired through our previous encounters with other texts. Second, Barthes claims that the act of rereading fundamentally alters our experience of a fictional narrative: "Rereading draws the text out of its internal chronology ('this happens before or after that') and recaptures a mythic time (without before or after)" (16). The insistent demands of the hermeneutic code, the desire to resolve narrative mysteries, loses its grip on the reader once the story's resolution becomes fully known. Interest shifts elsewhere, onto character relations, onto thematic meanings, onto the social knowledge assumed by the narrator: "rereading is no longer consumption but play" (16). The reread book is not the work we encountered upon an initial reading; it is "the same and new."

Much attention has been placed on the reader's experience of intertextuality. Indeed, the first of these two claims has even been used to deny the possibility and desirability of popular rereading. Mike Budd (1990), for example, writes, "The rereading performed while viewing the film the first time can thus become a justification for not viewing it, not rereading it, again. . . . For the film to become a commodity consumable in one viewing, rereading must be carefully contained, minimizing narrative or other puzzles that might prompt reflection or critical examination" (41). Budd, thus, uses Barthes as a basis for drawing a cultural distinction between high art texts, such as *Cabinet of Dr. Caligari*, which require rereading to achieve their full impact and popular texts which are routinely

disposed after a first "rereading." Resisting that argument, I want
to consider the second of Barthes' claims about rereading more fully
here, to focus on ways that rereading alters the priorities of the
narrative and allows readers to bring it more fully under their own
control.

Even in literary studies, the work of Tony Bennett and Janet
Wollacott (1987), Janice Radway (1984) and Helen Taylor (1989),
among others, points to the important role which rereading plays
in the popular consumption of books, requiring a reconsideration
of Barthes' insistence that rereading is a relatively rare occurrence.
Rereading, however, may be an even more important question for
media studies than it is for traditional literary studies. If, as Barthes
suggests, the economic rationale of publishing requires the contin-
uous sale of new books and thus discourages repeated consumption,
broadcasting does not sell programs to viewers but rather sells view-
ers to advertisers. If the same episode can be shown repeatedly and
still attract new or repeat viewers, then, the broadcasters have found
a way to expand economic revenues without additional expenses.
The most lucrative aspects of broadcasting are not the first showings
of new programs but rather repeats of old shows through reruns and
syndication. As Todd Gitlin (1983) has explained, "In a sense, every
series developed was an investment in the chance of syndication,
although only one in forty series on the air lasts long enough to be
syndicated" (66). Similarly, the economic logic of Hollywood now
emphasizes a limited number of major blockbusters, seen multiple
times by the cinema's dwindling audience, rather than a broader
range of films viewed only once. This push toward repeat viewers
is reinforced by videotape sales and rentals as an important sec-
ondary market for film releases. This experience of rereading must
be understood as a central aspect of the reception of both television
programs and contemporary films.

Despite the centrality of these practices to the economic struc-
ture of the film and television industries, relatively little research
has been done on their impact on the readers' experience of these
narratives. In one of the few studies specifically focused on the rerun,
Jenny L. Nelson (1990) argues that this practice dramatically alters
how we think about the medium. She identifies a number of reasons
why watching a series episode in rerun is a fundamentally different
experience from watching that same program on its initial airing.
Traditional genre distinctions blur as categories such as "50s TV"
(which includes *Dragnet* and *I Love Lucy*) become more descriptive

than the category of sitcom (which could include everything from *I Married Joan* to *All in the Family* and *Major Dad*). Our emotional response to particular programs shift as they become dated or obsolete, such that *The Mod Squad* moves from socially relevant to laughably bad, as televisual codes and ideological assumptions that are natural in one context seem obvious and forced in another. Subtle changes within the development of individual series become more apparent as the episodes are shown outside of their original sequence, so that "Hawkeye rooms with BJ on Tuesday and Thursday and with Trapper John on Wednesday and Friday" (85). The episodes become enmeshed in the viewer's own life, gaining significance in relation to when they were first encountered and evoking memories as rich as the series itself; these experiences alter viewer's identifications with characters and the significance they place upon narrative events. The pleasures offered by the rerun episodes, then, reflect not simply the enduring quality of the original programs but the ways they can be inflected through the viewer's repeated experience of them. As Nelson writes, "Any change in this one-sided relationship can take place only through *my* initiative. It is I who modulates an already familiar setting by taking it up again and transforming it" (88).

Rereading is central to the fan's aesthetic pleasure. Much of fan culture facilitates repeated encounters with favored texts. As P. L. Caruthers-Montgomery (1987) recalls, *Star Trek* fans watched the series countless times in reruns. They also made other attempts to duplicate the viewing experience by using audiotape recorders to preserve the soundtrack, writing detailed plot descriptions either for their own use or for publication in fanzines, or trying to memorize the dialog. The first professionally published *Star Trek* books were novelizations of the original episodes; only later did the professional novels build upon rather than duplicate the original stories. Guides to series such as *Doctor Who*, *The Avengers*, *The Twilight Zone*, and *The Prisoner* are also in wide demand. Where such professional program guides are unavailable, fans produce their own. One dedicated *Dark Shadows* fan, Kathleen Resch (n.d.), has spent years preparing a multivolume guide for the series, providing "accurate, fully-detailed summaries" of each of more than 1,200 aired episodes, helping to keep interest in the series alive during several decades when it was unavailable. An ad for *The Dark Shadows Storyline* claims, "the synopses are so detailed that seeing these fourth year episodes (if and when we do) will almost be an anticlimax." When

professional program guides appear, they lack both the accuracy and detail of the fan versions; such books typically make mistakes such as misnaming minor characters, providing vague or misleading explanations for motivations, and distorting narrative actions and their consequences. Fans often see these commercial publications as hackwork lacking the affection, dedication, and rigor fans bring to similar projects. As a result, they supplement rather than displace the amateur guides.

The development of affordable home videotape recorders makes the rereading process far simpler not only for fans but for all viewers. Most fans now can own copies of the complete episodes of their favorite series and watch them whenever they wish. All of the members of the *Beauty and the Beast* fan club told me that they had archives of episodes on videotape. Many of the Boston *Beauty and the Beast* fans also listed a number of other series they collected. Several suggested that they have learned to tape pilot episodes of new shows, if they think there's any chance they will like them, since network reruns are increasingly unpredictable and series runs short-lived. Those who lacked one or two episodes of their favorite series were in the process of getting copies from other club members.

The development of new fandoms has increased dramatically since the easy access of videotapes allows the introduction of programs to viewers who may have missed them or were unaware of them when they were first broadcast. Some British series—*Blake's 7, The Professionals, The Sandbaggers, Star Cops, Red Dwarf*—have developed vital American fan followings with little or no airplay in this country, largely on the basis of the underground exchange of videotapes. In a fairly typical transaction, my wife and I received the first seasons' episodes of *Blake's 7* as a Christmas present one year, never having seen the show before, and were so captivated by it that we negotiated with several different fans to acquire the remainder of the series. Since then, we have introduced a number of other people to the program ("New Souls for the Faith" as *Blake's 7* fans jokingly call them, a reference to a particular line from the series); each time, their initiation into the fandom obligated us to provide these new fans with access to videotape copies. As one fan explains, "Using the VCR and the pre-existing fan network, the TV viewer is freed of the constraints of local programing. Want to watch *B7* or *Sandbaggers* or *Red Dwarf,* but your station ignores your letters? Ask around, and soon you've got your own copy and you can ignore the stupidity of the program director!" (Meg Garrett,

personal correspondence, 1990). Even where programs are locally available, fans tap into the underground fan network to gain early access to popular series such as *Doctor Who* which airs in America a season or two after its British broadcast; conversely, *Star Trek: The Next Generation* is hotly sought by British fans for similar reasons.

The exchange of videotapes has become a central ritual of fandom, one of the practices helping to bind it together as a distinctive community. Sometimes, fans offer two blank tapes in return for one of program material or fans may barter and trade treasures from their collections, but just as often, fans expect nothing in return for taping a favorite series to help another fan add it to his or her video archive. No sooner do two fans meet at a convention than one begins to offer access to prized tapes and many friendships emerge from these attempts to share media resources. Fans describe this process as "cloning" a tape. Here, as elsewhere, fan terminology is suggestive: to copy a tape is simply a matter of mechanical reproduction; to "clone" a tape implies that it will maintain some ties to the original (just as in science fiction, a "clone" is a genetic copy rather than simply a simulacra). Fans frequently remember who made them a "clone" of a particular episode as well as who they have made "clones" for and can often trace this process across multiple generations. Their tapes retain pedigrees that situate their copies within fandom's social network. This is especially true within many fringe fandoms or fandoms for non-American series where a high percentage of the circulating tapes originated from a handful of people; here, the story of their origins may be known by many who never personally met these fans but still possess multiple-generation copies of their originals. The social institutions of fandom, thus, encourage and facilitate the rereading of prized texts. Fanzines frequently run want-ads from fans seeking obscure or short-lived series on tape or local interviews with stars of their favorite programs. One fan publication, APA-VCR, has members publish and regularly update lists of their video collections in order to facilitate the duplication and exchange of prized tapes; Members also run reports on syndicated shows appearing in their markets and volunteer to tape them for fans in other areas.

Videotape expands control over the programs, allowing us to view as often or in whatever context desired. Fan clubs may devote an entire evening to watching favorite episodes, spanning several seasons or even decades of broadcasting history in the process. My

wife and I watched the final season of *Blake's 7* in less than a week, sometimes viewing as many as three or four episodes in a row; our fascination with the unfolding plot could be satisfied through our control over the tapes in a way that it could not be through weekly broadcasts. When we finally reached the climactic episode, we watched it several times in succession, trying to develop a better sense of how the characters reached their fates. The Boston *Beauty and the Beast* club planned a summer weekend during which all of the series episodes would be shown in sequence; they called it a "Beastathon." Another club meeting was a marathon session where fans brought episodes of favorite series that might not be familiar to the other group members. Other fans may choose simply to review a favorite scene, to stop the tape and replay a difficult or significant bit of dialog, or trace the progression of a character's costumes and hairstyles across a number of episodes, fastforwarding through the narrative to focus only on the elements of particular emphasis upon this viewing. Facial expressions and body movements are scrutinized for subtle insights into the characters. Others may try to spot continuity errors (a *Twin Peaks* fan discovered that the shots of the moon that are a running motif are shown in an order that distorts the narrative time of the story) or props that are reused in new contexts (Fans of BBC series love to spot gadgets and costumes that are exchanged between *Doctor Who* and *Blake's 7*) or cast members who appear in other media universes (a *Batman* fan recognized many of the henchmen from their previous appearances on *Superman*). Changes in costume or hairstyle between episodes may be examined for evidence for shifts in character motivation and self-image. The introduction of a new fan to a particular program often requires a rehearsal of the basic interpretive strategies and institutionalized meanings common to the group, a process which makes effective use of the VCR's capacity to control the unfolding of program information. One unnamed fan's informally circulated essay described the process:

> The neofan will go over to an older fan's house. A favorite tape of the series is put into the machine. The neo may or may not watch the episode; the older fan will at least keep a vague eye on it. When a scene comes up that the older fan considers important, it will be replayed at least once, oft-times more. . . . This whole process means that fans learn to see things differently than a mundane (non-fan).

Part of becoming a member of a fandom is learning which
scenes are considered most revealing, fan-wise. Thus,
where a mundane would see the would-be target talking
with the boss while two agents stand uselessly in the back-
ground, a fan tunes in on the non-verbal interplay between
the two agents.

These viewing strategies, made possible by the technology's
potentials, extend the fans' mastery over the narrative and accom-
modate the community's production of new texts from the series
materials. These strategies also create the distance required to per-
ceive the series episodes as subject to direct intervention by the fan
and the familiarity with all aspects of the program world required
for the creation of new narratives. As Sean Cubitt (1988) suggests,
"Video has enabled TV to take on an emphatically Brechtian re-
flexivity, making transparent its recordedness, and its openness to
change" (80). This new relationship to the broadcast image allows
the fans' liminal movement between a relationship of intense prox-
imity and one of more ironic distance. Some viewings focus on
aspects of the text's construction, others on aspects of character
motivation, with the flow controlled by the readers' particular in-
terests at the moment.

One fan described her experience of multiple viewings of *Star
Wars*:

Each time I see it, a new level or idea about something in
it shows itself. As to the complaint that the characters were
shallow and there's no background—nitpicky! That's part
of the fun, piecing together from the few clues what the
Old Republic was actually like, who the Jedi were, what
Han's background was, etc., etc. . . . I'm fascinated with all
of the different versions around in fandom of how the Em-
pire came into being, what the Clone Wars were, what the
reaction of the cantina's bar man toward the 'droids shows
about the position of MAN in the Empire's culture, etc.
The marvelous thing about *SW*'s open-endedness is that
there is room in it for a fannish writer to extrapolate, to
fit their own theories and interests into the *Star Wars* uni-
verse. (Brown 1978, 7)

Her understanding of the film has become progressively more
elaborate with each new viewing as she has made inferences that

took her well beyond the information explicitly presented and that have both contributed to and built upon the shared lore of the *Star Wars* fan community.

Star Wars fandom may indeed be one of the most extraordinary examples of the productivity of this interpretive process. More than a decade after the last film in the series was released, fans are still publishing a substantial number of fanzines and fan novels, transforming some six hours of primary material into hundreds of new narratives spanning centuries of Imperial history. Every conceivable reference has been scrutinized and extrapolated in many different directions as the fans watch the films again and again, searching for new information that can feed their fascination with its universe.

Media critics often express skepticism about whether the formulaic texts of broadcast television and the Hollywood cinema warrant extensive rereading. Robin Wood (1986), for example, denies any possible parallel between academic rereading of high culture texts and fan re-reading of popular texts like *Star Wars*: "It is possible to read a film like *Letter From an Unknown Woman* or *Late Spring* twenty times and still discover new meanings, new complexities, ambiguities, possibilities of interpretation. It seems unlikely, however, that this is what takes people back, again and again, to *Star Wars*" (164). According to Wood's formulation, academic rereading produces new insights; fan rereading simply rehashes old experiences, a practice he labels as infantile and regressive. These films yield such easy pleasures on a first viewing, seem so transparent in their construction of reality, that they seemingly hold no secrets justifying a second look. Fans would certainly disagree with such claims, suggesting that these programs may be richer and more complex than critics like Wood are prepared to acknowledge. Yet, much of that richness stems from what the reader brings to text, not what she finds there. As we will see in chapter three, repeat viewers play with the rough spots of the text—its narrative gaps, its excess details, its loose ends and contradictions—in order to find openings for the fans' elaborations of its world and speculations about characters. The *Star Wars* fan cited above aptly describes this process. What critics like Wood might perceive as flaws create opportunities for viewers to intervene in the narrative, to reshape it according to their own plans.

Yet each reviewing also threatens to exhaust the narrative's emotional hold on the viewer, to wear out the material so that it may be enjoyed a little less the next time. Despite the remarkable

creativity of *Star Wars* fan writers, the fandom's membership has continued to decline, year by year, in the absence of new films which might spark new interests and offer additional raw materials for playful reworkings. Some fans ration the number of times they will watch a favorite narrative or space re-viewings so that a certain amount of forgetting allows them to look at the material with a fresh perspective. Watching the films seems a progressively less sufficient means of satisfying the desires that draw them back. This vague dissatisfaction often pushes them toward other ways of recreating the experience of the text. One fan writes: "For the first time in a long love affair with SF and SF-related things, I have been affected so profoundly by *Alien Nation* that I just can't get enough of it! My videos are getting worn out from watching them over and over, and I've even been forced to write my own stories just to get me through until the next episode is out" (Hillyard, 1990, 11). For these fans, a favorite film or television series is not simply something that can be reread; it is something that can and must be rewritten to make it more productive of personal meanings and to sustain the intense emotional experience they enjoyed when they viewed it the first time.

THE SOCIAL PRODUCTION OF MEANING

So far, our discussion has focused on the relationship between the individual fan and the broadcast material, though even this discussion has drawn us inescapably into the social network of an organized fan culture. For most fans, meaning-production is not a solitary and private process but rather a social and public one. Fan editor Allyson Dyar (1987) argues that most accounts of fan culture wrongly focus on aspects of the primary text rather than on ways that common references facilitate social interactions among fans:

> We started out watching the series [*Star Trek*] because we enjoyed the show but we watched the reruns, attended the conventions and published fanzines for something over-looked by these 'theories.' We fen [the fan slang plural of fan] are still around because *we enjoy each other's company.* . . . The majority of our social life revolves around fannish things: conventions, writing, drawing and publishing. While we fen still enjoy the series and movies, we enjoy sharing our enthusiasm with others even more. (2)

Fan reception cannot and does not exist in isolation, but is always shaped through input from other fans and motivated, at least partially, by a desire for further interaction with a larger social and cultural community.

Cassandra Amesley (1989) has focused attention on the comments *Star Trek* fans make while viewing the series in a group: "A new discourse emerges from the viewers which exists as counterpart to the original text, playing off it but providing creative pleasure for its participants" (337). Comments range from ironic reminders of conventions (such as the suggestion that red-shirted security crew-members are "dead meat"), repetition of favorite lines ("He's dead, Jim"), references to other texts in which the performers have appeared (Joan Collins' performance in "City on the Edge of Forever" provokes remarks about her role as Alexis on *Dynasty*), or acknowledgements of errors in continuity and other plot problems. Amesley suggests that this running commentary functions as a secondary text which has the potential of revitalizing the viewer's interest in the series even after repeated viewings: "Since there are so many fans to draw on, different readings can emerge all the time, as different questions raised outside a particular reading can be developed in different forms during it" (337).

Group viewing situations are common in fandom; fans wait in long lines to see the first showings of hot summer releases, knowing that the initial audience will be full of fans like themselves who will vocally participate in the emotional experience of the film. At one of the *Beauty and the Beast* fan club meetings, one member brought tapes of three episodes that had not yet been aired in the United States (due to its cancelation) but had been broadcast in French on a Quebec station. Here, mutual assistance was required to decipher the narrative content since none of the members was fluent in French. The members were encouraged to "shout out" if they could make sense of any of the words from their limited exposure to French in college or high school; there was an ongoing speculation about what was happening on the screen and, since I was a relative newcomer to the series, fans often provided me with background drawn from their previous knowledge about the characters and situations. Such mutual assistance occurs regularly at American screenings of Japanese animation, material which, like the Canadian prints of *Beauty and the Beast*, is frequently shown untranslated to an audience that understands little or none of the original language. Here, those who have seen the programs previously or who have

access to written synopses help new fans to comprehend the events or to identify the character relationships. This situation mirrors the ways opera buffs prepare for performances in languages they do not understand, though fandom encourages a public exchange of information during the actual presentation that the norms of opera-going prohibit. It is this public sharing that shifts fannish interpretations from individual to collective responses. The commercial narratives only become one's own when they take a form that can be shared with others, while the act of retelling, like the act of rereading, helps sustain the emotional immediacy that initially attracted the fan's interest.

CASE STUDY: ALT.TV.TWINPEAKS

Subscribers to computer nets, such as Compuserve or Usenet, may participate in electronic mail discussions of favorite genres and programs, with interest groups centered on everything from *The Simpsons* to *The Prisoner*, as well as more traditional fan interests such as *Star Trek*, comic books, and soap operas. These computer interest groups allow for almost instantaneous communication between their far-flung subscribers and handle a tremendous volume of correspondence. Alt.tv.twinpeaks, one such computer discussion group, emerged within just a few weeks of the series' first episode and quickly became one of the most active and prolific on the Usenet system, averaging one hundred or more entries per day during the peak months of the series' initial American broadcast.

The net group served many functions for the program's fans. One contributor provided a detailed sequence of all of the events (both those explicitly represented and those implied by textual references) and continued to update it following each new episode. Another built a library of digitalized sounds from the series. Excerpts of cryptic dialog were reprinted and closely analyzed. Fans provided reports from local newspapers or summaries of local interviews with its stars and directors. Others provided lists of the stars' previous appearances, reviews of Lynch's other films (particularly *Wild at Heart*, which appeared in the gap between the series' first and second seasons), accounts of the director's involvement with Julee Cruise's musical career, reactions to Mark Frost's ill-fated *American Chronicles*, assessments of Sherilyn Fenn's spread in *Playboy*, etc. Pacific Northwest-based fans provided details of

local geography and culture as well as reports about the commercialization of the area where the series was filmed. The net also became a vehicle for exchanging tapes with fans who missed episodes scrambling to find another local fan who would make them a copy and with many fans seeking a way to translate Pal tape copies of the European release version (with its alternative ending) into American Beta and VHS formats. When ABC put the series on hiatus in the middle of second season, the net provided a rallying point for national efforts to organize public support for the show; the net provided addresses, telephone numbers, and fax numbers for the network executives and concerned advertisers as well as reports on efforts in different communities to organize fans. Some fans even wrote their own *Twin Peaks* scripts as fodder for group discussion during the long weeks between episodes. When the series' return was announced, the net was full of news about celebration parties and speculations about its likely chances in the ratings. The group, however, spent much of its time in detailed analysis of the series and the decipherment of its many narrative enigmas. As one fan remarked just a few weeks into the series' second season, "Can you imagine *Twin Peaks* coming out before VCRs or without the net? It would have been Hell!"

Not surprisingly, these technologically oriented viewers embrace the VCR, like the computer, as almost an extension of their own cognitive apparatus. The net discussion was full of passionate narratives of the viewer's slow movement through particular sequences, describing surprising or incongruous shifts in the images, speculating that Lynch, himself, may have embedded within some single frame a telling clue just to be located by VCR users intent on solving the mystery: "I finally had a chance to slo-mo through Ronnette's dream, and wow! Lots of interesting stuff I'm amazed nobody's mentioned yet! . . . Reviewing this changed my thinking completely. I think BOB is not Laura's killer at all, but was her lover and grieved her death." Others soon joined in the speculation: Does Bob seem, just for an instant, to take on some of the features, say, of Deputy Andy, as one fan asserts? Is he beating Laura or giving her resuscitation, as several fans debate? What did you make of that shadow that appears for only a split second on the window behind his head, one fan asks? That door frame didn't look very much like the ones we've seen in other shots of the train car, another fan asserts, but rather more like the doors at the Great Northern. The viewer looks for glitches within the text (such as Laura's heart-

necklace that sometimes appears on a metal chain and sometimes on a leather thong) but more often, they were looking for clues that might shed light on the central narrative enigmas.

Fans might protest, as they often do, that those who centered only on the Palmer murder were missing the point of the series, yet their discussion consistently centered on the search for answers to narrative questions. The volume intensified each time it appeared that the series was about to unveil one of its many secrets; interest waned following the resolution of the Palmer murder, not sure where to center discussion, and only regained momentum as the Windom Earle plot began to unfold. Where the series itself did not pose mysteries, the fans were forced to invent them. In one episode from the second season, for example, Hank mockingly salutes Major Briggs, a throw-away gesture that is far from the focus of the scene, yet this gesture forms the basis of a whole series of exchanges among fans: "Is Hank doing dirty work for this classified program the Major is involved in? . . . I detected a can of worms being opened here." The complexity of Lynch's text justified the viewers' assumption that no matter how closely they looked, whatever they found there was not only intentional but part of the narrative master plan, pertinent to understanding textual "secrets".

The computer net only intensified this process, letting fans compare notes, allowing theories to become progressively more elaborated and complex through collaboration with other contributors. All of the participants saw the group as involved in a communal enterprise. Entries often began with "Did anyone else see . . . " or "Am I the only one who thought . . . " indicating a felt need to confirm one's own produced meanings through conversations with a larger community of readers or often, "I can't believe I'm the first one to comment on this" implying that their own knowledge must already be the common property of the group. Several contributors vowed that "We can solve this one if we all put our minds to it," suggesting a model of collective problem solving common in technical fields. Netters frequently begin new entries with extensive quotation from previous contributors' letters; while sometimes this is for the purpose of "flaming" or criticizing what someone has written, more often, it is so they can add new insights directly into the body of the previously circulating text.

FAN GOSSIP

While patriarchal discourse generally dismisses gossip as
"worthless and idle chatter," feminist writers have begun to reap-
praise its roles within women's culture. Deborah Jones (1980) de-
fines gossip as "a way of talking between women in their roles as
women, intimate in style, personal and domestic in topic and set-
ting, a female cultural event which springs from and perpetuates
the restrictions of the female role, but also gives the comfort of
validation" (194). While the fluidity of gossip makes it difficult to
study or document, Jones suggests that it serves as an important
resource which women historically have used to connect their per-
sonal experiences with a larger sphere beyond their immediate do-
mestic environment: "It is in terms of the details of the speakers'
lives and the lives of those around them that a perspective on the
world is created" (195).

Jones identifies four major classes of gossip: house-talk, which
allows for the exchange of practical information about domestic life;
scandal, which involves judgement about moral conflicts and di-
lemmas; bitching, which allows expression of anger and frustration
over the limited roles of women; and chatting, which is a process
of "mutual self-disclosure" designed to initiate personal intimacy.
Fans adopt all four modes in their discussion of television programs
(though in the process, they broaden their focus to encompass not
only their contradictory status as middle-class women within a pa-
triarchal society but also as consumers within a capitalist culture).
Fans exchange information about everything from the personal lives
of stars to the corporate decisions affecting the series' chances of
survival, from the availability of low-cost videotapes to the potential
syndication rights of a recently canceled program. Fans offer moral
judgement about the scandals surrounding interpersonal relations
of characters within the series and the real-world conduct of stars
during convention appearances or as revealed in commercial fan
magazines. Fans "bitch" endlessly about actions that alter the pro-
gram format or remove series from the air, complaints often cen-
tering around the fans' limited control over the decisions affecting
a favored text. Fans also initiate more personal conversations, chat-
ting about, say, responses they have received from family members
or workmates, discussions often spilling over into more intimate
topics such as health, romance, marital problems, or personal fi-
nances. As one fan told me, "We *live* by and for information ex-

change!" (Meg Garrett, Personal Correspondence, 1990) All of these forms of gossip are interesting to fans because of the light they shed on favorite programs or on their own participation in fan culture; they are exchanged because of their practical value in perpetuating fan culture and because they offer new ways of thinking about the programs. They also provide an outlet through which fans can voice their frustrations or laugh over their embarrassments.

The manifest content of gossip is often less important than the social ties the exchange of secrets creates between women (and for this reason, gossip about fictional characters may be as productive as gossip about real-world events.) As Patricia Meyer Spacks (1983) explains, "Gossip . . . uses the stuff of scandal, but its purpose bears little on the world beyond the talkers. . . . The relationship such gossip expresses and sustains matters more than the information it promulgates; and in the sustaining of that relationship, interpretation counts more than the facts or pseudofacts on which it works" (5–6). Gossip builds common ground between its participants, as those who exchange information assure one another of what they share. Gossip is finally a way of talking about yourself through evoking the actions and values of others. The same may be said of the function of television talk within the fan community. In an increasingly atomistic age, the ready-made characters of popular culture provide a shared set of references for discussing common experiences and feelings with others with whom one may never have enjoyed face-to-face contact. The fans' common interest in the same program sparks conversations soon drifting far away from the primary text that initially drew them together.

Both the open-endedness of soap opera narrative and its focus on relationships, as Mary Ellen Brown and Linda Barwick (1986) note, make such programs ideally suited for insertion into the oral culture of gossip: "Not only do soap operas deal with the subjects that have been of particular concern to women under patriarchy (domestic matters of kinship and sexuality) but they also do it in a way that does 'minister questions' and acknowledge the contradictions in women's lives." There is a great deal of research tracing ways soap opera fans exploit these openings within their daily interactions with family, friends, and work associates (Seiter, Borchers, Kreutzner, and Warth, 1990; Brunsdon, 1981; Hobson, 1982; Hobson, 1989). Fans offer moral judgement about characters' actions; they make predictions about likely plot developments or provide background about the program history to new fans. *Soap Opera*

Digest and other fan-targeted publications actively encourage such
speculation, polling fans for their opinions and offering a wealth of
information about contract disputes and the personal lives of the
series stars; this "insider information" is quickly translated back
into personal "gossip" about the series.

Fans discover that a much broader range of texts also offer the
potential for television "gossip." One *Beauty and the Beast* fan told
me what happened when a friend, who had previously expressed
distaste for the series, watched her first episode:

> It's Saturday morning about 8 o'clock. I'm not even up out
> of bed yet. A car pulls up—screech—she jumps out. She
> walks in through the door and I'm not kidding you—she
> grabs me and she sits me down in the chair: "Alright now—
> tell me. What is this? What's going on? How come? Boy!"
> . . . I gave her a couple of my zines and then she came back
> for some more. We talked a lot about the show after that.

This woman's story describes in particularly dramatic terms
the urge fans feel to reach out to others, to share their fascination
with the series and to discuss its characters and situations.

Interestingly, as textual material is inserted into oral discourse,
the fans often refocus their attention from events in the story onto
the interpersonal themes that have always been the focus of gossip—
onto religion, gender roles, sexuality, family, romance, and profes-
sional ambition. Some of their speculations center on questions
explicitly posed by the program narratives: Will Matt and Cathy
(*Alien Nation*) consummate their romantic relationship? How was
Amanda (*Star Trek*) able to communicate her feelings of affection
for the stoic Vulcan, Sarek, and what forms the "logical" basis of
their marriage? What are Vincent's secret origins on *Beauty and the
Beast* and how did he come to be under the care of Jacob Wells?
Yet just as frequently, fannish interests are drawn from the bound-
aries of the series. Fans often ask questions the producers wish to
repress: Is Captain Picard on *Star Trek: The Next Generation* Wes-
ley's father? Did he and Beverly have an affair and did Picard send
first officer Crusher to his death (in a science-fiction recasting of the
Solomon and Bath-sheba story)? Could Starksy and Hutch be gay
lovers? Why has Uhura been unable to achieve promotion within
Star Fleet while Chekov and Sulu now command their own ships?
The result is often a feminization of material originally targeted at

predominantly male audiences, a process reaching its fruition in the fiction fans themselves write about series characters and situations.

Spacks (1983) stresses the aesthetic dimensions of gossip, suggesting its close relationship to the art of fictionmaking ("fragments of lives transformed into story"): "Gossip is not fiction, but both as oral tradition and in such written transformations as memoirs and collections of letters it embodies the fictional" (15). Gossip "impels plots" (7), Spacks writes, focusing attention on those aspects of experience that form the basis for our fascination with fictional narratives; gossip fits those experiences into "established structures ... [and] familiar patterns" that make unusual occurrences seem more comprehensible to the listener (14). The translation of the transient oral texts of gossip into the more permanent and material texts of fan fiction may not be as big a step, then, as it would first appear. Both gossip and fiction writing provide fans with ways to explore more fully those aspects of the primary series that most interest them, aspects often marginal to the central plot but assuming special salience for particular viewers.

Many times, fans are drawn to particular programs because they provide the materials most appropriate for talking about topics of more direct concern, because they continually raise issues the fans want to discuss; such discussions offer insights not only into the fictional characters but into different strategies for resolving personal problems. The alien worlds of *Star Trek*, for example, may be read as offering alternative conceptions of masculinity and femininity as well as posing questions about interracial relations. Discussions of characters like Uhura or Saavik may provoke discussions about styles of conduct adopted by women who want to win acceptance in the workplace. The romantic interest Chapel shows toward Spock, or Troi displays toward Riker, may invite debates about strategies for juggling the competing demands of career and marriage. Considerations of the "prime directive" often blend into disputes about America's intervention in the third world. One *Star Trek: The Next Generation* episode provoked a heated debate on abortion:

> *Star Trek* also affirms choice—in "The Child," there is discussion of the possible danger of Deanna's unborn child to the ship, posed by unknown alien intent. Deanna's decision—her CHOICE—is to have the baby. The decision is not made by Captain Picard or Riker or the doctor or anyone else; it is made by the involved individual, Deanna Troi. (Rhodes, 1989, 4)

Others drew on different incidents in the series to support their own pro-life position:

> I can't imagine Dr. McCoy (or even Dr. Pulaski) per-
> forming an abortion, except to save the life of the mother;
> and even then I bet they'd do their damndest to save the
> baby too. . . . *ST* defends the unalienable rights of all living
> things—including "living machines" like Data and severely
> disabled people like Captain Pike—and opposes the bru-
> talization of the powerless by the powerful. (Burns 1989, 9)

Interestingly, *Star Trek* fans found the discussion of abortion appropriate as long as it was centered on the fictional characters and their on-screen adventures. Objections were raised to the introduction of "politics" into this fan forum as soon as the debate shifted onto the real-world implications of this issue. As one fan explained, "I have nothing against the debate on such an issue in the pages of a *Star Trek* magazine as long as it is applied to *Star Trek*." (Germer, 1989, 2) To talk about abortion directly would be to shift the terms of the debate and would threaten the cohesiveness of the group, thus blocking further discussion of a broad range of topics.

Gossip's power as a "feminine discourse" lies in its ability to make the abstract concrete, to transform issues of public concern into topics of personal significance. This shift in the level of discourse traditionally allowed women room in which to speak about factors that shaped their assigned social roles and their experiences of subordination. Often, it was a way of speaking through metaphor or allegory. If the public discourse of politics was reserved for men, the private and intimate discourse of "gossip" offered women a chance to speak about controversial concerns in a forum unpoliced by patriarchal authorities because it was seen as frivolous and silly. Gossip may have been a means by which women regulated violations of gender expectations and enforced conformity to social norms, as Jones (1980) suggests, yet it was also a way of speaking without being overheard about the most repressive aspects of those gender roles, a way of challenging those expectations without directing attention to the political dimensions of that debate.

To some degree, even though feminism has enabled more women to speak publicly about issues of concern to them, fan talk about television characters serves similar functions, creating a more

comfortable environment for addressing topical issues. Female fans are often uncomfortable identifying themselves as feminists and adopting its terms within their own discourse, as Constance Penley (1990) has suggested, even though their discussion of particular programs is often directed at issues central to feminist debate and analysis. Some women may discuss the marginalization of Uhura within the series but not the marginalization of all women within the workplace; they may criticize the macho posturing of Kirk and Riker but not the social construction of masculinity in the real world (though fans typically recognize that the characters within the fiction reflect real world contexts). In each of these cases, the programs provide tools to think with, resources that facilitate discussions. Popular texts, like traditional sources of "scandal," allow for a level of emotional distance not possible in a more direct confrontation with these same issues and yet also provide concrete illustrations absent in more abstracted debate.

3
Fan Critics

Many of us who are fans of *Star Trek* enjoy *Star Trek* despite its faults, not because we think *Star Trek* is perfect and not because we do not think it cannot be improved. To criticize *Star Trek*, then, means that we enjoy *Star Trek* enough to want it to be the best it can be, and we wish to point out flaws in the hope of improvement (that is, to *learn* from mistakes, rather than to pretend they do not exist). If we didn't *care*, we wouldn't criticize. (Joan Marie Verba 1989a, 1).

Organized fandom is, perhaps first and foremost, an institution of theory and criticism, a semistructured space where competing interpretations and evaluations of common texts are proposed, debated, and negotiated and where readers speculate about the nature of the mass media and their own relationship to it. As I have suggested in previous chapters, we tend to think of theory and criticism as specialized practices reserved for an educated elite, for the privileged members of de Certeau's "scriptural economy." Academic criticism and theory builds upon years of training and a complex professional vocabulary that seemingly precludes its duplication on a popular and unschooled level. Yet as Bernard Sharratt (1980) suggests, the intimate knowledge and cultural competency of the popular reader also promotes critical evaluation and interpretation, the exercise of a popular "expertise" that mirrors in interesting ways the knowledge-production that occupies the academy. Fans often display a close attention to the particularity of television narratives that puts academic critics to shame. Within the realm of popular culture, fans are the true experts; they constitute a competing educational elite, albeit one without official recognition or social power.

Sharratt (1980) sees this popular "expertise" as pseudoknowledge, a "self-pretence or semi-fantasy"; mastery has been "displaced" onto the popular as "compensation" for the knowledge and

respect denied these same groups within the educational system and power denied them within the political process. Yet, just as feminists have begun to reassess the potential strengths of "gossip" as a means of communication by and for women, we need to reconsider the importance of "trivia" as unauthorized and unpoliced knowledge existing outside academic institutions but a source of popular expertise for the fans and a basis for critical reworkings of textual materials. John Tulloch (Tulloch and Jenkins, forthcoming) offers a more sympathetic view of the popular critic's relation to the media. Drawing on the work of Adrian Mellor (1984), Tulloch suggests that *Doctor Who* fans are a "powerless elite" who claim a privileged relationship to the series by virtue of their mastery over its materials and yet who have little or no influence on "the conditions of production or reception of their show." What they do possess is "the power to gloss and to write the aesthetic history of the show," the power to analyze its contents and evaluate its episodes. The *Doctor Who* fans Tulloch studies exert this power to criticize production decisions running counter to their own interests in the program and to police violations of series continuity.

American media fans assert a similar cultural authority, claiming a moral right to complain about producer actions challenging their own interest in the series property. Consider for example how one black fan discusses *Star Trek: The Next Generation:*

> Your favorite character has been 'promoted' and (they hope) forgotten; your second favorite character's role has been considerably reduced and his characterization changed; the people who look like you have either been made into a caricature or removed from the bridge altogether, and stuck in unattractive costumes as well (I *Know* that's the division color. I'm sorry, but mustard is simply not a good color on black people). The weight of the show has been placed on an occasionally cute but *minor* character; the writers aren't doing anything with the two remaining characters, who get less interesting as time goes on—and there's a baby on the bridge where an adult should be. Given all that, might you not maybe possibly be just a little, tiny bit upset? (Junius 1989, 9)

Her persistent use of first-person and second-person possessive pronouns suggests how intimate the fan's relationship to the primary text may become; this fan views shifts in characterization or format

as acts committed against fans by producers (unwarranted damage to their common cultural property) and thus as acts warranting a direct personal response. Her expertise over the program, the emotional investment she has made in the characters, justifies an increasingly critical stance toward the institutions producing and circulating those materials as does her ability to appeal to common experiences and understandings from a broader fan community. This "moral right" to criticize the program's producers reflects the strength that comes from expressing not simply an individual opinion (though fans would insist on their individual rights to complain) but the consensus of the fan community, a consensus forged through ongoing debates about the significance and merits of individual episodes and about the psychology and motivation of particular characters.

"THE RIGHT WAY"

Meanings form the basis for the construction and maintenance of this fan community; the expectations and conventions of the fan community also shape the meanings derived from the series and the forms taken by the fan's own artistic creations. Fans tend to see themselves in highly individualistic terms, emphasizing their refusal to conform to "mundane" social norms and the range of different interpretations circulating within their community; they are nevertheless responsive to the somewhat more subtle demands placed upon them as members of fandom—expectations about what narratives are "appropriate" for fannish interest, what interpretations are "legitimate," and so forth. Fan club meetings, newsletters, and letterzines provide a space where interpretations are negotiated between readers. Fan-produced works respond to the perceived tastes of their desired audience and reflect the community's generic traditions as much as those originating within commercial culture. These discussions and materials further shape fans' perceptions toward close conformity to the community's own reading of the programs.

Such an interpretive community does not foreclose idiosyncratic differences in interpretation and evaluation (Fish, 1980). Fans thrive on debate and differences in opinion must be perpetuated so that the process of interpreting an otherwise completed narrative (a canceled series, an individual film) may be prolonged. Fandom's

institutional structure, however, does constrain what can be said about favorite shows and directs attention onto aspects of the original episodes with particular pertinence within fan criticism. David Bordwell (1989) has pointed toward the institutional basis of academic interpretation. While the demand for novel readings allows for different meanings to be attached to a given artwork, there are conventional ways of producing interpretations shared by most, if not all, scholars. A certain common ground, a set of shared assumptions, interpretive and rhetorical strategies, inferential moves, semantic fields and metaphors, must exist as preconditions for meaningful debate over specific interpretations. The same may be said for fandom where interpretive conventions are less rigidly defined or precisely followed than within the academy, yet are accepted nevertheless as a necessary basis for fan discussion. In the words of one long-time fan (Hunter, 1977), "*Star Trek* is a format for expressing rights, opinions and ideals. Most every imaginable idea can be expressed through *Trek*. . . . But there is a right way." As suggested in chapter two, an individual's socialization into fandom often requires learning "the right way" to read as a fan, learning how to employ and comprehend the community's particular interpretive conventions.

This chapter outlines some of the conventions of fan criticism, moving from factors shaping the inclusion of a particular program within the fan canon through the evaluation and interpretation of individual series episodes. It concludes with a consideration of the ways fannish reading practices may represent a particular inflection of gender-specific strategies of interpretation, may represent the institutionalization of a "feminine" approach to texts that differs radically from the more "masculine" style preferred by the academy. This concluding section is necessarily speculative, though it builds on a large body of work within reader-response criticism, yet it may invite us to reconsider the specific ways fannish reading relates to institutionally preferred approaches to interpretation. The next chapter builds upon this model to trace patterns of critical response to *Beauty and the Beast*, showing how fans drew both upon their metatextual understanding of the series and upon larger generic models in interpreting and evaluating program developments.

PROGRAM SELECTION

Many of the most highly rated programs fail to produce the kind of institutionalized fan culture that is the primary focus of this

book. Many fans are regular and enthusiastic viewers of programs that never motivate them to write stories, share letters, join clubs, or attend conventions. Almost all of the members of the Boston *Beauty and the Beast* fan club, for example, said that they regularly watched *L. A. Law*, a series addressing concerns of particular interest to them as young professionals or students living in or around a major city, but a series not accepted within the canon of media fandom. Its stars are not invited guests at fan conventions; there are, as far as I can tell, no letterzines or fanzines centered on the series. Individually, many of the club members have made *L.A. Law* a part of their lives as television viewers but they have not incorporated it into their collective experience as fans. Conversely, fictions can develop fan followings without becoming popular with a broader audience (*Starman, Buckaroo Bonzai, Tales of the Gold Monkey*) or without even being readily available to a larger viewership (*Blake's 7, The Sandbaggers,* Japanese Manga and animation). Many American *Professionals* fans, for example, became interested in this British program through reading fan fiction involving its characters and only subsequently made efforts to acquire tapes of the episodes. Or, consider the example of American fans of Japanese girls' comics, such as *From Eroica With Love*, comics untranslated and unmarketed to American consumers. These books can only be found by tracking them down to a small number of Japanese import shops clustered in a handful of cities; few, if any, American fans could have located these materials without first encountering the fan culture that surrounds them here and their desire to belong to this culture in almost all cases precedes their desire to read the original materials. Moreover, the attractiveness of these texts originate at least partially from their relevance to pre-existing modes of fan culture, specifically to the fans' own exploration of homoerotic romance and their discovery of a women's tradition of such stories in Japan.

While common sense might suggest that fans become fans because of their fascination with particular texts or performers, the reverse is often true. Fan writer Barbara Tennison described this process:

> While I enjoyed fandom, and writing fan stories, about TV shows, it was a case of finding that I liked fans and wanting to join in their activities; the TV viewing itself was more

like homework. . . . How many other fans enjoy the pro-
cesses of fandom more than, or at least as much as, the
supposedly central attraction of the shows and movies
themselves? Probably more than myself alone. (Personal
correspondence, 1990)

While there are many "fringe" fandoms centering on idiosyn-
cratic cultural choices, fans tend to focus their social and cultural
activity around programs with the potential of being accepted by
sizeable numbers of other fans. Zine editors must be able to antic-
ipate a readership for their publications, convention organizers an
audience for their presentations. Fan institutions may provide lim-
ited space for introducing and supporting emerging fan interests,
but this space generally does not constitute the primary appeal of
their efforts and must yield center stage to more popular interests.

Each adopted series has the potential of attracting new fans, of
drawing into fandom many who had no previous exposure to its
institutions, yet each new series also typically builds upon a core
of support from those already regarding themselves to be fans. Older
fans often look upon the emergence of new fan followings as a threat
or competition: *Star Trek* fans directed the same scorn and ridicule
at *Star Wars* fans as they, themselves, received from the older sci-
ence fiction fan community. Fears of competition may be valid,
since the emergence of a new fan interest can often be the center
of a succession of shifting alliances; fans tiring of old programs are
attracted by the possibilities promised by a new media universe,
bringing with them an already well-established vocabulary of cul-
tural practices and interpretive procedures. The development of an
American *Blake's 7* fandom, for example, was ideally timed to cap-
italize upon institutional conflicts within *Doctor Who* fandom
(which shared its focus on a British series) and declining interests
in *Star Wars* fandom (which shared its concentration on stories
about resistance movements), building upon a foundation of sea-
soned editors and writers and an audience already primed to pur-
chase fanzines and to attend conventions. This group has, in turn,
provided a large population base from which other followings for
British television (*The Professionals, The Sandbaggers, Star Cops*)
could emerge. Since fandom does not presume an exclusive focus
on an individual text, fans just as often expand their field of interests
to incorporate new programs.

THE CASE OF *ALIEN NATION*

The Fox network science fiction series, *Alien Nation*, to cite a recent example, debuted in the fall of 1989 and almost immediately began to develop a strong following. *Alien Nation* panels appeared at science fiction conventions by late fall; an *Alien Nation* fan convention was held in February 1990. I encountered *Alien Nation* songs at conventions by early 1990. A letterzine focused on the series, *Newcomer News*, debuted at MediaWest that spring as did a first-season episode guide (*A Tenctonese Guide to the Universe*) and calls for submission by a number of proposed *Alien Nation* fanzines (*Alien Relations, Fresh Beaver Tails: The Sam Francisco Treat; Slags Are People Too*), many of which planned to appear by fall of that year. Much of this initial activity was directed by people and institutions with a long history within fandom: the first *Alien Nation* convention was hosted by Creation Conventions, a commercial enterprise that produces several dozen conventions each year. Many of the earliest *Alien Nation* songs were written and performed by Roberta Rogow, a fan composer who has previously produced four tapes of songs primarily focused on *Star Trek* and edits several fanzines. The initial letterzine, the program guide, and one of the

3.1 *Alien Nation* protagonists, Matt Sikes and George Francisco. Artwork by Kate Nuernberg.

proposed fanzines originated from Starlite Press, a fan publisher claiming to have produced 72 volumes of fanzines over the past four years, including publications centered around *Star Trek: The Next Generation, Simon and Simon,* and *Hardcastle and Mc-Cormick.* Other fan publishing collectives also scurried to add *Alien Nation*-related zines to their inventories. The Boston-area *Beauty and the Beast* fan club expanded its scope to welcome members primarily interested in *Alien Nation* and drew upon its previous experiences of struggling with the networks as a basis for organizing a petition drive when the series was canceled.

While much of the fan discourse surrounding *Alien Nation* has stressed the "originality" of the series and the "creativity" of its producers, the speedy integration of the program into media fandom stems primarily from its remarkable compatibility with the groups' other interests. *Alien Nation* is a hybrid of the two genres (science fiction, action-adventure) most popular within the community and is therefore able to draw upon a large pool of potential fans and build upon pre-established cultural competencies. For some, the program's fascination lies in its detailed construction of a coherent and believable alien culture, the Newcomers, and its invitation to re-explore human culture and values:

> There's a natural built-in fascination because of the alien point of view; what I like to think of as "sf as social commentary." The Newcomers are the perfect foil to everything that is human in our attitudes towards sex, gender, identity, honesty, integrity, justice, etc. Like Spock in *Star Trek*, the Newcomers let us stand outside ourselves and look at the way humans act. (Urhausen 1990, 9)

For others, the interest of the series was its vivid exploration of male friendship, a theme central to many police and detective series:

> I'm a sucker for "partnership" shows, anyway, but what I love most about this one is that we aren't given everything all at once George and Matt's relationship reminds me so far of *Houston Knights*, or *Hardcastle & McCormick*: from initial animosity, sometimes almost outright dislike, this relationship has been progressing steadily into a real friendship. It's been a beautiful thing to watch developing all season. (Hartwick 1990, 16)

Still others seemed to be drawn to the romantic aspects of the series, to the suggestions of a potential interspecies love affair between Matt and Cathy:

> I like Cathy. . . . She and Matt are friends and maybe eventually their relationship may become even closer (If *Star Trek* allowed Sarek and Amanda a child and *Beauty and the Beast* did the same for Vincent and Catherine then it follows that Matt and Cathy could also. This is TV). (Wilson 1990, 8)

As these three examples suggest, an adopted series will initially be comprehended through its similarities and differences to other already canonized programs (*Star Trek, Hardcastle and McCormick, Beauty and the Beast*) and will appeal to fans whose earlier media interests predispose them toward particular generic situations and themes. The speed of *Alien Nation*'s acceptance speaks to the generic richness of this series, the degree to which it appeals to the values and competencies of a wide range of different fan communities, offering these diverse groups fresh new material to replace or supplement stories whose interest has been diminished through years of active interpretation: "Geez, pick a subject about newcomer life, any subject, and I'd like to see it explored" (Cox 1990, 7).

As a result, the *Alien Nation* panel at the 1990 MediaWest convention attracted the highest attendance of any event as large numbers of established fans wanted to see what type of fan culture would emerge from this still new series. *Newcomer News* sold out of its first printing early in the convention and its editors had to locate a local printshop which could produce new copies to satisfy the larger than expected demand for this *Alien Nation* letterzine. All of this excitement was generated by a program that remained at the very bottom of the *Nielsen* Ratings and was canceled by the network at the end of its first season. As soon as its cancelation was announced, the fan community was able to mobilize a campaign for its return, though their efforts have so far produced no tangible results.

CONSTRUCTING THE PROGRAM CANON

The selection of a particular television series is simply the first stage in a larger evaluative process. Not every series episode will

equally satisfy the interests that initially drew the fans to the program. The same may be said for other aspects of the program, including characters, alien races, recurrent narrative situations, or format changes. A primary function of fan publishing, then, is to provide a public forum for evaluating and commenting on individual episodes and long-term plot developments. Several issues of a *Star Trek* letterzine, such as *Interstat*, may be dominated by fans' responses to the release of a new *Star Trek* feature film; others will be full of evaluations of recently aired episodes of *Star Trek: The Next Generation*. *Comlink*, a letterzine with a general media focus, prepares an end of the season survey of its readers asking them to grade all of the *Next Generation* episodes and each of the recurring characters.

Sometimes, there are heated disagreements about the relative merits of any given text or character, yet, this situation is relatively rare; a high degree of consensus shapes fan reception and a fairly consistent set of criteria are applied by fans to each new episode. Some, such as "City on the Edge of Forever" or "Amok Time" (*Star Trek*), "Yesterday's Enterprise" or "Measure of Man" (*Star Trek: The Next Generation*), or the alien birth trilogy (*Alien Nation*) win almost universal acclaim, while others, such as "Spock's Brain" (*Star Trek*), "Justice" (*Star Trek: Next Generation*), "Animals" (*Blake's 7*), or "The Horns of Nimon" (*Doctor Who*) become common objects of ridicule. Some characters (Spock, Data, Vincent, Avon) become fan favorites, others (Wesley Crusher) develop only marginal followings, if at all. (It is worth noting, however, that these evaluations are subject to reassessment, so that Tarrant held little interest for the first generation of American *Blake's 7* fans, while more recent fans see him as central to their experience of the program.)

Where differences in evaluation occur, they tend to reflect the different social orientation of specific subsections of the fan community as much or more as they reflect individual differences in taste. *Treklink* editor Joan Marie Verba (1989b) analyzes the dramatic differences in fan response to *Star Trek V*:

> Although there are as many reasons for appreciating *ST* as there are *ST* fans, nonetheless, fans' interests (in general) can be divided into two major categories. I fit into the "*ST* as science fiction" appreciation category. I was reading sf before *Star Trek* came along; I watched *Star Trek* because

it is sf. To me, the opening line, "Space . . . The final Frontier . . . " is the essence of *ST*. Or, to put it another way, to me, the main theme of *ST* is the exploration of space and the consequences thereof (e.g., meeting other beings, making scientific progress, exchanging cultural information and philosophical insights, and so forth). To me, a "quintessential" *Star Trek* episode is one that explores these ideas. Of the movies, *ST I, II* and *IV* fit the "mission" idea best, as I see it. This orientation also means that it matters little to me whether those carrying out the mission are Kirk, Spock and McCoy or Picard, Riker and Crusher (Dr.). . . . The other major category of an appreciation, I think, does not approach *Star Trek* from the point of view of science fiction. In fact, these fans may not enjoy sf at all. Instead, they are interested in the "buddy" (Kirk-Spock-McCoy) or "family" aspect (the whole crew) of the series. . . . *ST V* was tailor-made for the fans of the "buddy" or "family" aspect of the show. (11–12)

Verba suggests that these same variations are also reflected in the other types of evaluations *Star Trek* fans make:

Once I realized this, other things in the past that have puzzled me fell into place: why some fans rated *ST III* the best of the movies, when it, to me, was quite obviously the worst; why a number of fanzines are dedicated to the Kirk-Spock friendship; why, in many of these stories, the authors are so quick to remove Kirk and Spock from the Enterprise, Starfleet and even the Federation (in contrast, to me, a story isn't "really" *Trek* unless it is in some way connected with space exploration, as defined above); why so many *Star Trek* fans are attracted to non-*Trek* programs such as *Starsky and Hutch* (another "buddy" series which I personally found uninteresting) and why some fans cannot make the transition to *TNG*. (11–12)

She does not offer any explanation for the emergence of these two very different ways of making sense of *Star Trek*, though they potentially reflect different reading backgrounds, social experiences, ideological orientations, desires. (At least one fan reader of this book in manuscript form questioned Verba's generalizations: "Most women *ST* fans I've talked to over 25 years *prefer* one interest, but I've met only a few that like the Kirk and Spock relationship to the

exclusion of being interested in the SF concepts of *Trek*. They may be more interested in people but they still enjoy speculating about Vulcan culture or Federation politics or Klingon languages or even starship hardware on occasion" [Meg Garrett, Personal Correspondence, 1991]). Yet as Verba suggests, the two readings (whether embodied in alternative groups of fans or in the same fan at different moments in the program's reception) are not simply idiosyncratic inflections. Each can find a basis in the series; each can find an institutional base of support within fan culture, as can other potential readings which Verba doesn't discuss, such as those that focus primarily on the program hardware or on the military chain of command, readings that are common to male computer net fans or to role-playing fans but not typical of the female fanzine readers and letterzine writers Verba is analyzing (Tulloch and Jenkins, forthcoming). Each reading will foreground certain aspects of *Star Trek* and will thus invite alternative evaluations.

Many fans justify these judgements according to general criteria applicable to any classical narrative. One fan praised the second season of *Star Trek: The Next Generation* for "exciting action-adventure, good character interaction, interesting moral problems" (Mike 1989, 6). Another dismissed "Conspiracy," a first-season episode, as "totally hackneyed" and predictable (Burns 1988, 8) Episodes are often disliked because they fail to resolve the questions they raise, because they develop too many plot lines to be presented with depth and coherence, or because performances or scripting are perceived as flat and one-dimensional.

More often, however, individual episodes are evaluated against an idealized conception of the series, according to their conformity with the hopes and expectations the reader has for the series' potential development. This program "tradition" is abstracted from the sum total of available material and yet provides consistent criteria for evaluating each new addition. A long-time *Star Trek* fan evokes this ideal in describing her continued commitment to the series:

> I have been a *Star Trek* fan since the first showing of the first episode. And I will be a fan, despite incoherent movies, insulting pro-novels, and rip-off series clones. I will be a fan because somewhere in my memory and my heart there is a captain who is charismatic, intuitive, intelligent, and brave (and occasionally pompous), a first officer who is

logical, incisive, brilliant, and caring (and occasionally te-
dious), a CMO who is perceptive, loyal, gruff and com-
passionate (and generally acerbic). With these three fly a
supporting crew of the finest the fleet has to offer in talent
and in character. They were no more than a glimmer in
the last movie, and apparently were on vacation during
the last book, but hopes do spring eternal. They may be
back in the next Paramount offering. And if they are
not. . . . I could never lose them anyway.

According to this criteria, the best episodes are those which not
only conform to the fans' expectations about favorite characters but
also contribute new insights into their personalities or motivations.
One fan praised "The Measure of a Man," a second season *Next
Generation* episode, because "it captured the essence of what Data
is" (Gilbert 1989, 7–8), while another commended "Heart of Glory"
because "we learned more about Klingons in that one episode than
in all the 79 original episodes and four movies put together" (Fluery
1988, 9). Fan favorites include episodes which place popular char-
acters in new situations or which center on the characters' pasts.
An otherwise mediocre episode may earn reserved praise if it in-
cludes a subplot or scene shedding light on an on-going character
relationship. One fan explained, for example, that while he was not
impressed by "the political overtones" of "The Arsenal of Free-
dom," the episode was "saved somewhat by Geordi's grappling with
command responsibilities and the increasing closeness of Jean-Luc
and Beverly" (Watts 1988, 15).

STAR TREK: THE META-TEXT

Such evaluations often blur the boundaries between aesthetic
judgement and textual interpretation. The "ideal" version of *Star
Trek*, the meta-text against which a film or episode is evaluated,
was constructed by the fan community through its progressively
more detailed analysis of the previously aired episodes. For the
occasional viewer, a given episode may be a more or less self-con-
tained narrative, following a series format, sharing certain broadly
defined generic features but enjoyable on its own terms based on
the amount of entertainment it provides on this particular evening's
viewing. Part of what distinguishes an episodic series like *Star Trek*
from a serial like *All My Children* is the degree to which each *Star*

Trek story remains self-contained. A typical *Star Trek* episode poses a problem needing to be solved by the episode's conclusion and that solution restores equilibrium on the ship; the established relationships must end exactly where they began. Kirk, Spock, and McCoy beam down to a planet, discover its maladjusted social system, and work to change it in the name of some universal moral value; a few "red shirts" (security agents) lie dead, whole planets may be transformed, yet little can alter the basic sets of relationships between the Enterprise crew. Kirk, Spock, and McCoy must reassemble for the program tag and offer some pithy exchange about Vulcan logic and human emotion, before the ship zooms away in search of "strange new worlds."

For the fans and perhaps for many regular viewers, however, *Star Trek* is experienced as something closer to a serial. No episode can be easily disentangled from the series' historical trajectory; plot developments are seen not as complete within themselves but as one series of events among many in the lives of its primary characters. For the fan, it is important to see *all* of the episodes "in order" in a way that it is not for the average viewer of that same program. The character's responses to a particular situation are seen as growing from that character's total life experiences and may be explained through references to what has been learned about that character in previous episodes. While *Star Trek: The Next Generation* makes occasional explicit references to program history, fans are capable of reading that history into a look, a raised eyebrow, the inflection of a line, or any other subtle performance cue that may be seen as symptomatic of what the character "had to be thinking" at that moment.

Such viewers form generalizations about those characters and their world reflecting the sum total of their knowledge about the series, be it gathered from aired material, program "Bibles" (official guides for potential writers for the series), interviews and convention appearances, or previously circulating fan speculations. Consider, for example, one fan's discussion of the different styles of leadership displayed by James Kirk in the original *Star Trek* series and by Jean-Luc Picard in *Star Trek: The Next Generation*:

> Patrick Stewart is a great actor with a lot of personal charm and good screen presence. Despite all that, Picard drives me nuts! He's so *guarded* and careful. He doesn't seem to *care* about anything. Always watching, figuring the odds. I

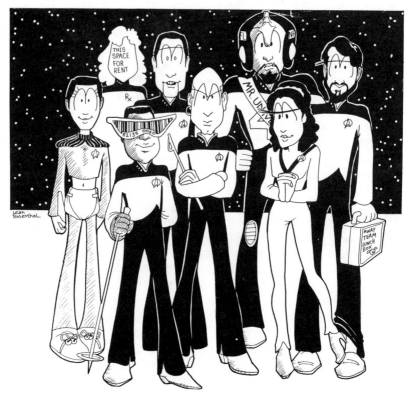

3.2 *Star Trek: The Next Degeneration.* Artwork by Leah Rosenthal.

don't know if anyone will understand what I mean by this, but he seems to me to be so *stingy* with himself. It's like he would never invest much time, energy, or emotion on anyone else. . . . I can't help but compare his behavior with Kirk's. Captain Kirk always cared and was always willing to help anyone in trouble. Picard seems more concerned with running a neat and efficient ship. He's more like a CEO than a Horatio Hornblower. (Bryant 1989, 7)

Questioned about these comments, the fan would certainly be able to support these generalizations about Picard's character through references to specific instances drawn from numerous episodes. In fact, the comments were precipitated by her reaction to one *Next Generation* episode, "Pen Pal," which she felt was a vivid example of the character's poor leadership: "In the same situation

as Picard's, Kirk would have immediately *demanded* a solution to the problem, a way to save all those lives." Yet it is doubtful that any *Next Generation* episode would perfectly illustrate all of the flaws she locates in Picard's character. Rather, she is offering a composite view of many different episodes and using that meta-text to comprehend and evaluate the character's conduct in particular narrative situations. Any new information the series provides about Picard will be fit into this existing grid of assumptions about his character and judged according to its conformity with what has come before. To some degree, such extrapolation is what all viewers do in making sense of program information, but, within fandom, it assumes an institutional status; elaborations become part of the program tradition, gain broad circulation and assume the status of accepted "facts" seen as binding not only on fans but on the program producers as well.

Many fan discussions develop and elaborate these meta-textual constructs, consolidating the information the series explicitly provided and offering speculations and extrapolations to better explain the motivation and context of narrative events. *Star Trek* fans have prepared elaborate time lines to situate each episode in a logical progression; others have tried to reconstruct the languages and cultures of the Klingons, the Romulans, the Vulcans, and the other alien races or to provide detailed explanations of the warp drive, transporter system, and the chemical composition of Vulcan blood.

Even where such elaborate speculations are not offered, fans still try to reconstruct likely events not directly represented on screen. Here's how one fan tries to explain the disappearance of Dr. Pulaski between the second and third season of *Star Trek: The Next Generation*:

> Considering what she went through to get on the ship, something drastic must've happened to send her away. Maybe Starfleet made her a research offer she couldn't refuse. They could've ordered her off, giving her a new assignment and/or promoting her. Maybe she had to take on a better job to pay off poker debts. Maybe she finally had a knock-down, drag-out fight with Picard neither could live with. Maybe she retired, or eloped with Riker's dad. Did she die? (Frayser 1989, 2)

This fan, thus, pools the information explicitly given about the character on the aired episodes (Pulaski's disagreements with Pi-

card, her research interests and ambitions, her previous romance with Riker's father) to offer a succession of speculations designed to account for a perplexing gap in the narrative information. *TV Guide* readers were told that Pulaski left because performer Diane Muldaur decided to accept a role on *L.A. Law*, but the producers failed to offer any explanation for the character's actions within the fiction. The fans' desire for continuity, consistency, and completeness mandated attempts to explain Pulaski's departure, even if such explanations could not be adequately anchored to the primary text. Such speculations, as we will see in chapter five, form the basis for the fan's creative reworking of the series. One has little trouble envisioning fan writers developing any or all of these lines of speculation into fanzine stories designed to explore more fully what motivated Pulaski's departure and what happened to her next.

Fans generally agree that these speculations should not contradict anything offered by the aired stories, though some episodes are more binding on fan speculation than others. *Star Trek* fans, however, enjoy much greater leeway in their use of information provided by the animated series episodes, the feature films, or the professional novels (which are seen as "unofficial" or noncanonical). Even more tenuous is the data offered by interviews with series producers and participants or provided by fan-produced works. Some fan myths, such as the tradition that Penda is Uhura's first name, gain wide circulation and hold almost the same degree of force within fan speculations as do the commercially produced materials, but more frequently, such additions are treated as mere speculations only accepted if compatible with the fan's own extrapolations.

These elaborations re-establish the completeness and continuity often lost in the producers' attempts to create self-enclosed episodes for a continuing series. This process also shifts attention onto secondary characters: Uhura or Sulu may be given only a handful of lines in any given story yet in the course of the series, fans may assemble sufficient background on these characters to reconstruct their life histories and to speculate about their motivations. Fan extrapolations even rescue interesting one-shot or background characters, such as Kevin Riley, "Broccoli" or Dr. M'Benga, and make them part of their understanding of the program's world. Joanna McCoy, for example, appears only in the program "Bible" and in early drafts of an episode script, not mentioned in the aired material until the animated series, yet she had by that point become a central figure in fan attempts to elaborate on the life and goals of her better-

known father, Dr. Leonard McCoy. Just as other fan extrapolations override gaps in the narrative information, these speculations focus on kernels of excess information, background details tossed into ongoing stories. Repeated viewings have placed increased attention on these narrative gaps and kernels, requiring their fuller integration into the fans' metatextual comprehension of the narrative world and the character relationships.

Such extrapolations also form the basis for the fans' evaluation of individual episodes or proposed plot developments. Fans complain when episodes fail to provide sufficient background on the characters or adequate motivation for their actions: "We've learned something new and/or seen some type of character growth with everybody else, but we don't know any more or see any difference in him [Riker] than when he first beamed aboard" (Watts 1988, 15). Actions or dialog substantially challenging this meta-textual construction will be dismissed as bad writing since they are "obviously out of character" with what the fan already "knows" about Picard and the other crewmembers. A consistent (and, typically, positive) pattern of changes might be attributed to character growth or maturation, especially if the fans can locate within the series specific instances reflecting the development of new skills or self-knowledge: Wesley is growing more mature; Geordi has come to master his new role as chief engineer; Riker is getting more comfortable with the demands of command; Sulu and Chekov are developing a closer working relationship. On the other hand, erratic fluctuations in characterizations, especially when not adequately grounded within this larger construct, are undesirable; fans call such inconsistencies "character rape."

Episodes are viewed negatively if they contradict information fans assume to be true about the series world or if they develop the program in directions frustrating fans' own sense of its "potentials." Several fans expressed disappointment about the first season departures of Tasha Yar and Beverly Crusher from *Star Trek: The Next Generation* because this meant that many interesting aspects of their characters would remain unexplored. Others protested that the producers had shifted interest from a Riker-Troi romance or de-emphasized Data's search for emotions, thus foreclosing themes fans enjoy. The introduction of Sybok, Spock's half-brother, in *Star Trek V* met with particular resistance from Trekkers who said that the character's very existence "goes against more than twenty years of established *Star Trek* background. . . . Frankly, I don't believe

that we long-time *Star Trek* fans are under any obligation to accept Sybok as presented" (Taylor 1989, 7). Fans similarly resisted a rumored plot for the sixth feature film consisting primarily of a flashback to the characters' days at the Starfleet Academy:

> If *ST VI* is based on the proposal that the NCC-1701 regulars were all at the Academy at the same time, I will not consider it *Star Trek*, but an alternative universe thereof. I might accept that, despite what we know of first season, Khan saw Chekov on the Enterprise. I will very reluctantly accept, despite 23 years of fan tradition, that Spock had a half-brother. But I will not accept that Kirk, Spock, McCoy, Scotty, Uhura, Sulu, and Chekov, despite their various ages and backgrounds, were at Starfleet Academy at the same time, or that they all knew each other before being assigned to the Enterprise (Verba 1990, 7–8).

As this passage suggests, some contradictions, while unpopular, may be more tolerable than others. *Star Trek* fans have found ways to explain away such apparent continuity problems as Khan's recognition of Chekov in *Star Trek: The Wrath of Khan* even though Chekov had not yet become a program regular when the Enterprise last crossed paths with Khan in "Space Seed" or radical reworkings of the make-up for the Klingons between the television series and the feature films. The fans have come to accept that their ideal *Star Trek* never aligns perfectly with what producers provide. They have found ways to talk around annoying details or perplexing gaps in character motivation: Chekov might have been a crewmember when the episode events occurred, may have been in engineering, say, but had not yet been assigned to the bridge, accounting for how he was known by Khan before the Russian ensign would have been recognizable to the viewers; "Basically, these knot-headed Klingons are a genetically engineered sub-race of the Klingons who have been slowly exterminating the Segh Vav, the parent race" (Landers 1989, 8). One way fans have of addressing these contradictions is to write stories or essays which develop these alternative explanations, so, for example, Randall Lander's account of the Klingon's genetic history forms the basis for a series of fan narratives.

Other changes cut too close to basic assumptions about what constitutes a good or credible *Star Trek* narrative to be so accommodated and must be rejected outright as "unforgivable" transgressions and unjustifiable infringements on the pleasures fans find in

3.3 Spock and Data: Two Generations of *Star Trek* protagonists. Artwork by M. A. Smith.

the program. Consider, for example, this fan's discussion of recent changes on *Star Trek: The Next Generation*:

> What do Roddenberry and Co. think they're doing?! . . .
> First they axe out Dr. Crusher with the excuse (cop-out really) that the character or her relationship with Picard isn't working, expecting us to buy that tripe and now they change the Romulans and expect us to buy *that*! No explanation, no nothing! They must realize that there may come a time when the fans will refuse to keep on 'buying it' and will 'check out' instead. . . . This time we won't need NBC to kill off *Star Trek*; its creator is doing the job nicely. (Cesari 1989, 4)

What's at stake for this woman is more than whether Romulans have ridges on their heads or whether Picard has romantic feelings toward the ship's doctor, though such issues are of vital interest to fans; these aspects of the series world have assumed particular meanings for her through her own progressive extrapolation of the program materials, implications contradicted or thrown into crisis by the producer's fickle decisions.

Fans particularly dislike major shifts in the program format not adequately explained or justified within its narrative logic, such as Pulaski's unaccounted-for absence at the beginning of *Next Generation*'s third season. Such situations make it more difficult for the fan to construct coherent explanations for the plot actions without depending on external factors (such as extratextual knowledge about the production process); such situations also are a forceful reminder that producers often care far less about the characters than the fans do.

Almost equally disturbing are characterizations which clash sharply with the overall program logic, even if that character behaves consistently from episode to episode. One fan dismisses Riker as "a Sixties stereotype on an Enterprise manned by Eighties' icons. . . . a cheap knockoff of that Sixties folk hero, James T. Kirk, who was supplied with a steady stream of willing yeomen and chesty aliens." She finds this character's misogynistic conduct inconsistent with the sexual politics represented elsewhere on the program and implausible given the series' twenty-fourth century setting: "As viewers, we're more sophisticated now and unwilling to cut Riker the same slack. Why the hell should we? We expect the *Star Trek*

officers to have some understanding of changing attitudes" (Hunt 1989, 2–3). While some fans could read the persistence of figures like Riker as evidence that the Federation has not yet resolved sexual inequalities, this fan chooses instead to read the character as ill-constructed and inconsistent with the program world.

EMOTIONAL REALISM AND GENDERED READERS

Fans want not simply internal consistency but also what Ien Ang has described as "emotional realism." Ang (1985) suggests that *Dallas* fans viewed the program not as "empirically" true to real-world experiences of upper-class Texans but rather as "emotionally" true to the viewers' personal lives: "The concrete situations and complications are rather regarded as symbolic representations of more general living experiences: rows, intrigues, problems, happiness and misery" (44–45). I would argue that "emotional realism" is not a property of fictions so much as it is an interpretive fiction fans construct in the process of making meaning of popular narratives. It is therefore possible for viewers to ascribe "emotional realism" to texts which break even more than *Dallas* does with empirical reality, to stories where earthmen and aliens navigate the stars and encounter strange new worlds far beyond the outer reaches of Southport, Texas. What counts as "plausible" in such a story is a general conformity to the ideological norms by which the viewer makes sense of everyday life. Such a conception of the series allows fans to draw upon their own personal backgrounds as one means of extrapolating beyond the information explicitly found within the aired episodes. Spock's troubled relationship to his father or Yar's feelings of social isolation can be understood through reference to similar situations in one's own life; Picard can be seen as something like one's father and the Enterprise crew can be understood as functioning like a community. Or consider how one woman discusses Star Fleet's policy to include families on long-term missions, a shift from *Star Trek* to *Star Trek: The Next Generation* that initially proved controversial with long-term fans: "Being a military wife, I can appreciate the concept *TNG* has of 'taking the family along.' Sure, there may be danger, but I'd rather face them with my mate instead of waiting safely planetside. (That might not sound logical, but what do you expect? I'm human, damnit, not a Vulcan!)" (Issacs 1988, 6). This self-conscious interpolation of the personal and the

experiential into the realm of the fictional helps to cement the close identification many fans feel with series characters and their world. (This interpretive strategy may be what some outside observers confuse with an inability to distinguish between reality and fiction.)

As some contemporary critics suggest, this style of reading—extrapolation that draws the reader well beyond the information explicitly presented in the text, the intermingling of personal experience and narrative events, the focus on a narrative's "world" rather than on its plot—reflects a gender-specific approach to narrative comprehension. Reader-response critics such as David Bleich (1986), Norman Holland (1977), Elizabeth Flynn (1986), Judith Fetterly (1986), and Patricinio P. Schweickert (1986) document the different ways in which men and women respond to literary works; this research finds its most compelling presentation in the Flynn and Schweickert anthology, *Gender and Reading* (1986). Bleich (1986), for example, surveys responses by male and female students to canonical literary works, concluding that men tended to read for authorial meaning, perceiving a "strong narrational voice" shaping events, while women "experienced the narrative as a world, without a particularly strong sense that this world was narrated into existence" (239). Female readers entered directly into the fictional world, focusing less on the extratextual process of its writing than on the relationships and events. Male reading acknowledged and respected the author's authority, while women saw themselves as engaged in a "conversation" within which they could participate as active contributors. These differences were particularly apparent when the students were asked to retell a story they had read:

> The men retold the story as if the purpose was to deliver a clear simple structure of the chain of information; these are the main characters, this is the main action; this is how it turned out. Details were included by many men, but as contributions towards this primary informational end—the end of getting the 'facts' of the story straight. The women presented the narrative as if it were an atmosphere or an experience. They generally felt freer to reflect on the story material . . . and they were more ready to draw inferences without strict regard for the literal warrant of the text but with more regard for the affective sense of human relationships in the story. (256)

The female reader saw her own "tacit inferences" as a legitimate part of the story, while the male reader tended to disregard such

inferences, discounting their relevance to a retelling of the narrative: "Men are cautious about 'accuracy' and they thus inhibit themselves from saying things that may not be literally documented" (260). Moreover, male readers tended to maintain the narratives' pre-existing focus on a central protagonist, while female readers expressed a greater eagerness to explore a broader range of social relationships, to "retell the story more in terms of interpersonal motives, allegiances, and conflicts" (257).

The comments and revisions offered by Bleich's students parallel strategies more freely adopted by fans in their playful construction of the program meta-text. Like Bleich's readers, *Star Trek* fans are less centered on Gene Roddenberry's personal vision of the future, though appeals to authorship are certainly common in fan discourse, than they are interested in examining the social relations between the entire crew. Perhaps most importantly, Bleich's female readers, like the *Star Trek* fans, depended on notions of "emotional realism" in making sense of these fictional relationships, relying upon their strong identification with the characters to work through personal problems. For the female reader, there could be no simple, clearly defined boundary between fiction and experience, since their metatextual inferences relied upon personal experience as a means of expanding upon the information provided and since character identification became a means of self-analysis.

It might be instructive to contrast the female fan culture that surrounds *Star Trek* with the predominantly male discourse of the *Twin Peaks* computer discussion group described in chapter two. On one level, the activities of the two fan communities closely parallel each other: both groups engage in repeated rereading and discussion of a common narrative as a means of building upon its excesses and resolving its gaps and contradictions; both groups draw not only on the material explicitly presented but also secondary texts, commentary by producers and stars, and the fan community's own speculations as a way of constructing an increasingly complex map of the program universe and its inhabitants. In other ways, the two groups' activities are strikingly different. The female fans of *Star Trek* focus their interests on the elaboration of paradigmatic relationships, reading plot actions as shedding light on character psychology and motivations; the largely male fans in the *Twin Peaks* computer group focus on moments of character interaction as clues for resolving syntagmatic questions. Confronted by a complex plot, the male fans sought to "get the facts straight," to determine the

guilt and innocence of the characters according to the author's own framework. The male fans' fascination with solving the mystery of "Who Killed Laura Palmer?" justified their intense scrutiny and speculation about father-daughter relations, sexual scandals, psychological and emotional problems, or romantic entanglements, issues that are the stock and trade of female fandom but often are of little interest to male fans. Sherry Turkle (1984) suggests that the hacker culture's focus on technological complexity and formal virtuosity stands in stark contrast to the group's discomfort about the ambiguities and unpredictability of interpersonal relations; here, the program discussion may have given participants a way of examining the confusions of human interactions by translating them into a technical problem requiring decoding.

Significantly, while female fans often use the program as a basis for gossip, appealing to conceptions of *Star Trek*'s "emotional realism" as a justification for drawing on personal experiences, this strategy was almost entirely absent from computer net discourse. *Twin Peaks* computer netters hid behind the program, moving through a broad network of texts but revealing little of themselves in the process. The group thus preserves a greater distance between the realm of the fiction and their own lives.

The rules of female fan interpretation dictate that explanations must first be sought within the fictional world before resorting to explanations that appeal to extratextual knowledge about authorship or the production process. Male *Twin Peaks* fans, on the other hand, consistently appealed to knowledge about Lynch as an author as a central basis for their speculations about likely plot developments and as evidence for their theories about the Palmer murder. Lynch's reliance upon intertextual references led the group to search beyond the city limits of Twin Peaks for a master text that might provide the key for deciphering the program: "Crack the code and solve the crime." Their search encompassed other narratives associated with Lynch (his previous films, the published Laura Palmer diary written by his daughter, the Julee Cruise album produced and written by Lynch) and from there, to a much broader range of materials somehow referenced by the series (*Vertigo, Laura, The Third Man, Double Indemnity*, even *Breathless, The Magic Flute, Heathers*, and *The Searchers*). The group's successful predictions of otherwise unlikely plot developments were sometimes ascribed to their suspicion that Lynch might be personally monitoring the nets: "I wonder how much we are writing our own show?" There was for a brief time a

hoax on the net: Someone submitting entries claiming to be Lynch; "Lynch" quickly withdrew from participation when other fans sought ways to prove his identity. Lynch became the source of all meaning within *Twin Peaks*, the focal point for the group's attempt to unravel its syntagmatic complexities and to evaluate its aesthetic merits.

These appeals to authorship help to justify these men's fascination with the soap opera-like dimensions of the series. Notions of authorship also provide a rationale for questioning the ideological and narrative stability of *Twin Peaks*, for articulating criticisms of textually preferred meanings. No sooner did the fans come to accept a previously outlandish line of speculation than that solution began to seem "too obvious" to be the real solution and the search for alternatives began again: "It seemed too obvious to be true. Lynch is one devious guy." "There are no cliches here. You will *not* get what you expect." "If David Lynch doesn't fuck with reality in his shows, who will?" Lynch's perversity and unpredictability were constantly evoked to justify the fans' equally outrageous speculations about lesser suspects in the Palmer murders: "With Lynch, I don't think you can rule out any possibilities." The fans' pleasure lay simultaneously in their textual mastery, their ability to predict the next twist of *Twin Peaks*' convoluted plot, and their vulnerability to Lynch's trickery, their inability to guess what is likely to happen next. Their greatest fear was that Lynch might not be fully in control:

> Am I the only one experiencing a crisis of faith? I waken in the middle of the night in a cold sweat imagining a world in which no one knows who killed Laura Palmer. I imagine Lynch and Frost just making it up as they go along, snickering about attempts to identify the killer when none exists. I see them ultimately making an arbitrary choice of culprits, a totally unsatisfying conclusion to the mystery.

Their pleasure in speculating about narrative enigmas, thus, depended upon the presence of a powerful author whose hand orders events and bestows significance.

The claim can be made that these different interpretive strategies are at least partially determined by characteristics of the two series: *Twin Peaks*, read as a mystery, certainly mandates greater focus on narrative enigmas than *Star Trek*, yet, as a soap opera, it also lends itself to paradigmatic explorations (Allen, 1985). Part of

the series' innovativeness involves the ways it plays these two sets of generic expectations (and the reading strategies they encourage) against each other. The male fans were perhaps drawn to the series because it promised spaces for syntagmatic speculations. In fact, the male fans wanted far more narrative complexity than Lynch could possibly deliver, pushing forward elaborate conspiracy theories or building "airtight cases" against such unlikely suspects as Dale Cooper, Deputy Andy, or Doc Hayward. Female fans of the same series embraced its paradigmatic dimensions, particularly the friendship between Sheriff Truman and Agent Cooper which becomes the focus of fan fiction about *Twin Peaks*. (See, for example, my discussion of one *Twin Peaks* story in chapter six.) When the male fans introduced their own "scripts," they centered around the creation of new narrative enigmas rather than on developing more fully the character relationships. While the characteristics of the two programs are relevant to the interpretations these fans form and certainly contribute to the kinds of fans each attracts, gender differences play a crucial role in determining how these two fan groups approach the broadcast narratives.

These different reading strategies, of course, do not simply reflect biological differences between men and women, an essentialist position Bleich briefly suggests but does not fully embrace. Rather, these different reading strategies are grounded in social experience. For Bleich (1986), who draws upon sociologically inflected theories of child development and language acquisition, these differences reflect the boy's push for autonomy and the girl's close identification with the mother and desire for affiliation, closeness, and community: "For the boy, both the content of the narrative and the source of the narrative are other. For little girls, this is obviously not the case. . . . The women 'become' the tellers of the tales that they are reading, and they therefore do not notice or demand to notice the author" (269).

There is something deceptively utopian, however, about Bleich's argument that women's reading practices insure a more comfortable, less alienated relationship to the narrative and "the mother language" than that required by masculine author-centered reading: "Neither the teller nor the tale is radically other for the women" (265). In practice, both the teller and the tale *are* often "radically other" for women within a world where publishing, broadcasting, and the film industry are all dominated by men; where most narratives center upon the actions of men and reflect their

values; where most existing generic traditions are heavily encoded with misogynistic assumptions; and where educational institutions reward masculine interpretive strategies and devalue more feminine approaches. In Judith Fetterly's words (1986), "As readers and teachers and scholars, women are taught to think as men, to identify with a male point of view and to accept as normal and legitimate a male system of values" (150–151). If women master these terms and strategies, they often remain a "second language" and not the "mother tongue" Bleich describes. As a result, women must often participate on an unequal footing with men within the narrative realm. The strategies Bleich identifies as characteristically feminine reflect, rather, ways women have found to circumvent male-centered narratives and to rewrite them in a fashion that serves feminine interests. Such strategies deflect focus from male protagonists and onto the larger sets of social relations constituting the narrative world; such strategies reclaim from the margins the experiences of female characters. These approaches are born of alienation and discomfort rather than closeness to and acceptance of narrative priorities.

Gendered reading practices, as Elizabeth Segel (1986) notes, reflect many of our earliest encounters with fiction, seeming natural precisely because they are deeply embedded within our sense of ourselves and the ways we typically make sense of our cultural experiences. Segel focuses on institutional practices segregating works into gender-specific categories (relationship-centered stories for girls, action-adventure stories for boys) and thus reinforcing particular reading interests:

> The publisher commissioning paperback romances for girls and marketing science fiction for boys, as well as Aunt Lou selecting a fairy tale collection for Susie and a dinosaur book for Sam, are part of a powerful system that operates to channel books to or away from children according to their gender. Furthermore, because the individual's attitudes towards appropriate gender-role behaviors are formed during the early years, the reader's choice of reading material may be governed by these early experiences long after she or he has theoretically gained direct access to books of all kinds. (165)

This early selection process affects the relative access men and women have to different generic models in their interpretation of

unfolding narratives and hence, has a strong impact on their reading interests and strategies. Girls, whose earliest reading focuses on romance and character relationships, learn to read for different things than boys, whose earliest books center on the actions of autonomous and heroic protagonists. Segal also suggests, however, that dominant educational philosophy, for the better part of this century, has assumed that girls could be more readily interested in reading masculine narratives than boys could be coaxed into experimenting with feminine stories. Girls were taught, then, to make sense of male-centered narratives while boys were only taught to devalue female-centered stories. Segal sees this process as having a largely negative impact on readers of both genders—teaching both boys and girls to devalue feminine experience and to look upon the male sphere of action as essentially closed to female entry: "Every trespass onto masculine fictional terrain by girls must have reinforced the awareness of their own inferiority in society's view" (177).

This practice may also have taught girls from an early age how to find their own pleasures in stories that reflect the tastes and interests of others, how to shift attention away from the narrative center and onto the periphery, how to reclaim their own interests from the margin and thus how to engage more freely in speculations that push aside the author's voice in favor of their own. Not all women will feel compelled to adopt such strategies; some will simply accept the limited range of women's fiction as a cultural space comfortably matched to their reading interests while others will more fully assimilate masculine reading interests and accept fictions on those terms. For many, however, there will continue to be a tension between their socialized reading interests and the commercial texts they encounter. The school girl required to read a boy's book, the teenager dragged to see her date's favorite slasher film, the housewife forced to watch her husband's cop show rather than her soap, nevertheless, may find ways to remake those narratives, at least imaginatively. Only by imagining the characters as having a life existing apart from the fictional narrative can these women envision their own stories rather than simply accepting those offered by the male-centered work. Women colonize these stories through their active interest in them, a process that helps to explain both why female fan culture clusters around traditionally masculine action-oriented genres and why the women must so radically reconceptualize those genres as they become the basis for fan enthusiasm. More traditionally feminine stories do not require such constant reworking in

order to become open to feminine pleasures; more action-centered fictions facilitate alternative pleasures for women, even if they must be accommodated more comfortably to the women's interests and tastes. Even where the male-centered stories are freely chosen and preferred by women, as certainly appears to be the case within fandom, they must nevertheless be reworked to provide a closer fit to these women's desires; they are not narratives naturally open to female appropriation, though they can be made into women's narratives.

Such an approach does, indeed, allow the reader to actively contribute to the narrative development. Elizabeth A. Flynn (1986) has proposed this type of relationship as a productive middle ground between active resistance on the one hand and passive acceptance on the other: "Self and other, reader and text, interact in such a way that the reader learns from the experience without losing critical distance; reader and text interact with a degree of mutuality. Foreignness is reduced, though not eliminated. Self and other remain distinct and so create a kind of dialogue" (268).

The result is the kind of textual proximity we have described earlier: the fan, while recognizing the story's constructedness, treats it as if its narrative world were a real place that can be inhabited and explored and as if the characters maintained a life beyond what was represented on the screen; fans draw close to that world in order to enjoy more fully the pleasures it offers them. This degree of closeness, however, can only be sustained as long as the imagined world maintains both credibility and coherence, and hence the importance the fans place on even the most seemingly trivial detail.

As Flynn (1986) suggests, this relationship works only if the reader may also maintain some degree of critical distance, recognizing the text as imperfectly designed to facilitate their pleasures and as requiring active rewriting in order to accommodate their interests: "Too much detachment often results in too much judgement and hence in the domination of the text; too much involvement often results in too much sympathy and hence in domination by the text" (270). If, however, the reader can strike a balance between personal experience and fictional narrative, personal ideology and authorial authority, without collapsing one into the other, then, Flynn suggests, "productive interaction" may lead the reader toward new insights about both the world of the text and the realm of their own experience. I would argue that the "emotional realism" of *Star Trek* promotes this complex and highly unstable relationship be-

tween reader and fiction and helps to explain the cultural and ide-
ological "productiveness" of fan culture. Fan criticism is the insti-
tutionalization of feminine reading practices just as the dominant
mode of academic criticism is the institutionalization of masculine
reading practices. Men may learn to read as fans, just as women
may learn to read within patriarchal norms of academic interpre-
tation, but both are running contrary to their own socialization.

This "emotional realism" stands at the intersection between
textually preferred meanings and larger social ideologies, between
the interests of the producers and the interests of the fan community.
Roddenberry's much-touted utopian vision offers an alternative way
of thinking about the future, resolving many of the problems that
confront 20th-century Earth. *Star Trek*'s future perfects human na-
ture, but bears recognizable relationship to the world inhabited by
its viewers. Thinking about such a society gives fans a basis for
making critical judgments about their own lives, for recognizing
earthly injustices unacceptable in the realm of Star Fleet, or pro-
posing new ways of structuring gender relations based more fully
upon notions of equality and the acceptance of difference. The Vul-
can philosophy of IDIC ("Infinite Diversity in Infinite Combina-
tions") becomes an ideal guide for conduct, shaping many aspects
of the fans' everyday life. Such a blurring of fact and fiction becomes
acceptable not because the fan is unable to separate the two but
rather because the notion of "emotional realism" implies the appl-
icability of the program's content to real-world situations.

The fannish ideal of "emotional realism" also insures that
transgressions of "common sense" assumptions about social reality
will be harshly criticized not simply as ideologically motivated but
as violating the integrity of the represented world. "Emotional re-
alism" means that the fans' understanding of their own experiences
may be influenced by fictional representations, but this same con-
cept preserves their ability to remain critical of a program's ideology.
Riker, thus, becomes a bad *Star Trek* character for some fans be-
cause he embodies attitudes they find socially undesirable and in-
consistent with the values they find within the series.

Situations transgressing the "emotional realism" of *Star Trek*
call attention to the producer's often suspect motives rather than
allowing these situations to be read uncritically as part of the series
reality. Consider, for example, how one fan reacts to the producer's
inconsistent treatment of Saavik, who was introduced in *Star Trek
II*, recast for *Star Trek III*, and then discarded in subsequent films.

3.4 *Star Trek: The Next Generation*'s Riker has proven a controversial character with fan critics. Artwork by M. A. Smith.

The producers publicly announced that Saavik might be pregnant with Spock's child, a child conceived when she helped the regenerated Vulcan through Pon Farr when they were together on the "Genesis planet" in *Star Trek III*:

> *Star Trek* has prided itself in addressing the issues of the day. Saavik represents an issue, not just of the day, but of time immemorial: the female (especially the potentially pregnant female) discarded when she inconveniences the male! . . . In *The Star Trek Interview Book*, Mr. [Harve] Bennett reportedly said that the *pregnancy and de facto abandonment of Saavik* were "Christmas stocking presents for the fans" and "a treat, it's our joke." Please, Mr. Bennett: ask a real-life woman in that situation whether it's a treat or a joke! Saavik is a test of the honesty and the emotional maturity of those involved in *Star Trek*. Here is a chance to treat a woman as something besides a discard! ST V will prove whether the test has been passed or failed. (Raymond 1989, 3–4)

The fans' commitment to *Star Trek* and their progressively more complex elaboration of its concepts provides a firm basis for criticizing its ideological construction and questioning its producer's motives.

Such a situation is a forceful reminder of the fans' powerlessness over the narrative's development, of the degree to which the fans' own pleasures are often at the mercy of producers who operate from a very different agenda. Fans have little say about what happens to their characters or their programs, but fans claim the right to protest and protest loudly decisions contradicting their perception of what is desirable or appropriate. The forcefulness with which fans express and defend these criticisms is rooted in the shared understandings of the fan community; these claims about the plausibility and coherence of the program's world or the merits of a given plot stem not from personal tastes alone but from the critical consensus of fandom. These fiercely held positions emerge and are reinforced through extensive fan discussions and are fundamentally grounded in criteria and suppositions accepted as valid by those participating within this discourse. These opinions can, thus, easily become the focus of large-scale letter-writing campaigns directed against pro-

ducers who grossly or consistently violate the fans' own sense of the program. In such cases, the social dimension of meaning production becomes the basis for collective action against the corporate executives or program producers who exercise such control over program content.

4

"It's Not a Fairy Tale Anymore": Gender, Genre, *Beauty and the Beast*

"Believe the impossible. Everything you've heard is true. It's not a fairy tale anymore." (*TV Guide* ad for *Beauty and the Beast*'s third season opener; Burke and Dunadee)

"Speaking of doing things the right way, anyone who starts a story with 'once upon a time' should end it with 'happily ever after.' " (*Beauty and the Beast* fan, personal interview, 1990)

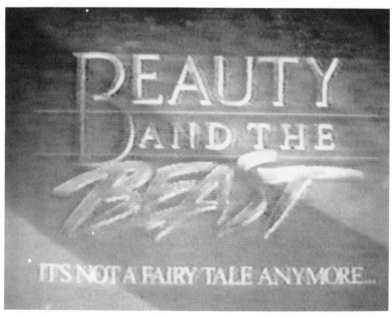

4.1 Network Promo for *Beauty and the Beast*'s third season premier.

The January 13, 1990 issue of *TV Guide* featured a profile of *Beauty and the Beast* and its faithful fans: "The show that wouldn't die . . . and the fans who wouldn't let it" (Carlson 1990, 2). *TV Guide* sympathetically documented the massive fan culture around the program, and the charity efforts of the Helper's Network and other local clubs. A particular focus was the grassroots movement directed in response to its initial cancelation and its much publicized return to the airwaves. While noting some fan dissatisfaction with plot developments in the program's third season, the magazine confidently concluded that "most fans will remain loyal." Ironically, just two days before this issue hit the news stands, CBS had canceled *Beauty and the Beast* a second and final time. The series which "refused to die" was now officially dead and many of its "loyal" fans reacted as much with relief as with mourning.

Beauty and the Beast fans, who only a few months before had seemed united in their efforts to save the show, now were sharply divided, unsure how to respond to recent format changes. Most fans were saddened by the departure of series star Linda Hamilton (who was pregnant and wanted more time to spend with her family) and by the producers' decision to dramatize the murder of her character, Catherine. Some continued to urge loyalty to the producers, expressing hope and confidence that they would resolve difficulties caused by the star's departure: "Respect them enough to trust them; trust them enough to believe; believe them enough to know that they will satisfy us" (Herbert 1990, 5). Others remained equally loyal to their own conception of the series which they felt had been violated by the network and the series' creators: "I don't even recognize this as *Beauty and the Beast* anymore. Do you seriously think that *This* is what people want to watch?" (Kopmanis 1990, unnumbered). Many expressed their sense of frustration and powerlessness, their inability to protect their favorite series from being radically altered.

The changes were widely perceived as an effort to attract a more masculine audience, even at the expense of the program's committed female fans and their desires for a happy resolution of the characters' romance. CBS President Howard Stringer lent credence to this claim with some particularly ill-conceived remarks at a network press conference about what he described as the "exotic" appeal of the "hot house" show: "I've gotten a lot of letters from nuns—I don't know what to make of that. Makes me very nervous actually. Were we targeting it just for nuns? I think we have to target priests,

too" (Ostrow, 1989, unnumbered). Convinced that the program's survival depended upon its ability to attract "priests" (and other masculine viewers) rather than an "exotic" following of "nuns" (and other female spectators), the producers not only shifted the series' focus from the love story toward more action-adventure plots but also killed the show's female protagonist, foreclosing a subsequent return to romance.

The heated reception of *Beauty and the Beast*'s controversial third season raises questions about the political and cultural status of television fans. *TV Guide* and the network both fell into the trap of taking for granted the fans' unconditional loyalty to the series and its producers. The *Beauty and the Beast* fans, however, were anything but uncritical; their membership within a larger community of fans and their public commitment to the program encouraged them to protest not only the network's actions endangering its future but also the producer's actions violating their collective sense of the program. Individually, they could draw upon the consensus of the larger fan community as a basis from which to criticize subsequent plot developments that ran counter to their expectations about the characters. Increasingly, many fans had come to recognize that their interests in the series were not aligned with the producer's interests. Moreover, these fans saw this conflict not only in personal terms ("You" vs. "Us") but in terms of a set of economic relations (producers vs. consumers) and political categories (male power vs. female desire). One fan described the producers as treating the fans like trained dogs: "Since the end of May, it's been 'sit fans, fetch fans, roll over fans, beg fans,' and now I suppose they'd like us to play dead, or at least quietly slink off, tail between our legs, whimpering softly and licking our wounds" (Landman 1990, unnumbered).

This controversy suggests how fan reading practices can be mobilized into active opposition to producer efforts, how the fans' own rewriting of the textual materials makes them active critics of future narrative developments and protectors of what they see as central to the program. By tracing fan response to *Beauty and the Beast*, then, it is possible to get a more concrete sense of the process by which a fandom may move from the eager acceptance of a new text toward active resistance to its subsequent transformations. But, first, it is important to get a firmer sense of the role of genre within popular television since producers, networks, and fans all appeal to generic conventions to justify their positions on the controversial third season.

ONCE UPON A TIME . . .

Traditional notions of genre as a class of texts, a set of narrative features and conventions, or a formula by which fictions are constructed seem inadequate to the struggle over *Beauty and the Beast*'s generic placement. For the most part, such models ignore the role(s) played by genre in readers' efforts to make meaning from textual materials. Thomas Schatz's claim (1981) that film genres represent a tacit contract between media producers and audiences seemingly gives equal weight to the role of formulas in both encoding and decoding films, for he speaks of a "reciprocal studio-audience relationship" (1986, 97). His account, however, implicitly favors the generic knowledge of the filmmaker over the activity of the spectator. Schatz gives us little sense of the nature of the audience's expectations or how they originate; these expectations are read from the texts, rather than documented through audience response. What Hollywood delivers is presumed to be what the audience wanted, largely based on the economic argument that the industry anticipates and markets to audience demand. Schatz's examples fit unambiguously within single categories (musicals, westerns) and therefore pose few problems about generic placement and interpretation. The reader's decision to purchase a ticket to such a film thus signals their acceptance of a set of conventional expectations about the likely development of the plot or disposition of the characters; once the appropriate genre is identified and accepted, readers simply interpret the narrative according to those conventions.

Most recent accounts focus even more explicitly on ways genre shapes the viewer's experience of given films, though, as with Schatz, this is typically characterized as a top-down process. Such accounts may discuss, often in highly sophisticated ways, the taxonomic problems encountered by scholars and critics in identifying the conventions and boundaries of particular genres, but take for granted that popular reading is determined, one way or another, by the reader's early and correct recognition of texts as belonging to particular genres. Rick Altman (1987), for example, suggests that genre "short-circuits the 'normal' sequence of interpretation" and usurps the function played by the interpretive community in making sense of the narrative: "Seen in this light, genres appear as agents of a quite specific and effective ideological project: to control the audience's reaction to a specific film by providing the context in which that film must be interpreted" (4). Dudley Andrew (1987) pushes this

concept of a top-down control over meaning-making even further: "[Genres] ensure the production of meaning by regulating the viewer's relation to the images and narratives constructed for him or her. In fact, genres construct the proper spectator for their own consumption. They build the desire and then represent the satisfaction of what they have triggered" (110). John Hartley (1985), writing from a different theoretical position, contends that "audiences' different potential pleasures are channeled and disciplined by genres," which pre-determine the range of their likely responses (as cited in Fiske, 114). These approaches offer us limited insight into the mental life of the viewer; even when theorists seem to be suggesting a "contract" between media producers and media consumers, that contract is, in fact, remarkably one-sided, a contract of adhesion allowing readers little more than the right to refuse engagement with a particular media product.

Such models may provide insight into the role of genres within the classical Hollywood cinema (though space alone requires me to concede that claim here); we should be suspicious, however, about importing them into television studies. If film scholars were forced to rethink the broad generic classifications of literary criticism (such as comedy and tragedy) into the much more specific categories of the Hollywood marketplace (such as screwball comedy, film noir, or the adult western), television critics are often forced to make the opposite move, creating relatively broad categories reflecting the blurred generic boundaries of network programing. Thus, David Thorburn (1987) sees melodrama as the dominant television form, a genre including "most made-for-television movies, the soap operas, and all the lawyers, cowboys, cops and docs, the fugitives and adventurers, the fraternal and filial comrades who have filled the prime hours" (539–540); David Marc (1984) offers a similarly broad notion of television comedy, while John Fiske (1987) makes large-scale distinctions between masculine and feminine programing.

If the Hollywood studio system promoted distinct genres as consistently appealing to particular audience segments, contemporary American television relies upon a process which Todd Gitlin (1983) has called "recombination" to broaden the appeal of any given program: "The logic of maximizing the quick payoff has produced that very Hollywood hybrid, the recombinant form, which assumes that selected features of recent hits can be spliced together to make a eugenic success" (64). The networks thus promote series which belong not to a single genre but to multiple genres, hoping

to combine the security that comes from building on past success with the novelty that attracts new audience enthusiasm; generic traditions are manipulated as well with an eye toward combining different demographic groups with different cultural interests into the large audience needed for ratings success (Tulloch, 1990).

Beauty and the Beast is a textbook example of this recombination process. The program was carefully constructed to build on multiple genre traditions in its quest for ratings; the polysemous address of the program also reflected creative differences between its producers and the network executives and sparked disputes with the program's fans. What remained unresolved throughout the series' run was its generic status and the interpretive strategies by which this program was to be understood.

Most accounts credit CBS Entertainment Division President Kim LeMasters with originating the idea for a series based on *Beauty and the Beast* following a viewing of Jean Cocteau's classic film. LeMasters approached Witt/Thomas productions about developing the idea into a series for possible inclusion in the 1988–89 season. As Producer Paul Witt explained in an interview shortly after the show's premier, "We didn't want another monster show. We didn't want a show where the beast breaks through walls. We wanted something classy" (Oney 1987, 37:2). Writer Ron Koslow, hired as the program's creator, viewed the show as a chance to create a "classical love story in classical terms" as well as to explore the mythic possibilities of a utopian society underneath the streets of New York City (Kloer 1987, 4). Koslow hoped to contrast the "frantic pace and intensity of New York" with the "lyrical romance of the underground." The program was intentionally constructed as a hybrid of several different genres and intended to attract a broad-based audience of women, men, and children (Gordon 1988, 26). Producer Witt similarly described the show as "consciously designed to have a split personality." He continued, "Everything above-ground is filmed in a stark, even brutally realistic style; everything below the surface is shot through a vaporous haze in hope of creating a mystical environment" (Oney 1987, 37:2).

This format requires a curious crossing of traditional gender boundaries: the professional stories with their adventure plots center on Catherine in her own sphere of action, while Vincent's world is the more domestic and relationship-centered. Catherine's job as an investigator for the district attorney's office ("where the wealthy and the powerful rule") provided a base for traditional action-adventure

plots; her professional activities bring her into contact with the harsher elements of contemporary life (street gangs, drugs, prostitution, child abuse, voodoo cults, subway vigilantes) and place her into dangerous positions from which Vincent can rescue her. (See, for example, "Terrible Savior," "Siege," "No Way Down," "Beast Within," "Dark Spirit," "A Children's Story," "Temptation," "Everything is Everything," to cite only first-season episodes which focus primarily on Catherine's confrontation of above-ground problems.) Vincent's role as one of the leaders of an underground utopian society ("a secret place far below the city streets . . . safe from hate and harm") allowed the series to shift its focus onto the dilemmas faced by this alternative community and its colorful members. Drawing on a nineteenth-century tradition of underground utopias and dystopias (Williams, 1990), these fable-like stories delve into Father's traumatic rejection of the world above ("Song of Orpheus"), and his struggle to articulate the ideals of a new kind of community. Recurring plot interests include his divisive dispute with a renegade community leader *Paracelsus* ("The Alchemist," "To Reign in Hell"), the community's festivities and celebrations ("Dead of Winter," "Masques"), and its struggles to define and preserve its ideals.

The romance between the two characters provides a bridge between the two worlds and thus allows smooth transitions across different generic traditions. As series writer Howard Gordon explained:

> It is a constant source of satisfaction for me that one week's episode may take us through the mean streets of Manhattan, while the next week may take us into the very bowels of the Earth, encountering mythic characters like *Paracelsus*. . . . The only necessary denominator is to have Catherine and Vincent involved in some organic context— though not necessarily with equal emphasis. The tough part here is to find some central subject which interfaces with both worlds, relying, hopefully, on only a modicum of coincidence. (Gordon 1988, 26)

Gordon identified three basic types of plots which had been woven into the *Beauty and the Beast* format: action-centered stories which place the characters into jeopardy and require some "climactic liberation" ("No Iron Bars a Cage," "No Way Down," "To

Reign in Hell"); relationship-centered stories in which Catherine and Vincent help a third party, often involving the uniting of young lovers ("China Moon") or the restoration of family harmony ("Everything is Everything," "A Children's Story"); fables which center upon moral dilemmas confronting the tunnel world community ("Fever," "Shades of Grey," "An Impossible Silence"). In each case, the romance between Vincent and Catherine plays a secondary but important role, motivating their involvement in each week's plot without becoming its dominant focus. Only a limited number of the episodes ever centered exclusively or even primarily upon the characters' relationship ("A Happy Life," "Orphans").

Critics praised the series for its generic innovations and advised against a return to television formulas (Burke and Dunadee, 1990). Network executives, however, pushed the producers to incorporate more and more elements of conventional action-adventure into the format as a means of insuring its success with traditional Friday-night viewers. In a recent interview, series writer George R. R. Martin suggests that the networks and producers were, from the beginning, sharply divided over the nature of the series and its desired audience:

> There were certain elements from the network right at the beginning that regarded us as a hairy version of *The Incredible Hulk*. If we were going to be primarily an action/adventure show oriented towards children with an obligatory beast-out at the second act's end, and a major rescue to end the fourth act, I really didn't want to be involved. But from talking to Ron Koslow, it became clear that his ambitions for the show were very high and that he regarded it as adult-oriented drama. (Grosse 1990, 53–54)

Martin recounts initial network resistance to the development of the Tunnel World population or the more romantic aspects of the story; CBS, he suggests, saw *Beauty and the Beast* as "a cop show with a hairy hero who saved people." *Beauty and the Beast* appealed to female viewers and seemed capable of attracting a younger audience to its early evening time slot, yet it appeared to perplex and even annoy many male viewers. Only as the program began to gain a greater following were the producers allowed to break more fully with action-adventure formulas and to explore its romantic and fantastic elements. Yet, as ratings declined in the second

season, producers responded to pressures to broaden its audience base by trying to attract more male viewers. Martin's account of the series' production, thus, explicitly links its development to shifts in the network's perception of its ratings. Crudely put, romance-centered episodes meant more female fans, while action plots held the prospect of enlarging its share of male viewership. The program's audience continued to be dominated by women, while the series ranked 50th among 1987–88 programs and 78th among 1988–89 shows. The network could foresee no course of action short of canceling the series altogether or radically altering its format. On Friday, May 19, the network announced that *Beauty and the Beast* would not be returning in fall 1989.

The program's most active fans were prepared for this event, having been closely monitoring the ups and downs of the series' ratings for months. By the end of the second season, there were more than 50 major fan organizations nationwide, with a combined membership of 350,000. Some 90 different fanzines and newsletters were in circulation and there was a computer net discussion group devoted to the program, creating many different linkages between local fan organizations. Ratings analysis had become a standard feature in fan newsletters and a hot topic on the computer nets. Fans flooded the corporate headquarters with some 2,900 telegrams and overnight letters, tying up the fax machine and switchboard for hours. The cancelation announcement occurred only several days before MediaWest, a Lansing, Michigan convention attracting media fans from across the country; *Beauty and the Beast* supporters spent much of the convention discussing additional strategies and gaining insight from other fans involved in previous struggles to save television series.

The network quickly retreated from its cancelation plans, suggesting instead that the series was on hiatus and would be returning as a midseason replacement. Fans maintained constant pressure to insure that the network did not quietly back from this commitment, as it had retreated from a similar promise to viewers of *Frank's Place* that same year. Fan activists prepared a strategic manual reported in several regional newsletters. This guide included not only the addresses of corporate executives but also those of major sponsors, local affiliates, significant publishers and broadcast journalists, and even Halloween costume manufacturers and literacy campaigns; anyone who might be solicited to support their efforts to keep *Beauty and the Beast* on the air (Burke 1989, 1–7). The Helper's

Network (based in Fullerton, California) ran a phone-information line with daily updates about the campaign and the network's responses ("The Beastie Girls" 1989, 131, 137). Fans were encouraged to wear program related T-shirts to attract interest in the show and to leave personal notes to potential fans folded in library copies of the classic works cited on the program. Fliers were distributed on street corners and at local PTA meetings. Fans called talk radio stations, were interviewed on local news shows, and made headlines in community newspapers, continually forcing the campaign into the public spotlight.

CBS's commitment for the production of 12 new episodes and to return the series to the air by January 1990 was widely seen as a victory for this grassroots campaign, as evidence that viewers had finally discovered ways to hold the networks accountable for their programing decisions. In the words of David Poltrack, a CBS senior vice president for planning and research: "We have been listening to all those people who have been writing, calling and sending us telegrams. The response of the *Beauty and the Beast* fans certainly helped us make the decision to bring it back next year. This is probably the biggest public response for a program that we've had since *Cagney and Lacey*" (Burke and Dunadee, 1990). By July, CBS was writing to the program's vocal fans, thanking them for their "enthusiasm and interest," pledging their "deep commitment to this very special property" and promising that they have "no plans to make drastic changes in the format" (Faiola, 1989).

Fans soon had new reasons to doubt these promises and to suspect that the network planed to restructure the series in order to broaden its audience. Koslow told reporters that "you are going to be seeing more danger, more momentum in the stories and some big surprises." His comments suggested that the show would be focusing more heavily upon action-adventure plots (Weiskind, 1989). *TV Guide* ran a leaked synopsis of the season's opening episode, describing in detail a plot that involved Catherine's impregnation, kidnapping, and death and Vincent's ruthless pursuit of the murderer. This synopsis was denied by program spokespersons yet later proven accurate in every detail. Network executives also expressed publicly their sense that the second season had focused too exclusively upon the Catherine-Vincent romance and that the series needed to broaden its focus. (As CBS Entertainment President Kim LeMasters explained, "The problem with *Beauty and the Beast* ended up being that stories between Vincent and Catherine just got

more and more narrow, and we were unable to explore issues that we want to explore" [Burke and Dunadee, 1990]). Loyal fans warned that they would probably stop watching if *Beauty and the Beast* became "all action and no depth" (Burke and Dunadee, 1990). As *Pipeline* editor Stephanie A. Wiltse explained, "When a network changes a show, it's like brain surgery with a baseball bat. We tend to feel that shows taken off for retooling have been the worse for it" (Burke and Dunadee, 1990). Wiltse subsequently embraced third season when it was aired as did many of the 2,200 subscribers of her newsletter, *Pipeline* (Personal correspondence, 1991). Wiltse reported that the third season episodes attracted an unprecedented response from her readers with letters running two to one in favor of the program changes (*Pipeline*, March 1990, p. 2). Other fan newsletters and letterzines, such as *The Whispering Gallery* and *Once Upon a Time . . . Is Now*, attracted more strongly negative responses with many expressing outrage against the "retooling" of the series. I have found a similarly negative reaction to the episodes from other fans I have contacted and from panel discussions at conventions I have attended, though it would be difficult to be sure how representative this sample may be of the total fan community.

This chapter has proved to be a controversial one with *Beauty and the Beast* fans and so I wanted to acknowledge their reservations here. I have received letters from fans across the country, some solicited, others unsolicited, expressing their appreciation for this chapter as accurately and sympathetically portraying their experience of the program. I have received a smaller number of letters and phonecalls complaining that I give a disproportionate amount of space to "dissidents" within the fandom and do not adequately represent the full range of fan responses to the third season. As one fan wrote, "I hope then you will forgive an unwillingness to let go unchallenged what could basically ennoble for posterity a rancorous scourge that did not originate from nor remain within the confines of the 'readings' you were discussing." (Personal correspondence, 1991). The heated tone of this and other responses I received reflects the passions that surround disputes about interpretations and evaluations within the fan community, as well as the stakes many fans invest in protecting the image of their favorite program.

So, I want to be clear about exactly what I am discussing in this chapter and why. My focus is primarily upon negative fan reaction, not because I feel these responses are necessarily representative of *all* fan response nor because I want to deny the role of

4.2 "Beastcake": Rita Terrell, Vincent as Minos of Ancient Egypt.

dissent and debate within the community's reception process nor because this negative reaction necessarily reflects my own judgments about the merits of third season episodes. Rather, critical responses raise most explicitly issues surrounding fan interpretation that are central to this book's argument. What I want to explore is how it is possible to remain a fan of a program while militantly rejecting producer actions that run contrary to one's own conception of the narrative. The tension between the producer's conception and the fan's conceptions of the series are most visible at moments of friction or dispute. I would argue that a similar gap exists even when the differences are not so great as to impair the fans' pleasure in the broadcast, though this claim would be harder to substantiate. In adopting this focus, however, I do not mean to represent this or any other fandom as univocal in its opinions and judgments.

Theories claiming that recognition of genre predetermines ideological response do not seem applicable to a text evoking as many different genres or as many different responses as *Beauty and the Beast* does. The producer's sense of its generic categorization differs from that of the readers and both contrast sharply with the network's perception of the same program. Series publicity signaled multiple genre categories as more or less equally appropriate: some ads feature romantic images of an embracing couple on a moonlit balcony, promising "a love story of a different kind," while others showed a roaring Vincent, poised for action, asking whether he was "Man or Beast?" (Burke and Dunadee, 1990). The reader must determine which generic formula(s) will yield the best results in appreciating and interpreting any given episode: just as the producers accented one or another generic tradition to attract different audience segments, some readers at least seem to have chosen to focus their emotional investment in the series romance as potentially rewarding while experiencing its action-adventure plots as a source of displeasure and dissatisfaction.

FROM READING THE ROMANCE TO READING AS ROMANCE

Peter J. Rabinowitz (1985) has suggested that genre study might productively shift its focus away from properties of fictional narratives and onto the "strategies that readers use to process texts," seeing genres as "bundles of operations," conventions, and expectations readers draw upon in the process of making meanings. As

Rabinowitz puts it, " 'reading' is always 'reading *as*' " (421). *Beauty and the Beast* will reveal different meanings, generate different pleasures if it is read *as* a romance or *as* an action-adventure series; or, to use Rabinowitz's example, Dashiel Hammett's *The Glass Key* poses different dilemmas when read *as* literature or *as* a popular detective story. Different genres evoke different questions readers want to ask and provide alternative rules for assigning significance and structure to textual content. Rabinowitz distinguishes between four basic types of interpretive strategies: (1) "rules of notice" which give priority to particular aspects of narratives as potentially interesting and significant while assigning others to the margins; (2) "rules of signification" which help to determine what meanings or implications can be ascribed to particular textual features; (3)" rules of configuration" which shape the reader's expectations about likely plot developments and allow the reader to recognize what would constitute a satisfactory resolution of that plot; (4) "rules of coherence" which shape the extrapolations readers make from textual details, the speculations they make about information not explicitly present within the story (421). The reader's experience, he suggests, thus requires an initial decision about what genre(s) will be most appropriately applied to a given narrative and then the systematic application of those generic rules to the process of comprehending the textually provided information.

Beauty and the Beast was readable within several different genres: as a fairy tale or fable which might provide "enchantment" to both children and adults; as a classical romance which, according to the producers, must end tragically; as a more contemporary romance which, according to fans, promises a happy resolution; as an action-adventure story about a couple of crime-fighters who struggle to impose their own notion of justice upon an imperfect world; as the saga of an underground utopian society's attempt to define and preserve its own values; as "quality television," a more nebulous category comparable to Rabinowitz's notion of "literature," which would foreground the series' production values, serious social themes, literary references, and classical musical performances as appeals to cultural respectability. Some of these generic placements would be mutually exclusive, or at least were perceived as contradictory within fan and producer discourse: romance fans were not drawn to the show for its action elements and vice versa. Others (romance, fairy tale, and "quality television") might be mutually reinforcing or potentially overlapping. Each reading, however,

would foreground different episodes or moments in episodes as particularly pleasurable or significant (rules of notice) and would ascribe alternative meanings to them (rules of significance); each would make its own predictions about likely plot developments (rules of configuration) and its own judgements about what would constitute a desirable resolution of its narrative (rules of coherence).

If the network and the producers sought to keep as many of these possibilities alive as possible in order to build a coalition of different audiences around the series, individual fans certainly preferred some readings over others. Some fans were drawn toward the "tunnel world" as an imaginary community whose values offer hopeful solutions to contemporary social issues, adopting it as a model for their own charity work; other fans were drawn to the series as exemplifying a particular notion of "quality television," tracking down the sources of literary references and musical passages or tracing the history of the character names and its symbolic imagery. While these potential interpretations do not completely disappear from the readers' experience of the series, most of the members of the Boston group were insistent that *Beauty and the Beast* was, first and foremost, a popular romance: "When you don't have that romantic element, the show goes down the tubes very quickly. You can do a show about the tunnel people and the tunnel world but that's not the major focus of the series. It's really about the love between these two people." (Personal Interview, 1990)

Aired episodes were evaluated, primarily, according to how much they contributed to the unfolding narrative of Vincent and Catherine's love. Asked to identify their favorite episodes, the Boston *Beauty and the Beast* fans consistently pointed toward episodes with a strong romantic focus or representing other important shifts in the character's relationship: "Once Upon a Time . . . ," "Masques," "A Happy Life," "Promises of Someday," "Orphans," "A Fair and Perfect Knight." Some cited the episodes involving the character of Elliott Burch, the only significant rival Vincent faced for Catherine's affections, while others focused their praise on the episodes involving the Paracelsus who threatens not only the romantic couple but the future of the entire tunnel world. Explanations given for these preferences focus on how these episodes had contributed to defining the characters and progressing the romance: "They are about characters I love and are truly romantic or [are] just *B&B* episodes as opposed to formula TV 'Cops & Robbers' episodes"; "These are episodes that emphasize Vincent and Cath-

erine, their relationship, and things, people and incidents (past or present) that affect their relationship, whether for good or bad." Many specifically opposed these relationship-centered episodes to the more action-centered episodes favored by the network executives: one women said that she preferred "those without violence and guns."

Asked to cite their least favorite episodes, many focused specifically on those episodes which contained the highest amount of violence or spent the greatest amount of time developing traditional action-adventure plots: "The Hollow Men," "The Outsiders, "Terrible Savior," "Dark Spirit." The fans complained that these episodes were "too ominous and dark," "concentrate on action without much character development," offered formulaic plots and too much emphasis upon "the problems of the guest star of the week." The action-focus of these episodes seemed irrelevant to their conception of the program (they "didn't move the relationship either forward or backward") and thus played a relatively minimal role in their interpretations. Their conception of the program's generic development, then, formed a solid basis from which the group could evaluate the merits of individual episodes.

"PROMISES OF SOMEDAY"

Fan interpretations consistently emphasized the most romantic aspects of the series text—even in episodes which are otherwise dominated by action-adventure. *The Whispering Gallery*, a popular regional newsletter, ran a regular column reviewing individual episodes, focusing primarily on those elements fans wanted to see developed more fully, and trying to speculate about "What They Don't Tell Us." These reviews give insight into the rules of notice fans applied in reading *Beauty and the Beast* as a romance and the rules of signification by which they assigned salience to those chosen elements. Consider, for example, one fan's discussion of "Terrible Savior," an episode frequently cited as one of the series' worst because of its focus on Vincent's violent struggle with a subway vigilante:

It starts out with us not knowing whether Vincent and Catherine have seen each other often or whether the subway slasher incident has brought them together. . . . We also

see that Vincent is sure of his relationship with Catherine
and she is still testing and learning. . . . Why does she fear
him? Does she not trust him yet? This is obviously the
case when she pulls away from him, and Vincent almost
strikes a lamp in his rage. We see Catherine's fear of Vin-
cent change after she confronts him then has time to think
about it. Vincent as always is forgiving, again. (The perfect
man). (Terhaar 1988, 5)

Here, dramatic moments within a suspense-centered plot are
being read for the clues they provide about the romantic relationship
between the protagonists, with gestures, looks, vocal tones mined
for their suggestion of a growing level of intimacy. Most of the first
two seasons' episodes, fans insist, provide some moments that are
meaningful primarily in terms of the character romance, even if
those moments are often marginal to the primary plot: "No matter
how grim it got, there was always a warm balcony scene at the end
of each episode." (Personal Interview, 1990)

Fan critics focused their primary interest onto such moments,
offering elaborate interpretations of each gesture or expression that
fit them within an overall progression of the relationship. Consider,
for example, one fan critic's reading of such a scene from "Chamber
Music," an episode otherwise dominated by Vincent's efforts to help
a young drug addict develop his musical skills:

Catherine and Vincent are sitting in the tunnel entrance
way listening to a concert in the park above them. This is
only the second time Catherine and Vincent have been out
on a "Real" date that didn't involve a murder, chase or
rescue. . . . Are we going to see more of these little romantic
times between Catherine and Vincent, where they are off
spending time alone? . . . Farther into the scene, it begins
to rain. Catherine begins acting like a care-free child, play-
ing in the rain, laughing exuberantly. I wonder if Catherine
has become much more comfortable around Vincent and
finally let loose a little. Her actions and movements in the
rain bordered on the seductive side, and we see Vincent
watching and enjoying this. What is he thinking about? He
smiles and chuckles along with her giddiness, but there is
a hint of maybe a little more of the physical (desire?) side
of this relationship. (Burke, 1988a)

As this example suggests, the fan's extensive extrapolations from these meaningful moments lead directly into speculations about possible future developments.

These localized interpretations are the raw materials from which fans construct a more global analysis of the series as rules of notice and signification are supplemented by rules of coherence and configuration. Fans may, indeed, engage in heated debates at this level of local interpretation, may disagree about how they read individual scenes or even the overall progression across scenes. Yet these disagreements occur within a shared frame of reference, a common sense of the series' generic placement and a tacit agreement about what questions are worth asking and what moments provide acceptable evidence for answering such questions. In one issue of *Whispering Gallery*, the newsletter editor raises questions about the second season: "A third element missing is the awakenings. The little clues and hints that maybe, just maybe Catherine might be starting to fall in love with Vincent, that maybe she can't live without him in her life or maybe Father is going to be a little more understanding of their relationship" (Burke, 1988b). Several issues later, another fan responds, citing specific moments in the second season which suggest to her such developments: "Think back to 'Brothers' and 'Chamber Music' and 'Remember Love.' . . . Check out the sickroom scene in 'Ashes, Ashes' and the balcony scene in the same episode. The final scene in 'Brothers,' the date scene and the parting scene in 'Chamber Music.' Don't tell me you don't see AND feel Catherine turn on to Vincent" (Almedina, 1988). Here, the individual moments which form the basis for this larger interpretation no longer need such detailed consideration; the scene from "Chamber Music" is reduced to a brief phrase, evoked for an audience which has already absorbed its local significance and fit it into their larger sense of the series' development.

Generic expectations are being fit to the particulars of this text; as rules of notice, signification, coherence, and configuration are applied episode by episode to the unfolding series, the more abstract generic formula is replaced by a program-specific meta-text. The fan's meta-text is always much more than simply the crude outline of a generic formula; it has built upon all the information specifically provided in the aired episodes, information offered by secondary sources (the "program Bible," published interviews) as well as upon the foundation of fan speculations about that information. Yet its point of origin is the reading hypothesis introduced by the viewer's

decision to interpret the text as belonging to a particular generic tradition. As Rabinowitz (1985) explains, "Literary works 'work' only because the reader comes to them with a fairly detailed understanding of what he or she is getting into beforehand. I am not denying that every work of fiction creates its own world, but I am saying that it can do so only because it assumes that the reader will have certain skills to begin with" (423).

The fan's predictions about future narrative developments are grounded not simply in their sense of the stories romances typically tell but also in their sense of these particular characters, the concrete problems to be overcome, and the circumstances that might create greater intimacy. Their interpretations must necessarily be confirmed and reconfirmed by references to specific episodes. Nevertheless, their descriptions of these characters and their problems still bear a striking resemblance to the conventions of the "Ideal Romance" Janice Radway identified. Radway characterizes romances as "exercises in the imaginative transformation of masculinity to conform with female standards;" romances describe the process by which men and women overcome gender differences in levels of intimacy and communicativeness to arrive at sharing and nurturing relationships (Radway 1984, 147). The man's harsh and stoic exterior masks "his hidden, gentle nature" (Radway 1984, 139). According to the fan community's reading, Vincent is torn between his gentleness and his realization of a darker, bestial side he fears will forever block his chances for romantic fulfillment. Only by resolving this contradiction can Vincent hope for happiness with Catherine. Moreover, Radway suggests, the ideal romance deals with "the female push toward individuation and actualization of self," the female push for autonomy and personal identity within terms compatible with the desire to reaffirm heterosexual marriage (Radway 1984, 147). The fans' Catherine must reconcile her desires for professional autonomy and romantic affection.

It is important to note that few of the members of the Boston *Beauty and the Beast* club regarded themselves to be regular readers of popular romances or regular viewers of soap operas, though some expressed interest in "literary classics" that told romantic stories, such as *Wuthering Heights* or *Jane Eyre*, and many listed television series with romantic subplots (*Remington Steele, Moonlighting, Scarecrow and Mrs. King, Dark Shadows*) as particular favorites. In fact, many of the women were openly hostile to the conventions of the popular romance, particularly those they saw as undermining

4.3 Fans tended to focus on the "fairy tale" romance between Vincent and Catherine. Artwork by Rita Terrell.

the autonomy of the female protagonist; traditional romances, they protest, transform women who are "very tough and feisty" at the book's openings into "Millie Milquetoast characters" by their conclusions. Those fans who did "occasionally" read romantic fiction were quick to assert that the conventions of that genre were changing in response to "feedback from the female fans" and beginning to reflect the greater possibility of feminine authority and independence following marriage. Almost all claimed, however, that *Beauty and the Beast* offered a style of romance not readily available in other popular fiction.

To understand the meanings these women placed on the romance, it is useful to consider their social status and ideological orientation. All of the women in the group worked outside of the home, some in traditional female service jobs (teachers, nurses), others in low-level or middle management jobs, and several in executive positions. Many of them were married, yet some were single. Most were in their early to mid-thirties, though several were older and a few younger. All of the women identified themselves as feminists, though some qualified that label in some fashion: "yes and no," "Yes, but not strident about it." This group differs sharply with the stereotype of bored housewives eagerly consuming popular romances; these women confronted the contradictory expectations surrounding femininity in the late 1980s, actively pursuing careers without rejecting romantic commitment or without losing aspects of traditional femininity they saw as desirable. These women did not feel entirely comfortable labeling themselves as feminists, despite the degree to which their professional lives broke with traditional feminine roles and the degree to which some of them remained entirely independent from men. They also did not feel comfortable identifying themselves as consumers of popular romances, an image too closely bound to restrictive notions of femininity.

Their emotional commitment to Catherine—a character herself torn between professional ambitions and a desire for a more traditional lifestyle—might help them to explore their own ambiguous relationship to feminism. These fans describe the characters in ways that evoke a break with conventional gender roles, while simultaneously attaching to them valued aspects of traditional gender identities:

> Vincent can be sensitive without being wimpy. I think all
> women want a sensitive man but there are some men who

have this sensitive side but then they lack a masculine side. I think he's a blending of both sides that's the most perfect. (Personal Interview, 1990)

Catherine is my favorite character on the show. I have a problem with the woman's movement in fact. Because of it, certain women are less valued because they stay at home or have kept certain aspects of their femininity. I find Catherine to be tough, resourceful, reliable. She can take care of herself. But she's also allowed to cry. . . . I see her more as a person than as a woman. She's not like certain women on shows now who are stereotypical women's libbers. They're tough—they act like men, while Catherine is strong yet very feminine and I like that about her. (Personal Interview, 1990)

We had a heroine of the rarest kind on television—one who developed strength, courage, and determination while remaining feminine and vulnerable. Too often strong, resourceful women are depicted as pseudo-males, aggressive and non-emotional (for a perfect example, see the third season). This was a fictional character I could feel proud to relate to—someone who was growing, someone capable of crumbling at times under the demands of others, just like we all are, but someone at all times in touch with her femininity, bringing a perfect balance to Vincent's primitive-male image." (Diane Davis, Personal correspondence, January 1991)

The relationship between these characters was seen, then, as one which would provide each with room to exercise both their strength and their vulnerability; the program, they hoped, would provide a romance relevant to an age of changing gender roles, a romance not based on submission but rather on mutual trust and commitment:

Vincent loves her—he loves everything about her and accepts her for the good and the bad. . . . He supports her whatever comes. (Personal Interview, 1990)

Vincent taught her to feel other people's needs and she's just grown so much [during the series] and of course, she gave it back to him. She let him know that he could be loved just the way he was, not out of gratitude for his help

or out of pity because he's alone, but just because he's
Vincent. (Personal Interview, 1990)

Romantic consummation, then, did not entail simply the ful-
fillment of the viewers' erotic fantasies, but rather posed an ideo-
logical solution, a reconciliation of differences, the possibility of
trust and intimacy between two people who are so different and yet
so alike:

> There is a confrontation and a resolution that has to hap-
> pen. It doesn't have anything to do with people going to
> bed together. It has to do with completeness. It can be
> touching. It can be hugging. It can even be just standing
> looking at each other but the completeness needs to be
> there and for Catherine and Vincent, they never got it. We
> only get a hint of it. (Personal Interview, 1990)

Such a reading helps to explain why Catherine was a particularly
pivotal figure for these women. As Radway (1985) suggests, the
romance's heroine becomes the focus for feminine identification; if
she can successfully negotiate these conflicting demands, her story
offers hope for the readers' own efforts to reposition themselves
during a period of social change: "I saw a lot of myself in her. The
character's gone through a lot of what I've gone through." (Personal
Interview, 1990) The fans' expectations about the likely develop-
ment of the series, thus, were bound to their hopes for Catherine's
success in resolving the dilemmas they confronted in their own
personal lives.

One member of the Boston fan club described her sense of the
program's overall plot: the first season saw the characters deciding
to "pursue a relationship together," a decision reached by the sea-
son's conclusion ("A Happy Life"); the second season should have
"deepened" their relationship by working to resolve the differences
which separate them, reaching a crisis point by the seasons' three-
part finale; the third season should have begun with their realization
"that they belonged together" and "move towards some of their
dreams, towards maybe some kind of life together below, some kind
of wedding or other symbolic ceremony. Then, at the end, they could
have had Catherine expecting a baby or having a baby and have it
end happily—play the thing through from beginning to end." (Per-
sonal Interview, 1990)

Her *Beauty and the Beast* had always been advancing toward a happy ending which would have resolved the difficulties separating the couple, revealed those problems to exist largely within the characters' minds, and allowed them the "satisfaction" of a traditional life together. Other fans offered similar visions of a desirable resolution:

I would like to have seen significant progress made in V & C's relationship throughout the season, perhaps resulting in a wedding or some other commitment vows or ceremony by the end of the season. But not without a *few* obstacles to overcome along the way to make things interesting. Vincent being able to come to terms with his dark side, which is essential if their relationship is to progress. (Survey Response, 1990)

Catherine and Vincent would have consummated their love, married and had a child. (Survey Response, 1990)

[The series should end with] Catherine moving into the tunnels. (Survey Response, 1990)

The consistency with which the fans return to these same images—marriage, sexual consummation, birth—as a means of resolving this "perfect and impossible relationship" points to the degree to which they rely upon familiarity with generic conventions to shape their experience of the series.

The fan's projections closely mirror Radway's account of the "Ideal Romance" formula:

1. The heroine's social identity is destroyed. [In "Once Upon a Time . . . ," Catherine is mistaken for another woman and disfigured; Catherine repudiates her previous engagement, rejects her place in her father's firm, and seeks a new life for herself.]

2. The heroine reacts antagonistically to an aristocratic male. [In "Once Upon a Time . . . ," Catherine reacts with fear and fascination upon her first encounter with Vincent.]

3. The aristocratic male responds ambiguously to the heroine. [Throughout the early part of first season, Vincent desires Catherine and yet he sends her away; Catherine fears Vincent in "A Terrible Savoir."]

7. The heroine and hero are physically and/or emotionally separated. [In "A Happy Life," Catherine fleas to New Jersey hoping to resolve her conflicting desires, planning to end her relationship with Vincent.]

8. The hero treats the heroine tenderly. [The characters embrace at the end of the first season.]

9. The heroine responds warmly to the hero's act of tenderness. [Catherine comes to feel closer to Vincent as second season begins.]

10. The heroine reinterprets the hero's ambiguous behavior as the product of a previous hurt. [Second season offers several episodes exploring Vincent's past, including a story of his first romantic experiences; the crisis which Vincent faces in reconciling his gentleness and his bestiality heightens throughout the season.] (Radway 1985, 187)

Having successfully mapped each of these expected movements within the series's romantic narrative, the fans came to anticipate the final completion of the formulaic plot:

11. The hero proposes/openly declares his love for/demonstrates his unwavering commitment to the heroine with a supreme act of tenderness.

12. The heroine responds sexually and emotionally.

13. The heroine's identity is restored. (Radway 1985, 187)

So grounded have these expectations become in the fans' interpretation of textual specifics, in meaningful moments from the episodes, that they seem to originate not from an outside interpretative formula but rather from within the series itself. *Beauty and the Beast* appears to promise the romantic resolution that its producers had consistently denied: Vincent and Catherine *must* consummate their relationship and thus provide appropriate closure to this romantic narrative.

"FEEL THE FURY"

As Radway (1985) documents, romance readers often turn to the back of the book to confirm that the resolution will satisfy their generic expectations before reading it; "Dot," the bookstore em-

ployee, advised the Smithton women on which books would best satisfy their tastes, which would frustrate their desires. The viewers of an unfolding television series, such as *Beauty and the Beast*, have no similar means of verifying that the program will bring its narrative to an appropriate resolution. Instead, the fans were forced to place their trust in the producers to provide them with the story they wanted to watch. The producers' persistent refusal to provide viewers with those plot developments (increased intimacy between Vincent and Catherine, Vincent's resolution of his personal conflicts, the achievement of stable romantic commitment) was perceived by some fans as a betrayal of implicit promises made by virtue of the program's apparent reliance on those generic formulas. Many members of the Boston club expressed the suspicion that, even if Linda Hamilton's departure had not forced the producers in other directions, they would not have delivered on their commitments: "It would have been a lot more near misses. They never would have given us our romance." (Personal Interview, 1990)

Their intense displeasure in the third season fed upon several years of disappointment in the series' refusal to gratify their romantic fantasies, a history of *TV Guide* blurbs promising romantic interludes which proved more teasing than gratifying, and scenes that edge toward romantic commitment, only to be interrupted or to have the characters back away from consummation. If, for many fans, the cryptic and hurried consummation in "Though Lovers Be Lost . . . ," the third season opener (with its trite images of "lava flowing and flowers opening") was a "ludicrous nightmare," denying viewers the desired warmth and intimacy, that moment was simply the last in a series of "insults" to their hopes and expectations: "They were tremendously electric scenes but afterwards you just felt annoyed."

By the beginning of the second season, the fans were already expressing disappointment about the producers' refusal to develop that potential. If the network complained that the second season had centered too closely upon Catherine and Vincent, that the romance seemed in danger of "imploding upon itself," the fans felt the season was too preoccupied with other subplots. Consider, for example, several fan responses to the series' second season:

The appeal, last year, was the *development* of Catherine and Vincent's relationship. This year the relationship has

stopped growing. My interest has dropped. (Fan response cited in Burke and Dunadee)

This year most of the episodes have centered on others, not on the relationship between Catherine and Vincent. While liking some of these other characters, it's not why I watch *Beauty and the Beast*. I find myself asking where Vincent and Catherine are. I miss the relationship I, as a viewer, have built with them. . . . I'm ready to move on [with the relationship], but the episodes don't seem to be. (Hughes 1989, 3)

Fans wanted something from *Beauty and the Beast* its producers were unable or unwilling to deliver. Initially, fans could find textual explanations for the couple's inability to achieve romantic fulfillment (Father's divisive influence, Vincent's anxieties and fears about his bestial nature, Catherine's desires for autonomy). Yet these explanations crumbled in the face of progressively more "teasing" and exploitation. Some fans shifted their anger onto the producers who would not deliver what the series appeared to be promising.

As a fan culture devoted to *Beauty and the Beast* emerged, as fanzine stories began to appear, these new narratives focused increasingly on the show's unfulfilled romantic possibilities, representing possible ways Vincent and Catherine could overcome the obstacles blocking personal fulfillment. Some fanzine stories even provided images of Vincent and Catherine as parents, living in the "world below" and raising a new generation. The fanzine titles, *Cascade of Dreams, A Promise of Eternity, Sonnets and Roses, Tunnels of Love, A Life Without Limits, Crystal Visions,* and *Faded Roses,* evoke the program's most sentimental images as a basis for new narratives fulfilling those romantic fantasies frustrated by the broadcast episodes.

By the time the belated third season began, the fan community had a firm sense of how the romance between Catherine and Vincent should be resolved. Each saw its resolution in somewhat different images, under different circumstances. Yet a consensus had evolved that the characters *must* overcome the intense differences separating them and achieve the family happiness so long denied them. This solid meta-text allowed some fans to deny the "authenticity" of the third season episodes, rejecting them from the series's canon and dismissing them as binding on fan speculations:

4.4 Fans invisioned a future for the characters that went well beyond the aired narrative. Artwork by Rita Terrell.

I looked at it as a separate version of possible reality. . . .
I don't choose to believe this is going to be the reality for
these characters. In my mind, they are off living happily
ever after and I will continue to read stories and write
stories about them. . . . I don't feel emotionally depressed
about it because I don't feel any ownership of the third
season. I don't feel that that's really what happened to the
characters. (Personal Interview, 1990)

For others, however, the televised images proved too vivid,
their closeness to these characters too strong, to allow them distance
from the events: "What should have been a joyous time for Cath-
erine and Vincent has turned into a terrible nightmare and I feel
trapped in it with them" (Freeman 1990, 3).

The *Beauty and the Beast* these fans had watched and supported
was officially dead; its producers and the network had killed it,
shifting the program toward generic formulas that held no com-
pelling interest for them:

I think they were going for the heroic image, not realizing
that when we saw Vincent, we didn't just see the heroic
image. We saw the romantic Vincent. They did their best
to build the perfect heroic image which meant that they
had to provide an equally great villain. . . . The problem
is that to do so—they sacrificed the romantic side of the
plot and that did it! That act of killing Catherine made
him the greatest villain I've ever seen. Nonetheless, they
had given up forever the chance to go back and bring in
the romantic element of Catherine, which is what they had
that was so valuable to begin with. (Personal Interview,
1990)

These fans felt no "ownership" of the third season episodes
because the producers had violated the spirit of what attracted these
women to the show. Instead of the possibility of greater intimacy
and romance, of a reconciliation of differences, the long-delayed
consummation scene was reduced to a succession of quick and
cliched images. So cryptic and confusing was the sequence that some
fans have jokingly referred to Catherine's baby as the result of an
"immaculate conception." Rather than using consummation to
achieve greater trust and intimacy between the two lovers, of re-
solving the conflicts separating them, sexual intercourse broke the

empathic bond that joined them; Vincent lost his memory not only of that moment but of much that transpired between the couple:

> For two years, we've waited for that grand, passionate kiss of our dreams and what we get instead is mouth-to-mouth resuscitation and not much of that! . . . The fact that Vincent *never* once remembered that anything had happened just makes it worse. For him, subjectively speaking, nothing *did* happen. And now that she's dead, nothing can *ever* happen. . . . Why did the writers deny this experience to Vincent and Catherine (and to us) when they'll never have the chance again?!" (DeLeon 1990, 3)

From that moment, the program assumed the worst features Radway's readers identified in the "failed romance": "Where the ideal romance appears to be about the *inevitability* of the deepening of 'true love' into an intense conjugal commitment, failed romances take as their principal subject the myriad problems and difficulties that must be overcome if mere sexual attraction is not to deteriorate into violence, indifference or abandonment" (Radway 1985, 162). The series moved relentlessly to foreclose any possibility of romantic fulfillment for Vincent and Catherine, and in the process, took away much the fans had found endearing about earlier episodes. Catherine is tortured and murdered. Vincent goes on a rampage seeking vengeance for her death, his gentleness often overpowered by bestial fury. Violence invaded the "special places" from previous episodes, spaces saturated with meaning through the fans' repeated rereadings of those scenes and embedded within the fans' own narratives. Beloved characters were revealed as traitors or killed.

The producers sought to appease fans by the introduction of a new female protagonist, Diana, who some fans suspected was designed to be a future lover for Vincent, a new "Beauty." They felt this development would only further undermine the "specialness" of the Vincent-Catherine romance. Moreover, some felt that Diana's strength and independence pushed too far against romantic conventions; they insisted that she lacked those aspects of traditional femininity that had drawn them to Catherine: "Diana can take care of herself. She doesn't need to look to anyone for help. But I can't picture her on the balcony in a silk nightgown. . . . Catherine was all soft and Diana is all hard edges." (Personal Interview, 1990)

Several of the women suggested that they liked Diana's character and that she might become the focus of a fascinating series but that Diana did not fit their expectations for *Beauty and the Beast*.

Not all *Beauty and the Beast* fans rejected the third season; indeed, some preferred it to the previous seasons, suggesting that the introduction of Diana renewed their interests by restoring elements lost during second season's development. Morgan, one member of the Boston group, felt the producers had weakened Catherine's character to the point that she no longer could function as a focus of her identification: "When Catherine was first introduced, you saw the softness and the strength. By the time they killed her, all she was was soft, soft, and soft. Keep pushing down, all you get is soft." (Personal Interview, 1991) Morgan saw Diana as a stronger, more "realistic" female character: "Catherine went around issues rather than face them. Diane confronts problems face to face. . . . Vincent was stronger than Catherine emotionally; he was Catherine's support. Diana would have been the other way, constantly telling Vincent that he needed her help. The result would have been a more equal partnership between them" (Personal Interview, 1991). Both Morgan and Cindy, another member of the Boston group who also expressed a preference for the third season, stressed that they were not centrally interested in the romance but rather saw it as one of several important aspects of the program. Cindy emphasized that third season allowed the producers to explore Vincent's personality, broaden Father's character, and focus more fully on the tunnel world:

> If they weren't going to progress the love story, it was time to move onto something else. . . . There are so many different directions that program could have gone and it looked like they were starting to explore them when it ended. . . . As far as I'm concerned, the tunnel world could have been its own show and I would have watched it. Who cares about New York? I've seen other cop shows. I want to go down and look at this community, how they live, how they do their laundry. The third season was starting to really focus on that world down there. . . . There's nothing so special about Catherine. I want to know more about Vincent, who he is, why he's there. (Personal Interview, 1991)

Here, as well, their interest in the third season reflects something other than an unconditional commitment to the series. These

women endorsed the third season precisely because it came closer to fulfilling the generic potentials they saw in the series, because it better satisfied their interests in the characters and their world.

As third season unfolded, tensions between fans and producers erupted publicly. Some fans wrote angry letters demanding the series's immediate cancelation; some broke all ties with *Beauty and the Beast* fandom. Letterzines and club newsletters overflowed with pained reactions to the third season as well as equally passionate defenses. Some reacted with relief when the series was finally pulled from the air. Both Morgan and Cindy described to me tense encounters with other fans as a result of their willingness to publicly defend the third season and this is one reason why they wanted me to include some acknowledgement of third season fans in this chapter. Yet it would be a mistake to describe this traumatic break between some fans and producers (as well as between different segments of the fan community) as the end of *Beauty and the Beast* fandom. The characters had established such a coherence and stability through the fans' own meta-textual extrapolations that they retained a life within fan culture even after the series itself ceased production. Fans could now turn their attention entirely to the creation and consumption of zine narratives more perfectly fulfilling their generic expectations and satisfying their desires. "Classic" fans, (i.e. fans of the first two seasons), could write stories in which Catherine lives and finds happiness with Vincent; Third season fans could write stories that built upon that season's new developments. The Boston meetings are often spent in informal discussions of recent zines, evaluations of their contents, exchange of fliers, solicitation of stories for zines the members were editing, or speculations about narratives fans would like to write. The infrastructure established during the long struggle to protect the series from cancelation now serves as the basis for an autonomous fan culture, drawing inspiration from the broadcasts yet taking the characters in directions unimagined by the producers. The next chapter looks more closely at fan writing as a critical response to television programs, as a way of rewriting the series in order to better facilitate fannish interests.

5
Scribbling in the Margins: Fan Readers/Fan Writers

[The signs of consumption] are thus protean in form, blending in with their surroundings, and liable to disappear into the colonizing organizations whose products leave no room where the consumers can mark their activity. The child still scrawls and daubs on his schoolbooks; even if he is punished for this crime, he has made a space for himself and signs his existence as an author on it. The television viewer cannot write anything on the screen of his set. He has been dislodged from the product; he plays no role in its apparition. He loses the author's rights and becomes, or so it seems, a pure receiver. (Michel de Certeau 1984, 31)

Four *Quantum Leap* fans gather every few weeks in a Madison, Wisconsin apartment to write. The women spread out across the living room, each with their own typewriter or laptop, each working diligently on their own stories about Al and Sam. Two sit at the dining room table, a third sprawls on the floor, a fourth balances her computer on the coffee table. The clatter of the keyboards and the sounds of a filktape are interrupted periodically by conversation. Linda wants to insure that nothing in the program contradicts her speculations about Sam's past. Mary has introduced a Southern character and consults Georgia-born Signe for advice about her background. Kate reviews her notes on *Riptide*, having spent the week rewatching favorite scenes so that she can create a "cross-over" story which speculates that Sam may have known Murray during his years at MIT. Mary scrutinizes her collection of "telepics" (photographs shot from the television image), trying to find the right words to capture the suggestion of a smile that flits across his face. Signe writes her own explanation for how Sam met Al and the events that brought them together on the Quantum Leap project. Kate passes around a letter she has received commenting on her

5.1 The Many Faces of *Quantum Leap*'s Sam Beckett. Artwork by Kate Nuernberg.

recently published fanzine; the letter includes praise for Signe's entry, only the second fan story she has published and her first in this particular "universe." Each of the group members offers supportive comments on a scene Linda has just finished, all independently expressing glee over a particularly telling line. As the day wears on, writing gives way to conversation, dinner, and the viewing of fan videos (including one that Mary made a few weeks before).

For the fan observer, there would be nothing particularly remarkable about this encounter. I have spent similar afternoons with other groups of fans, collating and binding zines, telling stories, and debating the backgrounds of favorite characters. This same group of women had come together earlier in the week to show me videotapes of several *Quantum Leap* episodes and to offer me some background on the program and the fan traditions that surround it. For the "mundane" observer, what is perhaps most striking about this scene is the ease and fluidity with which these fans move from watching a television program to engaging in alternative forms of cultural production: the women are all writing their own stories; Kate edits and publishes her own zines she prints on a photocopy machine she keeps in a spare bedroom and the group helps to assemble them for distribution. Linda and Kate are also fan artists who exhibit and sell their work at conventions; Mary is venturing into fan video making and gives other fans tips on how to shoot better telepics. Almost as striking is how writing becomes a social activity for these fans, functioning simultaneously as a form of personal expression and as a source of collective identity (part of what it means to them to be a "fan"). Each of them has something potentially interesting to contribute; the group encourages them to develop their talents fully, taking pride in their accomplishments, be they long-time fan writers and editors like Kate or relative novices like Signe.

This scene contrasts sharply with the passivity and alienation Michel de Certeau evokes in the passage that begins this chapter. If de Certeau raises the possibility that readers of literary works may become writers (if only by scribbling in the margins, underlining key passages, etc.), he maintains little such hope for the viewers of television. Broadcast technology resists popular colonization; the concentration of economic power and cultural production seems so immense that there are much more limited opportunities for viewers to directly intervene in the production process. No longer a writer, the television viewer becomes "pure receiver," the perfect counter-

part to the broadcaster, the ideal consumer of advertised goods. De Certeau's belief in the powers of textual poachers stumbles here against his anxieties about the powers of the broadcasting industry and the general bias against technology within his account: "The reader's increased autonomy does not protect him, for the media extend their power over his imagination, that is, over everything he lets emerge from himself into the nets of the text—his fears, his dreams" (De Certeau 1984, 176). De Certeau again displays his concern about the ideological implications of the viewer's "surrendered intimacy," the fan's emotional proximity to the text. De Certeau fears that the reader may be drawn too close to the television screen, may submit too fully to its fascinations to be able to extract a personal vision from its compelling images.

De Certeau is wrong to deny the possibility of readers "writing in the margins" of the television text, a practice occurring with remarkable frequency in the fan community. Indeed, we have already identified a number of ways fan practices blur the distinction between reading and writing. The fans' particular viewing stance— at once ironically distant, playfully close—sparks a recognition that the program is open to intervention and active appropriation. The ongoing process of fan rereading results in a progressive elaboration of the series "universe" through inferences and speculations that push well beyond its explicit information; the fans' meta-text, whether perpetuated through gossip or embodied within written criticism, already constitutes a form of rewriting. This process of playful engagement and active interpretation shifts the program's priorities. Fan critics pull characters and narrative issues from the margins; they focus on details that are excessive or peripheral to the primary plots but gain significance within the fans' own conceptions of the series. They apply generic reading strategies that foreground different aspects than those highlighted by network publicity. The *Beauty and the Beast* fans who were so disappointed by the program's third season that they wrote and published their own narratives further blur the boundary between reader and writer; these fans reject narratively specified events in order to allow the completion of their presumed generic contract with the producers. These fan stories build upon the assumptions of the fan meta-text, respond to the oft-voiced desires of the fan community, yet move beyond the status of criticism and interpretation; they are satisfying narratives, eagerly received by a fan readership already primed to accept and appreciate their particular versions of the program.

The next four chapters focus on forms of cultural production characteristic of fandom. This chapter looks generally at fan fiction, its place within fan culture and its relationship to the originating narratives. Chapter six deals more closely with one specific genre of fan fiction, slash, as illustrating the complex factors shaping the stories fans write about favorite programs and characters. Chapter seven looks at fan video-making and gives closer consideration to the aesthetic dimensions of textual poaching. Chapter eight considers fan music making (or filk) as an expression of a modern-day folk community organized around patterns of consumption and cultural preference.

"SILLY PUTTY"

Fan writing builds upon the interpretive practices of the fan community, taking the collective meta-text as the base from which to generate a wide range of media-related stories. Fans, as one long-time Trekker explained, "treat the program like silly putty," stretching its boundaries to incorporate their concerns, remolding its characters to better suit their desires. Flip open an issue of *Datazine*, one of several publications that serve as clearinghouses for information about fanzines, and you will find there stories of every conceivable kind and orientation, based around dozens of different series: adult stories about the *Thundercats* or *He-Man*, *Star Trek* stories set entirely in the "Mirror, Mirror" universe, *Blake's 7* stories centered on the characters' childhoods, anthologies of *Miami Vice*-related poetry (entitled logically enough, *Miami Verse*), cross-over stories focusing on the shared adventures of Danger Mouse and *The Professionals'* CI-5. Not a single such story but whole zines full of them; not a single zine but dozens of them. A typical issue lists some 258 different current publications (with a number of them having published 30 issues or more) and another 113 publications in planning stages. These figures represent only a small percentage of the output from the fan-writing community, since *Datazine* is only one of several such listings, each attracting different zine editors and many zines do not advertise in these publications, relying on convention sales, word of mouth, or ads in other program-related zines to attract their customers. *Datazine*, until recently, appeared six times a year trying to keep tabs on the latest output from the fan press with a substantial number of new zines listed in each issue.

Moreover, these figures do not represent the large number of works handled through underground story circuits and not published within bound zines or the incalculable number written simply to be shared with a close friend or to be buried in the bureau drawer unread by anyone. As a result, no one has been able to produce a reasonable estimate of the full scope of media fandom's writing and publishing activity or its readership.

These zines may run from small newsletters and letterzines commenting on aired episodes to full-length novels, comic books, songbooks, cookbooks, program guides, and collections of essays; most commonly, however, the zines are photocopied anthologies of short stories, poems, and artwork centering on one or more media "universes" and written by multiple authors. Not surprisingly, most zine publishing focuses around programs with large fan followings, such as *Star Trek*, *Doctor Who*, *Beauty and the Beast*, *Star Wars*, *Blake's 7*, or *Man from UNCLE*. There are other zines catering to so-called "fringe fandoms" around programs which were short-lived (*Max Headroom*, *Paradise*) or have limited followings (*Voyage to the Bottom of the Sea*, *Rat Patrol*, *Hawaii 5-O*), films which never found their audience (*Buckaroo Bonzai*, *Tron*, *Escape from New York*), series which do not primarily appeal to adults (*The Real Ghostbusters*) or which have not received broad circulation in the United States (*The Sandbaggers*, *Black Adder*, Japanese animated series). Even where these fandoms are so small and specialized that they can not sustain their own publications, there is typically space for these stories in general focus zines (such as *Frisky Business*, *Prime Time*, *Everything but the Kitchen Sink* or *What You Fancy*). One issue of *Southern Lights* (Wortham, 1988), for example, includes representative stories from most of the major fandoms as well as poems and stories set in the worlds of *Wizards and Warriors/ Taxi*, *Moonlighting*, *Silverado/Big Valley*, *Scarecrow and Mrs. King/ Remington Steele*, *The Devlin Connection*, *The Master*, *It Takes a Thief*, *M*A*S*H*, *Airwolf*, *The Ghostbusters*, and *Magnum P.I.*

Most academic studies of fan writing have focused primarily, if not exclusively, on *Star Trek* zines (Bacon-Smith, 1986; Jenkins, 1988; Lamb and Veith, 1986; Penley, 1991, forthcoming; Russ, 1985). This focus reflects the important role of *Trek* fandom in developing the conventions and setting the standards for media zine publishing (adopting them from older forms found in literary science fiction fandom). More practically, *Star Trek* references will be immediately recognizable to a broad readership outside of fandom

(a temptation that I have only partially resisted in this book). Yet, in focusing so heavily on *Star Trek*, one runs the risk of removing *Trek* fan writing from its larger context, from this broad array of different "universes." This exclusive focus on *Star Trek* misrepresents the range of fan publishing and ignores key moments in its history since some old-time fans claim that *Starsky and Hutch* and *Star Wars* were perhaps as historically important as *Star Trek*; it also disregards the nomadic or intertextual dimensions of fan culture. Perhaps most alarmingly, an exclusive focus on *Star Trek* may perpetuate journalistic stereotypes that see "the Trekkie phenomenon" as a strange aberration. If *Star Trek* fan writing existed in such isolation, one would be tempted to look for an explanation in the qualities and properties of the primary text, to answer the question posed by so many press accounts, "What is it about *Star Trek* that generated this kind of response?" When we see fan publishing sparked by everything from *Lost in Space* to *Max Headroom*, from *Alias Smith and Jones* to *Batman*, then, explanations must consider the fan community and its particular relationship to the media as well as the properties of the original series.

ZINES AND THE FAN COMMUNITY

The astounding array of different fan stories, the relatively low barriers of entry into fan publishing, and its status as a cottage industry encourage us to see fan writing in highly individualized terms. Despite the recent development of larger fan publishing houses and zine distributors, fanzines continue to be a mode of amateur, non-profit publication. Anyone who has access to a word processor, a copy center, and a few hundred dollars start-up cash can publish their own zine (with varying degrees of quality and success). *The Professionals* fandom initially rejected the expense of zine publishing altogether (as well as diminished the risk of prosecution for obscenity and copyright infringement), establishing story circuits as alternative means of distribution; here, fans pass stories informally through the mails or order individual stories on loan from a central library. In either case, readers only pay the cost of postage and are encouraged to make their own copies of stories they like. Only recently, in the United States and Australia, have *Professionals* zines begun to be more widely available.

Fanzine publishing remains highly receptive to new participants. As Constance Penley (1991) notes, fanzine editors are torn between competing impulses toward "professionalism" (the development of high technical standards and the showcasing of remarkable accomplishments) and "acceptance" (openness and accessibility for new and inexperienced writers). Push comes to shove, professionalization gives way to acceptance; even the most polished zines occasionally include work that falls outside their overall standards but represents the fledgling efforts of new fans. Any fan who writes stories has a good chance at publication, since most zine editors struggle to find enough acceptable material to fill their zines and take pride in their receptiveness to new contributors. In fact, many fans turn to writing to support their zine-buying habits: contributors get a free copy of the published zines. Women who have low prestige jobs or who are homemakers can gain national and even international recognition as fan writers and artists; fan publishing constitutes an alternative source of status, unacknowledged by the dominant social and economic systems but personally rewarding nevertheless.

This same nurturing atmosphere extends to the development of new publications. Established publishers often publicize newer zines, running advertisements for them free of charge, inserting fliers in their mailings or printing them in their issues; established editors see these newer publications not as competition but rather as welcome additions to the community. While publications like *Generic Ad Zine, The Communications Console, The Zine Scene*, or *Datazine* act as information clearing houses and certain conventions, such as MediaWest, serve as major marketplaces for fanzines, there remains little centralization with zines published in suburban areas and small communities scattered across the country. Just as anyone who wants to can probably get published within fandom, anyone with the ambition can probably establish their own zines to print the kinds of stories they want to read and write.

Yet many of these same factors direct our attention to the communal basis of fan publishing. Precisely because the boundary between writer and reader is so flimsy, fanzine editors and writers remain more responsive than commercial producers to the desires and interests of their readership. Readers typically order zines directly from the writers and editors or interact with them across a dealer's table at conventions; such person-to-person contact invites reciprocality. Readers and writers depend upon each other for the

perpetuation of the fandom: editors are expected to charge only the costs of production (and possibly enough to provide start up capital for a new zine), but are discouraged from turning zine-publishing into a profit-making enterprise; readers may share zines with other readers but are urged not to photocopy them so that the editors may insure sufficient sales to recoup costs and finance publication of the next issue.

The recent discovery that some dealers had been "bootlegging" zines, copying them for sale without their editors' authorization, focused renewed attention on the ethical commitments between zine editors and their readers. Some editors charged that "bootleggers" "hurt fandom" by endangering chances of making back production costs. Others defended the practice as making the stories accessible to a broader readership and challenged the editor's rights to copyright original stories based on characters already appropriated from others' copyrighted works. Some charged that the "profiteering" of a small number of zine editors, who overpriced their publications, made such practices more attractive. A small number of zine editors now run notices encouraging their readers to copy and circulate their materials, insisting that they write primarily to share their ideas with other fans not as part of a system of economic exchange. Others run editorials denouncing "bootlegging" as an outrageous violation of fannish ethics and as an attempt to commercialize fan culture. Susan M. Garrett (1989) cites greed as one of the "seven deadly sins of fandom," motivating "the worst crimes imaginable because they cause the most damage: bootleggers, simultaneous submissions, exorbitant prices for zines out of a love of profit, taking deposits and never putting out a zine, etc." (4). This distaste toward making a profit from fandom reflects less a generalizable political or economic resistance to capitalism than the desire to create forms of cultural production and distribution that reflect the mutuality of the fan community. Fanzines are not commercial commodities sold to consumers; they are artifacts shared with friends and potential friends.

These social interactions also influence the stories that are written and the ways they relate to the original programs. If any fan writer has the potential to make a major contribution to the development of fan literature (introducing new genres or conceptions of the characters), most choose to build upon rather than reject or ignore fan traditions. Most new fan writers create stories that fit comfortably within the range of precirculating materials. New writers look toward already established writers both for personal guid-

ance and generic models. Zine editors articulate their own sense of what kinds of stories are appropriate for submission to their publications; fan writers cater to those demands (if not always, at least on occasion) while seeking editors apt to be sympathetic to their current efforts. Fans often discuss story ideas informally with other fans before committing them to the page; ideas originate from collective discussions of the aired episodes and from critical exchanges in the letterzines. Stories are often workshopped with other fans (either formally or informally) and revised in response to the group's feedback. One publication within *Professionals* fandom, *Cold Fish and Stale Chips*, publishes fragments of stories their writers have been unable to complete and encourages feedback and advice from fellow fans about possible developments and resolutions. Others, such as *Treklink* and *Art Forum* (both now defunct), provided ongoing discussions of techniques of fan writing and artwork as well as tips from more experienced fans. These various forms of interaction pull fan writers toward the mainstream of community interests and insure conforming audience desires and expectations.

Even after they are published, the community offers feedback, designed to help the writers better satisfy fan tastes in future productions. Historically, many zines have regularly published "Letters of Comment" evaluating and responding to the published works, a tradition within science fiction fandom that dates back to the letter columns of Hugo Gernsback's pulp magazines. These letters suggest further directions for development within ongoing series or alternative ways the same story might have been told. Consider, for example, the kinds of issues editor Susan M. Garrett (1989) suggests might be appropriate to raise in a "Letter of Comment":

> Is the story consistent with what you know of that show? Were the characters and dialogue true to the series or were they false and stilted? Was the plot logical or did it hang too much upon coincidence? Did the author have some original ideas, was the story just the "same old thing" or was it "the same old thing" in a new and vibrant style? Was the tone of the story depressing or cheerful? Did the setting add to the story? . . . Was the description good, overdone or minimal? Did the story have a central idea or point? Did you like it? Did you understand it? (53)

Some of Garrett's criteria reflect classical standards of "good writing," others the demands of fidelity to the aired material and

to the fan meta-text, others fandom's own generic traditions ("the same old thing") or reader's personal tastes ("Did you like it?"). "Letters of Comment" are expected to be "constructive criticism," phrased in supportive, "non-hurtful" language and to reflect the shared interests of readers and writers. Although they can serve as weapons in ongoing "fan feuds," these letters are more often acts of friendship, endorsing new writers or providing suggestions for how contributors might further develop their talents. This collective input shapes fan fiction, just as historically it played a key role in the development of professional science fiction, though plenty of space remains for purely idiosyncratic or innovative stories.

TEN WAYS TO REWRITE A TELEVISION SHOW

As I have already suggested, fan culture reflects both the audience's fascination with programs and fans' frustration over the refusal/inability of producers to tell the kinds of stories viewers want to see. Fan writing brings the duality of that response into sharp focus: fan writers do not so much reproduce the primary text as they rework and rewrite it, repairing or dismissing unsatisfying aspects, developing interests not sufficiently explored. A survey of some of the dominant approaches employed by fan writers indicates the community's characteristic strategies of interpretation, appropriation, and reconstruction.

1) Recontextualization: Fans often write short vignettes ("missing scenes") which fill in the gaps in the broadcast material and provide additional explanations for the character's conduct; these stories focus on off-screen actions and discussions that motivate perplexing on-screen behavior. Jean Lorrah's *Night of the Twin Moons* series (1976a, 1976b, 1978, 1979) includes many such sequences, focusing primarily around the several *Star Trek* episodes dealing with Spock's relationship to his parents and his Vulcan upbringing ("Amok Time," "Journey to Babel," "Yesteryear"). Here, Lorrah draws heavily upon her meta-textual understanding of the *Star Trek* characters, their history, cultural backgrounds, motivations, and psychology, to resolve questions posed by the episodes: Why, for example, did Sarek and Amanda fail to attend Spock's wedding in "Amok Time"? Or how might have Dr. McCoy helped Amanda to adjust to the discovery in "Journey to Babel" of her husband's concealed history of heart

attacks? Lorrah (1976a) explains, "*The Night of Twin Moons* grew out of the questions I had about 'Journey to Babel' and 'Yester-year.' Notably, what kind of woman could both be interesting enough to win Sarek, and be able to stand to live with the Sarek we saw in those episodes for forty years?" (iii). To answer those questions, Lorrah not only wrote scenes that connected the program events into a more coherent and satisfying whole, but also created a history and a future for the characters; her account forms the basis of several novels. Lorrah's stories invite fans to reread the aired episodes and fit information from the series into the larger framework provided by her *NTM* "universe." Much fan writing follows this same logic, drawing on moments of key emotional impact in the original texts (Luke's discovery of his ancestry in *Star Wars*, Avon's attempt to kill Vila in *Blake's 7*, Sam's efforts to save his brother in Vietnam in *Quantum Leap*) as points of entry into the character's larger emotional history; fans create scenes that precede or follow those moments. Such episodes may form the basis for short stories and vignettes or for longer works that knit together a number of such sequences from across the full run of the series.

2) *Expanding the Series Timeline:* As *NTM* suggests, the primary texts often provide hints or suggestions about the characters' backgrounds not fully explored within the episodes. Fan writers take such tantalizing tidbits as openings for their own stories, writing about events preceding the series' opening: Bodie's background as a mercenary in *The Professionals*, Spock's experiences serving with Captain Pike in *Star Trek*, Anakin Skywalker's seduction into the dark side in *Star Wars*, Remington Steele's disreputable apprenticeship with Daniel Chalmers, the Doctor's rebellion against the other Time Lords in *Doctor Who*. Bonnie Vitti, editor of *Children of the Federation*, a zine devoted to stories about *Blake's 7* characters as children, describes what led her to explore this somewhat off-beat premise:

> Deeply engrossed in *Blake's 7* fandom at the time, I spent a long train ride speculating [with a friend] . . . about why Avon was the way he was. The usual business of failed relationships and betrayal didn't seem to explain his extreme wariness, arrogance, and emotional distance. He'd had all that from the beginning of the show, before he learned about Anna or lost Cally and Blake. It seemed to me that he must have been hurt very badly at a very early age, and it had wounded his psyche so deeply that he was

never willing to completely trust anyone again. From that discussion came the seeds of my first long *B7* story, "The First Battleground." (Vitti, 1990)

Here, the fans' commitment to "emotional realism" encourages them to expand the series' framework to encompass moments in the characters' past that may explain actions represented on the program.

Similarly, the vagaries of commercial broadcasting and filmmaking often mean that series stop abruptly or conclude unsatisfactorily, failing to realize their full potentials. *Alien Nation* ended on a cliff-hanger; George Lucas completed only one of a promised three *Star Wars* trilogies; *Beauty and the Beast* denied fans the anticipated resolution of the Vincent-Catherine romance; *Blake's 7*'s fourth season concluded the series with the apparent deaths of its major characters. In other cases, such as *Star Trek*, the fan simply wanted more stories than the producers provided. Fan writers respond to the community's desire to continue these narratives by creating their own versions of the characters' future lives. *Star Wars'* fans recount the triumph of the rebellion, the final defeat of the evil emperor, and the construction of a new Alliance of benevolent Jedi Knights. *Star Trek* fans, well before Paramount decided to continue the saga itself, had already constructed numerous versions of how the characters died, how the Enterprise met its destruction or simply how the crew felt when the Enterprise's five-year mission reached its conclusion or when they retired from Star Fleet. *Alien Nation* fans are beginning to write stories that tell what happened following the cliff-hanger episode and one can anticipate a similar response from regular viewers of *Twin Peaks*, a series that pointedly refused closure.

These stories do not directly contradict the broadcast material and seemingly fulfill the generic promises of the originals. Yet for the fans of *Beauty and the Beast* and *Blake's 7*, writing beyond the ending often means a rejection of the producers' own versions of the characters' fates, a refusal to legitimize unpopular endings. Those fans of *Beauty and the Beast* who were unsatisfied with its third season write stories where the events of the last eight episodes are revealed to be a dream, where Catherine's death was faked so that she could be put in the witness protection program, or where the narrative is simply assumed following the second season cliff-hanger with no attention given to the program's short-lived reincarnation. The "post-Gauda Prime" story constitutes one of the dominant genres of *Blake's 7* fan writing, represented by multiple examples in almost every zine; some zines even fea-

ture only "fifth season" stories. Fans offer diverse explanations for the survival of one or more of the protagonists from the massacre of the fourth series' final episode. Common devices include the suggestion that the events were faked by Blake as a loyalty test for Avon and his crew, that the man Avon killed was Blake's clone or that most of the crew was shot with stun guns rather than lethal weapons. Leah Rosenthal and Ann Wortham's "Season of Lies" (1988); imagines that the broadcast episode was produced by Servalan as part of a propaganda campaign to discredit Blake and his rebels, while Susan R. Matthews' (*The Mind of a Man is a) Double-Edged Sword* trilogy (1983, 1985, 1988) posits that all of the events of the third and fourth season were part of Servalan's psychomanipulation of Avon and did not really occur. Susan Boylan's "Deliverance" (1989) accepts the events as given but proposes an appropriate afterlife: Blake and his crew are recruited by an archangel to foment a rebellion in Hell. Some stories focus primarily on the immediate aftermath of those tragic events (Avon's psychological destruction, the reconciliation between Avon and Blake, Servalan's domination over one or more of the survivors, or simply their burial within a common grave); others spend much of their length trying to explain other controversial plot twists (Anna Grant's betrayal of Avon, Cally's death, the destruction of the Liberator, Avon's attempted murder of Vila, etc.). Still others take the characters' survival for granted, using it as a starting point for new adventures which integrate series survivors with original characters or place them into new contexts. Several fans have constructed full seasons of post-Gauda Prime episodes, following closely the original program format. Other stories, such as Katrina Larkin and Susanne Tilley's popular *Hellhound* series (1988), place the characters in radically different circumstances (a punked-out *Miami Vice* lifestyle, encounters with figures based loosely on personalities from other popular programs). *Hellhound* treats the *Blake's 7* characters and events with an even bleaker tone and harsher edge than the original series. The traumatic season finale allows for dramatic shifts in characterization and plot construction; the destruction of old narrative situations opens room to explore possibilities that fall beyond the parameters of the original series.

3) Refocalization: While much of fan fiction still centers on the series protagonists, some writers shift attention away from the programs' central figures and onto secondary characters, often women and minorities, who receive limited screen time. *The Hellguard Social Register* (Blaes, 1989) publishes stories about Saavik and other Romulan characters, while *Power* (McEwan,

5.2 Refocalization: *Roving Reporter*, a *Doctor Who* fanzine, centers on the adventures of Sarah Jane Smith, one of the Doctor's companions. Artwork by Martin F. Proctor.

1989) offers narratives concerning the female characters of *Blake's 7*, both those who are recuring regulars (Dayna, Jenna, Cally, Servalan) and those who appear in only a single episode (Avalon, Zeeona). *Roving Reporter*, a *Doctor Who* zine, publishes fiction centered around one of the doctor's companions, Sarah Jane Smith. *Tales of Hoffman* focuses on the character of Dr. Julia Hoffman on the original *Dark Shadows*.

Jane Land's *Demeter* (1987) puts Uhura and Chapel in command of an all-female landing party on a voyage to a lesbian separatist space colony; their adventures not only provide these characters with a chance to demonstrate their professional competency but also to question the patriarchal focus and attitudes of the original series and its male protagonists. Jane Land (1987) describes some of the concerns that led her to write this novel: "If sexism is still a fact of life several hundred years in the future, then why? And how do the women feel about it? How does it affect them, personally, professionally, politically, socially?" (n.p.). Land (1986) characterizes her project as rescuing one *Star Trek* character from "an artificially imposed case of foolishness," reconceiving her in terms more appropriate to the interests of the female fan community: "Try to think objectively for a minute about what we know of Christine Chapel's background, education, accomplishments . . . and you will come up with a far more interesting character than she was ever allowed to be. The Christine I found when I thought about her was neither wimp nor superwoman, but, I hope, an intelligent, complex, believable person" (n.p.).

Here, fan writers reclaim female experiences from the margins of male-centered texts, offering readers the kinds of heroic women still rarely available elsewhere in popular culture; their stories address feminist concerns about female autonomy, authority, and ambition. Refocalization may be the only way of redeeming characters who are inconsistently characterized; fans argue that where television series have introduced strong female protagonists (Catherine in *Beauty and the Beast*; Dayna, Jenna, Cally, and Soolin in *Blake's 7*; Yar in *Star Trek: The Next Generation*; any number of companions on *Doctor Who*; Col. Wilma Deering in *Buck Rogers*), the producers soften those characters as the series evolves, resulting in alarming disjunctions between what we know of the character's background and how that character behaves in a given episode. By refocalizing the series narrative, fan writers explore the psychology of these characters (explaining why Uhura sometimes adopted stereotypically feminine styles of conduct) or develop narratives allowing them to achieve their full

potential (as in stories where female officers are at last given the chance to command).

4) *Moral Realignment:* Perhaps the most extreme form of refocalization, some fan stories invert or question the moral universe of the primary text, taking the villains and transforming them into the protagonists of their own narratives. Characters like Servalan, Paracelsus, the Master, Darth Vader, and the Sheriff of Nottingham are such compelling figures that fans want to explore what the fictional world might look like from their vantage point; such tales blur the original narrative's more rigid boundaries between good and evil. *Star Trek* fans have written large numbers of stories set in the "Mirror, Mirror" universe (where the benevolent Federation is a totalitarian dictatorship and Kirk's rule is maintained through blackmail and assassination); others construct narratives that look sympathetically at the Klingons or the Romulans, questioning the 1960s series' cold war logic. Moral realignment may take many different forms. In some stories, the villains remain villains but events are written from their perspective, as in the many stories exploring Servalan's ruthless personality and her power struggles with Avon and Blake; such stories facilitate the fans' fascination with this dark character without necessarily embracing her motives or tactics. A smaller number provide sharp critiques of Blake's terrorism or Kirk's gross violations of the prime directive, asserting a world view where the program bad guys may in fact be fighting on the morally superior side.

Karen Osman's *Knight of Shadows* (1982) offers one fan's version of Darth Vader's youth and his decision to align himself with the Empire. Osman develops the story through a series of shifting perspectives that complicate any easy assignment of moral values. Early in the book, Osman focuses on the character of Jessha, Darth's young bride and her contempt for the Dark Lord of Sith who seems indifferent to her feelings and comfort. These same passages also consider how Darth's dark personality was shaped by a cold and abusive relationship with his father and by the expectation that he must soon assume the rule of his people. At times, the writer's initial wariness towards Darth gives way to admiration for his ambition, his physical mastery, and his commanding personality. *Knight of Shadows* also traces the power struggle between Jessha's brother Koric and Darth for the Sith throne. Osman initially portrays Koric as a young idealist and suggests the compromises and betrayals he must make to gain power; he soon becomes a leader as ruthless as the one he seeks to displace. Similarly, Obi-Wan Kenobi and the Jedi ini-

tially represent a morally superior force in their struggle with the Emperor. Yet, Osman also questions the psychomanipulation tactics that General Kenobi employs to insure Darth's compliance to his demands, describing Obi-Wan as "an alien presence, controlling, manipulating" (98). Her Kenobi is motivated less by a sense of justice and democracy than by a desire to preserve the Jedi's autonomy and privilege. By the conclusion, the reader is uncertain how to feel about Darth's decision to align himself with the Emperor rather than with the Jedi, even though that ambivalence stands in stark contrast to the moral certainty of the original *Star Wars* films. There are no good guys and bad guys in the realm of court intrigue Osman creates, simply people struggling to promote their self interests and to survive in a treacherous world.

5) *Genre Shifting:* If, as was suggested in chapter four, genre represents a cluster of interpretive strategies as much as it constitutes a set of textual features, fans often choose to read the series within alternative generic traditions. Minimally, fan stories shift the balance between plot action and characterization, placing primary emphasis upon moments that define the character relationships rather than using such moments as background or motivation for the dominant plot. *Star Trek* thus becomes a series centered on the "great friendship" between Kirk, Spock, and McCoy rather than about their efforts to "explore strange new worlds" or their struggles with the Romulan and Klingon empires. More broadly, fan stories often choose to tell very different stories from those in the original episodes. Here, *Star Trek* or *Blake's 7* may form the basis for romantic fiction involving couples only suggested in the series: Kirk and Uhura, Data and Yar, Blake and Jenna, Riker and Troi, Picard and Crusher. Jane Land's *Kista* (1986) strands Chapel and Spock on a primitive planet, forcing them to work through their unacknowledged feelings for each other, building toward their marriage and the birth of their child. Jean Lorrah's *Trust, Like the Soul* (1988) offers a curious love story: "Suppose Tarrant *does* reverse the memory tubes on Ultraworld, and Avon and Cally wake up in one another's bodies?" (*Datazine* blurb). Lorrah's story not only focuses on the deepening relationship between a gender-reversed Avon and Cally but also explores how Cally would respond to being seduced by Servalan and how Vila might act if Avon was suddenly available to him as a sexual partner.

Romance is only one generic model fans may evoke in constructing their own stories from program materials. Jacqueline Lichtenberg's long-running *Kraith* series (1976), for example, re-

constructs *Star Trek* from several different generic perspectives, including mythic adventure, courtroom drama, mystery and spy intrigue. *Kraith* moves in and out of the science fiction conventions that structure the original series: Kirk is placed on trial before an interplanetary tribunal for his repeated violations of the prime directive and acts of xenophobia against alien races; Spock is called to fulfill his irreplaceable role in a ritual necessary to unify and perpetuate Vulcan culture. *U.N.C.L.E. Affairs* (Arellanes, 1989) publishes stories situating Napoleon and Illya within a world harboring supernatural forces, including vampires, cat people, and other "things that go bump in the night." A number of *Professionals* stories introduce elements of fantasy— elves, shapeshifters, etc.—into that program universe. Such stories expand the generic material available to writers, while still drawing heavily on the original programs and their fannish traditions.

6) Cross Overs: If genre-shifting reads the series through the filter of alternative generic traditions, "cross-over" stories blur the boundaries between different texts. One zine, *CrosSignals* (Palmer, 1990) focuses entirely on such multimedia stories: McCall (*The Equalizer*) awakens to find himself in the mysterious Village (*The Prisoner*) but is rescued by the *Airwolf* team; Scott Hayden (*Starman*) witnesses a murder and is taken for questioning by Crockett and Tubbs (*Miami Vice*); Tony Newman and Doug Philips (*Time Tunnel*) join forces with the Enterprise crew (*Star Trek*). Some stories merge texts which share common genres or are set in the same cities (*The Equalizer/Beauty and the Beast*) or utilize common actors (a *Scarecrow and Mrs. King/Remington Steele* crossover based on the fact that Beverley Garland plays the leads' mother in both series). Others explore more unlikely combinations: Diane Chambers (*Cheers*) finds herself in the world of *Fraggle Rock*; The Ghostbusters join forces with the medieval exorcists from Tanith Lee's *Kill the Dead*, a fantasy novel loosely based on *Blake's 7*. Some series formats (*Doctor Who, Quantum Leap*) lend themselves particularly well to cross-overs, since the primary texts already involve a constant dislocation of the protagonists. The TARDIS has materialized every place from the Planet of the Apes to Fawlty Towers, even on the set of *Wheel of Fortune.* One story has the Doctor teaming with another group of unlikely time travelers, Dr. Peabody and Sherman (*Rocky and Bullwinkle*). Sam Beckett (*Quantum Leap*) finds himself occupying the bodies of everything from martian invaders (*War of the Worlds*) to Indiana Jones and helping to resolve problems fans locate within their "universes." Lee Kirkland's *Quantum Beast: All's Well that Ends Well* (1990), for example, has Sam

resolve fans' concerns about third season *Beauty and the Beast*, leaping into Vincent's body, rescuing Catherine and reuniting her with her lover.

"Cross-over" stories break down not only the boundaries between texts but also those between genres, suggesting how familiar characters might function in radically different environments. "Cross-overs" also allow fans to consider how characters from different series might interact: Would Kirk be annoyed by the fourth Doctor's flippant attitudes? Would Avon admire Spock's cool expertise with the computer? Would Starsky and Hutch work successfully with Bodie and Doyle? How might Cowley handle a confrontation with his counterpart on *The Sandbaggers*?

7) Character Dislocation: An even more radical manipulation of generic boundaries occurs when characters are removed from their original situations and given alternative names and identities. The program characters provide a basis for these new protagonists, yet the fan-constructed figures differ dramatically from the broadcast counterparts. In O. Yardley's "Stand and Deliver" (n.d.), a *Professionals* circuit story, highwayman Bodie holds up a blue-blooded Doyle and Doyle later recruits Bodie to join Major Cowley's men as a political spy. Here, the story preserves their roles as government agents but fits them into a different historical context. Yet *Professionals* fans have broken even more broadly with the program format, as the characters are dislocated into various historical or mythic contexts: Anne Carr's "Wine Dark Nexus" (n.d.) features Bodie as an Egyptian and Doyle as a citizen of Atlantis, who are kidnapped and sent to Crete to become bull dancers; Jane's "The Hunting" (n.d.) evokes a medieval fantasy realm where the human Bodie befriends an elfin Doyle. Many of these stories occur within *Professionals* fandom, perhaps because fans often like the characters of Bodie and Doyle better than they like their original context. Character dislocations are also very common in the works of fan artists like Jean Kluge, TACS, and Suzan Lovett who place series characters in various mythic or historical settings; these representations often are reprinted in full color on zine covers and may serve as inspiration for future "alternative universe" stories.

8) Personalization: Fan writers also work to efface the gap that separates the realm of their own experience and the fictional space of their favorite programs. "Mary Sue" stories, which fit idealized images of the writers as young, pretty, intelligent recruits aboard the Enterprise, the TARDIS, or the Liberator, constitute one of the most disputed subgenres of fan fiction. So strong is the fan

Figure 5.3 Transformations: *The Professionals*'s character, Ray Doyle, as an elf. Artwork by Jean.

taboo against such crude personalization that original female characters are often scrutinized for any signs of autobiographical intent, though there is at least one zine which proudly publishes nothing but "Mary Sue" stories. Other attempts to integrate program materials into fan's own experience have been better received. Some very early examples of *Star Trek* fan fiction, Jean Lorrah and Willard F. Hunt's "Visit to a Weird Planet" (1968) and Ruth Berman's "Visit to a Weird Planet Revisited" (1976) play with the consequences of a transporter glitch that trades characters Kirk, Spock, and McCoy aboard the Enterprise for actors William Shatner, Leonard Nimoy, and DeForest Kelly on the studio set. A more recent example is Jean Airey and Laurie Haldeman's *The Totally Imaginary Cheese Board* (1988) in which Avon finds himself at Scorpio, a popular *Blake's 7* fan convention, due to another teleport malfunction; the character is initially highly suspicious of the fans' activities, confused by his encounters with series stars, and deeply disturbed by his viewing of fourth season episodes representing events still in his own future. He eventually warms to his role as celebrity and embraces his fans. The story ends with the hope that Avon, whose ruthless violence and tragic fate reflected his profound alienation and perpetual betrayal, may deal with these situations differently now that he knows he is so beloved and has seen what the future holds for him if he is unable to change his ways. Airey and Haldeman include portrayals of program performers, active fans, the actors' real-world spouses, and the hotel where Scorpio was held. Their story exploits the "double viewing" practices of fandom: Avon is represented as existing simultaneously as a character on a BBC program and as a real-world personality inhabiting Earth's future. Another such work, Barbara Wenk's *One Way Mirror* (1980) explores how a typical *Star Trek* fan might respond if she found herself a captive aboard a starship and forced to become the Vulcan third officer's lady. Wenk posits that Gene Roddenberry was "a renegade Imperial Starfleet officer who fled to Earth and wound up writing ST to make money. (Evil Imperials have to live too, you know.) However, the only episode in which he could Dare To Tell The Truth (this was the sixties, remember! Peace and Love) was 'Mirror, Mirror' [an episode where Kirk finds himself in a parallel universe that inverts the moral order of his own]" (Barbara Wenk, Personal Correspondence, 1991). The protagonist's initial fascination with a world so much like her favorite fan universe gives way to fear as she learns that her knowledge of the program tells her just enough to get herself into further trouble; she survives in part by recounting program episodes to her bemused mate in an odd twist on the legend of Scheherazade.

9) Emotional Intensification: Because fan reading practices place such importance on issues of character motivation and psychology, fans often emphasize moments of narrative crisis. Fans relish episodes where relationships are examined, especially those where characters respond in a caring fashion to the psychological problems, professional turning points, personality conflicts, and physical hurts of other major characters: Spock joyfully grasps Kirk's arms in the climax of "Amok Time," when the captain, believed to be dead, reveals himself to the guilt-ridden Vulcan; Starsky and Hutch hug each other as Hutch cries over the death of one of his girlfriends; Cooper tucks a feverish Truman into bed following Josie's death on *Twin Peaks.* Series episodes where characters undergo painful transitions or gut-wrenching revelations also enjoy high status within the fan canon as do episodes where characters touch and care for each other (be it Crusher's comforting of a tormented Picard in "Sarek" or Sam Beckett's futile attempts to touch his holographic companion during a moment of emotional need).

One genre of fan fiction, "Hurt-Comfort," centers almost entirely upon such moments, sometimes building on a crisis represented within the series proper (as in stories where Bodie nurses the wounds Doyle receives in "Discovered in a Graveyard"), other times inventing situations where the characters experience vulnerability (as in stories where Spock helps to reconcile Kirk to the death of McCoy). Here, emotional or physical pain is a catharsis; these traumatic moments provoke a renewal of the commitments between partners. Post-Gauda Prime stories often center on the slow process of reconciliation between Blake and Avon. Cop and spy stories (*Man from UNCLE, Simon and Simon*) frequently explore the consequences of a close brush with death or one partner's decision to retire from active duty, building toward the team's recognition of their mutual dependency. Kirk or Chapel help Spock through the madness of Pon Farr. "Hurt-Comfort" stories may focus on male-female couples (Spock and Chapel, Amanda King and "Scarecrow," Laura and Steele), yet, most often, the stories center on male-male couples (Simon and Simon, Starsky and Hutch, Bodie and Doyle). Such stories provide a plausible reason for these "men of action" to overcome their stoicism. The evoked emotions may be fraternal, maternal, romantic, or erotic, depending on the fan's interpretation of the series; what matters is that affect gains overt expression within scenarios of growing intimacy and trust between the two protagonists.

These angst-ridden stories allow fans to express their own compassionate concern for characters, such as Spock, Avon, Illya or

Vincent, who seem to be deeply pained or emotionally divided. These stories offer a way of working through the conflicts and personality problems that make these characters such fascinating figures: Could an emotionally repressed Spock learn to accept Kirk's love and friendship or to feel comfortable with his own feelings of affection and desire? Could Avon build trust and intimacy with Blake or Cally? What situations might lead a deeply disturbed Vincent into a reconciliation with his beastly side and a consummation of his romantic desires for Catherine? By contrast, such stories also explore what happens to characters who seem in command of their destiny when situations turn against them and they are forced to confront their worst nightmares: How might Kirk deal with public humiliation, the destruction of the Enterprise, the death of his comrades, or a courtmartial and dishonorable discharge from Star Fleet? How would Blake cope with the betrayal of his cause or the fruitless death of his crewmembers? How would such normally masterful characters confront situations of dependency and vulnerability? Such questions cut to the heart of our culture's patriarchal conception of the hero as a man of emotional constraint and personal autonomy, a man in control of all situations; "Hurt-comfort" stories point toward the limitations of such characters and depict their rehabilitation into more emotionally nurturing and democratic leaders.

10)*Eroticization:* Fan writers, freed of the restraints of network censors, often want to explore the erotic dimensions of characters' lives. Their stories transform the relatively chaste, though often suggestive, world of popular television into an erogenous zone of sexual experimentation. Some stories simply realize the sexual subplots already signaled by the aired episodes: the undercover adventures of Napoleon Solo, Avon's sadomasochistic play with Servalan, Vincent's late-night visits to Catherine, or John Steed's ambiguous relationship with Emma Peel. Or, in "Slash" fiction, the homosocial desires of series characters erupt into homoerotic passion as Kirk and Spock, Riker and Picard, Crockett and Castillo, even Simon and Simon become bedmates and lovers. Sexuality in fan fiction occurs most regularly between recurring characters (Kirk and Spock), while sexuality in the original series most often involved protagonists with guest stars (Kirk and Edith Keeler, Areel Shaw, Ruth, Janice Lester, Reena, Helen Noel, Sylvia . . .). Sexuality on series television is often simply a diverting interlude in the character's life or perhaps a tool by which immediate goals may be achieved (as in Spock's seduction of the Romulan commander), rarely resulting in permanent entanglements. (Fans have labeled television's refusal of stable romance

"the dead girlfriend of the week syndrome" or the "*Bonanza* syndrome" in honor of the ill-fated love life of that program's Cartwright brothers.) Sexuality in the fan stories is more often a way of resolving ongoing conflicts or of solidifying already strong relationships. Yet sexuality in fan fiction also has its playful side with writers constantly searching for ways to create stories based on unlikely combinations of characters. One series of *Blake's 7* zines, *Avon, Anyone?* (Marnie, n.d.) and *Vila, Please* (Marnie, n.d.), mates one of the program regulars, story by story, with almost all of the other major characters.

Some of these approaches to fan writing actively expand textual boundaries, constructing histories or futures for the characters that go beyond the range of stories that could be told on television; others rework the program ideology (foregrounding marginalized characters, inverting or complicating codes of good and evil, introducing alternative sexualities) in order to make the texts speak to different perspectives; still, others playfully manipulate generic boundaries, defamiliarizing stock conventions so that the same narrative may yield many different retellings. Often, multiple forms of rewriting occur within a single story: many of the historical stories about Bodie and Doyle cited above, for example, are also examples of slash romance.

Though many fans claim absolute fidelity to the original characterizations and program concepts, their creative interventions often generate very different results. As fan writer Jane Land (1987) explains, "All writers alter and transform the basic *Trek* universe to some extent, choosing some things to emphasize and others to play down, filtering the characters and the concepts through their own perceptions. This is perfectly legitimate creative license" (ii). If the guiding hand of powerful producers like John Nathan-Turner or Gene Roddenberry restrains the diversification of the program myths within the professionally produced materials, the popular proliferation of fanzines results in much greater openness; the original text splinters into hundreds of different narratives all loosely drawn from the same base stories. *Southern Seven*, a *Blake's 7* zine, organizes its contents according to season (including, of course, "fifth season" stories that go beyond the original series ending), suggesting that the program is open to intervention at any point. *Beauty and the Beast* fans now differentiate between stories that occur before the third season, stories that ignore or rework the third season, and stories that accept the third season as given. *Doctor Who* zines often concentrate on the adventures of specific doctors, as in, for example, *Baker's Dozen* (Stevens and Nasea, 1986), which features stories about the fourth and sixth doctor (Tom and Colin Baker, respectively). Some fan stories evolve their own "alternative

universes" as the basis not only for further stories by the same writer but for stories by other fans who become fascinated with a particular retelling of the program mythos. In some extreme cases, as in some of the alternative universes centering around *Star Wars* (such as Maggie Nowakowska's epic *Thousandworlds* series), these narratives develop such complexity that little if any traces of the original fictional universe remain.

Fans read these stories not so much to relive their own experience of the television episodes as to explore the range of different uses writers can make of the same materials, to see how familiar stories will be retold and what new elements will be introduced. If any given story lacks the credibility and authority of the broadcast episodes, the cumulative effect of reading many such stories is to alter one's perception of the series. Readers return to it with alternative conceptions of the characters and their motivations, repositioning the events into a greatly expanded narrative and a more fully elaborated world.

CASE STUDY: LESLIE FISH'S *THE WEIGHT*

No single work of fan literature encompasses the full range of rewriting strategies described above. Yet a closer look at one particular narrative may illustrate the systematic reworking of broadcast texts characteristic of this mode of cultural production. Leslie Fish's epic *The Weight* (1988), a serial novel which runs for 473 pages of small print and narrow margins, stands as a recognized classic within *Star Trek* fan writing, still being discussed and circulated more than fifteen years after its initial publication. Fish combines action-adventure sequences, political and theological debates, romantic and sexual encounters, communal rituals, and folk songs, along with a diverse array of other generic materials, into a complex and compelling narrative of Kirk's attempt to regain his ship, his crew, and his dignity following a disastrous time travel experience. Her novel offers insight into the psychology of the major characters and a compelling critique of the program's ideology. *The Weight* begins with mild grumbling about bureaucratic incompetence and ends with all of the regular characters verging on open revolt against Federation authorities. If official *Star Trek* novels are required to return the characters to the place where they began, to introduce no dramatic changes to the narrative format, Fish fully exploits the freedom of fan writing to change all the rules of the

game; Fish takes obvious pleasure in systematically dismantling the fictional world and gradually remaking it in alternative terms. Fish also manages to introduce a cast of original characters, including several strong and heroic women, whose motivations and actions prove as intriguing as those of Kirk, Spock, and McCoy. Despite all of these changes, Fish remains faithful to the core of the series, making frequent references to program history as a basis for the characters' histories and motivations.

The Weight began in 1976 as a short story written in response to an earlier fan work, Ed Zdrojewski's "The Sixth Year." Fish quickly discovered that her story could not be told in a few pages but required monumental development; *The Weight* grew by installments over a three-year period, fueled by tremendous response from the fan community. Some eagerly embraced her particular vision of the *Star Trek* characters and their universe while critics jokingly called her ever-expanding story "The Interminable Weight." *The Weight* was serialized over 11 issues of *Warped Space* and only assembled into a single volume in 1988, after years of circulation in dog-eared copies of the original zines or faded multiple-generation photocopies. Fish's narrative, in turn, inspired other writers to make their own contributions to its development; several related stories by other fans, as well as the Zdrojewski original, appear in the single volume edition.

In Zdrojewski's short story (1988), the Enterprise travels back in time to the 1990s, a time when the Earth has been devastated by biological warfare (The Malthusian disaster of 1987) and the collapse of technological society, seeking an explanation for the mysterious disappearance of Chicago. There, through a series of clumsy mistakes, Kirk is tricked by Yeoman Pennington, a member of the underground organization, People for Temporal Control. Pennington escapes with the blueprints for a primitive phaser. Her renegade actions reshape Earth's future development. When the Enterprise returns to its own time, its dilithium crystals drained beyond use, they discover not the technological utopia Roddenberry envisioned but "an anarchist's dream—an agricultural society with no technology and no government" (17). Spock has ceased to exist in a world which never developed the space travel needed to facilitate the mating of a Vulcan man and an Earth woman. Discredited and disillusioned, driven almost insane by his failure to avert this disastrous reshaping of the Federation's historical development, Kirk allows his crew to beam to the planet's surface to begin a new life

for themselves; the captain alone remains on his ship, recognizing that Earth's failure to advance technologically leaves it unprotected against an all but inevitable Klingon-Romulan invasion. As the story's final line explains, "It was a terribly lonely universe he had created" (18).

The Weight begins where "The Sixth Year" ends: Kirk must somehow regain his sanity, reclaim the respect and loyalty of his crew, and fix the problems caused by his mistakes. "Citizen Kirk" joins forces with a small band of technologically inclined anarchists. Facing persecution from their Luddite neighbors, the anarchists decide that his more advanced world represents the only hope for their future. What Kirk has not told them is that his alternative time line is dominated not only by national governments but by an interplanetary federation which sets its own rules for member planets' development. There is no space in that world for the development of an autonomous anarchist community, especially not on the Earth they hope to reclaim for themselves and their children.

This deception forms the work's central moral conflict: without the colonists' help, Kirk has no chance of returning to his own time and restoring his friend to life, yet Kirk and his crew find it increasingly difficult to lie to these brave men and women who are sacrificing their lives to bring about what they hope will be an anarchist utopia. The book's first half centers on their efforts to rewrite Earth's history and to prepare for the rise of the Federation; the second half centers on what happens to the Enterprise and the anarchists when they must find a place for themselves in the Federation they have helped to create, a Federation which sees any society lacking a strong central government as hopelessly primitive. This Federation wants to dump them on a planet, visited by the Enterprise in "This Side of Paradise," whose flora will put the anarchists into a drug-induced bliss. Having operated according to anarchist principles during their long voyage home, the series characters find themselves torn between their loyalty to Star Fleet, which requires them to deliver the anarchists to the mind-control planet, and their commitment to their friends, which may require them to rebel against the Federation high command. As the final chapters unfold, the characters make their own decisions about their political commitments, finding different ways to confront and resolve their disillusionment with the system they had once sworn to protect. Meanwhile, the anarchists must cope with their alarming discovery of the truth about Kirk's world and its government.

Complicating the issue is the fact that many of the anarchists are literally doppelgangers of the regular characters, reflecting back to them how they might have behaved if they had been born into this alternative cultural context. As one of the anarchists explains:

> We're your other selves. . . . We're too close to you to be calm, cool and objective about us. Everything we do is a commentary on yourselves, a proof of what you could do if you wanted to. We're not quaint foreigners that you can tolerate and smile at and walk away from; we're the dark sides of yourselves, and you can't lose us or ignore us. (427)

Kirk's double is the anarchist's female "coordinator," Jenneth Roantree, whose strength, courage, and intelligence make her more than a match for the starship captain. Her nurturing relationship with her community poses a fascinating alternative to his exercise of hierarchical authority. Kirk and Roantree feel an immediate attraction and soon become passionate lovers, only to discover that they are in fact two embodiments of the same person. Kirk is horrified by the discovery that he has, in effect, made love with himself and is initially unable to cope with the feminine side of his personality. Kirk is still haunted by the gender-bending events of "Turnabout Intruder," a series episode in which an ambitious ex-girl-friend, Janice Lester, "borrows" his body: "I'm afraid of . . . seeing myself as something different, alien . . . not what I really am, and Janice Lester's body was so utterly different. . . . Anything—a Vulcan, an Andorian, even a Tellarite—I could have stood it better. . . . Dear God, can that be true? Is a woman—a human female—more alien to me than any nonhuman I know?" (52). As Fish's narrative unfolds, Kirk overcomes his fear of the feminine and discovers through Roantree's example the possibilities of a more egalitarian relationship with his crew.

Fish uses the character of Jenneth Roantree, as well as other female anarchists such as the engineer Ann Bailey and the scientist Quannechota Two-Feathers, to challenge the gender stereotyping of the original series. Fish explains: "I designed Jenneth and Quanna to be strong female characters because I was a trifle annoyed at some of the mental and emotional lightweights that often show up as heroines in *Trek* literature (including the aired episodes!) . . . Making Jenneth Kirk's alter-ego is a way of making her unexpected character strength more readily (and quickly!) understandable in the

genre" (Fish 1977, 13). Fish portrays these characters as more than capable of assuming traditionally masculine responsibilities. Uhura describes Roantree as "brilliant, talented, brave, strong . . . almost frighteningly strong . . . and of course, she's open and friendly and cheerfully uninhibited as the rest of them—and perceptive and kind. All our Captain's virtues, with a few more of her own. She seems larger than life, like something out of our childhood dreams" (93). Jenneth Roantree embodies a robust style of feminine strength which celebrates the female body, relishes sexual pleasure, values the maternal and assumes gender equality. Critics charge that Fish's characters lack "feminine" qualities and measure themselves too much against male standards. *The Weight*, however, actively encourages such questions, and especially inviting a reconsideration of the ways series regulars combine gender traits.

Fish gleefully documents the confusion and anxiety with which Kirk and the other male characters confront this powerful woman, as well as the aspirations she awakens within the female crewmembers. Uhura sees Roantree as a potential champion who may challenge Star Fleet's sexist treatment of its female officers and open doors for other women to gain command positions; Uhura conspires with Christine Chapel to convince Roantree to accept a post in Star Fleet. Their scenes together provide nuanced pictures of these two women's responses to the patriarchal attitudes and institutions they encounter in the *Star Trek* universe: the ambitious Uhura wants to confront the problem directly and force dramatic social changes, "to take on Starfleet and drive a big fat wedge into that little crack in the armor" (211); Chapel quietly yet decisively sides with the colonists, taking actions that insure their chances for survival. In a heated exchange with Jenneth Roantree, Uhura explains the harsh realities she has had to confront:

> Once machinery could take over most physical work, it was possible again to let women spend most of their time breeding, nursing and raising children. . . . Oh, women are still allowed to try for any work they want—but they're hardly encouraged at it. . . . They're disliked, considered neurotic, pressured into marrying, passed over for awards and positions they deserve. . . . Ah, let me put it this way, there are no female Starship captains. Not in all of Starfleet. . . . My chances [of getting her own ship] are poor. "Insufficient training and experience" they say—after

neatly sliding me into a position where I'm unlikely to get either. (443–444)

Fish focuses attention throughout *The Weight* on the sexist treatment of women within the original episodes, constructing an image of the future to account for why women have made so little progress over hundreds of years of social and technological change. For the colonists, this failure to fully utilize half of its human resources makes no sense, since in their world, power is not distributed on the basis of gender and no great efforts are made to distinguish between the sexes. Fish's anarchists offer perplexed and pointed comments on the values they encounter on the Enterprise, everything from Uhura's scanty attire ("Her personal foibles don't seem to bother the crew any. I still don't know why she doesn't wear any pants with that shirt, but her people seem used to it" [195]) to Kirk's inability to display emotions ("For some reason which I do not understand, he does not dare to let himself cry. . . . Where on Earth did he get an inhibition like that?" [102]).

The interweaving of these many characters, their emotional turmoil, their psychological development, and their radicalization make *The Weight* a compelling blend of agit-prop and popular fiction. Fish's fan novel shows the obvious influence of the sixties' counterculture and the New Wave science fiction writers (not to mention feminists like Ursula LeGuin or Joanna Russ) with its heavy focus on sex, drugs, politics, and music. Yet her epic maintains strong traces of Gene Roddenberry's original conception of the characters and thus insures its credibility with her fan readership. A committed anarchist, Fish leaves little doubt where her own sympathies lie; she builds a strong case for the colonists' way of life, which includes group marriage, free love, communal folksings, ritual and recreational drug use, and democratic participation within all decision making. She also gives her *Star Trek* characters time to reach their own conclusions about where their loyalties belong. At one point late in the book, Christine Chapel confronts Dr. McCoy, trying to force him to recognize what she has discovered about Federation authority: "It's not paranoia, Doctor; we're all growing up. . . . The anarchists didn't do it knowingly. All they did was show us, by contrast, what our lives are really like. Having to 'play Anarchist' for their benefit made us reconsider our own values, our own beliefs. . . . We're learning, finally, that no rule is perfect. . . . There is no Big Daddy who can be trusted absolutely" (391–392).

The political transformation of Kirk, from the strict yet benevolent patriarch seen in the aired episodes into a long-haired radical, remains central to the narrative and pivotal to its resolution. Her Kirk proves flexible in his responses to new conditions. "Citizen Kirk" is a charismatic leader who commands respect and affection even under a more democratic distribution of power and comes to feel great love for his anarchist band. The starship captain chooses to marry Spock's double, Quanna, and sides with the colonists in open opposition to Star Fleet command. Until the very end, however, he cannot tell them the truth about their world and never makes a final break that would commit himself fully to their ranks.

Despite her primary focus on Kirk, Fish finds ample time to develop the other *Star Trek* characters and their various responses to this cultural and ideological confrontation. The functionalist Scotty has little trouble working with the anarchists, once he learns to overcome his quick temper and sometimes possessive attitude towards the ship. The humane McCoy learns from the colonist's compassionate treatment of Kirk, abandoning professional dignity and claims of expertise to discover the value of their more traditional medicines and holistic approaches. The patriarchal Dr. M'Benga, on the other hand, proves rigid and insensitive, refusing to adopt to the new ways. M'Benga treats the female anarchists with a patronizing attitude and a disregard for the value their culture places on reproductive freedom. Spock remains similarly suspicious of the anarchists; their emotional expressiveness, social nudity, and sexual freedom, their refusal of discipline and rejection of any and all forms of authority; indeed, their entire way of life opposes everything the Vulcan holds dear. Spock displays great jealousy over their demands on Kirk's affections, though he finally assists their escape from Federation hands in a gesture of friendship to his captain and a display of begrudging admiration for their self-sufficiency and intelligence. Fish reverses most fan thinking that has portrayed Kirk as dogmatic and authoritarian and Spock as accepting of alternative beliefs and lifestyles. Fish maintains optimism that both men might find a place for themselves in an anarchist society, though she recognizes how embedded their characters are within a patriarchal and hierarchical culture.

Fish's *The Weight* is remarkable in the scope and complexity of its conception, the precision of its execution, and the explicitness of its political orientation. Not all fan writing is this self-conscious about the ways it rewrites the program ideology and reconceptual-

izes the series characters. Some writers claim that their fiction simply provides new adventures involving the regular characters, though this is rarely literally the case. Most struggle to maintain greater fidelity to the broadcast episodes. Yet Fish's work is far from unique. *The Weight* combines many of the strategies of textual revision outlined above: she expands the temporality of the series; she questions its basic ideological assumptions; she explores the erotic and psychological dimensions of its characters; she refocalizes the narrative around female characters (if not always, at least during some key sections of the novel); she introduces new generic material that broadens the range of acceptable *Star Trek* plots. All of these practices surface, more or less self-consciously, in a range of fan narratives. The next chapter looks more closely at a particular genre of fan writing, slash, which represents an equally radical reworking of television materials.

6

"Welcome to Bisexuality, Captain Kirk": Slash and the Fan-Writing Community

> The sensuality that may be occasioned by intimacy, trust, and fairness is quite unlike that sexuality which is driven to hit on a particular gender embodiment. The sensuality that arises in a relational context of actual people being together and actually being themselves—not stand-ins for a gender type—is radically different from that sexuality which requires that the 'other' not deviate from a particular standard of sexedness. Such a sensuality may be deeply satisfied with giving expression and meeting a mutually felt responsiveness. . . . [Such a sensuality] may be experienced in a particular relational context as a transient release from gender altogether. (This sensual possibility is what explains why someone who has an ostensible sexual orientation may nevertheless, in a particular relationship, be quite sexually expressive and responsive with someone who is not apparently the "object" of that orientation.) (Excerpt from John Stoltenberg, *Refusing to be a Man: Essays on Sex and Justice* [1989]: 106; circulated by a "slash" fan [personal correspondence, 1991])

James T. Kirk, "T for Tomcat," man's man, youngest starship captain in Federation history, confronts a problem of an unfamiliar kind, a question of sexual orientation and personal commitment. In a plot familiar to readers of "slash" fiction, Kirk and Spock are stranded on a desert planet with little chance of immediate rescue; the Enterprise is away on an emergency mission delivering plague serum to Mmyrrmyon II, when Spock prematurely enters Pon Farr, the Vulcan mating fever. Spock will die if he does not achieve immediate sexual release. Kirk comes to the slow, reluctant realization that the only way to save his friend's life may be to become his sexual partner. Kirk reassured himself, "No one is asking you to

enjoy yourself" (4). It seemed the logical thing to do at the time. The situation does not remain that simple; Spock resists, angry at the captain's violation of his privacy, unsure what the consequences of these actions might be, yet soon succumbs to reason, to need, to pleasure. Instead of the anticipated displeasure, Kirk experiences intimacy, warmth, release: "Relief flooded through him and Kirk stopped for a moment, just holding Spock in his hand, not daring to look at him, just letting the knowledge be there between them, that this was going to work" (5–6). Spock survives, Kirk endures (well, perhaps a little more than endures), and the two return to the Enterprise, now confronting the aftermath of that desperate situation. Kirk is haunted by the memories which intrude into his otherwise "healthy" erotic fantasies of sex with blue-skinned Andorian women; the captain is uncertain what these strongly felt desires say about his masculinity, what it all means for his sexual orientation: "Welcome to bisexuality, Captain Kirk, where gender has nothing to do with who you want" (11–12).

Thus begins Gayle Feyrer's *The Cosmic Fuck* series, a vintage example of Kirk/Spock fan erotica, a story exploring what is for the story's protagonists a "strange new world"—the realm of bisexuality and its unsanctioned pleasures. As the series continues, Kirk works through his initial discomfort and anxiety, learns to adjust to these unfamiliar sensations, comes to accept his own break with the regimentation of sexual orientation; Spock learns to be more open about his feelings, moves beyond the chemical analysis of Kirk's sperm ("fascinating, Captain") to a more spontaneous expression of his affections. The men's love grows and their consciousness expands through the magic of the mind meld. In the end, their love is so firm it can be broadened further, incorporating McCoy in a friendly menage a trois that mirrors the familiar gathering of three buddies that concludes many of the broadcast episodes. *The Cosmic Fuck* series outlines within a simple, uncluttered plot (indeed, within what may be the archetypical K/S plot) many of the basic premises of "slash" fiction: the movement from male homosocial desire to a direct expression of homoerotic passion, the exploration of alternatives to traditional masculinity, the insertion of sexuality into a larger social context.

The colorful term, "slash," refers to the convention of employing a stroke or "slash" to signify a same-sex relationship between two characters (Kirk/Spock or K/S) and specifies a genre of fan stories positing homoerotic affairs between series protagonists.

6.1 "Intimacy, Trust and Fairness": *The Man From UNCLE*'s Napoleon Solo and Illya Kuryakin. Artwork by Suzan Lovett.

Slash originated as a genre of fan writing within *Star Trek* fandom in the early 1970s, as writers began to suggest, however timidly, that Kirk and Spock cared more deeply for each other than for any of the many female secondary characters who brush past them in the original episodes (Nolan, 1985). Slash was initially met with considerable resistance from fans who felt such writing was an improper use of program materials and violated the original characterizations (Jenkins, 1988). In a 1977 essay on fan writing, Kendra Hunter dismisses slash as a form of "character rape," a violation of the fans' desire to remain faithful to the original program: "It is out of character for both men, and as such, comes across in the stories as bad writing. . . . A relationship as complex and deep as Kirk/Spock

does not climax with a sexual relationship" (81). For many early fans, slash as a premise questioned the masculinity of the protagonists and challenged their heroic stature. This controversy continues to the present (with some cons still refusing to allow the public distribution of homoerotic publications for fear of offending actor guests and many fans violently offended by the very idea of slash) though slash has progressively gained a broader acceptance within fandom. Some of the earliest stories still circulate in multiple-generation photocopies; early slash zines sell at high prices from zine dealers at conventions and remain in demand as collector's items; one fan publisher recently began to reprint *Alternatives*, a zine which published many of the earliest slash stories. Since the mid-1970s, slash has spread to other media interests, most notably *Starsky and Hutch, Miami Vice, Blake's 7, Man from UNCLE, Simon and Simon* and *The Professionals*, and has encompassed a broader range of characters and their narrative situations. Slash, as chapter five demonstrates, is simply one of a number of important forms of fan writing; one can survive quite comfortably within fandom without developing a taste for slash or without even reading any of it. Slash does, however, constitute a significant genre within fan publishing and may be fandom's most original contribution to the field of popular literature.

Fan writer Joan Martin (n.d.) offers this definition of the genre:

> In slash, the protagonists not only love each other but become (or are) lovers. Most commonly, slash tells first time stories [i.e. stories about the initial sexual encounter between a particular set of partners], but some stories involve an already established relationship. Slash includes anything from soft romance to varying amounts of explicit sex. Sometimes it includes very little but sex. . . . Generally, slash offers strong characters who are able to cope with their world and who aren't victims of it. It combines love and sensuality. It may include violence, but warmth and love transcend the violence. . . . It offers detailed and loving descriptions of beautiful men making love lovingly. It presents love as entailing mutual respect and possible only between equals; sex as a mutually undertaken, freely chosen, fully conscious interaction; and love and sex together as a source of great joy to the protagonists. (1–3)

As this description suggests, slash involves both a set of generic formulas and an ideology about same-sex relationships. Slash stories

center on the relationships between male program characters, the obstacles they must overcome to achieve intimacy, the rewards they find in each other's arms. Slash fiction represents a reaction against the construction of male sexuality on television and in pornography; slash invites us to imagine something akin to the liberating transgression of gender hierarchy John Stoltenberg describes—a refusal of fixed-object choices in favor of a fluidity of erotic identification, a refusal of predetermined gender characteristics in favor of a play with androgynous possibility. There are considerable implications behind shifting our conception of male heroes, since a fairly rigidly defined and hierarchical conception of gender remains central to all aspects of contemporary social and cultural experience. Stoltenberg (1989), among others, has called for a reconsideration of how sexual orientation reinforces other forms of patriarchal authority:

> Ultimately it is not possible to support one's belief in gender polarity (or 'sex difference') without maintaining gender hierarchy (which in our culture is male supremacy). . . .
> To be 'oriented' toward a particular sex as the object of one's sexual expressivity means in effect having a sexuality that is like target practice—keeping it aimed at bodies who display a particular sexual definition above all else, picking out which one to want, which one to get, which one to have. Self-consciousness about one's "sexual orientation" keeps the issue of gender central at exactly the moment in human experience when gender really needs to become profoundly peripheral. Insistence on having a sexual orientation in sex is about defending the status quo, maintaining sex differences and the sexual hierarchy; whereas resistance to sexual orientation regimentation is more about where we need to be going. (106)

Stoltenberg's position is a controversial one, a tactical response to contemporary sexual politics; the public announcement of sexual identities remains a significant political goal within the gay community, even as the deconstruction and transcendence of those orientations remains an essential first step from homophobia and misogyny within heterosexual male culture. Slash, as well, would seem to be a tactical response to similar concerns. Slash confronts the most repressive forms of sexual identity and provides utopian alternatives to current configurations of gender; slash does not, how-

ever, provide a politically stable or even consistently coherent response to these concerns. Slash also runs the risk of celebrating gay male experience (and more traditional forms of male bonding) at the expense of developing alternative feminine identities. Slash may, finally, be more important because of its questioning of sexuality and popular culture than for its specific answers.

Linda Williams (1990) and Andrew Ross (1989) argue for the utopian potential of the pornographic imagination, while conceding that much of traditional pornography has been reactionary in its construction of sexual identity. Ross, in particular, calls for research into the complex ways consumers experience pornographic materials: "It would tell us how people variously respond to the invitation to think of their bodies as a potential source of achieved freedom, rather than a prison house of troublesome bodily functions or a pliant tool for the profitable use of others" (177). While sharply critical of commercial pornography, Stoltenberg (1989) has also argued for the possibility of alternative forms of erotic literature where "mutuality, reciprocity, fairness, deep communion and affection, total body integrity for both partners, and equal capacity for choice-making and decision-making are merged with robust physical pleasure, intense sensation and brimming-over expressiveness" (112). Slash may represent the fullest articulation of this new liberatory imagination, pointing to new directions in the construction of gender and the representation of sexual desire. Slash breaks as well with the commodification of pornography, offering erotic images that originate in a social context of intimacy and sharing.

Academic writers, such as Patricia Frazier Lamb and Diana L. Veith (1986), Joanna Russ (1985), and Constance Penley (1991, forth.), characterize the genre as a form of "erotica" or "pornography by and for women," stressing slash's important contribution to debates about sexual representation. That description, however, remains inadequate to the range of slash stories; sexually explicit sequences often constitute only a small section of lengthy and complex narratives. If, as Stoltenberg (1989) claims, pornography represents "sex that has no past (the couplings are historyless), no future (the relationships are commitmentless), and virtually no present (it is physically functional but emotionally alienated)" (107), slash is centrally concerned with how sexual experience fits within the characters' pasts, presents, and futures. Sexual scenes are often anchored to specific narrative moments (most often a crisis within the character interactions: Doyle's near-death experiences in *The Profes-*

sionals, Blake's guilt over Gan's death in *Blake's 7,* Spock's Pon Farr in *Star Trek*) and make sense in relation to those plot developments, even if the story itself consists of little more than a sexual vignette. (Fans describe such stories as "PWP," or "Plot, What Plot?" stories.) Where specific events from the original series are not explicitly mentioned, sexuality is still assumed to shed light more generally on characterization. Often, slash stories incorporate other generic traditions (historical romance, horror, action-adventure, undercover missions, landing parties, crossovers, etc.) so that the sex gets embedded within a larger plot structure even at the level of the individual narrative. While character sexuality constitutes one of the most striking characteristics of slash, and most slash fans concede that erotic pleasure is central to their interest in the genre, it seems false to define this genre exclusively in terms of its representation of sexuality. Slash is not so much a genre about sex as it is a genre about the limitations of traditional masculinity and about reconfiguring male identity.

This chapter reviews the major claims made by previous academic treatments of slash, their important contributions and their limitations, before offering my own model of the genre's narrative and thematic structures. I am not looking for one fixed explanation for slash or a justification for why women read and write this curious fiction. Many slash fans protest that their activity needs no justification to "mundane" society or uninitiated fans. Rather, I will give a sense of the complexity of this cultural phenomenon and suggest the various meanings slash assumes for female fans.

"SLASH" AS FEMALE PORNOGRAPHY

Both fan and academic writers characterize slash as a projection of female sexual fantasies, desires, and experiences onto the male bodies of the series characters. If 90 percent of all fan fiction is written by women, as Camille Bacon-Smith (1986) estimates, slash remains an even more exclusively feminine genre. I know of only a few men who have written slash stories and only a slightly larger number who regularly read them. Indeed, several times when I ordered slash zines, the editors wrote notes explaining that they have few male readers and assuring me that I can receive a refund if I am offended. The widespread assumption among slash fans that straight, bisexual, and lesbian women may "instinctively" recognize

the pleasure of reading male-male erotica, while straight, bisexual, and gay men may not, speaks volumes about their conception of masculinity and the critical edge of slash fiction.

Feminist critics like Joanna Russ are interested in slash stories because they offer insights into female sexual fantasy; slash contains much Russ (1985) finds lacking in pornography aimed at a predominantly male audience: "the lovers' personal interest in each other's minds, not only each other's bodies, the tenderness, the refusal to rush into a relationship, the exclusive commitment to one another" (85). While the stories may provide detailed descriptions of specific acts, the emphasis is much more on the emotional quality of the sex than on physical sensations: "Something strange was happening to Bodie—not a physical arousal . . . not yet . . . His entire chest felt as if it was liquefying, softening, melting in the tenderness he was experiencing for this man, spreading its warmth through his body, making his forearms ache with wanting" (E.T. n.d., 11). Characterization is not suspended during sex but rather sex becomes a vehicle by which character emerges in particularly sharp detail. Sex is most often represented within committed relationships as part of a meaningful exchange between equals, not anonymous or depersonalized.

The focus is often on sensuality (especially the stroking and sucking of breasts, the fondling of flesh, the massaging of backs and feet) rather than on penetration and ejaculation (the most common images in traditional pornography). The characters lie in each others' arms, cuddling, in the warm afterglow of sex or by the day's first light, exchanging affectionate intimacies: "Supple, silky arms tightened around him. Hutch opened his eyes to reflected sunlight off water, sunny warmth beside him, under him. . . . They kissed before saying a word to each other" (Bright n.d., 14).

Russ (1985) sees slash as responsive to deeply felt desires of its female writers and readers for "a sexual relationship that does not require their abandoning freedom, adventure, and first class humanity . . . sexual enjoyment that is intense, whole and satisfying . . . [and] intense emotionality" denied to women within commercial pornography (90). Slash readers do not display a literal wish to become male, Russ argues, or even necessarily an over-valuing of masculine experience, so much as they construct a realm where "questions about who is the man and who is the woman. . . . cannot even be asked" (96). Just as Stoltenberg (1989) calls for men to refuse masculinity as a constraint on their sexual identity, Russ claims that slash allows women to refuse the dominant social con-

struction of femininity, to imagine "a love that is entirely free of the culture's whole discourse of gender and sex roles" (Russ 1985, 89).

SLASH AS ANDROGYNOUS ROMANCE

Patricia Frazer Lamb and Diana L. Veith (1986) discuss K/S as a reworking of the conventions of romantic fiction, an attempt at constructing a loving relationship between equals: "Theirs is a union of strengths, a partnership rarely possible between men and women today and just as unlikely—if not more so—between men and women in the ST television universe. . . . The zines assume that the basis for Kirk's and Spock's mutual commitment is their unquestioning reliance on one another's courage, strength and wits" (238). This mutuality and equality requires a break from heterosexual norms, since, Lamb and Veith contend, patriarchy allows little space for this reciprocity within male-female romance. As Leslie Fish (1984), one of the earliest slash writers, explains, "If any man tried to treat me the way Romantic heroes commonly treat 'their' women, I'd punch his darkly-handsome-broodingly-rich front teeth out! . . . The appeal of K/S is that this is the one place where we *can* see love between equals—something never completely available in the real world" (5).

To insure this possibility of sexual equality, slash involves, Lamb and Veith (1986) suggest, a play with androgyny; both Kirk and Spock mix and match traditionally masculine and feminine traits, sliding between genders as they struggle for intimacy. Kirk is sexually promiscuous, an undisputed leader, always ready for action and in command of most situations (masculine), yet he is also beautiful, emotional, intuitive, sensuous, and smaller (feminine); Spock is rational, logical, emotionally controlled, keeps others at distance, and stronger (masculine) while he is also virginal, governed by bodily cycles, an outsider, and fully committed to sexual fidelity (feminine). Slash depends not simply on a mapping of conventional male and female roles onto the relations between two male characters, not in creating consistently femme or butch versions of Kirk and Spock. Rather, slash explores the possibility of existing outside of those categories, of combining elements of masculinity and femininity into a satisfactorily whole yet constantly fluid identity. Con-

sider, for example, the play with stereotypical conceptions of gender
and sexuality within these passages:

> It was a strange dichotomy, Blake being so large and the
> kiss being so delicate. . . . Avon ran his hand up Blake's
> stomach to his chest, loving the baby smoothness which
> felt almost like a woman but wider, harder, flatter. His
> palm centered on one nipple and he watched Blake's face.
> (Arat 1988, 104)

> They seemed to melt together. Lips sinking soft into soft,
> arms encircling. Such languorous kisses, savoring every
> nuance, lips brushing, nuzzling, lapping and overlapping.
> Smooth surfaces, moist inner edges. Cool and hot blending
> to warm. Covering each other's mouths with sweet wet
> sucking, like two vaginas hungering on each other . . .
> strange that thought didn't frighten, only moved him. . . .
> Different alike different. Male male. Human Vulcan. How
> female this vulcan love of delicacy, of touches that barely
> touched. You are as infinitely mysterious as a woman to
> me. (Feyrer 1986, 21)

> Bodie was in fact asleep, face half-averted, one hand curled
> and relaxed on the pillow; cynical disdain smoothed from
> his face, his hair ruffled, he looked very different—vulner-
> able. Or maybe not. Doyle remained just inside the door,
> leaning against it as he studied the sleeping face. . . . Poor
> sod looked exhausted, his eyebrows and lashes darker than
> usual against seemingly bloodless skin. (H.G. n.d., 1)

What remarkable images—men's bodies represented as smooth
and womanly, male kisses described like the meeting of two vaginas,
a cop depicted with china doll fragility! Yet the identification of
these characters (Blake, Spock, Bodie) as feminine is easily revers-
ible; the next passage may refer to Avon's pouting lips, Kirk's hazel
eyes, or Doyle's shapely buns while Blake may become burly, Spock
rigid, and Bodie athletic. In slash, both characters can be equally
strong and equally vulnerable, equally dominant and equally sub-
missive, without either quality being permanently linked to their
sexuality or their gender.

The love of Kirk and Spock, within the Lamb and Veith (1986)
formulation, replaces the restricted possibility of a romance between
heterosexual men and women. The media simply does not provide
the autonomous female characters needed to create a heterosexual

6.2 "The emphasis is more on the emotional quality of the sex than the physical sensations": *The Professionals'* Bodie and Doyle. Artwork by Suzan Lovett.

romance between equals; fan writers have chosen the path of least resistance in borrowing ready-made figures, such as Kirk and Spock, to express their utopian visions of romantic bliss. Lamb and Veith's explanation is consistent with a much broader body of work on women's writing, such as Carolyn G. Heilbrun's discussion of the homoerotic fiction of Mary Renault (1979), that points to a failure of female authors to construct compelling female characters and a tendency to project their own desires and ambitions onto traditionally masculine protagonists. Forced to work within generic traditions created by and for men and already codified with patriarchal assumptions, female writers have often found it easier to rework or invert those assumptions than to create a totally alternative set of conventions or to find appropriate models for autonomous female characters.

However suggestive it may be, such an explanation does not fully situate slash within its larger context in fan culture. Certainly, the mass media constructs more vivid and compelling male protagonists than female secondary characters. Yet Lamb and Veith ignore the degree to which some popular narratives (*The Avengers* or *Aliens* for instance) do provide strong female characterizations and represent men and women working side by side for a common cause. If female fans are often not entirely satisfied with the development of characters like Catherine, Uhura, Jenna, or Yar, such characters do exist and provide resources for the construction of female-centered narratives. Lamb and Veith do not discuss the large numbers of heterosexual romances and erotic stories that circulate within fandom and the degree to which stories about Blake and Jenna or Spock and Chapel also engage in the project of constructing models for a more intimate and reciprocal form of romance. For example, "Comfort," an alternative universe *Blake's 7* story by "Paula" (1990), depicts the first few moments of a potential love affair between Blake and Soolin as the two comfort each other over the death of Dayna, their mutual friend. "Paula" portrays Soolin's reluctance to make herself vulnerable to any man, her inability to conceive of sexuality as anything other than a weapon, while Blake's love is described as accepting and nurturing: "Blake was an open, giving man whose caring spread to everyone around him" (48). Blake offers Soolin sex on her own terms, allows her to play the dominant role in their love-making, while helping her to become more open to her feelings; this Blake-Soolin relationship essentially reverses the traditional vocabulary of heterosexual pornography

with its focus on female nurturing and male independence. "Comfort" ends without a commitment which might decrease Soolin's autonomy; the characters simply acknowledge future possibilities for mutual satisfaction: "Being together now, needing each other now was what really mattered. . . . She had expected no commitment and she was not ready to make one. But she had learned now how a commitment might feel and she knew that one day she would want that from someone" (51).

Since Lamb and Veith (1986) wrote their essay, the fan community has also begun to generate a smaller (but growing) number of lesbian stories envisioning this type of reciprocal relationship occurring between two female characters. In D'neese's "If I Reach Out, Will You Still Be There?" (1989) Troi helps Yar explore her alienation from the other Enterprise crewmembers, her conflicting desires for independence and commitment: "Why are you afraid to admit that you need someone? Is it such a terrible crime to want to be held, to share your pain with another?" (42). In J.D. Reece's "A Friendly Drink" (1990), Jenna becomes infuriated by the constant bickering and jousting for power between the male crewmembers and goes on a shoreleave to "let off steam." A sympathetic Cally joins her and the women find comfort together denied them in their daily interaction with the competitive and possessive men. Reece's descriptions capture the two women's strength and independence, focusing on the hardness rather than the softness of their bodies:

> [Cally] gathered Jenna closer, her dark mouth closing fully over Jenna's in a kiss that exhibited a blessed lack of human uncertainty. Jenna's mouth accommodated the touch, added energy, drawing fire from that banked and constant warmth. She crossed her wrists behind Cally's neck, pulling her tightly into the rising warmth of her body, strong arms expertly levering the taller woman into a complete embrace. Cally uncurled her long legs and half-rolled across her, acceding to the insistent hug, her weight an enticing challenge on Jenna's comfortably pinned curves. It promised to be a fairer match than most. (46)

Here, only the fleeting reference to Jenna's "curves" evokes traditional conceptions of the feminine body and within the amorphous prose of slash, that same phrase might just as easily refer to Avon's hips as to Jenna's. In lesbian slash, as with male-centered

slash, sexuality involves a dispersal of traditionally masculine and feminine traits: Yar's short-cropped hair and muscular physique, Troi's fuller hair and more buxom build; Yar's stoicism and volatility, Troi's empathy; Troi's "strong fingers" and Yar's "pale skin;" Cally's confidence and maternalism, Jenna's larger size and shapely curves. That the conventions of lesbian slash follow so closely those of the older and more fully developed male slash is not surprising, but it does point to the degree to which these same models are and have been available for narratives that more directly represented female experience.

SLASH AND FANTASY IDENTIFICATION

The development of forms of same-sex romance within a female writing community cannot therefore be explained in purely negative terms—"a failure of imagination," an absence of preconstructed models. We need to consider the particular fascination of these male characters and the degree to which the questions slash explores can be expressed most effectively through the representation of male-male romance. Constance Penley's work on slash (1990, 1991, forthcoming) focuses attention upon the complex libidinal economy surrounding the figures of Kirk and Spock. Such characters become the focus of erotic stories, Penley argues, because they already hold a sexual fascination for female fans who use the writing and reading of slash to play with different identificatory positions: "If, in the psychoanalytic account of fantasy, its two poles are being and having, this fantasy has it all, and all at once: the reader/writer can be Kirk or Spock (a phallic identification, rather than a regression to the pre-Oedipal) and also have them (as sexual objects), since, as non-homosexuals, they are not unavailable to women" (1990, 259). Penley places particular emphasis upon the tendency of slash writers to depict Kirk and Spock as lovers while simultaneously asserting that the protagonists are not gay and have no history of previous homoerotic experiences; such a formulation allows the writers to maintain their own sexually charged relationship with these characters even while they are describing Kirk and Spock's commitment to each other. What Penley does not note is that this conception of their sexuality may also allow the women to reconcile their reworkings with the episodes' ample evidence of previous heterosexual encounters.

These women's pleasure in multiple identifications is reflected by the narrational structures characteristic of slash writing. Slash stories often play with shifting points of view and the construction of shared subjectivities. In one sequence from Leslie Fish and Joanne Agostino's "Poses" (1977), Kirk and Spock stand at their usual positions on the bridge, each reflecting on their recently discovered attraction:

> He peered surreptitiously at Kirk, and saw only the side of his head and one hand tapping quietly on the arm of the chair. Those hands . . . amazing how strong they were, how tightly they could grip, how cool and delightful against bare skin. . . . Those big arms, like thick cool bands, moving across one's back, pressing at the secret tender place . . . the marvelous texture of that big, lush body. . . . **What am I thinking! Control this! I can control this. I am a Vulcan. The Mind rules.** . . . Kirk squirmed in the command chair, feeling sweat soak into the shirt between his shoulder-blades. His senses seemed to have expanded; he could feel Spock sitting only ten feet away, watching, waiting, saying nothing, but acutely aware of him. It was as if an invisible electric current connected them, keeping them painfully conscious of each other. He couldn't keep the Vulcan out of his thoughts, couldn't ignore him or stop musing about him or concentrate on anything else. (84–85)

Here, the description allows readers to experience both men's growing desire and to participate within their erotic fantasies.

This shifting point of view structure may become the organizing principle of a narrative. "A Momentary Aberration," a *Professionals* circuit story by L. H. (n.d.), describes a brief encounter between Bodie and Doyle in the back of Cowley's car as the men return late at night from a mission. In its opening section, the writer describes Doyle's impressions looking at his partner in the semidarkness, feeling a rising desire to touch and cuddle him, and finally acting on that desire, slowly at first and later with more insistence. L. H. then doubles back in time describing Bodie's impressions, as pretending to be asleep, he eagerly accepts his fellow agent's attentions. The same moments are retold, first with identification established with Doyle, then with equally close identification established with Bodie, allowing the same sexual experiences to be shared with both men.

The process of sexual fantasy is consciously explored in a large number of slash stories. Sebastian's "On Heat" (n.d.) opens with Doyle masturbating to an elaborate fantasy of being seduced by his partner: "Caught in an ecstatic, painful stasis where he dared not continue with the usual rhythmic caressing his body pleaded for, he held still, trembling, his mind racing with fevered images of Bodie's lips and tongue on him. . . . Bodie, touching him with such intimacy, pushing into him. . . . His mouth turned and searched blindly for the lips that were not there, never had been, never could be" (2). Bodie enters the bedroom to find Doyle, still lost in reveries and holding himself, resulting first in intensely homophobic confrontation and later in more passionate love-making when, as is so often the case in slash, erotic fantasies become realities.

One M. Fae Glasgow story (1988) restages Freud's "Child is Being Beaten" scenario as Blake, trapped in a closet, watches with charged fascination as Avon and Vila play dominance and submission games (the childlike thief spanking the wayward computer technician): "The big rebel thrust into his clenched fist, fucking his hands as he imagined himself fucking Avon, sheathed in the submissive body, causing the moaning and writhing. The image flipped in his mind. He saw himself under Avon, welcoming the pounding, the thick heavy flesh stretching him wide, wider as Avon filled him. The picture transmuted again, replaced by the reality before him"(10). Not only does Glasgow's story reproduce the multiple identificatory positions of the Freudian scenario (with Blake simultaneously wanting to be, to have, and to watch Avon as he is "being beaten") but Cally subsequently acts as a psychotherapist, urging Blake to examine his conflicting feelings ("I saw him under me, but also me under him. How could I want things so completely opposite?" [14–15]).

"FRAUGHT WITH DANGER"

This play with multiple identifications extends as well to the writing and circulation of slash. Many slash writers adopt pseudonyms, some of which bear political significance ("The PTL Club," "The Fifth Amendment"), evoke older traditions of feminine writing ("Anais," "Sappho," "Eros"), or provide painful puns ("Betina Sheets," "Lotta Sleaze"). As I have corresponded with the slash writers, many volunteered the stories behind their pseudonyms,

stories which speak both to their personal interests in writing and to larger traditions within the fan community. The selection of a pseudonym involves the construction of an alternative identity, a simultaneous revelation and masking of the name of the author; the identities of writers are often openly known within the fan community even as they are cloaked on the printed page. Fans at conventions may wear name tags bearing their "pseuds," their "mundane" names, or both. Yet a major scandal erupted in *Blake's 7* fandom when an anti-slash fan publicly and (some charge maliciously) identified the real names of several notable slash writers to one of the program's actors who had strong personal and moral objections to the genre; this incident sparked a debate about the "politics of naming names" (or "outing") within and outside of fandom, a debate that soon encompassed many other disputes. Writers often evoke different themes and tones as they assume different authorial identities, sometimes writing under multiple "pseuds" to signal their movement between fandoms or genres or to reflect different moods and styles.

Many slash writers see this practice as necessary for their own protection: British *Professionals* fans fear prosecution under tough anti-obscenity laws; many slash writers hold sensitive positions (clergymen's wives, school teachers and children's librarians, nurses) threatened if their erotic writing became associated with them; others face opposition from spouses or parents about their fan activities. Yet for many, hiding their true identities is part of the game, with the reading and writing of slash often charged with a pleasure in breaking with traditional feminine roles. Fans romanticize the "shocking" and "scandalous" quality of their underground activities (feelings that are especially acute for women in traditionally feminine careers and monogamous heterosexual relationships). These writing women fantasize about how others would react if they knew of their involvement with slash; a familiar fan joke speaks of slash readers begging their friends to retrieve their zine collections upon their deaths, lest their slash falls into the "wrong hands." This pleasure in scandal may also be tied to the use of the word, "slash," which bears violent or obscene connotations. The sound of the word evokes an aggressive pleasure in ripping or tearing traditional boundaries. To become a writer of slash, then, frequently involves the assumption of a secret activity; to read slash is often seen as a covert operation into a "forbidden zone" of sexual license and exploration. Joan Martin (n.d.) captures these women's scandalous

pleasure: "Slash is a wonderfully subversive voice whispering or shouting around the edges and into the cracks of mainstream culture. It abounds in unconventional thinking. It's fraught with danger for the status quo, filled with temptingly perilous notions of self-determination and successful defiance of social norms" (3).

There is a risk, however, in becoming so preoccupied with the erotic dimensions of slash, in becoming so fascinated with its "scandalous" quality that we ignore its larger narrative content and its complex relationship to the primary text. Slash, like other genres of fan fiction, represents a mode of textual commentary. Although fan critics sometimes accuse slash writers of borrowing little more from the original series than the character names and a few taglines (Spock's "Fascinating, captain"; Avon's "Well, now"; Sam Beckett's "Oh, boy"), the writers see slash as reflecting something they have found within the broadcast material. Slash allows for a more thorough exploration of issues of intimacy, power, commitment, partnership, competition and attraction apparent both in the scripted actions of those characters and also in the nuances of the actors' performances (ways they look at each other, ways the actors move in relation to each other). What fans have discovered in these programs is a subtext of male homosocial desire.

SLASH AND HOMOSOCIAL DESIRE

Eve Kosofsky Sedgwick (1985) introduced the term, "male homosocial desire," to discuss the representation of masculinity—especially male friendship and competition—within classic literary works, such as *Our Mutual Friend, Adam Bede, A Sentimental Journey*, and Shakespeare's sonnets. Sedgwick uses the term, "homosocial" to refer to "social bonds between persons of the same sex" (1), noting that it is a neologism that at once suggests links to "homosexuality" and signals its difference from that explicitly sexual category. Her chosen term, "male homosocial desire," bears a specific political significance: most accounts would deny that these idealized forms of male friendship had anything to do with sexual desire. Sedgwick posits "a continuum between homosocial and homosexual—a continuum whose visibility, for men, in our society, is radically disrupted" (1–2). While feminist scholars have increasingly accepted the concept of a continuum existing between female friendship and female-female love, Sedgwick argues, a patriarchal society

consistently constructs boundaries between acceptable and unacceptable forms of male friendship; patriarchy is held together, she suggests, through homophobia which is part of a system that enforces compulsory heterosexuality as well as restricts the range of behaviors open to men and women. Fictional representations of male friendship often depend for their emotional power upon the suggestion of strong homosocial desire between men, even as they isolate that desire from any explicitly recognizable form of sexuality: "For a man to be a man's man is separated only by an invisible, carefully blurred, always-already-crossed line from being interested in men. Those terms, those congruencies are by now endemic and perhaps ineradicable in our culture" (89).

Those themes Sedgwick finds in eighteenth- and nineteenth-century British fiction (the triangulation of desire between male rivals, the emotional intensity of male competition, the barely repressed fantasies that bind male friends together) are equally apparent within the narrative structures of contemporary popular culture—in the "great friendship" theme fans locate within *Star Trek*, in the partnership between Starsky and Hutch, Napoleon Solo and Illya Kuryakin, or Bodie and Doyle, in the sparky confrontations between Blake and Avon. Critics, producers, fans have often discussed these relationships in terms of something akin to male homosocial desire: April Selley (1986), drawing on Leslie Fiedler (1975), fits "the friendship between an American, white male, Captain Kirk, and the alien, green-blooded Mr. Spock" (89) within a larger tradition of eroticized male friendships, including those in *Huckleberry Finn*, *Moby Dick*, and *The Deerslayer*. *The Professionals* creator Brian Clemens (1986) describes Bodie and Doyle as an attraction of opposites: "Ray and Bodie are the blade and the steel, the flint and the wheel, each complementary and indispensible to the other. . . . Bring them together and sparks will fly" (14). If these programs evoke an ideal of male bonding, they must also repress the specifically sexual dimension of these relationships; the male characters are inscribed into short-lived relations of heterosexual desire (the romantic guest of the week) lacking the depth and intensity that binds the two men together. While Kirk loves many women in the course of the series, he loves none so dearly as he loves Spock; Kirk consistently renounces romantic ties that might interfere with his professional duties, while he has just as persistently been prepared to disobey orders and put his job at risk to protect his "friend."

Despite such attempts to focus these male characters' sexuality on short-lived heterosexual relationships, fan writer Barbara Tennison (1990) denies that program information about those characters necessarily prohibits the possibility of male-male love:

> From the screen, a goodly number of media characters have no definite sexual orientation; the assumption that they are straight is made because that is the recognized norm in our culture. A good many other characters demonstrate heterosexuality on occasion, but don't establish a committed relationship of the sort which might exclude other sexual activity. Again, the assumption that ALL their activity would be hetero is implied by the culture, not inherent in their screen behavior. . . . Being gay (or bi) is no more a public display than being straight, and in many ways is likely to be less publicly on display. In our culture, someone who's openly gay has made that choice by conscious decision after being presented (endlessly) with the straight option as a preferable choice. Someone who's ostensibly straight, particularly if s/he shows reservations about it, is *not* necessarily aware of the gay option, or not willing to pay the social price it exacts. This doesn't mean that character is straight, or that we the viewers must assume s/he is. (1)

Writing from an explicitly lesbian position, Tennison questions the heterosexist logic of commercial television narratives and of fans who object to slash because it is inconsistent with their characterizations on the episodes:

> As a gay person who doesn't consider being gay to be abnormal or bad, I object to the idea that an "undeclared" character on screen cannot, within the normal framework of life and the universe, be developed as gay. . . . I also challenge the notion that attraction toward members of the opposite sex necessarily excludes attraction towards one's own sex; bisexuality is also an option (and, again, it may not be a momentous decision to characters in an SF universe.) . . . All of which is to say, the screen universe is already an alternative to our own, cultural mores, sexual standards and all; we do not have to consider that a character's sexual choices are dictated by what *we* consider more likely or most common in our environment. We as

viewers certainly don't have to be governed by what the scriptwriters consider normal for their culture. (1)

Much like Sedgwick, Tennison adopts as her writing project the task of making visible invisible aspects of sexual experience, pulling to the surface the subtext of male homosocial desire.

Slash turns that subtext into the dominant focus of new texts. Slash throws conventional notions of masculinity into crisis by removing the barriers blocking the realization of homosocial desire; Slash unmasks the erotics of male friendship, confronting the fears keeping men from achieving intimacy. Here, the "dead girlfriend of the week" syndrome is read as reflecting serious problems with male sexuality which must be resolved before satisfactory and sustained relationships can be built. Sexuality exists on a continuum within slash that blurs the constructed boundary between friends and lovers, creating stories about "comrades who also found pleasure in the other's body" (Adams n.d., 9). As such, the genre poses a critique of the fragmented, alienated conceptions of male sexuality advanced by a patriarchal culture.

A focus on how slash constructs a continuum between homosocial and homosexual desire may explain why the protagonists of slash stories are male lovers and yet often have had no previous history of gay relationships: the barriers between men must be intensified to increase the drama of their shattering; the introduction of sexual taboos requires greater trust and intimacy between the men before they can be overcome. This convention may not be so much homophobic (though it is often that) as it represents the power of homophobia to block greater sharing (emotional and physical) between men. Such an account also may explain the relative scarcity of lesbian slash, since, as Sedgwick (1985) suggests, women have historically enjoyed a more fluid movement through the homosocial continuum. Female fans may not see as great a need to work through these issues for the programs' female characters. As slash writer M. Fae Glasgow explains, "Most women in fandom have longstanding female friendships. . . . If we want to see strong female-female relationships, all we have to do is look in our own lives. To us that's mundane. To us that's as everyday as sliced white bread. Slash is something way out there—a total fantasy. Not many of us know men who incorporate this ideal bonding into their relationships and that's what we want to see" (Personal Interview, 1991).

THE FORMULAIC STRUCTURE OF SLASH

The narrative formula of slash involves a series of movements from an initial partnership, through a crisis in communication that threatens to disrupt that union, toward its reconfirmation through sexual intimacy. These conventions represent both the dystopian dimensions of conventional masculinity and the utopian possibility of a reconstructed masculinity. Dramatic moments occur around boundaries within the continuum of male sexual and social desire; emotional intensity surrounds those moments when the men finally confess their feelings to each other. Here, sexual scenes merely confirm the partners' acceptance of these revelations as a basis for their new commitments. Some slash stories, particularly those within *Blake's 7* fandom, emphasize the dystopian dimension of male-male desire, focusing on the distrust, struggles for dominance, and sexual violence that block the transcendence of those boundaries; other slash stories, particularly those within *Star Trek* fandom, highlight the utopian possibilities that exist within male-male love, celebrating the increased intimacy of the mind meld and the deeper commitment of the Vulcan telepathic bond. The differences between *Blake's 7* slash and *Star Trek* slash reflect the different tones of the original episodes as well as the specifics of their cultural and historical origins (the American "New Frontier," Thatcherite England). Yet implicitly or explicitly, both utopian and dystopian elements can be located in most slash stories. The genre as a whole represents the conscious construction of a male homosocial-homosexual continuum, a concern surfacing explicitly within the writer's treatment of these relationships and implicitly within the story's plots.

The narrative trajectory of the prototypical "first time" story, a dominant subgenre of slash fan writing, involves four basic movements, each embodying a particular point of transition between homosocial and homosexual desire:

(1) *The Initial Relationship*: The story's opening frequently describes and re-establishes the pair's basic relationship as it has been previously represented within the original series: in the case of Kirk and Spock, Starsky and Hutch, Napoleon and Illya, or Bodie and Doyle, this initial relationship is an ideal partnership but one impeded by certain barriers to full communication. In the case of *Blake's 7* slash, a pre-existing climate of distrust, suspicion, and competition works to both express and repress the men's strong feelings. More accurately stated, the opening describes the pair's

relationship as it has been read from the aired episodes by fans. From the opening, slash stories presume that the characters possess sexual desires never made explicit (or even directly suggested) within the series, though many fans would insist that they recognize visible signs of such desires within the character's on-screen behavior.

The opening passages frequently center on one member of the pair as he takes inventory of his feelings for his partner:

> The crazy, tender melting Bodie could inspire in him when he was least expecting it no longer disconcerted Doyle. He had long since accepted that where Bodie was concerned he had few defenses against the uncharacteristic marshmallow softness that sat so oddly in his otherwise detached persona. Sometimes, the ache to risk losing the effortless rapport he and Bodie shared and blurt out the truth was almost irresistible. But how did you explain that Ray Doyle, well-known lover of ladies and all round stud had fallen in love with his partner? Prepared to launch into speech he would catch that ironical gaze and his nerve would fail him. Maybe one day, he thought, resigned to his own ineptitude. (H.G. n.d., 1–2)

> Funny thing is, if he [Dietrich from *Barney Miller*] were a woman, he would be perfect. Great cook, sparkling conversationalist, knows sports but appreciates culture. Likes jazz. Is considerate and generous in his dealings with people, as I ought to know. How many people offer to put you up in their place indefinitely when you're in a jam. Altogether he's a much better man than I'll ever be.... He forces me to mellow out, to cool down. What could be so bad if he were attracted to me? (Barry 1989, 93)

Such sequences often involve the elaborate exploration of the "semiotics of masculinity," to use Tania Modleski's telling phrase (1982), as characters read hidden emotions from surface behaviors. In Kami Saiid's "Lover's Quarrel" (1988), Blake visits Avon in his room; the author describes the rebel leader's ongoing assessment of his friend's appearance, movements, and gestures: "The lower lip protruded slightly, a look that in Blake's private thoughts drove him crazy. It was almost as if Avon knew it, too, because he affected that pout often, silent, contemplative, ever wary. Blake had had

dreams about the lips, the eyes . . . and the other parts of Avon, too" (58). Here and in other such moments, characters retrace the steps of the fan viewers who have searched the performers' bodies for suggestions of these same unexpressed feelings.

Alternatively, the slash story may begin in a situation emphasizing the strengths and limitations of these relationships. Stories drawn from cop shows often open within situations associated with traditional masculinity (the poker game, the steam room, the sporting club, the tavern, the military training mission, the fishing trip) or in the context of the characters' professional lives (a stake-out, an undercover operation). Here, the homosocial is expressed most freely, apart from the watching eyes of women; here, homosexual desire is also most rigorously policed. *The Professionals* story, "As the Night Closes In," for example, opens with Bodie and Doyle working out in the CI-5 Gym:

> He was reaching out for his partner when Bodie suddenly exploded into action, his foot darting out to curl round Doyle' ankles, his forearms coming up to contact painfully with Doyle's chest. Doyle grunted in surprise as he landed heavily on his back, winded. Bodie followed up his advantage by straddling Doyle's legs and pinning his outflung arms above his head. . . .
> "Has anyone ever told you, Goldilocks, you look gorgeous when you're angry?"
> Doyle laughed, and for long minutes, the mood held then the smile slowly faded from Doyle's face as he watched the expression in Bodie's eyes change. The look of hunger and longing in the dark blue eyes stunned him. He felt his mouth go dry. Hunger from Bodie? Now, after all this time?
> ("As the Night Closes In," anonymous circuit story, 1–2)

The writer shifts between the different meanings of male physical contact as competition fades into desire.

The undercover operation bears a particular importance in this regard: the characters are asked to shed their normal identities, to assume a mask which not only justifies but actively requires otherwise prohibited forms of intimacy. In Lynna Bright's *Murder on San Carmelitas* (1986), Starsky and Hutch must pose as gay lovers when they infiltrate an island inhabited primarily by wealthy homosexuals; their operation requires them to share a bed, to publicly display their affections, even to pose together for erotic photographs,

while any slip would make them vulnerable to discovery by the organized crime boss they are stalking. This masquerade awakens feelings both men have repressed and forces a reconsideration of their relationship: "Pretending to be Starsky's lover these weeks had enabled him to experience his partner in some—to say the least— novel ways. He had rediscovered, by way of some crazy back door, what it meant to be somebody's lover. Problem was, that somewhere along the line, the feelings he'd been pretending to feel had become . . . possible, had become pleasures. The farce he and Starsky had to perform daily was becoming the one real thing in his life" (36).

Not infrequently, slash stories open with the injury or near-death experience of one of the partners (or the death of another significant character); such moments of "hurt-comfort" force a recognition of the fragility of their relationships and what would be lost should their friend be killed. In Belle's "He Who Loves," (1988) for example, Illya is badly wounded by THRUSH agents who recognize that the quickest way to influence Napoleon Solo is to torture his partner; the agents successfully resist their pressure tactics, yet the incident awakens Napoleon to his affection for his partner: "Illya's injuries brought out a caring and compassionate part of my personality that I rarely display to the public. Why? Just imagine for a moment a secret agent with a reputation as a softy. See? In order to be effective in my work, I had to spin a hard, uncrackable web around all my more tender emotions" (62). Napoleon takes Illya home from the hospital and nurses him, taking pleasure watching him sleep in his bed, touched by the things his partner reveals as he talks in his sleep: "I was seeing Illya in a whole new light, and I was beginning to wonder what other surprises he had in store for me" (63).

(2) *Masculine Dystopia:* The activation of male desire intensifies the barriers to its fulfillment. The male protagonist dares not act on his erotic fantasies, convinced that the other partner could not possibly share such feelings and that voicing them could damage the mens' working relationship. Kirk would not threaten Spock's Vulcan reserve and dignity by forcing his all-too human feelings upon him; Spock would not compromise Kirk's command by asking him to be his lover. Bodie, his partner fears, is too much of a "man's man" to feel comfortable working side by side with a "bent" partner. To push forward risks those forms of comfortable intimacy they already share or, conversely, in *Blake's 7* slash, allows one party an advantage in the characters' constant struggle for control. Often,

writers inventory the consequences of acting on homosocial desire—
the threat to the characters' professional status, their own sense of
masculinity, and their friendships.

Pulling back from such risks, characters attempt to repress sex-
ual feelings, but "self-control" often breaks down normally accept-
able forms of nonverbal communication. These shifts are not ex-
plained to the partner and thus require active investigation:

> Troubled and restless, he got out of bed and showered and
> dressed, his mind preoccupied with the enigma of Bodie.
> Something was badly wrong with his partner, badly wrong
> between them. Over the past weeks Bodie had become a
> taciturn stranger, and whenever they were together Doyle
> had felt oddly ill at ease. Somehow he knew that the unease
> didn't originate in himself, that he was picking it up from
> Bodie through the close rapport they'd developed over
> years of shared trust and dependence. They still worked
> well together, but that's all it was—work. The special close-
> ness they had shared both as partners and friends seemed
> to have gone. Bodie was trying to shut him out. ("Breaking
> Point," anonymous circuit story, 9–10)

Here, the dystopian dimensions of traditional masculinity are
most rigorously asserted: one partner cannot communicate his feel-
ings, the other is unsure how to approach the issue; the smooth,
easy communication that previously drew them together is threat-
ened, if not totally destroyed, by all that goes unsaid. As fan writer
Shoshanna Green explains, "[Given] the smooth shading between
friendship and love, it makes perfect sense that the frightened part-
ner cannot shut off or hide the sexual attraction and leave the friend-
ship unchanged, because the 'two things' are not distinct, are only
one thing, and cannot be artificially divided without fracture and
upheaval" (Personal Correspondence, 1991). The reader feels
Spock's restraint and Kirk's anxiety, Bodie's desire and Doyle's lust,
and knows (what genre expectations already suggest) that the two
men want the same things and feel the same way.

Conversely, a character may act upon that desire before real
communication has been established, resulting in disturbing epi-
sodes of rape and brutality. In London Bates' "Nearly Beloved/
Rogue" (1986), Avon and Blake are reunited, the emotional and
physical wounds of Gauda Prime still gaping between them; an
angry Blake rapes a remorseful Avon, while Avon, eager to suffer

for his crimes, accepts and even embraces the brutal treatment: "Looking over his shoulder, he saw that Blake's face was set in a kind of rage as a cold fury lit Blake's eyes and the set of his mouth. He didn't seem to really note who or what Avon was. . . . Blake was battering him, pounding into him with enough force to make the smack of flesh on flesh" (56). Often, as in "Nearly Beloved/Rogue," the story begins on a moment of maximum distrust: Avon's feelings of betrayal upon the discovery that Anna Grant, his former lover, was a Federation spy; Vila's sense of confusion after he has almost been shoved out an airlock by Avon in "Orbit"; Blake and Avon's confrontation following the tragedy of Gauda Prime.

The characters' power struggles in the broadcast episodes re-surface within their bedroom play; sexuality intensifies rather than resolves the forces keeping them apart. Sylvia Knight's "Descending Horizon" (1988) describes the initial sexual encounter between Blake and Avon in terms of a battle for dominance, starting with playfully "waspish" comments, moving toward a fight over who will insert and who will receive: "Perhaps if he could make Avon surrender now, in bed, it would be a symbol between them. All that was needed to win that final commitment. The acknowledgement that Avon wanted to be there. Or all that was needed to convince Avon that Blake was a selfish prick and there could never be a true partnership between them" (7). Each touch brings with it a risk of submission as well as a risk of aggression. Blake asserts his demands on Avon, only to intensify his partner's consuming rage: "With a quick jerk, Avon twisted free. He crouched back on the bed, eyes narrowed, nostrils flaring. They were both breathing quickly. With that one gesture, Blake had made them antagonists. . . . For a minute they stared at each other. Waited for one to give way" (10). Their sexuality extends their power games in new directions, opening the men to new dangers until gradually the stakes become too high. Avon submits to intense feelings, whimpering in pleasure, convinced that their coupling has shattered all of the barriers, while Blake is startled by this response and tries to share it only too late:

Blake was more dazzled by that softness than by all the driving passion that had preceded it. It was more than he had ever hoped to see on Avon's face, this rapture, this aching sweetness. He had captured Avon, but he no longer knew who it was he held. . . . Blake lifted his hand to touch Avon's cheek and froze. Whatever Avon had expected to

find on his face, it was not surprise, not astonishment. And whatever he saw, it was not enough. Avon had been utterly lost in passion. Lost, had believed that place of sweet abandon he discovered was already shared, matched soul to soul. Now, even as Blake reached out to touch it, to share it, it was gone. A wash of pain obscured the tenderness, then black fury blazed across both. Blake felt an instant of pure fear looking at that face, thinking he would have to fight to keep his head, or his cock, still attached to his body. Then the fury was masked over, blank and cold. (12)

Knight's writing vividly captures the hunger both men have for greater intimacy and trust but also all of the forces that prevent them from finding it with each other—for more than that one fragile moment of seemingly unlimited possibilities. Blake and Avon spend most of the rest of the story trying to get back to where they began.

The dynamic of the Avon/Vila relationship is different, not a struggle for dominance between two powerful men; rather, it often centers around the need to resolve class inequalities before true intimacy can be achieved. In Hakucho's "Just Say No" (1990), Vila, the submissive Delta, cannot refuse Avon's sexual attentions, having spent a lifetime being raped, threatened, and manipulated by powerful Alpha men who took what they wanted from him. Avon must teach him how to refuse attentions before either man can enjoy the sex shared between them. In Jane Carnall's "Civilized Terror," (1987b) Avon accidentally sparks Vila's memories of previous abuse when he approaches him with a belt in his hand as the two are undressing: "He was an idiot, he was a damned fool, he should have known this Alpha was like all the other Alphas he'd ever known except with more of a taste for privacy than some. . . . Why the hell else would an Alpha want a Delta, anyway, if not because the Delta was a meaningless bundle of nothing that the Alpha could treat any way the Alpha pleased?" (3). Vila and Avon, both shaken by the incident, try to reconcile their previous sense of the relationship with what occurred when they moved to consummate it:

> He had thought the dark sardonic glint in Avon's eyes, the ironic twist to that cool mocking mouth, the clean sharpness of this Alpha's mind . . . meant something. Meant that this Alpha wasn't just like the other Alphas, the arrogant bastards; that maybe this Alpha didn't think of Vila as just another Delta. . . . Silently, muffling his ragged breathing

with a fold of the quilt, Vila cried for lost hope and lost dreams, as a child not born a Delta might have cried for a lost toy. . . . [While elsewhere Avon has similar thoughts:] If only—if only, if only Vila had really been what his sham seemed; an equal, a sparring partner, someone who shared a quirked sense of humor and the occasional thoroughly dishonest impulse. He had thought that Vila had solidity, a curious strength hidden behind his fragile look. And he had been wrong. Vila was nothing. Just another Delta. It was stupid to feel quite so disappointed. (4)

Carnall's narrative hinges on class barriers and the distrust they breed, the difficulty in overcoming them and achieving communication within a world where neither man can comfortably express his true feelings.

Not all fan stories paint Vila as a victim of sexual abuse; some allow Vila to challenge the repressiveness of Avon's Alpha upbringing. Here, class imposes different modes of expressivity, different ways of loving. Vila as a Delta is portrayed as more in touch with his feelings, better able to communicate them, more sensuous and frequently less inhibited. Avon as an Alpha is shown as overly private, governed by logic rather than emotion, preoccupied with work rather than pleasure, and prudish about nudity and open sexuality. As Vila says in M. Fae Glasgow's "There Is None So Blind . . ." (1989), "We're from two completely different backgrounds. . . . We go at life from two opposite approaches; you're all intellectual and cleverness, I'm all feelings and instincts. . . . I'm the one who's good at relationships, I'm the one who can cope perfectly well with his feelings, but you're the one who keeps us in control, who channels all this energy and emotion." The conflict between them centers around what codes will govern their relationship. As Avon responds, "I'm the one who sees absolutely no need to call attention to the fact that we have sex with each other and you're the one who wants me to call you 'darling' in front of everyone" (9). Here, Avon does not help Vila work through his fear; Vila helps Avon overcome his inhibitions.

Blake's 7 stories differ from cop-show slash because its futuristic setting allows fan writers to imagine a time when bisexuality is the social norm and homophobia is no longer an issue. Jane Carnall's "Mental Health" (1987a) parodies contemporary sexual attitudes, treating Tarrant's rampant homophobia as "a type of mental illness, supposed to be incurable" and noting, with alarm, that "at least ten

percent of the Terran human population are completely heterosexual" (5). While Carnall's story is satirical and not intended as a literal treatment of her sense of the program universe, many *Blake's 7* stories assume that most of the characters would have had bisexual experiences, particularly given their prior history within the Federation penal system. If the imagined society no longer practices mandatory heterosexuality, however, slash's dramatic structure requires the creation of some other blockage to prevent the easy fulfillment of erotic desire and so barriers resurface in the form of class difference within Avon/Vila stories or power struggles within Avon/Blake stories. What is at stake is again the repressive quality of traditional masculinity, though here it is not simply emotional restraint but also ways male sexuality gets bound to notions of competition, dominance, and violence.

(3) *Confession*: Just as the tension between the two men becomes almost unbearable, just when communication seems on the verge of breaking down completely and their partnership appears to be forever doomed, there comes the moment of confession, a "telling of secrets" as either verbally or physically one man finds a way to communicate to the other the "unspeakable" desires. In Diane's "Teddy Bears' Picnic" (1990) Harry Truman convinces Dale Cooper to take a day off the Laura Palmer murder case and join him for a picnic in the woods; both man see the outing as a chance to express their increasingly romantic feelings towards the other. After much fumbling, Cooper initiates the conversation:

> I'll have to lay my cards out with you and it's not easy for me to do it. I talk a lot and act like I'm terminally cheerful. I have strange quirks, you've probably noticed. I don't make friends easily because of them. . . . I can't remember the last time I felt as comfortable with anyone as I feel with you. . . . If this makes you uncomfortable, I'm sorry because it damn sure does me. I've fallen in love with you, Harry Truman. Now, what are *we* going to do about it?"
> (Diane, 173)

Such moments bear emotional power because slash narratives go to such lengths to demonstrate the impossibility of such love, to identify the forces preventing the open expression of feelings between men.

Sometimes, this confession provokes a second series of dystopian scenes as the partner, suddenly aware of the other's atten-

tions, flees in horror or hits back brutally, trying to repress his own rising desires. "Stormy Weather" describes Doyle's anxious response to an advance from his partner:

> Silence; pain and confusion and the remnants of anger were an undercurrent in the room, dragging them down. Doyle swallowed hard on trite words and cliches that rose, and he stood up, taking a hasty step away from the seated man, his mind reeling from the totally unexpected reason for his partner's recent behavior. . . . This simply couldn't be happening to him. But it was. He could still feel the hard imprint of Bodie's lips on his. Doyle was conscious of the other's eyes upon him as he tried to make sense of it all. What in damnation could he say to Bodie? That he reciprocated? He didn't. *I'm terribly flattered, Bodie, but sorry no go.* Hell no. It was an impossible situation. A sudden surge of irrational anger towards his partner caught at him unawares. Damn Bodie for putting him in this predicament. ("Stormy Weather," anonymous circuit story, 9–10)

Often, however, the confession is met only with acceptance as the barriers dissolve; the partner has agonized without reason since his friend has already accepted their shared feelings and has simply been waiting to act upon them. In "Midnight Snack" (n.d. anonymous circuit story), Bodie responds to Doyle's confession by asking, "Ray, don't you see? It's the same for me, mate. Been having the devil's own time tonight trying to hide it. Had no idea, till you said that just now, you see, that you were feeling the same way. Guess we've both been pretty thick about all this, haven't we?" (10). One scenario invites further examination of their initial relationship; the other provides an idyllic model of total acceptance of feelings and alternative forms of male friendship.

(4) *Masculine Utopia*: Confession paves the way for physical release as bodies long kept apart are finally brought together in moments of sexual intimacy: "When they pulled back to catch their breaths, Avon realized for the first time they were both on the same level, both understanding each other now, speaking one language" (Solten 1988, 55). The eroticism of slash is an erotics of emotional release and mutual acceptance; an acceptance of self, an acceptance of one's partner. Here, the play with androgyny Lamb and Veith (1986) identified bears new significance: the men find the freedom to love each other fully and openly by entering into a utopian space

where gender and sexual identity is fluid and the barriers between self and other can be readily transcended.

This sense of fluid identity is perhaps most vividly expressed within K/S where the Vulcan mind meld allows both men to share thoughts and physical sensations, to merge consciousness within a bond that permits no more space for emotional repression: "Their touching brought them closer here than any kisses of the flesh could ever hope to bring them, for they were truly blending now, merging soft and changing as each unique and separate mind became also the other, repatterned, linked, bonded in completed knowing" (Gerry Downs, *Alternative: The Epilog to Orion*, 1976, 12, as cited in Lamb and Veith, 1986). Even in the absence of such supernatural metaphors, descriptions create a sense of absolute revelation through sexual sharing:

> The pleasure was an undoing, like nothing he'd ever known before, or dreamed he could know. It was strong wine; thick, honeyed, so dizzying he couldn't think, only help-lessly, lovingly act. . . . This was deeper [than previous het-erosexual experiences], a mystery unfolding some of its answer with each eager transition of his flesh into Star-sky's. . . . Neutralizing every shadow of their past and their future, it revealed the depth of their love. So simple, the solution. Me and thee. (Bright 1986, 99)

In some stories, one or both of the protagonists are prepared to sacrifice their current professional status in order to better facil-itate their relationship: Spock and Kirk abandon Star Fleet to settle on Vulcan together; Blake turns his back on the revolution to be with Avon; Bodie retires from CI-5. More often, the men make their professional and personal life work together, forcing bosses to accept their new commitment. If the characters have been causal about their previous sexual experiences, moving from one female lover to another, the discovery of the ideal male lover forecloses further promiscuity; sexuality is linked here to a commitment embraced enthusiastically by both parties, though some slash leaves open the possibility of that commitment spreading outward, as when *Star Trek* slash evolves from the Kirk/Spock couple toward a threesome with McCoy. In such stories, this openness is seen as building upon the security the men have found together rather than as posing a threat to their intimacy.

6.3 Fluid Identity and Androgynous Possibility: *Master of the Revels*, an alternative universe involving characters from *The Professionals*. Artwork by Suzan Lovett.

It is important to be careful in describing this new relationship. Constance Penley (1991) rejects Lamb and Veith's claim (1986) that slash involves an androgynous play with traditional gender identities, insisting that "Kirk and Spock are clearly meant to be male" (154). Penley, I would argue, holds too narrow a conception of androgyny. Androgyny, at least as the concept is embodied within slash, does not mean a "loss of masculinity" so much as it means the opening of new possibilities within the homosocial continuum, a broadening of the range of different styles of human interaction available to these characters. Slash does not imply that homosexual desire is any less "masculine" than repressed homosocial desire, though it does call into question any rigid boundary between masculinity and femininity. Barbara Tennison (n.d.) addresses this issue directly in "Masque For Three—Night's Masque," a slash story based on Japanese comic book characters:

> As touch became caress became arousal, he waited for the sensations to become unfamiliar, trying to gauge the point at which he, as well as Dorian, would leave masculinity behind. He could not find it. No single step of the road to passion seemed forced; nothing surprised him except the ease with which it was accomplished. Long-fingered hands and a ready mouth travelled over him, exciting fire and amazement at his own—most male—reaction. (24)

Series protagonists are particularly effective vehicles for exploring this transition precisely because their heroic status—their "manhood" —remains unquestioned by the reader. The men have discarded the dystopian side of masculinity, yet in doing so, they have accented its most positive dimensions. Kirk remains the brave captain, Spock his loyal second-in-command; Bodie and Doyle or Starsky and Hutch work together effectively as a team, perhaps even more effectively, as a result of having integrated their sexuality into their larger social experience. Blake, Avon, and Vila have resolved their differences and can now function more efficiently in their struggle against the Federation.

Both the rhetorical and narrative structures of slash are highly melodramatic, reflecting strong roots in traditional women's fiction; the issues of intimacy and commitment are raised with equal intensity within the popular romance, as recent feminist readings of that genre have suggested (Radway, 1984; Modleski, 1982), and the

general plot movement described here mirrors the structure of traditional romance as attraction begets misunderstanding yet gives way to nurturing acceptance. The writers' faith that sexual consummation may signal an ideological solution to character differences mirrors similar assumptions shaping fan responses to *Beauty and the Beast*'s controversial third season. Slash's all-too-often purple prose borrows much of its hyperbolic intensity from other popular writing targeted at a female readership. Yet it matters that these scenarios are being played out between two men—not only because homoerotic commitment is so rare within commercial forms of popular fiction (even within popular fiction intended for gay readers) but also because issues of emotional openness and male intimacy are precisely those traditional masculinity denies public examination. Traditional romance generally leaves unquestioned its assumptions about gender. The woman's perception of a "dark side" to male sexuality is later attributed to misunderstandings and dissolves in the happiness of the couple's commitment. The woman must accept her role as wife without asserting demands for autonomy. Slash makes masculinity the central problem within its narrative development and tries to envision a world where conventional sexual identities are redefined in a more fluid, less hierarchical fashion. Slash, as I have shown, posits an explicit critique of traditional masculinity, trying to establish an homosocial-homoerotic continuum as an alternative to repressive and hierarchical male sexuality. Both partners retain equality *and* autonomy while moving into a more satisfying and committed relationship.

FANS DEBATE SLASH

The ideology of slash remains open to debate and cannot be reduced simply to pre-existing political categories. Slash, as I have suggested here, has many progressive elements: its development of more egalitarian forms of romantic and erotic relationships, its transcendence of rigidly defined categories of gender and sexual identity, its critique of the more repressive aspects of traditional masculinity. Yet, fan writers also accept uncritically many ways of thinking about gender that originate within the commercial narratives, most especially elements of homophobia and an often thinly veiled distaste for female sexuality and feminine bodies. Slash, like most of fan culture, represents a negotiation rather than a radical break with

the ideological construction of mass culture; slash, like other forms of fan writing, strives for a balance between reworking the series material and remaining true to the original characterizations.

The fans themselves are increasingly critical of many of slash's basic conventions. Slash fans raise questions about the homophobia implicit within this attempt to construct a homoerotic romance. Slash fans are concerned about the refusal of sexual identity to these male-male lovers, especially the large number of stories which explicitly deny previous homosexual experiences or gay orientations: the constant litany of "I'm not gay; I just love (fill in the blank)" or as one fan aptly rephrased this convention, "I'm not gay; I just like to suck Spock's cock." They call for more stories which go beyond the first-time encounter and model a sustained relationship. They question the isolation of these characters from gay lifestyles and the stereotypical ways those lifestyles are often represented. Slash fans charge that most stories ignore the political dimensions of sexual preference and fail to address AIDS. Heated discussion surrounds works like the *Blake's 7* story, "Nearly Beloved/Rogue" or the *Professionals* story, "Consequences" which some fans charge romanticize rape and others insist allow them to work through the powerful emotions surrounding sexual violence in a less immediately threatening context. (Both writers have asked me to make clear that they did not intend their stories to romanticize rape and that they have been surprised (alarmed?) by the stories' reception by other fans. I cite these stories here not to chastise their writers, whose work I admire, but rather to illustrate the range of debates that slash provoked even among those who accept its general premises. Fan stories are as open to multiple interpretations as the original television programs; fan writers no more control their works' meanings than the original producers can.) Some fans are worried about the scarcity of lesbian slash and the seeming compulsion of some slash fans not only to assert publicly their own heterosexuality but to deny the existence of lesbians within slash fandom. Some fans are anxious about the misogynistic treatment of female characters (Ann Holly or Anna Grant for example) within many slash stories which often seek to contrast the mens' previous romantic failures with the rewards they find within an all male couple. Fan publications like *On the Double* and *The Terra Nostra Underground* provide space where these and other issues may be debated. Fan writers are beginning to construct new narratives addressing these concerns and

in the process, to redefine the slash genre in accordance with a greater awareness of sexual politics.

As these debates suggest, slash has established channels of communication between lesbian, bisexual, and straight women, provided common terms within which a dialogue about the politics of sexuality may be conducted, and created opportunities where the social construction of gender may be explored with greater openness and self-consciousness. A literature that explicitly constructs a continuum of male homosocial desire also may bridge gaps within the continuum of female homosocial desire, acknowledging commonality between groups patriarchal norms work to separate. Slash fans are being increasingly drawn into a political alignment with the gay community as they examine the implications of their own writing; they are being educated through letterzines and other fan publications about aspects of the gay experience very foreign, one presumes, to many of the middle-class straight women who were drawn to slash primarily because of their interest in Kirk and Spock. Not all of slash is politically conscious; not all of slash is progressive; not all of slash is feminist; yet one cannot totally ignore the progressive potential of this exchange and the degree to which slash may be one of the few places in popular culture where questions of sexual identity can be explored outside of the polarization that increasingly surrounds this debate.

Slash represents a particularly dramatic break with the ideological norms of the broadcast material, even as it provides a vehicle for fans to examine more closely the character relationships drawing them to those programs. It allows us a vivid illustration of the political implications of textual poaching, the ways readers' attempts to reclaim media materials for their own purposes necessarily transform those "borrowed terms" in the process of reproducing them. Slash poses complex and fascinating questions about the nature of female sexual desire, about erotic fantasy, and its relationship to media narratives; slash clearly speaks on a highly personal level to the women who read and write it. The features of slash as a literary genre may allow women to explore both their desires for alternative modes of masculinity and their fears about the limitations of contemporary gender relations.

However, those conventions also represent group resources arising from the communal process of fan writing and responding to the tastes of the fan readers. The persistence of a basic narrative formula, certain tropes of physical description, narrational patterns,

common perceptions of the characters and their relationships reflect the degree to which personal desires of individual readers take shape through terms established by the larger community of fan writers. Moreover, the meaning of slash resides as much in the social ties created by the exchange of narratives, the sharing of gossip, and the play with identity as it does with the words on the page.

7

"Layers of Meaning":
Fan Music Video and the
Poetics of Poaching

The art of consumption, Michel de Certeau (1984) tells us, is the "ancient art of 'making do'." De Certeau frequently adopts aesthetic metaphors in his discussion of the practices of everyday life, speaking of consumers as poets, comparing styles of consumption with literary styles, characterizing readers as writers. These analogies, like much of his evocative writing, are rhetorical flourishes. Yet, one can't help but wonder whether there isn't something more substantial to his talk of an aesthetics of appropriation, an art of "making do." De Certeau's emphasis upon the tactical nature of consumption and the nomadic character of the consumer's culture rejects investigation of the aesthetic dimensions of the reader's artifacts; the "marks of consumption" are "invisible" and transient, fluid and uncontainable, not open to direct examination or reproduction and hence, de Certeau's dependence upon metaphorical evocation rather than ethnographic documentation.

As this book has consistently demonstrated, however, fan culture is nomadic, ever-expanding, seemingly all-encompassing yet, at the same time, permanent, capable of maintaining strong traditions and creating enduring works. Fans are poachers who get to keep what they take and use their plundered goods as the foundations for the construction of an alternative cultural community. As chapter six's discussion of slash suggests, fan-generated texts cannot simply be interpreted as the material traces of interpretive acts but need to be understood within their own terms as cultural artifacts. They are aesthetic objects which draw on the artistic traditions of the fan community as well as on the personal creativity and insights of individual consumer/artists. If there is an *art* of "making do" as opposed to simply a vocabulary of tactics or a configuration of local practices, that art lies in transforming "borrowed materials" from mass culture into new texts. A fan aesthetic centers on the selection,

223

inflection, juxtaposition, and recirculation of ready-made images and discourses. In short, a poached culture requires a conception of aesthetics emphasizing borrowing and recombination as much or more as original creation and artistic innovation.

"HALF-AND-HALF THINGS"

Mikhail Bakhtin's influential work on hetroglossia (1981) offers insight into the process by which fan artists transform these "borrowed terms" into resources for the creation of new texts. Bakhtin rejects notions of original authorship in favor of a conception of the writer as always already confronting a history of previous authorship: "Language has been completely taken over, shot through with intentions and accents. . . . Each word tastes of the context and contexts in which it has lived its socially charged life" (Bakhtin 1981, 293). In his account, writers, just as readers, are poachers, since their words come not from a dictionary but out of "other people's mouths." Each word the writer chooses from the cultural lexicon already bears previous associations and meanings: "The word in language is half someone else's. It becomes 'one's own' only when the speaker populates it with his own intention, his own accent, when he appropriates the word, adapting it to his own semantic and expressive intention. . . . Expropriating it, forcing it to submit to one's own intentions and accents, is a difficult and complicated process" (Bahktin 1981, 293–294).

Writers' mastery over their appropriated terms does not come easily; old meanings are not striped away without a struggle; writers can never fully erase the history of their previous use or the complex grid of associations each term sparks in the reader's mind. At most, writers can hope to activate certain pre-existing meanings while suppressing, albeit imperfectly, others. Some words yield readily to the writer's demands while others persistently refuse "assimilation." The finished *text*, then, (following its original meaning as something that has been woven together) represents an attempt to coordinate the diverse materials the writer has appropriated, to evoke or to erase previous meanings, to bestow coherence and consistency. Bahktin's term, hetroglossia, refers to the conditions against which any creator must struggle in specifying a term's meaning within a particular context.

Fan music videos vividly illustrate the aesthetic regulation of hetroglossia. Using home videotape recorders and inexpensive copy-cords, fan artists appropriate "found footage" from broadcast television and re-edit it to express their particular slant on the program, linking series images to music similarly appropriated from commercial culture. Video artist M.V.D. (Personal Correspondence, 1991) has described these videos as "half-and-half things" which are neither a "Reader's Digest of the shows we love" nor "fancy pictures to entertain the eye while we listen to our favorite music"; fan music video is, rather, a unique form, ideally suited to demands of fan culture, depending for its significance upon the careful welding of words and images to comment on the series narrative. As M.V.D. explains, "Images pull out the words, emphasize the words, just as the words emphasize the pictures. If I've done a good job with a video, I can portray an emotion and I can hold that emotion throughout the song. I can bring a new level of depth to that emotion through my images and I can make you think about the program in a different way."(Video artists are identified in this chapter by their initials only, because several of them expressed concerns about possible legal prosecution for their appropriation of media images and copyrighted music. I have, in any case, been unable to contact many of these artists for permission to discuss their works, since their addresses are not commonly known within fandom.)

While some videos build upon fan-generated and circulated songs, neither the sights nor the sounds found in most videos originate with the fan artists; the creator's primary contribution, in most cases, comes in the imaginative juxtaposition of someone else's words and images. One K.F. video adopts "Leaving the Straight Life Behind" as a playful commentary on the relationship between Starsky and Hutch. The television images (the two men playing chess in their bathrobes, Starsky grabbing his partner and embracing him, the cops dancing together at a disco, even a shot of the two men leaping in bed together) gain new meaning from their insertion within this new context (which evokes slash traditions) and from their connection to Jimmy Buffet's music. The song, in turn, gains new associations from its contact with the borrowed images, shifting from a pop fantasy about escaping from mundane constraints into a celebration of "coming out." Each time the phrase, "Leaving the Straight Life Behind," is repeated, the video shows another shot of Starsky and Hutch in a suggestive position, providing a precise image of what it means to abandon the "straight life." Both song

and images retain traces of their previous context(s) that are shaped by the fan artist and that shape the viewer's experience. The fan spectator recognizes (and perhaps finds humor in) the fact that these images had a more "innocent" motivation within the series episodes than that suggested by K.F.'s video; Starsky may appear to be pulling Hutch into his arms while actually he is pulling him to safety from a sniper's bullet. Fans also take pleasure in the knowledge that mundane listeners would be disconcerted by the suggestions of homoeroticism K.F. finds within the lyrics of that "golden oldie."

Sometimes, the song's origins form a central aspect of its meaning in this new context. J.E. uses John Denver's "Calypso," a song written about the voyages and adventures of Jacques Cousteau, to accompany images of the Enterprise and its crew (under Captains Kirk, Picard, and Pike) venturing into "the final frontier." *Star Trek*'s idealized conception of scientific exploration is well matched to Denver's romantic treatment of the Calypso's missions in the "silent world" beneath the sea; both crews "work in the service of life and the living, in search of answers to questions untold"; both have strange adventures where few (if any) men have gone before. The analogy is strengthened not only by footage of the crew helping the whales in *Star Trek IV* but also by a succession of sea-like creatures drawn from *Next Generation* episodes, including what look like giant jellyfish swimming among the stars.

K.S. found "Reviewing the Situation," a song performed by Fagin in *Oliver!*, an appropriate expression of the aspirations and reservations of Vila (*Blake's 7*), another thief similarly trapped by circumstances he neither understands nor controls. A remarkable summary of his character, the video shows Vila reflecting on his friendships and working relationships ("All my dearest companions have always been villains and thieves"), his romances, his dreams of escape, and hopes for financial success. Each reprise returns to an ever more demoralized figure, drinking himself further into a stupor, unable to imagine a viable future that involves leaving his comrades. Each lyric prompts a flood of images, drawn from across the entire series: "I wonder who the boss will be," for example, shows Vila receiving instructions from Blake, taking orders from Avon, and being bullied by Tarrant, each leader encroaching further and further upon his self-respect. As the song continues, the selected scenes progress toward the dark events of the fourth season. K.S. ends the video just seconds before the character's death, at a moment when there are no more options to consider. Much like Fagin,

Vila has spent so much time "reviewing the situation" that he has been unable to act to change his fate.

Sometimes, images are borrowed from their original narrative context and made to tell fundamentally different stories: P.F.L. retells the children's story, "Peter Rabbit," with footage from *Blake's 7*. She casts Blake as the adventurous Peter, Travis as Mr. McGregor, and Jenna, Avon, and Cally as the stay-at-home Flopsy, Mopsy, and Cottontail. P.K.'s "Big Bad Leroy Brown" reworks the futuristic images of *Star Wars* in terms of this contemporary ballad of urban crime and romance: the Death Star becomes "the south side of Chicago," Vader's TIE Fighter a "custom Continental," his light saber a "razor," and a succession of alien creatures "junkyard dogs." Luke and Darth battle for the affections of Leia, with their confrontation from *The Empire Strikes Back* re-edited to suggest Skywalker's triumph. Neither P.F.L. nor P.K. completely divorce these images from their original meanings. Rather, their videos play upon the reader's ability to see these images as simultaneously contributing to a new narrative and bearing memories of their status in a very different context.

Most frequently, the song lyrics amplify, critique, or parody aspects of the original series, while the images become meaningful in relation both to the song's contents and to the fan community's collective understanding of the aired episodes. When C.C. characterizes Illya Kuryakin and Napoleon Solo as "So Happy Together," she is commenting on their representation in *Man From UNCLE* as well as their portrayal within fan fiction. The song's swinging sixties sound fits well with the series' pop imagery while the lyrics ("You and me, me and you, no matter what they talk about, it had to be") express the effortless partnership of these two "special agents."

FAN VIDEO/FAN WRITING

If fan writers borrow characters and concepts from television programs, fan videomakers, literally, appropriate program images and popular songs as the material basis for their own creations. The pleasure of the form centers on the fascination in watching familiar images wrenched free from their previous contexts and assigned alternative meanings. The pleasure comes in putting words in the character's mouths and making the series represent subtexts it nor-

mally represses. Slash videos, such as K.F.'s "Leaving the Straight Life Behind" or C. C.'s "So Happy Together," allow for an explicit display of the signs of homosocial desire fans locate *within* the broadcast episodes.

The nonverbal dimensions of performance (the exchanged glances, gestures, and expressions actors bring to their roles) become the focus of interest as those decontextualized gestures reveal "hidden" aspects of television characters. As videomaker M.V.D. (Personal Interview) explained, "You discover things because you turn the volume off. If I played that same scene and you heard the original words, you wouldn't see it the way you do in my videos." The male protagonists look long and meaningfully into each others' eyes, move in unison, touch and embrace each other, even climb into bed together in sequences that assume new significance when they are stripped of their original narrative context and divorced from the delivered dialog. The pop romantic songs pull to the surface the characters' mutual desires and focus attention on emotions masked by codes of conventional male conduct. Such videos reinforce fan understandings of these relationships, providing a visual foundation for the fan writers' attempts to construct the series characters as the protagonists of homoerotic narratives. Some "slash" videos incorporate footage of look-alike actors in gay porn films (typically as a joke, since the audience is supposed to recognize that they are not from the original series). Yet this is rarely necessary or desirable since the video's credibility depends on the artist's ability to locate series images demonstrating the characters' "special closeness."

Since many fan video artists had previous experience as zine editors and writers, it is not surprising that their videos draw upon those same conventions. One can find equivalents within music videos for most genres of fan writing, from slash to cross-over stories. D.C.B. and K.L.'s "We're Going to Score Tonight" cleverly combines footage from *Starsky and Hutch* and *The Professionals*, depending on principles of classical continuity editing (particularly eye-line matches) to construct an impossible bowling competition between the two series' partners; particularly effective is a sequence where Bodie and Doyle look with disappointment and envy as their American counterparts walk away with their dates. M.B. achieves a similar effect in a music video playing upon the fact that actor Martin Shaw appeared in both *The Professionals* and *The Seventh Voyage of Sinbad*. For the most part, her video focuses on Rachid,

the relatively minor character Shaw played in the mythic adventure film, yet, at one key moment, Sinbad pears through his telescope over the side of the ship and sees Bodie, Shaw's *Professionals* partner, rowing his boat across the water. Here, the video evokes the tradition of historical crossovers within *Professionals* fan writing, creating an impossible juxtaposition between two characters who inhabit different worlds, different centuries and different fictional narratives.

Fans call these works "constructed reality videos"; their creators build original narratives, often involving multiple media universes, through their recontextualization of borrowed images. The California Crew's "Hungarian Rhapsody" suggests the potential complexity of the "constructed reality" video. The group displayed their knowledge of Los Angeles geography as well as their combined familarity with a large number of different fan universes in a six-minute video that combines footage from *Remington Steele, Magnum P.I., Riptide, Moonlighting, Hunter, Simon and Simon*, and other popular series. The series protagonists assemble at the Universal Sheriton Hotel, a location where each of the series had filmed, to attend a detectives convention. Just as Steele is preparing to address the group, Tom Magnum answers the phone and learns of the murder of producer Stephen J. Cannell (footage drawn from his cameo on a *Magnum P.I.* episode). What follows is a remarkable montage sequence—some 189 shots long—as the various characters try to solve the crime and chase the suspect through the hotel. California Crew intertwines multiple lines of narrative development: Magnum tries to leap between two buildings, only to end the video trussed in a hospital bed; Rick Simon tackles the suspect, yet Steele takes the credit; Laura Holt watches a television news report of the incident. Working entirely from "found footage," woven together from several different series, California Crew constructs a compelling and coherent crossover. A spokeswoman for the group (Personal Interview) ascribed their success to the breadth of their membership, which includes fifteen people with diverse backgrounds in the fan community: "We each tape all of the episodes of our favorite series. Between us, we have practically everything. Some of our people have 800 tapes because they've been taping since the '70s. We've got an excellent library at our fingertips. If I want to know when *Simon and Simon* filmed at the Sheriton Universal, I know the person in the group to call to find the right shots."

"TAPESTRY"

Much as in fan writing, video artists may shift focus from the series' privileged male leads onto secondary characters, editing together shots and scenes from a number of episodes to examine these figures' contributions to the program. The Excalibur collective has produced videos focusing on each of the *Blake's 7* characters, using the Queen song, "Another One Bites the Dust." Each video shows Dayna, Tarrant, or one of the other protagonists in action scenes blasting away one after another of Servalan's men ("another one down and another one down and . . ."), before finally meeting their deaths on Gauda Prime as yet "another one bites the dust." The images remind fans how much these secondary characters contributed to the program. The Bunnies from Hell's "Tattered Photograph" centers on Sylvia Van Buren, a recurring guest character on the television series, *War of the Worlds.* Sylvia is a survivor of the 1953 Martian invasion of Earth. A shot of the character contemplating an old photograph bridges between footage of the character (and the actress) from the 1952 film and the 1989 series. The video offers a poignant picture of a woman driven mad from years of struggling against the aliens, haunted by memories of her lost love ("She loves him inside though years ago he died"). Flashback scenes show her dancing with her fiance from the '50s film, while the contemporary sequences find her alone in her dimly lit apartment, cringing in terror. The lyrics speak not only to the character's sad final years, but also capture the audience's reaction to seeing actress Ann Robinson age between the two roles ("Such a lovely girl she was, such a lovely face she had").

Subplots introduced and developed across a number of episodes are restructured into compressed narratives. One M.V.D. video, based on Carole King's "Tapestry," examines the romance between Yar and Data in *Star Trek: The Next Generation.* Although the two characters make love in "The Naked Now" and Data is shown in "The Measure of a Man" as having kept a hologram of Yar in his study, program publicity has sought to deflect fan interest from this relationship (which a studio publicist has characterized as a "one-night stand") and denied that the android feels emotions. These claims are steadfastly rejected by fans who insist that the episodes reveal a different interplay between the characters. Adopting this position, M.V.D. traces the Yar-Data relationship across the program's first and second seasons. The video includes their hesitant

coupling ("He moves with some uncertainty as if he didn't know just what he was there for or where he ought to go") and its uncomfortable aftermath at the episode's tag; it also spotlights Yar's death and funeral and Data's later contemplation of her hologram in his study, moments where the relationship is explicitly acknowledged in the program narratives. She also incorporates earlier scenes which suggest romantic possibilities, such as moments when the characters exchanged affectionate glances as they work together or when a bemused Yar watches Data's clowning. Fans, already familiar with the aired episodes, gain a new perspective on that relationship as a subplot recognizable only retrospectively. As M.V.D. explains, "What comes through in 'Tapestry' is a tremendous sadness for the potential of that relationship that was lost and for the fact that this inhuman android still loves her, even after death" (Personal Interview, 1990).

Just as fan videos rearrange the text to privilege secondary characters or subplots, the form allows an exploration of the generic conventions of popular television. V.B. has created a series of *Beauty and the Beast* videos examining the questions surrounding the series' generic placement. One video, a mock commercial, edits together shots of Vincent in action, chasing down villains, leaping through windows, smashing walls, dodging bullets, snarling and roaring, clawing and mauling all unfortunate enough to cross his path. The fake preview ends ironically with CBS' original slogan for the series, "*Beauty and the Beast*. So romantic you can feel it." A second V.B. video focuses on the more romantic aspects of this same series, including scenes of Vincent and Catherine sitting on the balcony looking out over the moonlit city, walking together through the tunnels, dancing in the rain, and falling into each other's arms. The two videos viewed together convey the tension between the fan's desired series and the producers' efforts to attract a male action-adventure audience; other than Vincent and Catherine, little would suggest that the scenes belong to the same program.

Series conventions are often evoked in a playful fashion, as when one video edits together scenes of Doyle undressing to "The Stripper" and another links the notorious "crotch shots" from *The Professionals* to "I am a Rock." Other times, as in the V.B. videos or in another focusing on the evil twin brother plot as it has been played on countless television dramas, fans criticize the programs' conventionality. Yet videos may also invite us to look at the familiar elements in a dramatically different fashion. M.V.D.'s "Long Long

Way To Go" uses Phil Collins' poignant song to underscore Kirk's pained responses to the deaths of his crewmembers. The dead "red shirts" and McCoy's perennial proclamation, "He's dead, Jim" are the focus of countless jokes, yet her images offer no comic distance from the all-too-human suffering and loss ("Someone's son lies dead in a gutter somewhere. . . . we've still got a long long way to go, I can't take it anymore"). The video shows how keenly Kirk felt each death. Kirk tries to "switch off" his feelings, retreating to his room or to the company of his friends. Yet he is finally unable to "shut out" the agony of so many young men and women. The relentless repetition of deaths forces viewers to question their own ability to take these moments of human loss so lightly.

FAN VIDEO AND MTV

Fan artists insist that their works bear little or no direct relationship to MTV's commercial music videos. As M.V.D. (Personal Correspondence, 1990) explains:

> MTV is fine arts turned kinetic. It doesn't really have a pattern. The story is almost incidental. A lot of times MTV focuses on the performer first with, perhaps, a story underlying it. Our videos wouldn't be classed under fine arts; they would be classed under literature. The structure that underlies my music videos is the identical structure that underlies a short story. You are analyzing a character through a music video in the same way that you analyze character through a story. It has a purpose. It has a conclusion. There is a change in a character you are drawing your reader through. You want to produce identification and emotional response.

Like M.V.D., academic critics, such as E. Ann Kaplan (1985, 1987), John Fiske (1987), David Tetzlaff (1986), and Lauren Rabinovitz (1989), emphasize the nonnarrative dimensions of commercial music videos, linking them either to the aesthetic heritage of the avant-garde or to the new sensibility of a postmodern society: "images from German expressionism, French surrealism and Dada (Fritz Lang, Buñuel, Magritte and Dali) are mixed together with those pillaged from the *noir*, gangster and horror films in such a way as to obliterate differences" (Kaplan 1985, 150).

According to this postmodern reading, MTV's hodge-podge of borrowed images and reworked devices celebrates a refusal to make sense of the cultural environment, a willingness to blur boundaries between artistic categories. Pop art swallows high art, while the line between the advertisement and the program vanishes. MTV, these critics argue, is about style and sensation rather than meaning, about affect rather than cognition, about performance and spectacle rather than narrative. As John Fiske (1987) writes, "The visual images often have no meaningful connection to the words of the lyric, but are cut to the beat of the music. . . . Style is a recycling of images that wrenches them out of the original context that enabled them to make sense and reduces them to free-floating signifiers whose only signification is that they are free, outside the control of normal sense and sense-making and thus able to enter the world of pleasure" (250). Most critics suggest that rock fans watch MTV with little expectation of a linear narrative, surrendering instead to the rapid flow of images and the rhythm of the music. What gives this form its coherence is not the logic of the images but the centrality of the performer whose presence and appearance is continually reinscribed. For all their artfulness, the primary function of these image sequences is to sell albums and to build public recognition for particular musicians. The lack of visual continuity shifts greater attention onto the consistency provided by the music and the stars.

Fan music videos differ from this description in every detail. First, if what fascinates critics about MTV is its refusal of narrative and its seeming rejection of referentiality, fan video is first and foremost a narrative art. Not only do the selected images draw their meaning from pre-existing narratives (which is probably equally true for many of the appropriated images used on MTV, as readings by Lisa Lewis, 1990, suggest), the videos also mirror dramatic structures in their organization and are structured from the point of view of specific characters. Often, this involves the construction of a frame story into which other images may be inserted as memories or fantasies. One *Alien Nation* video, "Can't Keep from Loving You" opens and closes with Matt Sikes staring contemplatively through a rain-streaked window. Series fans recognize the moment from the program's final episode when the character reacts to his break-up with Cathy. Subsequent images, which trace the development of their relationship, are thus readable as Sikes' memories as he reflects on times spent together and tries to cope with his loss. Other videos borrow their structures from the original text's nar-

rative development, as P.K.'s version of "Holding Out for a Hero" which works through *Raiders of the Lost Ark* in sequence while providing images matched to the complex lyrics of that Bonnie Tyler song.

If MTV is a postmodern art of pastiche that isolates images from their original context(s) and unmoors them from their previous associations, fan video is an art of quotation that anchors its images to a referent, either drawn from the fans' meta-textual understanding of the series characters and their universe (as in "Can't Keep from Loving You") or assigned them within the construction of a new narrative (as in California Crew's "constructed reality" videos or P.K.'s "Big Bad Leroy Brown"). On MTV, the appropriated images function as *images*, as free-floating signifiers; images in fan videos are shorthand for much larger segments of the program narrative. Each image in "Can't Keep from Loving You" references a specific, recognizable episode of *Alien Nation* as well as broader narrative patterns (the evolving relationship between Matt and Cathy). Any individual fan probably will not recognize all of the images (except in the most general terms) and will not have time to trace through all of the associations those images evoke. The experience of watching the video will nevertheless draw fans back to the original series and invite them to reconsider its narrative development. As such, the videos are a kind of memory palace, encapsulating a complex narrative within a smaller number of highly iconographic shots.

As John Fiske (1987) notes, the excess of commercial music video resists narrativization, even when, as in the video segments in *Miami Vice*, embedded in a developing story. The program's musical interludes, Fiske argues, "rarely advance the narrative, or increase our understanding of the characters, plot or setting, or provide any clues to the solving of the enigmas that drive the narrative" but rather provide a source of pleasure in style and spectacle (255–258). These sequences focus on "objects that are the bearers of high-style, high-tech, commodified masculinity," on sleek automobiles driving along neon-lit streets, on the hands on the steering wheel, on the "feel" of the street and the "look" of the city: "This fragment within the narrative links with other fragments of the viewer's cultural experience [particularly with the iconography of pop music] rather than with the rest of the narrative" (257).

By contrast, *Miami Vice* fans use the music video form to explore male-male relationships central to their interest in the program. L.B.'s "Lonely Is the Night," for example, represents a crisis

in the partnership between Crockett and Tubbs. Unlike the program's linkage of consumption and male potency, the video focuses on issues of intimacy and trust, the pressures that push the two men apart and the feelings that draw them together. Crockett sends Tubbs away ("Really thought that I could live without you, Really thought I could make it on my own"), yet spends much of the video in lonely and silent suffering, walking along the beach, fishing from his boat. Air Supply's lyrics, while specifically addressing heterosexual romance, confess Crockett's needs for male companionship ("Now I'm so lost without you"). Tubbs' absence has forced Crockett to rethink his feelings. While the character expresses a desire for reconciliation, the video ends with him still very much alone, walking the streets, searching for his lost friend.

VOICING THE CHARACTERS' THOUGHTS

If MTV treats the performer's voice as the central organizing mechanism, nondiagetic performers play little or no role within fan videos. Fan viewers are often totally disinterested in the identity of the original singer(s) but are prepared to see the musical performance as an expression of the thoughts, feelings, desires, and fantasies of the fictional character(s). In "The Last Time I Felt Like This," a *Scarecrow and Mrs. King* video, L.B. uses a duet to articulate the romantic feelings of the two protagonists. Early in the video, she chooses first a shot of Lee Stetson speaking and walking with Amanda to accompany the introduction of the male voice ("Hello, I don't even know your name") and then a shot of Amanda returning his gaze to establish the female response ("Do I smile and walk away?"). Subsequently, L.B. can rely on the alteration of male and female voices to shift attention between the two characters as the verses forge them into a couple. The singers' voices seemingly emerge from the characters' mouths and tell their parallel stories of romantic discovery ("The last time I felt like this, I was falling in love").

L.B.'s focus on the gender of the musical performers is relatively unusual. More often, the videomakers are indifferent to the identity of the original singer, with male voices speaking thoughts of female characters and vice versa. As one member of the California Crew (Personal Interview, 1990) explained, "It isn't disturbing to someone necessarily because you are listening to the words. You don't pay

attention to whose voice it is. . . . Mentally, you are just putting words together with the pictures." The performer's personality must be effaced so that the singer may speak more effectively on behalf of the fictional character. The original programs offer fans the visible surface with the characters understandable only through their statements and actions; fan criticism assigns motives and psychological explanations for this on-screen conduct; fan video can take this one step further, linking surface images with music that speaks from an emotional depth, putting into words what characters feel and cannot say.

J.E.'s "This Man Alone" examines the alienation that prevents McCall (*The Equalizer*) from establishing permanent contact with any of the many people who come in and out of his life. The song's use of the third person poses questions about his feelings and motivations ("No one knows what's in his soul. . . Has he something to atone?") while the images suggest answers to these enigmas (including recurring shots of a childhood trauma, glimpses of his interaction with a lost lover). The video's ending, showing McCall walking in the park with a beautiful woman, hints at the possibility he may find a way to no longer be "a man apart." (Here, the relation between performer voice and character voice seems particularly complex, since the song is performed by Edward Woodward, the actor who plays McCall, yet it originally references a similar fictional character, Callan, who Woodward played in a British television series. Our appreciation of the video does not require us to recognize Woodward or the song's source in *Callan*—I didn't recognize either until informed of this fact by the artist—yet, such knowledge expands the field of associations evoked by the piece.)

When the singer's voice is not anchored to a particular character, as in mixed media videos where images are drawn from a number of different programs, the singer's voice is typically assumed to speak on behalf of the individual fan or the larger fan community. L.B.'s version of "Holding Out for a Hero" assembles heroic images from dozens of texts, ranging from *Rambo* to *Gone with the Wind*, from *Lethal Weapon* to *Butch Cassidy and the Sundance Kid*. What structures the images is the singer's search for a flesh-and-blood lover who can fulfill the larger-than-life ideals of her screen idols ("Where have all the good men gone?"). The video inventories countless hours lost in the movies or absorbed in television, hours which cannot be duplicated by the experience of mundane life ("I'm holding out for a hero until the end of the night").

This focus on subjective experience is facilitated by the video-makers' preference for soft-rock and pop songs rather than the hard rock, rap, and heavy metal music most associated with MTV. While videomakers claim their art draws on a broad range of musical styles (pointing, for example, to their use of folk songs, show tunes, and classical music), the songs most frequently adopted are those by performers like Dire Straits, Simon and Garfunkel, Air Supply, Billy Joel, The Eagles, Jimmy Buffet, and Linda Ronstadt, and are characterized by their lyrical focus on relationships and feelings. If, as E. Ann Kaplan (1987) suggests, MTV is dominated by images of adolescent rebellion and narcissistic love, fan videos center on male bonding, romantic awakening, and group commitment. These themes reflect not only central concerns of fan gossip, criticism, and fiction, but also speak to the desires for affiliation that draw people into the fan community. Watched by a hall full of fans at a "con" or in someone's living room, those videos allow for a shared emotional experience, a bonding between group members in response to the song and images. Slower, more intimate songs also serve the needs of the video artists for the longer shots needed to develop narrative context rather than the quick cuts of the commercial videos. Moreover, such songs depend upon the legibility and audibility of the lyrics, insuring that the words and their meanings will be immediately accessible to the video's audience.

START MAKING SENSE

Perhaps most importantly, if MTV decenters and disorientates spectators, inviting them to suspend judgement and reject prior expectations, fan video evokes the cultural competency and shared knowledge of the fan community. If commercial videos encourage spectators to take pleasure in the decision to "stop making sense," as some critics have claimed, fan videos demand the active participation of the viewer as a precondition for making meaning of their quick yet logical progression of images. Most music videos focus on programs which already have canonical status within the fan community (*Star Trek, Blake's 7, The Professionals*) or at least those beginning to develop fan followings (*Quantum Leap, Wise Guy, Alien Nation*). The videos tap into the viewers' pre-existing fascination with these characters, relying on their familiarity with the

core narratives to construct a context where this sequence of shots makes sense.

The artist's contribution involves linking illustrative images in such a way as to express the commonplaces of fan speculation. If many academic accounts envision a postmodern spectator for the commercial videos, for whom all images have ceased to bear meaning, the fan spectator is drawn to images already saturated with meaning, hoping for the artist to focus attention on a narrower range of associations relevant in the present context. The same images, the same shots resurface in video after video, achieving different yet related meanings in each new context; the fascination is in seeing how different artists assign their own meanings to the raw materials they share. The music video presents a cognitive puzzle, asking the viewer to decide what meanings are relevant to each image as it flows past at a remarkably high speed.

Not surprisingly, the videos require the fan to acquire not simply familiarity with the program universe but also with the particular conventions of the fan video. Most of the artists I interviewed conceded that people had to learn how to read their videos, though most also insisted that they were designed so that at least some of their significance would be recognized even by someone not particularly familiar with the original series or its fannish interpretations. A member of California Crew (Personal Interview, 1990) discussed one *Remington Steele* video which she felt yielded maximum enjoyment to series enthusiasts but could be understood by a neofan: "You try to keep your ideas simple. You show that they [Laura and Remington] were good together but they also had problems. They have a fight and storm away in one shot or they are very close and hug each other in another. They share a lot of happy moments together. You hope you are going to evoke in your audience a sense that this person's really lost something, even if they don't recognize the characters or their particular situation." Experienced *Remington Steele* fans, on the other hand, can gain a more sophisticated understanding of the video based on their previous background with the characters and their ability to peg the scenes to particular episodes. (Indeed, part of the pleasure for such a fan would reside in the challenge of quickly identifying the shots and recalling their original contexts.)

M.V.D. (Personal Interview, 1990) distinguishes between convention videos, which need to be broadly drawn to allow immediate recognition from a wide range of fans, and "living-room videos,"

made for a more select and analytic audience familiar with the community's interpretive conventions:

> They can't take the complex ones in a large group. They get hyper. They aren't concentrating that deeply. They want to all laugh together or they want to share their feelings. So it's got to be obvious enough that the people around them will share those emotions. . . . The living room video is designed to be so complicated that you'd better know everything about the show or it isn't going to make much sense. These videos are for a very small in-group that already understands what you are trying to say. It's like fan writing. You don't have to build up this entire world. You can rely on certain information.

M.V.D. stands at the back of the room as her videos are shown at conventions, taking detailed notes on fan response. She restructures her programs to the particular interests attracted to a given gathering. She also custom packages her "living room videos" to the tastes of specific fans, avoiding songs that feature slash elements if they are apt to offend, focusing on favored fandoms and featuring videos most apt to reap rewards under closer examination.

THE POETICS OF POACHING

What M.V.D. describes as her "living room videos" constitute some of the most sophisticated work within this still emergent art, and as such, they usefully illustrate the aesthetic criteria by which the community evaluates the form. First, fan artists seek a level of technical perfection difficult to achieve on home video equipment. Beginning videomakers often rely on a small number of long takes, depending upon "internal edits" (i.e., those created by the original filmmaker) for visual interest. Some of the earliest fan videos consisted of little more than episode sequences attached to song favorites; these so-called "song tapes" depended heavily upon the chance juxtaposition of words and images rather than bringing their materials under tighter artistic control. One fan video, for example, connects Paul Darrow's bath scene in *The Legend of Robin Hood* to the *Sesame Street* classic, "Rubber Ducky," so that the Sheriff of Nottingham appears to be explaining to King John "what makes bathtime special fun." Another achieves chilling, though unpre-

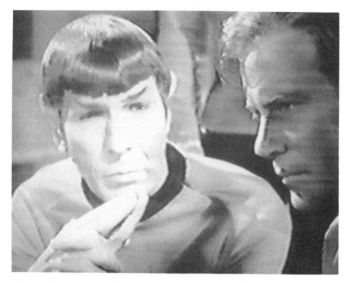

7.1 Decontextualized images of homosocial bonding from *Star Trek* assume homoerotic possabilities in M.V.D.'s music video, "I Needed You."

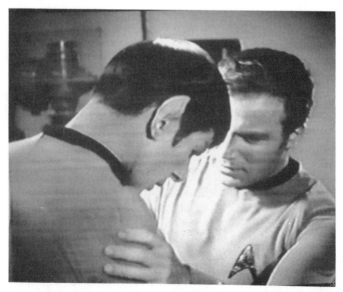

7.2 Kirk comforts Spock in M.V.D.'s "I Needed You."

7.3 A mind meld from M.V.D.'s "I Needed You."

7.4 "I cried a tear": M.V.D.'s "I Needed You."

7.5 "You held my hand": M.V.D.'s "I Needed You."

7.6 "I can't believe it's you / I can't believe it's true": M.V.D.'s "I Needed You."

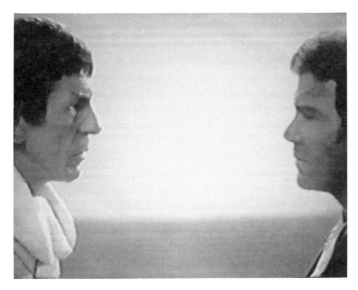

7.7 "You even called me friend": M.V.D.'s "I Needed You."

7.8 Closing images of comfort and friendship: M.V.D.'s "I Needed You."

dictable, results by playing "Send in the Clowns" under the fatal
final moments from "Blake."

More experienced video artists, like M.V.D., create montage
sequences depending upon many rapid cuts and a tighter link be-
tween words and images. These effects are particularly difficult to
achieve on home machines which often roll-back several seconds
when placed on pause and will remain on pause for only a few
minutes before switching off. Such machines give the artists little
time to cue and copy clips and increase the likelihood of "rainbow
lines" between edits. Many fan artists employ the most sophisticated
equipment they can find to allow them maximum control over the
video image and some, like M.V.D., increasingly rely upon laserdiscs
for their masters to allow more flexibility and sharper images.

Fan artists experiment with the special functions of their VCRs.
L.B.'s *Hardcastle and McCormick* video, "Can't Hurry Love"
makes extensive use of forward scan footage, while P.K. has slowed
down the lightsaber battle between Darth Vader and Luke Skywalker
into a ballet timed to the cadences of classical music. Other fan
artists manipulate the machines to create freeze frame, jumpcuts,
reverse-motion, repeated actions, and certain optical effects. Most
artists, however, focus primarily on getting a close match between
the music and the action.

Some fan videos draw their images from a small number of
episodes or in some cases, from only a single episode. M.V.D.'s
"living room" videos use a much broader range of program ma-
terials. "I Needed You," a *Star Trek* video which is 3 1/2 minutes
in length, employs 55 shots (of which less than half are linked by
internal edits); the images are selected from many series episodes
and four of the feature films. Cuts are timed so that the shots change
with each line and at several places, she makes multiple shot changes
within a single line.

M.V.D. often chooses an image that evokes the lyric's meaning
even when removed from context (e.g., "I cried a tear" shows Spock
crying or "You held my hand" shows Kirk and Spock holding
hands). Yet most of the word-image connections depend upon the
viewer's familiarity with the particulars of the series narrative. The
lines, "I sold my soul/You bought it back to me," for example, shows
images from "The Menagerie," an episode in which Spock risked
his career to help his previous Captain, Christopher Pike, only to
be successfully defended by Kirk at his court-martial trial. "I can't
believe it's you/I can't believe it's true" parallels Spock's smiling

response to the reappearance of Kirk at the end of "Amok Time" after he has been convinced that he killed the captain under the influence of the Vulcan mating urge. While such images may not be immediately recognizable to an uninitiated viewer, these sequences hold particular significance for *Trek* fans, marking major turning points in the relationship between Kirk and Spock. This is particularly true of later linkages in the video, such as the line, "When I was lost/You took me home" which centers on Spock's death and resurrection within the *Star Trek* films or "You even called me friend" which occurs when a resurrected Spock first acknowledges his recognition of Kirk.

Besides local connections between words and images, M.V.D. develops larger narrational and narrative structures. This particular video traces the history of the "great friendship" between Kirk and Spock, a theme of central concern to the program fans and extensively elaborated within fan criticism and fan fiction. The images follow more or less in sequence with the early verses centering on moments from the television episodes and later verses on the feature films. A pivotal moment occurs on the lines, "I'll never leave / Why should I leave? / I'd be a fool," which span the gap between the two, cutting from a sequence of Kirk and Spock together in "The Empath" to Spock, alone, on Vulcan, trying to achieve the Vulcan discipline of Kolinahr in *Star Trek: The Motion Picture*, having "foolishly" abandoned Star Fleet. The next lines, "I finally found someone who really cares," reinscribe their relationship, bridging between Spock on Vulcan and his reappearance on the Enterprise. Subsequent verses recount the events surrounding Spock's death in *Star Trek II*, his rescue and resurrection in *Star Trek III*, and his decision to return to duty at the beginning of *Star Trek IV*. The song's final refrain, which simply repeats "You needed me," highlights moments from throughout the series when they had been drawn together from mutual need. The video ends on a scene from "Requiem for Methuselah" when Spock used his mind-meld to ease his friend's pain.

The video's story, simple in its broad outlines but encompassing much of *Star Trek*'s trajectory, is told from Spock's point of view as M.V.D. is careful to establish through the song's first verse. The opening lines involve a series of alternations between shots of Spock alone ("I was confused") and shots of the two men together ("You cleared my mind") which work with the song's own first-person narration to confirm the identity of the narrating voice. Each

line points toward Spock's otherwise unspoken needs and Kirk's compassionate responses. Subsequently, the song can move from images of Kirk helping Spock to images of Spock helping Kirk, establishing the mutual needs central both to the song's lyrics and the fan's conception of the relationship. M.V.D.'s careful introduction of Spock's perspective allows spectators a consistent way of orientating themselves to the rapid flow of scenes.

Its structure, then, is deceptively simple, a tribute to the artist's accomplishment in pulling together so many borrowed images into a coherent form that achieves the dense "layers of meaning" M.V.D. sees as desirable. The story is told in such a straightforward fashion that it is readily understandable to even a casual viewer, who will recognize the relationship between these two characters, if only in its broadest outlines. Indeed, M.V.D.'s video could introduce a neo-fan to the particular themes and interests of the fan community: "The music videos give you just enough of the touches of the world, just enough information about the episodes those scenes come from to attract your interest in watching more of the series" (M.V.D., Personal Interview, 1990). For the more committed viewer, the video does much more, evoking many key moments and analyzing particular aspects of the protagonists' complicated relationship. Such a video will reward repeated viewings, repay close analysis, and trigger fan discussions.

M.V.D. estimates that such a video may take six to eight hours to create, though this estimate assumes that the artist has already mastered the images available within the series product and knows where to look for the scenes she needs. Given the time commitment required to make a music video, some fan artists are astoundingly productive; M.V.D., for example, has created more than 14 hours of music videos which range from *Star Trek*, *Blake's 7*, *The Professionals*, and *Starsky and Hutch* (where she began working with the form) to a number of more marginal fan interests. Few artists can match her prolificness, yet, a number of videomakers, working individually or as part of groups like California Crew, Liberation Television (LTV), Excalibur, and Bunnies From Hell, have created large bodies of work.

VIDEO ART AND THE FAN COMMUNITY

Like other fan artists, videomakers maintain close contact with the larger fan community. Fandom blurs any clear-cut distinction

between media producer and media spectator, since any spectator may potentially participate in the creation of new artworks. Most of the artists entered the field with little technical training and no previous experience, often having seen someone else's videos displayed at a convention and been inspired to try their own hand. These artists gain national and sometimes international recognition within fandom; their videos compete in competitions and receive awards. Some have transferred skills made in fan videomaking into professional skills and are beginning to earn a living from their craft. Yet their reputations cement their allegiance to the community, rather than distinguish them from it.

The circulation of their videos, even more than the circulation of fanzines, involves person-to-person transactions. The fan artists personally show their videos at conventions and often interact with the audience during their exhibition. The tapes are not sold commercially and are not mass produced; their restricted circulation reflects both technological limitations and concern about copyright enforcement. Most often, the videos are obtained directly from the artist with the consumer providing a blank tape onto which they may be copied. Several conventions run duping services where those attending may make their own copies of favorite videos. Some of the more popular artists rely on friends to act as regional duping centers to allow their works broader circulation; though the artists regret the loss of personal contact with their public, time spent copying their work for friends is time when their video recorders can't be used making new videos.

Many of the earliest videomakers were self-taught, experimenting with their home video recorders, discovering for themselves what effects they could achieve. Increasingly, fan artists are holding workshops at conventions teaching other fans the secrets of their craft, though some insist that the peculiarities of different VCRs require newcomers to develop their own techniques. As one member of Bunnies From Hell explained at a MediaWest workshop on videomaking, "You have to know yourself, you have to know your own reflexes and your own machines. If you have a machine that has a four second rollback, you have to adjust to it. You need to know how long the machine will stay on pause without shutting off. . . . My technique probably won't work for you and your equipment." Other times, the techniques are taught, informally, with new fan artists learning tricks working alongside more established videomakers. This process is particularly facilitated by the tendency

of fans to work in video collectives which periodically initiate new members.

While the fans are driven toward higher standards of technical perfection, a more sophisticated understanding of the form's potentials and a greater mastery over their equipment, many express concern that notions of professionalism may discourage new fans from trying their hands. As one member of California Crew explained at that same MediaWest workshop, "We really want other people to do videos. We don't want to intimidate people. It took us eight years to get where we are today. You aren't going to start out looking like California Crew. Don't be disappointed if you aren't blown away by your first one. . . . You learn from your mistakes." These artists are anxious that fan music videos remain a communal artform that originates within and speaks to the particular interests of fandom rather than a means of showcasing the talents of a small number of skilled craftspeople who have mastered the form and invested in sophisticated technology.

The nature of home video means that fan artists finally cannot control the circulation and exhibition of their tapes. The videos they have carefully copied for friends (always at slower speeds) may be easily recopied countless times and circulated much more broadly within fandom. In some cases, I have received videos which bear no traces of who made them, when, or where. Fan artists lack the technology to generate their own credits. As the videos circulate more widely, attribution of authorship sometimes disappears or is misdirected. I have had more trouble (and less success) tracking down the fan artists for this chapter than any of the others. While pleased at their video's broad acceptance, most of the artists I interviewed are concerned about the quality of these multiple-generation copies and are worried that people often see their videos only in technically flawed prints. Having worked so hard to overcome "rainbow lines" and other glitches, they fear most people see all but unwatchable versions of their work. Just as media producers cannot control fan artist's appropriation of their images, fan artists cannot police the circulation of their videos; once out of their hands, the videos belong to the fan community and circulate according to its fancies.

Fan art is important as a means of commenting on the original program, as a form of cultural creation with its own aesthetic principles and traditions. Fan art also plays a central role in solidifying and maintaining the fan community; the creation, exhibition, and

exchange of videos creates the conditions for a communal artform, one contrasting with the commercial culture from which it is derived in its refusal to make a profit and its desire to share its products with others who will value them. Fan videos are a source of pride not only to the artists who created them but to the fandom from which they originated, standing as a tangible demonstration of the value derived from endless hours collecting tapes and watching episodes. What the videos articulate is what the fans have in common: their shared understandings, their mutual interests, their collective fantasies. Though made of materials derived from network television, these videos can satisfy fan desires in ways their commercial counterparts all too often fail to do, because they focus on those aspects of the narrative that the community wants to explore. The next chapter looks more closely at the role cultural production plays in constructing and sustaining the fan community.

8

"Strangers No More, We Sing": Filk Music, Folk Culture, and the Fan Community

> I was with the Midwest crowd
> Who stood in line for blocks.
> I cheered on the Reliant's end.
> I shed a tear for Spock's
> And we talked for three days running
> Of how Khan did push his luck.
> And I am saved!
> I am saved!
> I am saved!
> (Julia Ecklar, "Born Again *Trek*," 1984a)

Julia Ecklar's passionate song, "Born Again *Trek*" expresses sentiments shared by many within the fan community upon the release of *Star Trek II: The Wrath of Khan*. The first generation *Trek* fans had waited for the better part of two decades for a revival of their favorite media universe, through countless repeats of the original series episodes, through a succession of rumors concerning its possible return either as a network series or as feature films, through a promising yet disappointing animated series, uneven professional novels, and a lackluster first movie. What Ecklar's song captures so vividly, then, is the sense of tremendous relief and jubilation those fans felt when they first saw *Star Trek II*, a film widely praised by Trekkers and seen upon its release as sparking a revival of interest in the series: "Sixteen years it's been / But now *Trek* has been born again / I'm proud to be a born again *Trek* fan."

At once a personal expression of one fan's response to the film and a statement of generally shared sentiments and experiences within fandom, "Born Again *Trek*" is a rallying cry for the reconstruction of *Trek* fan culture and for the recruitment of new fans ("Now it's our solemn duty / To see that everyone's been saved").

250

Ecklar's song evokes the fans' shared cultural knowledge and competency through her constant in-references (Surak, the IDIC, The Great Bird); she articulates the fans' sense of possession over the program materials ("proud of *my* ship and all her men"; "*We've* still got full main phasers"), even to the point of expressing defiance against producer actions which met fan displeasure ("*We* know Spock's not dead! / If *they* will not bring him back / *We'll* make Khan films instead"). Playfully evoking religious imagery, Ecklar treats *Trek* fandom as a "faith," calling upon her fellow fans to "Spread the word throughout the land" and ending with a proclamation that "the legends will live on eternally."

Ecklar's song suggests many of the themes we have considered in previous chapters (the translation of program material into new texts that more perfectly serve fan interests, the sense of possession the fan feels toward favored media products, the celebration of intense emotional commitments, and the religious fervor that links fandom to its roots in fanaticism); the song seems to be a telling and exemplary artifact of *Star Trek* fan culture. Yet the lyrics of Ecklar's song already point away from an exclusive focus on a singular fan-text relationship onto a consideration of *Trek*'s placement within a broader configuration of fan interests. Ecklar contrasts Admiral Kirk to Buck Rogers (then the focus of his own television series) and proclaims that "It's time to show those Jedi where we stand," a reference to *Star Wars* fans. She treats these other media texts as competing with *Star Trek* for a privileged position within the fan canon. Placed within its original context either as part of one of Ecklar's convention performances or on her semiprofessional *Genesis* tape, "Born Again *Trek*" would be read in relationship to songs commemorating a number of other science fiction, fantasy, and horror texts (*Ladyhawke*, *Escape from New York*, *Firestarter*, *Ender's Game*) and even songs which build upon high culture (her performances of Leslie Fish's adaptations of Kipling poems or a song based on William Faulkner's "A Rose For Emily.")

Ecklar's eclectic music, like that of many other fan composers and performers, refuses to be contained within the program-specific categories by which scholars characterize media audiences. Ecklar sings not as a Trekker but as a fan, a category defined less by specific cultural preferences than by nomadic raids on the full range of mass culture. The intertextual dimension of fan culture has resurfaced repeatedly throughout this book, in my reading of Jean Kluge's artwork (chapter one), in my analysis of fan criticism and canon

formation (chapter three), in my discussion of cross-over stories and mixed media zines (chapter five), and in my account of the "constructed reality" videos (chapter seven). Fan music-making (or filking, as fans call it) offers another point of entry into the cultural logic of fandom, another way of understanding the nature and structure of the fan community and its particular relationship to dominant media content.

Filking, like fan fiction, may be a vehicle for building or commenting upon pre-existing media texts, a way of pulling to the surface marginalized characters or subplots. Fans often write songs from the perspective of fictional characters, singing in their voices, and expressing aspects of their personalities. Just as a fan writer may develop a story around the character of Uhura, a filker may develop a song centered around Chapel or Yar, female characters whose voices are rarely allowed to be heard within the aired episodes. Ecklar's "One Final Lesson" (1984b) explores Saavik's reaction to the death of her mentor, Spock. Ecklar delves beneath the surface of this cryptich character, making her speak the feelings both Vulcan reserve and producer disinterest prevented her from expressing within *Star Trek II*. The Great Broads of the Galaxy's "Born of Your Sun" (n.d.) examines Chapel's anguish over her unrequited love for Spock. Singing as these characters allows filkers to explore issues unresolved by the primary text and to challenge its preferred meanings. Singing as these characters also allows them to play with the possibility of shifting between existing social categories, of seeing the world from varied perspectives. Rache's "A Reasonable Man" (n.d.) reconsiders *Robin of Sherwood* from the vantage point of the Sheriff of Nottingham, involving the same type of moral inversion that we identified within certain categories of fan writing (Jenkins, 1990).

Moreover, filking may add yet another dimension to the practice of textual poaching since motifs and themes from the mass media are often attached to tunes scavenged from popular or folk music, frequently with a keen awareness of the meanings that arise from their careful juxtaposition. Some songs, such as "Sound of Cylons" (*Battlestar Galactica*) or "Making Wookie" (*Star Wars*), pun upon the original titles and toy with their previous associations. Several *Blake's 7* songs borrow their music from Elvis Presley hits, an in-joke reference to the fact that series star Paul Darrow (Avon) played Presley in the British stage show, *Are You Lonesome Tonight?* Other songs borrow their tunes from television theme songs (Mar-

rianne Wyatt's "Gilligan's Liberator," Aya Katz's "The Blake Bunch," both based on *Blake's 7*), thus fitting the program within a larger grid of pop culture references. Even where such associations are not explicitly evoked, however, filk music's reliance upon found musical material gives a sense of the "already read" to representations of future societies. The art of filk, much like the art of fan video, involves the skillful management of hetroglossia, the evocation and inflection of previously circulated materials.

Filking differs in a number of significant ways from the other forms of fan culture studied in the previous chapters. Filk, even more than fan writing or fan video, is receptive to a broad range of media products, including many that have not yet gained a stable place within the community's canon. While fan writing and fan videomaking represent predominantly female responses to the media, men and women play equally prominent roles within filk, sometimes collaborating on songs, other times exploring themes or subjects of a more gender-specific interest. If fan writing and fan videomaking can still be understood primarily in terms of textual interpretation and appropriation, filking more often speaks directly about fandom as a distinctive social community. This chapter focuses on this final aspect of filk—its role as a cultural expression of the ideals, beliefs, and activities of fandom, as a means of articulating an alternative social identity, and as a resource for integrating the community's diverse interests.

"ALL OF THE ELEMENTS ARE THERE"

Filk takes many forms: lyrics are published in fan songbooks or as one element among many in fanzines; filk clubs host monthly meetings; filk conventions are held several times a year; filk is circulated on tapes, either informally (through barter) or more commercially (through several semi-professional filk tape distributors). Yet it is important to position filk songs initially within their original and primary context as texts designed to be sung collectively and informally by fans gathered at science fiction conventions.

For more than six decades, the science fiction convention has been a crossroads where fans can interact with their favorite writers or performers, get to know other fans with common interests, exchange ideas, and showcase their own creative productions. The con is the center not only of the fan art world (as has been suggested in

previous chapters) but also of fandom's alternative community. For some fans, the con provides their initial exposure to fan culture and a point of entry into its social order. For others, the con renews contact with old friends known only through fandom. Many fans attend only one or two cons a year. Some can only afford to attend those held within their home town or their own geographic region. A more limited number of fans spend many weekends a year going from city to city to attend cons, constituting the "flying island" which Barry Childs-Helton (1987b) describes in one of his songs: "They land and play / now they're flying away / to meet you at another village, another day." These traveling fans experience a strange continuity as they encounter the same faces (fans, guests, merchants), the same activities, and the same attitudes as they move from con to con. It is for these fans, perhaps, that the sense of fandom as an alternative social community is most keenly felt.

While there are a number of cons centering around specific fan interests, specializing on a single program (*Star Trek*) or a configuration of programs (cons devoted to spy shows, British television, or slash), or on specific activities (filking, gaming, weapons), science fiction cons frequently draw together fans from across many different interests. Most of the times and spaces of the con are, thus, set aside for special purposes—panel rooms; art galleries; gaming rooms both for role-playing games and computer games; masquerade halls; screening rooms for cult movies, television episodes, Japanese animation, and fan-produced films and videos; a huckster hall where fans may buy commercial merchandise and fan-produced goods. These specialized activities often overflow their properly assigned spaces, intermingling in the hallways and in the con suite, common spaces which serve as intersections where many different interests converge (McEwan, 1990).

The filksing could be understood, then, as one specialized activity among others, as a time and space for fans who like to sing. It might more productively be seen as one of the places where fans with many different interests come together, where they reconfirm their common identity as part of a more loosely defined fan community. While only a small percentage of those attending any given con participate in the filksinging, its ranks typically embody a cross section of the larger fan community, attracting men and women, young fans and more mature ones, and a fair percentage of minority fans. Filksings are often scheduled late at night to avoid conflicts with most of the other con activities. Some fans undoubtedly attend

cons just to participate within the filksing but, many more wander over at the end of a favorite film, after the completion of a gaming session, after the masquerade or the guest of honor presentation. As filker Mark Boardman explained to me, "Fandom is like the periodic table. All of the elements are there" (Personal Interview, 1989). The structure of the filksing must be one which incorporates different fannish interests into its repertoire of songs, one which encourages participation and opens itself to various musical tastes, styles, and competencies.

Brenda Sinclair Sutton's "Strangers No More" (1989) aptly summarizes the place of filking within the fan community; Sutton indicates both the eclecticism of its themes and the ways fan music creates commonality among strangers drawn together from a multitude of more specialized and distinctive interests. Starting with one couple preparing to go to a science fiction convention and their movement from their mundane workday world into the more exciting sphere where they choose to spend their leisure, the song traces how the fan community is built—person by person—much as the music itself is produced through many voices, "layer upon layer":

> She drives a truck.
> He computes.
> That one teaches school.
> The only rule among us is
> There really are no rules.
> Some like ose, some fantasy,
> Some science fiction strong.
> The one thing which unites us
> Is our love of harmony and song. . . .
> Strangers no more, we sing
> and sing and sing and sing.

The music pulls the group together, resolving the differences separating them, providing a common basis for interaction: "I may not know you Friday night / But we're good friends when Sunday's gone. . . . Strangers no more, we sing." (The term, "ose," in "Strangers No More" refers to songs which are grim and depressing, as in the all but lethal fan pun, "ose, ose and more-ose.")

CASE STUDY: PHILCON, 1989

A closer examination of one specific evening of filksinging (the Friday night session of Philcon 1989) will allow a more concrete

discussion of how a conception of cultural inclusion and social integration has been structured into the filking process. Philcon, held in Philadelphia, is fairly typical of the larger east-coast cons, featuring role-playing games as well as a mix of literary and media-oriented programing. This particular filksing was scheduled to begin at 11 p.m., actually got under way about half an hour later due to straggling and some confusion about room allocations, and continued until 4 a.m. At its peak, this filksing attracted forty participants, though more typically it maintained a steady population of twenty to thirty fans and sometimes dwindled down to six or seven.

The participants were arranged informally either on the floor or in a somewhat lopsided circle hastily formed by rearranging the chairs in the hotel conference room. The filksing preserves no formal separation between performance space and spectator space. Indeed, the organization of the filksing insures that the center of interest circulates fluidly throughout the floor. This filksing was organized according to the principle of "Midwest chaos," which simply means that whoever wants to play a song starts whenever there is an empty space in the flow of music. Sometimes, there are gaps when no one is ready to perform; more often, several fans want to sing at once and some negotiation occurs. Eventually, anyone who wants to sing gets a chance (though fan humor abounds with jokes about the sufferings of those waiting for their more aggressive friends to yield the floor). Other filksings are organized as what fans called "bardic circles," a practice which is also called "pick, pass, or perform." Here, each person in the room is, in turn, given a chance to perform a song, request a song to be performed, or simply to pass, insuring an even broader range of participation. At still other conventions, special songbooks are distributed to participants and songleaders conduct the sing as a "choir practice."

Music is provided in a haphazard fashion with whoever happens to know a particular tune participating and some songs performed a cappella. A number of participants brought guitars and several performed on the harp. Filk's reliance upon tunes "borrowed" from other well-known or traditional songs ensures that both musicians and singers typically know much of the music that is performed. Filks, like traditional folk music, also often have repeated choruses, which can be easily mastered even by the most "neo" of filkers and which, thus, encourage all of those in attendance to participate. Those who don't sing hum or whistle, tap their feet, drum on their chairs with pencils. Some particularly complex or

moving songs are performed solo, but at this filksing at least, the tendency was for most of the songs to become collective performances, even if only during the chorus.

While some filkers have polished voices and a few earn money by performing professionally, the climate of the filksing is one of comfortable amateurishness. The singing stops periodically as new guitars are tuned or performers struggle to find the right key. Voices crack or wobble far off tune, and, particularly as the evening wears on, songs grind to a halt as the singer struggles to remember the words. Such snafus are accepted with good humor and vocal expressions of support and acceptance. "If it ain't tuned now, it never will be," one woman jokes and another responds, "Put it this way, it's close enough for filking." A harpist, hesitant about the appropriateness of a traditional folk tune for the occasion, was reassured, "That doesn't matter. Who do you think we steal our tunes from?"

While some filk songs evoke specialized knowledge either about fan culture or popular texts making them cryptic to the uninitiated, the verbal discourse surrounding the filksing provides new fans with the information needed to appreciate the performed material. "Does anyone need that last verse explained?" one performer asked after a song particularly heavy with fan slang. The nonprofessionalism and the constant verbal reassurances create a highly supportive climate, encouraging contributions even from fans who have previously displayed little or no musical talent.

Some of the songs were original, written by the performer and "tried out" for the first time at this session; others were older favorites, either part of the singer's personal repertoire or pulled from filk "hymnal," remembered from other cons, or fondly associated with particular fan musicians. New songs are often greeted with vocal approval, passed around the room and hastily copied by those who wish to add them to their own notebooks. Several fans played half-finished songs, asking other filkers for advice on their completion.

One constantly meets a sense of filking as a spontaneous and on-going process of popular creation, one building upon community traditions but continually open to individual contribution and innovation. Some traditional filk songs have acquired literally hundreds of verses as new filkers try their hands at adding to the general repertoire. In other cases, popular filk songs are parodied or pirated, sometimes numerous times. Such parodies are generally regarded as compliments by filk composers since they mark the

songs' general acceptance within the fan community. Several times during the evening, a traditional filk or folk song was followed by one or more of its parodies advanced by another singer in the circle. Filk songs are not closed or completed, but rather open and fluid, not so much personal expressions as communal property. The "flying island" of fandom insures that a song performed at one con may quickly be accepted into the general repertoire to be sung at other cons scattered throughout the country and occassionally refit to the new context and occasion. Sometimes, I have found, those performing the song elsewhere have little sense of its original writer or of the context where it was initially introduced.

Songs were organized through a process of free association. One song triggers a memory or a response from another singer and initiates a cycle or exchange of songs. Roberta Rogow led the group in a biting parody of *Beauty and the Beast*, "The People in the Tunnel World," only to provoke another filker to respond with "Living Down Below," a song more sympathetic to the program. A song about Kerr Avon was matched with a song about Roj Blake. At other points, the group sang songs about their misadventures traveling to various cons or tributes to the ill-fated crew of the space shuttle Challenger. When the fans ran out of theme-related material or lost interest in the theme, someone introduced a new topic and the sing took a totally different direction.

Partially as a product of this fluidity, partially as a result of the climate of acceptance which characterizes the filksing, a surprising range of texts and themes may be evoked in the course of the evening. More than 80 different songs were performed at this particular session. A fair number of them concerned fannish interests in media texts, including both those which have already attracted considerable followings (*Star Trek, Blake's 7, Star Wars, Beauty and the Beast, Indiana Jones*) and more idiosyncratic choices (*The Fly*) or emerging fandoms (*Quantum Leap*). Other songs built upon literary topics, including songs dedicated to Gordon Dickson's "Dorsai" novels, Robert Heinlein's *Green Hills of Earth*, Anne McCaffrey's *Pern* books, Marion Zimmer Bradley's *Darkover* series, and the writings of C. J. Cherryh. The fans sang works by several of mainstream performers whose style and subject matter make them particularly amenable to fannish appropriation, including those of Garrison Keeler, The Smothers Brothers, Tom Lehrer, Mark Russell, and Allan Sherman. Space-boosting songs, songs promoting NASA and its goals, are a long tradition in fandom and were well represented

during the session, yet more surprising were the large number of songs devoted to other contemporary events (the San Francisco earthquake, the Iran-Contra scandal, the Pentagon appropriations controversy, the fall of the Berlin Wall), suggesting how fandom provided a vehicle for more specifically political concerns.

The diversity of this material makes filk notoriously difficult to define. Its boundaries continually expand to incorporate new materials that reflect the particular contribution of a new filker or a new fandom. Sourdough Jackson (1986), a member of Denver's Filkers Anonymous, struggles with this problem:

> Filk songs are the folk songs of fandom. Filk covers all of the SF and fantasy field, but is not limited to it. You get filk songs about the space program, about fandom itself, about computers and about various occurrences in history. Some songs go to familiar traditional tunes, to pop songs, to Broadway and/or Gilbert and Sullivan tunes, and to completely original tunes. Some songs are short and simple, while others are long and complex. . . . Quality of melody, lyrics and performance covers the entire spectrum. Styles, ditto. (5)

The eclecticism of filk music defies easy analysis, description, or definition. Yet, precisely because of its slipperiness as a classification, filk offers insight into the "nomadic" quality of fan culture.

The range of songs represented at the filksing may be read as a palimpsest of the diverse interests which brought the assembled fans together with songs reflecting both traditional hard science fiction and fantasy, technoculture and mythic adventure, politics and pleasure, war and romance. Old-time fans suggest that most of the earliest filk songs centered around literary science fiction texts, a tradition which can be traced back in fandom at least as far as the 1940s. As fandom has expanded its original boundaries to encompass media texts, gaming, and computers, filk has incorporated these new subjects into its repertoire. One reason why filking attracts both men and women is that within the fairly open space of the sing, many different perspectives and interests may be explored, whereas both traditional literary fanzines and the new media fanzines embody more narrowly specialized interests and particular styles of interpretation. Filker Mark Blackman (Personal Interview, 1989) predicts that as filking becomes more widespread, it may subdivide

into more specialized subfandoms and the diversity which characterizes the contemporary filksing may give way to the gender or program-specific nature of the fanzine publishing community. For the moment, filk still represents a microcosm of the larger fan community and the many different interests that cluster around science fiction and fantasy.

"SCIENCE WONKS, WIMPS, AND NERDS"

By far, however, the largest class of songs at Philcon concerned not media or literary texts but fan culture itself, with songs commemorating or commiserating about previous cons, fanzine publications, costume competitions, and the problems of maintaining ties to a mobile community. If the other songs reflect special interests, albeit those shared by large numbers of fans, it is this last group of songs which most persistently articulates the groups' collective identity and points toward their common interests. Often, these songs act as triggers for discussion as fans exchange memories of shared experiences.

Some of the most powerful of these songs are anthems (Julia Ecklar's "Born Again Trek" [1982]; L.A. Filkharmonic's "Science Wonks, Wimps, and Nerds" [Fletcher, Robin, and Trimble, 1985]); others are thoughtful explorations of childhood memories or celebrations of the fan's deeply felt commitments to media products, to the space program, to various other causes. Yet, perhaps most frequently, filk songs offer representations of fandom that are comic and playful, that depend upon broad exaggeration. The use of humor contributes actively to the articulation of a group identity, the invocation of shared experiences, and the creation of common feelings. As filker Meg Garrett explains, "If you 'get' the joke, punchline or reference and laugh when the rest of the fan audience laughs, it reinforces the sense of belonging, of 'family,' of shared culture" (Personal correspondence, 1990) Such songs are sung loudly and boisterously, and often end with moments of communal laughter—a laughter born of warm recognition or playful transgression, of loving parody or biting satire, but a laughter whose primary function is creating fellowship.

Filk songs may evoke the negative stereotypes of fans circulated by the mass media or by cultural critics, yet inflect them in directions more sympathetic to the community's own interests—pushing them

to absurd extremes, celebrating their transgressiveness rather than accepting them as rebuking, redefining them in terms which proclaim the pleasures and idealism of fandom. The L.A. Filkharmonic's "Science Wonks, Wimps, and Nerds," written in response to a 1982 *Los Angeles Herald* review of *Star Trek II*, challenges the categories thrust upon fans by the "stereotypical minds" of "all the mundane and Philistine herds," evoking instead an image of fans as "prophets, inventors, and movers." The song conceives of fans not as passive consumers of the "vicarious thrills" offered by media texts but as active participants in society, dreamers who are finding ways to translate their dreams into "accomplishments [that] speak much louder than words." Fans are linked to "physicists, researchers, astronauts, programers," professionals who are often themselves science fiction fans and who share in the fans' attempts at "grasping the future, making it ours," and are contrasted to those outsiders who lack the imagination to comprehend fan culture.

This song adopts a position of militant resistance to media stereotypes, yet, others embrace those stereotypes only to push them to absurd extremes, relishing precisely the fan's self-proclaimed rejection of emotional restraint or social propriety. Fan songs speak with guiltless pleasure about the erotic fantasies ("Video Lust" [Davis and Garrett, 1989]) and loss of bodily and emotional control ("The Ultimate Avon Drool Song," [Lacey, 1989], "Revenge of The Harrison Ford Slobber Song" [Trimble, 1985]); fans sing with ironic glee of lives ruined and pocketbooks emptied by obsessive collecting of media-related products, of houses overrun with fanzines. The Great Broads of the Galaxy's "Trekker" (n.d.) awakens one morning to discover that her husband, thoroughly disgusted with her endless expenditures of time and money on her fandom, has "taken the kids and moved to Delaware / Bye, Bye, Bye." The protagonist of Roberta Rogow's "I've Got Fanzines" (n.d.) has such a collection of fan-produced works that she has "no room . . . to live in" and has been forced to sleep in her garage. Still other songs evoke media creators as deities, appealing to them to complete their unfinished sagas ("Dear Mr. Lucas" [Christy, 1985]), to resolve displeasing elements in the favored texts ("Roddenberry" [Ross, 1988]) or to rescind decisions to cancel popular programs ("An Irate Fan Speaks" [McManus, 1989b] and "Do Not Forsake Me" [McManus, 1989a], both about the final episode of *Blake's 7*); such songs suggest the fan's extreme respect for certain textual producers as well as the mix of fascination and frustration which sparks fannish production.

However, fannish obsession with media texts need not be viewed entirely in relation to the categories of consumption or adoration proposed by dominant stereotypes; filk also offers extreme images of fannish productivity, of editors who become fixated on publishing fanzines, of artists who cannot stop painting, and of fans who choose to spend their lives con-hopping. The protagonist of Sally Childs-Helton's "Con Man Blues" (1987a), perhaps the ultimate fan hero, was conceived on "a pile of T-shirts / in the back of a huckster's van," the offspring of a fan and a filker, and delivered on stage during a world con masquerade, destined to spend his life in con culture.

Other songs articulate a gleeful refusal to embrace media texts that witlessly attempt to exploit the fannish community's commitment to the genre. Dennis Drew's "Smurf Song" (n.d.) expresses the singer's violent fantasies of ridding the planet of the little blue cartoon characters. One Chris Weber song (1982) complains that "All you get is drek" when they put "sci-fi on TV," while Duane Elms (1985) tells editors who cynically recycle old ideas to "Take This Book and Shove It." Roberta Rogow's "Lament to the Station Manager" (n.d.) complains of how local stations constantly replay bad *Star Trek* episodes, such as "Spock's Brain," while systematically excluding the series' best efforts, such as "Amok Time" and "City on the Edge of Forever." The fans' proprietary response, not simply to individual media and literary texts, but to science fiction as a genre authorizes them to criticize the shoddy products released by the culture industry and marketed in their name.

"ESCAPE FROM MUNDANIA"

The bankrupt values and lack of imagination filkers recognize in media producers and literary hacks get mapped onto the larger social order through an evocation of a long-standing distinction between fan culture and the mundane world. This distinction is partially one between the fannish and the nonfannish, a contrast essentially reversing the normal-abnormal dichotomy drawn in journalistic accounts of fan culture (see chapter one). Fandom becomes the standard against which consumer culture is measured, thereby expressing both the pleasure fans find within fan culture and the displeasure they feel toward many aspects of their everyday lives. This highly critical stance is clearly expressed in Barry Childs-

Helton's "Mundania" (1987a) (sung to the tune of Leonard Bernstein's "America" from *West Side Story*):

> I know a place where you can get real.
> Lots of folks think it's a good deal.
> Be just exactly what you seem
> As long as you don't think or daydream.
> Buy what you see in Mundania.
> Don't domesticate me in Mundania.
> Free to agree in Mundania.
> No where to flee in Mundania.

Childs-Helton's biting satire of American consumer society characterizes "Mundanes" as living a "Barbie and Ken" existence in suburbia, watching soap operas, discussing *Reader's Digest* articles, eating Big Macs, gossiping about the neighbors, and engaging in quick sex at single's bars before settling down to raise their 2.3 children: "A nice padded cell in Mundania / Boring as hell in Mundania." It vividly expresses the profound alienation many fans feel in a world whose values are fundamentally at odds with their own and where they enjoy limited creative freedom within fairly menial jobs. Mundania contrasts sharply with the sense of community, creativity, and intensity they find within fandom.

More generally, filk celebrates pleasure over restraint and open-mindedness over imposed moral standards, assigning in each case the negative values to the "Mundanes." "Mundania" is perceived not simply as a separate cultural realm but as one diametrically opposed to the fan's pursuit of pleasure, one implicitly if not explicitly present in most representations of con culture. The traditional killjoy figure can be found in the dismissive husbands in "Trekker" and "I've Got Fanzines" who finally cannot live with the wife's fannish interests, in the reporters from Lee Gold's "Reporters Don't Listen to Trufen" (1986) who ignore rational explanations of fan culture to spread exotic stereotypes that titillate mundane readers, in the hotel staff and Amway salesmen who accidentally stumble into a filksing in Rogow's "A Use For Argo" (1989). Fans embrace pleasure; "Mundanes" suppress or deny it.

Interestingly, this fan/mundane opposition remains even when the filkers describe fictional characters from favored media and literary texts. The Dorsai may be unbeatable and inexhaustible warriors in Gordon R. Dickson's novels, but in Chris Weber's "What

Does a Dorsai Do" (1985). they conform to a more mundane sub-
urban lifestyle after their workday is done; his Dorsai dances to the
"Tommy Dorsai Band," takes their kids to Disneyland, and wears
a "dorsai gator on his dorsai preppie shirt." The song involves an
ironic reversal of the structure of the filker's own social experience
where one often accepts mundane values at work while enjoying a
fannish leisure culture. (It is also interesting that the Weber song,
like "Escape from Mundania," characterizes mundanes through
their consumer choices and cultural preferences, just like fans them-
selves are characterized through their tastes and leisure activities.)
Conversely, other songs identify favorite characters with fannish
excess, casting them into situations mirroring the filkers' represen-
tations of con life. Leslie Fish's "Banned from Argo" (1977) rep-
resents the Enterprise crew running amuck on a shoreleave planet
for "three days or more" (the typical length of a con) with disastrous
and scandalous results. Kirk engaged in group sex with five different
genders of aliens. Chapel used a Vulcan love potion on Spock. Scotty
outdrank seven space marines and Chekov put a shuttle craft on
the city hall roof. Uhura rigged their communication system so that
all speakers appear nude. Space pirates stumble upon their recre-
ational activities and are so shocked that they flee in horror, mir-
roring the response of the mundanes who find themselves at fan
cons in other filk songs. The end result is that the program char-
acters, like the proverbial congoers who are refused booking at ho-
tels, are "banned from Argo, just for having a little fun."

"TOAST FOR UNKNOWN HEROES"

If fans in filk songs differ from mundanes in terms of the in-
tensity of their feelings and in their commitment to pleasurable
pursuits, they are also contrasted in terms of the shallowness and
short-sightedness of mundane thinking. Fans see themselves as peo-
ple who dream, who use imagination and creativity both in con-
structing their culture and in making sense of their social experience.
They are technological utopians who see possibilities for human
progress to which many of their contemporaries remain blind. In
that sense, they are different from mundanes, yet they are like chil-
dren in their innocent hopes and imaginative fantasy lives. A fair
percentage of filk songs involve idealized representations of child-

hood, representations that may be read as reflections of the fans' own self image.

These autobiographical tendencies are highly visible in Bill Roper's "Wind from Rainbow's End" (1986). The song begins with a description of a lonely schoolboy, picked on by his classmates because of his difference from other children, who found an escape through reading fantasy and science fiction. These childhood fantasies provide a "mighty shield . . . for the schoolyard battlefield," a place to escape from an unsympathetic environment. The song ends with the boy grown, yet still finding fantasy a way to deal with his adult-world problems. The child has become a fan while his mundane schoolmates have moved from "Sally, Dick, and Jane" books to equally "mundane" adult reading. Roper's song concludes with a warning, however, suggesting the danger of becoming so identified with the fantasy that one can't find a way back to reality again. As this example suggests, fan songs of childhood retain the opposition between fan and mundane, often transforming it into an opposition between child and adult (or here, the opposition between bookworm and bully).

A more complex play between adult and child characterizes T. J. Burnside Clapp's "Robin Hood" (1988). While the song asserts several times the impossibility of adults remembering or re-experiencing the vividness of children's imagination, of admitting to a time when their play could "turn a backyard garden / into twelfth-century England," the songwriter proceeds to recount her own childhood play experiences, assuming in the process the role of children at play: "I'm Robin Hood / You're Marian / Let's fall in love." Adults may, as the song asserts, "lose their fantasies," but the songwriter casts herself in a role which is neither child nor adult, but that of fan who maintains close ties to the imaginary even as she moves into maturity. By the final line, she can sing, again adopting the voice of the child: "They'll never see how we feel." (The duality of the song's address may be explained by the fact that the songwriter was herself only 12 at the time it was composed; yet, this still leaves unresolved what this song means when it is performed by the adult members of Technical Difficulties.)

Fans, the filkers claim, are not simply dreamers who maintain the imagination and idealism of their childhood; they are also "doers" who envision a better world and are working to transform those dreams into a reality: "Look where hopes and fantasies lead us, / Making life better, our efforts do aim" (as "Science Wonks,

Wimps, and Nerds" proclaims). It is this willingness to act upon their fantasies, these songwriters suggest, that links the fans to a larger group of technological utopians, a group which also includes scientists and astronauts. Fans display a proprietary interest in the space program much like that exhibited toward favorite media and literary texts. The Challenger might have been "carrying Humanity's dreams," as one Doris Robin song (1985) claims, but the fans hold a special claim on those dreams, since they have maintained faith in NASA's goals even when the "mundanes" have lost the ability to imagine their fulfillment. This closeness is suggested by the proprietary "we" which runs through so many of the songs ("We will reach the stars"), expressing the psychological investment they make in the space mission. It is also suggested by the frequency with which fan songs center on characters who are neither fan nor astronaut but share traits of both groups. Like the astronauts, these characters are actively involved with the mission, but, like the fans, they must be witnesses rather than participants in the actual space flights. Mike Stein's poignant "The Final Lesson" (1989) describes the thoughts of Christa McAuliffe's son watching with his class as his mother blasts into space only to explode, while William Warren Jr.'s "Ballad of Apollo XIII" (1983) describes the experience of Mission Control as it waits to see if the damaged ship will be able to regain contact with them. Leslie Fish's "Toast for Unknown Heroes" (1983a) celebrates the everyday workers whose efforts enable the astronauts to soar, yet who can only watch the spacemen gather the glory. Such figures bridge the gap between the historical reality of the astronaut and the fantasy participation of the fans.

These space songs reflect some of the deepest ideological commitments of the fan community—a search for technological utopias, a fantasy of human progress which facilitates their critique of their own contemporary surroundings. Leslie Fish's "Hope Eyrie" (1983b), arguably the most beloved of all filk songs, presents the quest for space as part of an ongoing struggle to cast off the deadening weight of passing time and approaching death:

> Cycles turn
> while the far stars burn.
> People and planets age.
> Life's crown passes to younger lands.
> Time brushes dust of hope from his hands
> and turns another page.

But the Eagle has landed.
Tell your children when.
Time won't drive us
Down to dust again.

Fish's song speaks to what she perceives as humanity's eternal quest for an accomplishment which will stand the test of time, one she finds in the Apollo moon landing. Such songs allow the filkers to imagine their own relationship to the future, a topic of immense interest to them as a result of a lifetime of reading and watching science fiction. For the filkers, the future will be continuous with the past because it has been built upon foundations of the past and defined through decisions made in the present. These choices are posed in different ways: for some, the choice between apathetic acceptance of man's decline and a forward movement to better worlds of tomorrow; for others, the choice between missiles and rockets, war and peaceful exploration. One side, that most often attributed to the mundanes, represents postmodern cynicism and complacency; the other embodies the fan's passionate faith in human progress.

Like many concepts circulating within the fan community, the community's embracing of NASA's mission is ideologically impure, combining concepts of enlightenment philosophy with a radical critique of consumer capitalism and military expansionism. If, for many, NASA's goals have always been bound closely with military interests, the filkers often represent the Reagan-Bush administration's "Star Wars" program as a fundamental betrayal of the Kennedyesque ideals of the space "mission"; it is a corruption of the "final frontier"; it holds no faith in the future and substitutes destructive bombs for utopian spaceships. If filkers embrace the space program, they are just as militant in opposing the stockpiling of weapons; many of their songs make significant contributions to the anti-war movement. Fish devotes one filk tape, *Firestorm*, to a representation of "the downfall and destruction of our modern technological civilization" and "descriptions of a very independent people who have been through the horror of massive war once and don't intend to make the same mistakes again" (Firebird Catalog description). Just as their sense of possession of media texts authorizes their criticism of the culture industry, their intense commitment to NASA justifies their moral claims to challenge its ful-

fillment of those goals, providing a basis for opposition to government practices.

A number of different yet interrelated conceptions of fans run through the filk song repertoire. Fans are represented as both passionate lovers and harsh critics of media culture. Fans are defined in opposition to the values and norms of everyday life, as people who live more richly, feel more intensely, play more freely, and think more deeply than "mundanes." Fans are seen as people who carry the dreams and fantasies of childhood into their adult life. Fans are represented as technological utopians who maintain an active commitment to Earth's future in space. The communal quality of the filksing allows such claims to be made not *for* or *to* but *by* the fan community itself, enabling them to be read as reflexive artifacts that collectively shed light on the ideals, values, and lifestyles of the group that produced them. Such songs play a pivotal role in articulating and maintaining a common identity for fans that reflects and integrates the group's own diverse interests and challenges the dominant negative stereotyping of fans.

"NEITHER FISH NOR FOWL": FILK AND THE FOLK TRADITION

Filk poses interesting questions about the aesthetic status of fan culture and its relationship to older folk traditions. As Sally Childs-Helton, an ethnomusicologist as well as a filker, explains, "It is definitely the traditional music of a true folk group, yet that folk group is based in popular culture. And the music is both traditional and popular, both in genre and transmission. Filk is neither fish nor fowl, neither pure traditional or pure popular" (Personal Correspondence, 1990). Filkers borrow their subject matter from the contemporary mass media and their tunes from either folk music traditions or from the repertoire of showtunes and pop hits; the craft comes through the combination of these "poached" materials into a form that expresses the fans' interpretation of the primary text or fandom's identity as a social and cultural community. Filk originated as a form of music that could be sung communally and its pleasure comes less from the quality of its performance than from the sense of community it generates. Filk shares many of the features musicologists have traditionally used to define folk music: oral circulation rather than fixed written texts, continuity within musical tradition, variation in performance, and selection by a community

that determines which songs are preserved, which discarded. These distinctions separate folk from commercial music that has been taken over ready-made by consumers and remains unchanged. For many scholars, what is at the heart of folk music is the community's refashioning and recreation of the music in the name of defining a collective identity, a process that also characterizes filk as a cultural practice.

Filkers clearly gain a sense of identity by linking their contemporary musicmaking to older folk traditions. A widely circulating joke claims that the United States is one of the few countries which has a filk song for its national anthem, since Francis Scott Key, like many fan lyricists, set his words to a pre-existing tune. Bards, troubadours, minstrels, and harpists recur as images throughout filk songs; many filkers see themselves within these more traditional terms. Filksings are organized around "bardic circles" or "choir practices" and songbooks are called "hymnals."

Meg Garrett, a member of the L.A. Filkharmonics, offered one perspective on the filkers' claimed ties to traditional folk music:

> I think of it [filk] as the modern equivalent of the folk process. Up until recently, if one wanted to express oneself in song—and you couldn't compose a tune—you just used a folk tune that you and your cultural group knew (owned by virtue of the fact you know the words and the tune). After all, until recently no one made a living of composing songs—performing them, yes; composing alone, no. . . . Now, since copyright exists, ownership of a tune is possible and it makes money too. And we all know many more contemporary popular songs than folk songs. The filker, as always, borrows what he/she knows that's appropriate though now what is borrowed is often copyrighted material. . . . I think people have always used what's around them—commercial culture surrounds us, so that's what we use. If a lumberyard is closer than a forest, you'll buy rather than cut a piece of wood that you need. (Personal Correspondence, 1990)

Garrett suggests, then, that filk raids commercial culture for its materials just as earlier folk music drew upon legends, folklore, and gossip for its narratives. While filk has had to adapt folk music practices to a different context, one where music has become increasingly professionalized and ownership more rigidly asserted, the

composers and performers adopt a similar logic in relationship to their cultural environment. Filk turns commercial culture back into folk culture, existing as a mediator between the two musical traditions. Its raw materials come from commercial culture; its logic is from folk culture.

The complexity of this relationship is already signaled by the term, filk. The fans account for its use to describe their music by reference to a typo on an early convention program turning "folk music" into "filk music." The term was adopted by the fan community because it signaled both the similarity and difference of their music from traditional folk music. Filk is like folk but it is not folk. The one letter difference separates it as a musical category from the traditions from which it originates.

What filk suggests is that commercial culture, which often seems so omnipotent in its ability to construct the fantasy life of its mass audience, is shadowed by a residue of folk culture whose forms and traditions, however marginalized, persist as potential forms of resistant cultural activity. Such a culture need not be perceived as more "authentic" than commercial culture but rather as a traditional vocabulary of tactics for cultural appropriation and meaning production. Such an active folk culture provides models for cultural creation and circulation and offers a powerful source of collective identity for modern-day poachers.

I want to be clear about what I mean by folk culture since the term has been the subject of controversy. John Fiske (1987, 1989, 1991) repeatedly has asserted that fans must create their culture from the raw materials provided by commercial culture because there are no other resources available to them. Fiske expresses skepticism about any connection between modern "popular culture" and more traditional forms of folk culture. What I am describing as folk culture here, however, is not the same as the notion of folk culture Fiske rejects. It is not a culture originating in "a comparatively stable, traditional social order, in which social differences are not conflictual" but rather one linked directly to early movements of popular resistance against institutional authority and cultural hierarchy; it is not a folk culture drawing upon cultural resources that originate exclusively within the folk community but rather one appropriating its resources from those already in broad cultural circulation and often from those which originate elsewhere, in the dominant culture (Fiske 1989, 168–177). What Fiske rejects is an overly romantic conception of folk culture, one that could not have

existed historically but serves simply as the utopian fantasy of an intellectual elite. The myth of "folk culture" is powerfully conservative, especially as it gets evoked within the academy or by other cultural custodians; "folk culture" gets robbed of its historical ties to social struggle and instead becomes the universal legacy of a peculiarly American culture (thereby evoking myths of national character and transcendent meaning).

As Roger Chartier (1984) argues, there was no pristine moment of folk culture, no moment of popular creation not already informed by larger cultural practices and social institutions, not already shaped by either elite or mass cultural materials. Folk culture has always been a culture of resistance, appropriation, and redefinition, an art of "making do"; folk culture has always drawn on previously circulating images and inflected them in ways that serve subordinate interests. Chartier sounds very much like Fiske when he writes:

> What is 'popular' is neither culture created for the people nor culture uprooted; it is a kind of specific relation with cultural objects. . . . The search for a specific and exclusively popular culture, often a disappointing quest, must be replaced by the search for the differentiated ways in which common material was used. What distinguishes cultural worlds is different kinds of use and different strategies of appropriation. (Chartier 1984, 235)

Radical folklorists, such as Jose Limon (1983), William Fox (1980), and Luigi Lombardi-Satriani (1974), have traced ways that folk culture defines itself in opposition to hegemonic authority. Fox shows how the survival of folklore in the face of contemporary mass culture may stand as an "indirect or implicit challenge to the social order," providing a space for alternative voices and reinforcing notions of group solidarity (1980, 250). Folklore holds the "ability to accumulate and assert, often by metaphor and analogy, both past injustices and hopes and aspirations left unfulfilled by the social order" (Fox 1980, 250).

Folklore serves these purposes, George Lipsitz (1990) argues, not only for the traditional social communities that dominate folklore research but also for the subcultural groups that are the focus of media studies research: "Even with a decline of identification with the traditional sources of popular narratives—region, occupation, race, ethnicity and religion—contemporary society offers new

possibilities for sources of identity, possibilities likely to produce stories underscoring the tensions between lived experience and the self-congratulatory propaganda for the status quo that is generated from within the culture industry" (Lipsitz 1980, 234). Lipsitz's own study of the "Mardi Gras Indians" stands as a powerful example of the ways that traditional folklore research can contribute to our understanding of contemporary popular culture. Lipsitz demonstrates how this black subculture borrows images from a number of different cultural traditions—old world carnival, traditional African rituals, turn-of-the-century wild west shows—to develop a complex set of cultural practices, This group, like many other folk communities, has constructed its identity and its practices through creative appropriation and careful reworking of materials not of its own making, a new culture from nomadic scavenging. Lipsitz carefully situates these practices within their own complicated history, showing both how they emerged through raids of commercial and traditional culture and how the Mardi Gras Indian's music has been recently adopted by the commercial music industry.

Like the earlier forms of "popular" culture Chartier discusses, and like the rituals of the Mardi Gras Indians Lipsitz documents, fan culture is not a "pure" or "authentic" folk culture, but it *is* vitally connected to folk culture traditions, and a history of "different kinds of use and different strategies of appropriation" (Chartier 1984, 235). Fan culture is made by a new type of cultural community, where affiliation is voluntary and based on common patterns of consumption, common ways of reading and relating to popular texts, yet, one serving many of the traditional functions of folk culture. Fan composer and performer Leslie Fish makes a similar point:

> Previous folk cultures were created semi-voluntarily, at best—based on geography (the local village), work-groups (sailors, cowboys, etc.) or churches (Mormons, Amish, etc.) in which the individual had but little choice to belong. Leaving one's home town, job or church involved isolation, economic hardship, even persecution which could be downright difficult to survive. Modern industrial society, for all its relentless public homogeneity and alienation, has made it physically easier for people to leave the communities and churches they were raised in, easier to go from

one job to another, and easier to find people with similar tastes and goals. This means that *voluntary* subcultures are much more feasible now than in the past, and fandom is an outstanding example. Begun as a literary club, evolving into a literary/social subculture, by generating its own subsidiary economy, pro-space politics and finally a broad spectrum of its own art and music. . . . fandom has become a full-range folk culture. (Personal Correspondence, 1990)

Fan culture conforms to all of the traits Fiske (1989) has identified as characteristic of traditional folk culture. Fan culture, like traditional folk culture, constructs a group identity, articulates the community's ideals, and defines its relationship to the outside world. Fan culture, like traditional folk culture, is transmitted informally and does not define a sharp boundary between artists and audiences. Fan culture, like folk culture, exists independently of formal social, cultural, and political institutions; its own institutions are extralegal and informal with participation voluntary and spontaneous. Fan texts, like many folk texts, often do not achieve a standard version but exist only in process, always open to revision and reappropriation; filk songs are constantly being rewritten, parodied, and amended in order to better facilitate the cultural interests of the fan community.

Fan culture transforms the potentials implicit within residual cultural traditions into action, drawing on the vocabulary of folk practices to rework commercial culture into a form more compatible with the community's own interests. Folk music can express the complaints of consumers much as it earlier expressed the complaints of workers, articulating both the solidarity they find within the fan community and the disappointment they feel toward much of popular culture, both the ideals they endorse and those they reject. Mass culture imagery is evoked not because it is the only possibility available to fans, but because such imagery is immediately accessible to their desired audience and allows the fan to move from a sphere of local face-to-face contacts into a culture that is national and even international in scope. Using these images facilitates communication within an increasingly alienated and atomized culture. Such images can be made to stand for more personal and political concerns of the fans who chose these vehicles for their ideas. They are also a source of pleasure for the fans, offering them utopian possibilities not present within the realm of everyday experience.

FILK IN TRANSITION

Just as it would be a mistake to divorce fan culture from the larger history of folk cultural practices, we must also not treat fan culture as a fixed form, existing outside of history, impervious to change. While filk is a longstanding tradition within the literary science fiction fan community, it generally enjoyed only a marginal place at fan conventions prior to the late 1970s. Filker Roberta Rogow recalls that "filk used to be something that was done behind closed doors by consenting adults" (Personal Interview, 1989). Filkers gathered informally in hotel lobbies, abandoned function rooms, hallways, or suites. Leslie Fish recalls: "I recall one filksing that wound up in the large cargo-elevator, riding from penthouse to basement and back, singing up and down the height of hotel until well after dawn; I later heard that the hotel security staff had gone nuts trying to find us, because by the time they reached the floor where the last complaint had come from, we were long gone" (Personal Correspondence, 1990). By the late 1970s, filk began to command a scheduled slot at many conventions and grew in prominence within fandom throughout the 1980s. The first filk convention, Bayfilk I, was held in Oakland, California in the spring of 1982, hosted by Off Centaur Publications, and was soon followed by Filkcon, hosted by Margaret Middleton, in the Southeast. At writing, there are at least four regular filk conventions held each year and while attendance is small compared to some other fan conventions, they maintain a sufficient following to insure their survival. The communal filksing described above, then, represents a particular moment in the development of this fan tradition: one when filk has gained sufficient respectability and popularity to be provided a meeting place and to attract participants from a number of different fan interests, yet one when filk still functions primarily in relation to general conventions rather than as the exclusive focus of its own gatherings.

Filk's relationship to the fan community is currently undergoing another dramatic transition, one brought about by semiprofessional companies recording the works of individual filk "artists" and attempting to circulate them to a larger listening audience. Personal tape recorders have long been a fixture at filksings and some filk clubs barter for recordings of their sessions. Individual fan musicians have sometimes recorded their own music and circulated it on tapes: Leslie Fish recorded two filk LPs, *Solar Sailors* and *Folk-*

songs for Folks Who Ain't Even Been Yet in the 1960s, and Omicron Ceti Five released another collection of *Star Trek* filks, *Colors of Love*, during this same period. Roberta Rogow, who currently has five different tapes of media-related filk songs in circulation, characterizes her tapes as "electronic fanzines." But, if Rogow's tapes, which have a first run of 200–300 copies and are marketed personally by the musician, maintain the same cottage industry status as other fan publications, the recording of filk has increasingly concentrated in the hands of two semiprofessional manufacturers, Firebird Arts and Wail Songs, who sell recordings for a limited profit, contract for exclusive rights to certain fan musicians, and market tapes with print runs that may reach 2,000 copies. Each company currently offers roughly 50 different tapes either recorded live at filk conventions or increasingly, recorded under studio conditions and offering the music of a single "star" performer or group; each is aggressively expanding its catalog by recruiting more performers and generating more studio tapes.

Such a development has the potential of bringing filk into contact with a broader audience and thus expanding its influence. A few filk songs are starting to receive limited radio play. Firebird recently linked its release of a new tape, *Carmen Miranda's Ghost*, with the commercial publication of a science fiction anthology of the same name, and the book's introduction included a description of filk tapes and an address where they may be purchased. People can buy and enjoy filk tapes who have never attended a filksing at a con and be drawn into the fan community. The semiprofessional tape producers and distributors are already having some impact on the nature of filk as a musical tradition. A star system has started to emerge as individual performers are drawn from the community and featured on their own tapes. A form of music founded on ideals of musical democracy, an acceptance of various competencies, has become more hierarchical due to the push toward professional standards of technical perfection. The result has been an increased complexity of song lyrics, a movement away from songs which can be quickly learned and sung by the fan community to those which require greater practice and showcase the particular vocal abilities of their performers. Some filk tapes, like those of Kathy Mar, resemble pop rather than folk music and rely heavily on elaborate mixing and sampling techniques only possible under studio conditions. Several filkers told me that release of their latest tapes had been delayed because they lack the technical polish of other con-

temporary filk recordings and required further studio work to conform to audience expectations. Firebird is actively seeking a "breakthrough" tape to attract a broader audience for filk and sees such professionalism as necessary for expanding the market for their releases. The semiprofessional concerns have been far less willing than the original fan producers to risk violations of copyright law, refusing to allow direct references to media characters or the use of songs not in the public domain. Some filkers have reworded their original media-related songs to give them a more generic quality. Others have written new songs, songs which borrow generic features from science fiction without directly evoking specific copyrighted texts. Filk, built from fragments borrowed nomadically from other media commodities, now runs the risk of itself becoming another commodity as segments of the filk community feud over the proprietorship of songs and the percentage of return each artist will receive.

While criticized by some, others stress the degree to which these semiprofessional concerns remain deeply rooted within the fan community. As Leslie Fish explains, "There is no distinct division between 'professional' and 'amateur' filksinging, since the only way to advertize filkmusic tapes is to print ads in fan magazines and to go to the convention filksings and sing the songs before live audiences" (Personal Correspondence, 1990). Filk's chances of reaching a large audience is limited both by its subject matter, which appeals to the specialized knowledge of the fan community, and its musical conventions, which emphasize spirited singing over refined voices. Most filkers stress that filk will necessarily remain somewhat tied to its folk cultural origins, even as the development of semiprofessional filk companies may alter its economic base. The future of filk will, thus, like its history, be a complex one, torn between its roots in folk cultural traditions and its ties to commercial cultural materials, originating within the fan community and yet sold back to that community as a commodity.

CONCLUSION
"In My Weekend-Only World . . .": Reconsidering Fandom

In an hour of make-believe
In these warm convention halls
My mind is free to think
And feels so deeply
An intimacy never found
Inside their silent walls
In a year or more
Of what they call reality.

In my weekend-only world,
That they call make-believe,
Are those who share
The visions that I see.
In their real-time life
That they tell me is real,
The things they care about
Aren't real to me.
<div align="right">(T. J. Burnside Clapp
"Weekend-Only World" 1987,
Fesarius Publications)</div>

"Get a life," William Shatner told *Star Trek* fans. "I already have a life," the fans responded, a life which was understood both in terms of its normality by the standards of middle-class culture and by its difference from that culture. This book maps some major dimensions of that "life." If fans are often represented as antisocial, simple-minded, and obsessive, I wanted to show the complexity and diversity of fandom as a subcultural community.

This account offers a conception of fandom that encompasses at least five levels of activity:

a. Fandom involves a particular mode of reception. Fan viewers watch television texts with close and undivided attention, with

a mixture of emotional proximity and critical distance. They view them multiple times, using their videotape players to scrutinize meaningful details and to bring more and more of the series narrative under their control. They translate the reception process into social interaction with other fans. John Fiske (1991) distinguishes between semiotic productivity (the popular construction of meanings at the moment of reception) and enunciative productivity (the articulation of meaning through dress, display, and gossip). For the fan, this otherwise theoretically useful distinction breaks down since the moment of reception is often also the moment of enunciation (as is literally true within the group viewing situations described here). Making meanings involves sharing, enunciating, and debating meanings. For the fan, watching the series is the beginning, not the end, of the process of media consumption.

b. Fandom involves a particular set of critical and interpretive practices. Part of the process of becoming a fan involves learning the community's preferred reading practices. Fan criticism is playful, speculative, subjective. Fans are concerned with the particularity of textual detail and with the need for internal consistency across the program episodes. They create strong parallels between their own lives and the events of the series. Fan critics work to resolve gaps, to explore excess details and undeveloped potentials. This mode of interpretation draws them far beyond the information explicitly present and toward the construction of a meta-text that is larger, richer, more complex and interesting than the original series. The meta-text is a collaborative enterprise; its construction effaces the distinction between reader and writer, opening the program to appropriation by its audience.

c. Fandom constitutes a base for consumer activism. Fans are viewers who speak back to the networks and the producers, who assert their right to make judgments and to express opinions about the development of favorite programs. Fans know how to organize to lobby on behalf of endangered series, be they *Twin Peaks* fans exploiting the computer networks to rally support for a show on the verge of cancelation or *Beauty and the Beast* fans directing anger against a producer who violated their basic assumptions about the program. Fandom originates, at least in part, as a response to the relative powerlessness of the consumer in relation to powerful institutions of cultural production and circulation. Critics claim that fans are little more than an extension of the market logic of commercial broadcasting, a commodity audience created and courted

by the culture industries (Tulloch and Jenkins, forthcoming). Such a position is false to the reality fans experience when they come into contact with systems of cultural production: media corporations do indeed market to fans, target them for program merchandizing, create official fan organizations that work to regularize audience responses, and send speakers to conventions to promote new works or to squash unwanted speculations. Yet network executives and producers are often indifferent, if not overtly hostile, to fan opinion and distrustful of their input into the production process. Fan response is assumed to be unrepresentative of general public sentiment and therefore unreliable as a basis for decisions. The media conglomerates do not want fans who make demands, second-guess creative decisions and assert opinions; they want regular viewers who accept what they are given and buy what they are sold. Official fan organizations generate and maintain the interests of regular viewers and translate them into a broader range of consumer purchases; i.e., spinoff products, soundtracks, novelizations, sequels, etc. Fandom (i.e., the unofficial fan community) provides a base from which fans may speak about their cultural preferences and assert their desires for alternative developments.

d. Fandom possesses particular forms of cultural production, aesthetic traditions and practices. Fan artists, writers, videomakers, and musicians create works that speak to the special interests of the fan community. Their works appropriate raw materials from the commercial culture but use them as the basis for the creation of a contemporary folk culture. Fandom generates its own genres and develops alternative institutions of production, distribution, exhibition, and consumption. The aesthetic of fan art celebrates creative use of already circulating discourses and images, an art of evoking and regulating the heteroglossia of television culture.

The nature of fan creation challenges the media industry's claims to hold copyrights on popular narratives. Once television characters enter into a broader circulation, intrude into our living rooms, pervade the fabric of our society, they belong to their audience and not simply to the artists who originated them. Media texts, thus, can and must be remade by their viewers so that potentially significant materials can better speak to the audience's cultural interests and more fully address their desires.

Fan art as well stands as a stark contrast to the self-interested motivations of mainstream cultural production; fan artists create artworks to share with other fan friends. Fandom generates systems

of distribution that reject profit and broaden access to its creative works. As Jeff Bishop and Paul Hoggett have written about subcultural communities organized around common enthusiasms or interests, "The values. . . . are radically different from those embedded within the formal economy; they are values of reciprocity and interdependence as opposed to self-interest, collectivism as opposed to individualism, the importance of loyalty and a sense of 'identity' or 'belonging' as opposed to the principle of forming ties on the basis of calculation, monetary or otherwise" (Bishop and Hoggett 1986, 53). Fanzines are most often sold at cost; the circuit stories are made available for fans to make their own copies; fan videos are exchanged on a tape-for-tape basis; filk songs traditionally circulated through word-of-mouth. There is evidence that these practices are beginning to change—and not necessarily for the better. Witness the emergence of semiprofessional publishers of zines and distributors of filktapes, discussed in the previous chapter, yet even these companies originate within the fan community and reflect a desire to achieve a better circulation of its cultural products.

Fandom recognizes no clear-cut line between artists and consumers; all fans are potential writers whose talents need to be discovered, nurtured, and promoted and who may be able to make a contribution, however modest, to the cultural wealth of the larger community. In researching this book, I spoke to many who had discovered skills and abilities that they had not recognized before entering fandom; they received there the encouragement they had found lacking from their interactions with other institutions. They often gained subsequent opportunities on the basis of these developed skills.

 e. Fandom functions as an alternative social community. The song lyrics that open this chapter, like the filk songs discussed in the previous chapter, capture something essential about fandom, its status as a utopian community. "Weekend-Only World" expresses the fans' recognition that fandom offers not so much as an escape from reality as an alternative reality whose values may be more humane and democratic than those held by mundane society. T. J. Burnside Clapp contrasts the intimacy and communalism of fandom to the alienation and superficiality of mundane life:

> I see them daily, months on end.
> The surface all I see.
> Do they hold the things in their hearts

That I do in mine?
We talk of mortgages and sports
And what's new on T.V.
But we grow no closer
With the passing time.
T. J. Burnside Clapp,
"Weekend-Only World", 1987,
Fesarius Publications

She can spend far less time in the company of fans, in that "weekend-only world" of the con, yet she has "lived a lifetime in those few but precious hours" and has felt closeness to many who were strangers before fandom brought them together. She gains power and identity from the time she spends within fan culture; fandom allows her to maintain her sanity in the face of the indignity and alienation of everyday life: "It keeps me safe through weeks so long between."

Writers such as Hans Magnus Enzensberger (1974), Frederic Jameson (1979) and Richard Dyer (1985), have pointed toward the utopian dimension of popular culture; its appeal to the consumer is linked to its ability to offer symbolic solutions to real world problems and felt needs. Jameson has shown how mass-culture texts must evoke and manage social and political anxieties and fantasies. Traces of these countercultural impulses remain present, even within texts that otherwise seem reactionary: "Genuine social and historical content must first be tapped and given some initial expression if it is subsequently to be the object of successful manipulation and containment" (Jameson 1979, 144). Richard Dyer has similarly argued that entertainment offers us an "image of something better" than the realm of everyday experience; entertainment gratifies because it holds open the imagined possibility of satisfying spectators' actual lacks and desires. Entertainment, Dyer asserts, teaches us "what utopia would feel like" (Dyer 1985, 222). In a discussion of the American musical, Dyer contrasts popular entertainment with real-world problems: popular entertainment promises abundance instead of scarcity, energy instead of exhaustion, intensity instead of dreariness, transparency instead of manipulation, community instead of fragmentation. Science fiction has often been discussed as providing readers with the image of a better world, an alternative future, an ideal against which to measure contemporary life but also a refuge from drudgery and constraint (Lefanu, 1988).

Fan culture finds that utopian dimension within popular culture a site for constructing an alternative culture. Its society is responsive to the needs that draw its members to commercial entertainment, most especially the desire for affiliation, friendship, community. Mass culture provides many images of such a world—the tunnel community of *Beauty and the Beast*, the expanded family of the Enterprise Crew, the political commitment of the Liberator, the ideal partnership of countless cop shows, the merry men of Sherwood Forest, the dedicated members of the Blackwood project. The characters in these programs devote their lives to goals worth pursuing and share their hours with friends who care for them more than life itself. The fans are drawn to these shows precisely because of the vividness and intensity of those relationships; those characters remain the central focus of their critical interpretations and artworks.

Life, all too often, falls far short of those ideals. Fans, like all of us, inhabit a world where traditional forms of community life are disintegrating, the majority of marriages end in divorce, most social relations are temporary and superficial, and material values often dominate over emotional and social needs. Fans are often people who are overeducated for their jobs, whose intellectual skills are not challenged by their professional lives. Fans react against those unsatisfying situations, trying to establish a "weekend-only world" more open to creativity and accepting of differences, more concerned with human welfare than with economic advance. Fandom, too, falls short of those ideals; the fan community is sometimes rife with feuds and personality conflicts. Here, too, one finds those who are self-interested and uncharitable, those who are greedy and rude, yet, unlike mundane reality, fandom remains a space where a commitment to more democratic values may be renewed and fostered. Noncommunal behavior is read negatively, as a violation of the social contract that binds fans together and often becomes the focus of collective outrage.

Nobody can live permanently within this utopia, which becomes recognizable as such only against the backdrop of mundane life; fans must come and go from fandom, finding this "weekend-only world" where they can, enjoying it for as long as possible, before being forced to return to the workaday world. Within the few short hours they spend each month interacting with other fans, they find something more than the superficial relationships and shoddy values

of consumer culture. They find a space that allows them to discover "what utopia feels like."

In a telling critique of the politics of postmodernism, Lawrence Grossberg notes that while we often think of political resistance in negative terms—as a rejection or repudiation of existing conditions—it may also have a more positive or celebratory dimension:

> Opposition may be constituted by living, even momentarily, within alternative practices, structures and spaces, even though they may take no notice of their relationship to existing systems of power. In fact, when one wins some space within the social formation, it has to be filled with something, presumedly something one cares for passionately.... And it is here that questions of desire and pleasure must be raised as more than secondary epiphenomena. (Grossberg 1988, 169–170)

Fandom constitutes such a space, one defined by its refusal of mundane values and practices, its celebration of deeply held emotions and passionately embraced pleasures. Fandom's very existence represents a critique of conventional forms of consumer culture. Yet fandom also provides a space within which fans may articulate their specific concerns about sexuality, gender, racism, colonialism, militarism, and forced conformity. These themes regularly surface within fan discussions and fan artworks. Fandom contains both negative and positive forms of empowerment. Its institutions allow the expression both of what fans are struggling against and what they are struggling for; its cultural products articulate the fans' frustration with their everyday life as well as their fascination with representations that pose alternatives.

In making this claim, I am not asserting that fandom necessarily represents a progressive force or that the solutions fans propose are ideologically consistent and coherent. A poached culture, a nomadic culture, is also a patchwork culture, an impure culture, where much that is taken in remains semidigested and ill-considered. As Grossberg asserts, a politics of consumption:

> does not say that people always struggle or that when they do, they do so in ways we condone. But it does say, both theoretically and politically, that people are never merely passively subordinated, never totally manipulated, never entirely incorporated. People are engaged in struggles with,

within and sometimes against real tendential forces and determinations in their efforts to appropriate what they are given. Consequently, their relations to particular practices and texts are complex and contradictory: they may win something in the struggle against sexism and lose something in the struggle against economic exploitation; they may both gain and lose something economically; and although they lose ideological ground, they may win some emotional strength. (Grossberg 1988, 169–170)

The irony, of course, is that fans have found the very forces that work to isolate us from each other to be the ideal foundation for creating connections across traditional boundaries; that fans have found the very forces that transform many Americans into spectators to provide the resources for creating a more participatory culture; that fans have found the very forces that reinforce patriarchal authority to contain tools by which to critique that authority. We should not be surprised that in doing so, fans absorb much that we as leftist academics may find aesthetically dubious and politically suspect. What *is* surprising, particularly in the face of some fifty years of critical theories that would indicate otherwise, is that fans find the ability to question and rework the ideologies that dominate the mass culture they claim as their own. A character in Lizzie Bordan's *Born in Flames* describes political alchemy as "the process of turning shit into gold"; if this claim is true, there may be no better alchemists on the planet than fans.

I am not claiming that there is anything particularly empowering about the texts fans embrace. I am, however, claiming that there is something empowering about what fans do with those texts in the process of assimilating them to the particulars of their lives. Fandom celebrates not exceptional texts but rather exceptional readings (though its interpretive practices makes it impossible to maintain a clear or precise distinction between the two).

This is a book about fans and fan culture. It is not about the media industry and it is not about popular texts. I have no particular objections to studying these topics and have done so on other occasions; both seem necessary to a full understanding of mass culture and media consumption. Only by analyzing the structures of the primary text can we fully understand what fan interpretation contributes in the process of appropriating these programs for their own uses (thus, for example, my account of *Beauty and the Beast* ac-

knowledges generic features of the program and aspects of its production history as well as the categories by which fan critics evaluated and interpreted it). Only by locating the market conditions that block fan access to the means of mass cultural production can we understand the political dimensions of their relationship with the media. I am not privileging the fan here, because I want to decenter the text or even prioritize consumption over production. Indeed, my hope is that fan critical practice may provide a model for a more specifically drawn, more exploratory and speculative style of media criticism: one alive to the pleasures of the text but retaining some critical distance from its ideological structures. What I want to reject is a tradition that reads the audience from the structures of the text or in terms of the forms of consumption generated by the institutions of production and marketing. What I want to challenge is the tendency to create a theoretical fiction that masks rather than illuminates the actual complexities of audience-text relations.

Media theorists have always made claims about the audience. What audience research contributes to this debate, then, is not the focus on the audience but rather a reconsideration of the most productive methods for making meaningful generalizations about the nature and character of audience response. Media scholars cannot help but talk about the audience in relationship to media culture; the question is what types of audience(s) we will talk about and whether they will be allowed to talk back. Much of what passes for critical theory lacks even the most rudimentary grounding in empirical reality, drawing its assumptions about spectatorship through a combination of personal introspection and borrowed authority. The result is a curious theory that cannot be tested and must be taken on blind faith. I question what forms of popular power can be founded on theories that require our unquestioning acceptance of hierarchical knowledge and which become accessible only to an educated elite.

The problem I confronted upon entering media studies, having already spent a number of years in the company of fans, was that the dominant conceptions of television spectatorship seemed radically at odds with my own experience of the media. The sweeping claims of ideological critics were totally implausible in their dismissal of popular readers as positioned by the text and unable to resist its demands. Such approaches cannot begin to account for the

writing and circulation of fanzines or the mixture of fascination and frustration that runs through fan discourse. As Ien Ang writes:

> Ethnographic work, in the sense of drawing on what we can perceive and experience in everyday settings, acquires its critical mark when it functions as a reminder that reality is always more complicated and diversified than our theories can represent, and that there is no such thing as 'audience' whose characteristics can be set once and for all. The critical promise of the ethnographic attitude resides in its potential to make and keep our interpretations sensitive to the concrete specificities, to the unexpected, to history.... What matters is not the certainty of knowledge about audiences, but an ongoing critical and intellectual engagement with the multifarious ways in which we constitute ourselves through media consumption. (Ang 1990, 110)

In other words, ethnography may not have the power to construct theories, but it can disprove them or at least challenge and refine them. While I have drawn on theory as a tool for understanding fandom as a set of cultural, social, and interpretive practices, I have not drawn upon fandom as a means of developing a new theory of media consumption. I distrust the move which takes concrete, culturally situated studies of particular fan practices, of specific moments in the ongoing relationship between audience(s) and texts, and translates them into data for the construction of some general theory of the media audience. Fan culture differs in a qualitative way from the cultural experience of media consumption for the bulk of the population. It is not simply that fan interpretations are more accessible to analysis, more available for observation than the transitory meanings produced by nonfan viewers, but rather, participating within fandom fundamentally alters the ways one relates to television and the meanings one derives from its contents. The fan audience is in no sense representative of the audience at large, nor can we go from an understanding of a specific subculture to an account of *the active spectator* (a phrase which necessarily remains a theoretical rather than an ethnographic construct). I am not even sure that the types of fans I have discussed here, fans of a particular configuration of popular narratives, are necessarily identical with other varieties of fans, fans of specific media personalities, rock performers, sports teams or soap operas. These groups will have

some common experiences as well as display differences that arise from their specific placement within the cultural hierarchy and their interests in different forms of entertainment.

It strikes me as ironic, however, that before Cultural Studies began to research fan culture, fans were dismissed as atypical of the media audience because of their obsessiveness and extreme passivity; now that ethnographic accounts of fan culture are beginning to challenge those assumptions, fans are dismissed as atypical of the media audience because of their activity and resistance. Both positions portray the fan as radically "Other" rather than attempting to understand the complex relationship between fan culture and mainstream consumer culture. We cannot afford to dodge that question; we can neither afford to move from the extreme case to the general (as has been true of some recent work within the Cultural Studies tradition) nor can we afford to ignore the connection that places fan culture on a continuum with other media consumption. We can, however, insist that any theory that is constructed to account more generally for the relationship between spectators and texts not preclude the existence of the practices documented here. We can even hope for theories that can explain their persistence in the face of strong countervailing pressures. A model that sees only media effects on passive spectators falls short of this test; a model that allows for different forms of interaction, that posits a more active relationship in which textual materials are appropriated and fit to personal experience does not. Fandom does not prove that all audiences are active; it does, however, prove that not all audiences are passive.

APPENDIX
Fan Texts

Fans draw on many texts as a basis for their cultural productions. This guide is intended as an overview of some of the most commonly referenced television series and films. It is not intended to be exhaustive but it will provide a resource for readers unfamiliar with particular texts discussed in *Textual Poachers*.

ALIEN NATION
1989–1990 (USA) Fox

Cast

Detective Matt Sikes:	*Gary Graham*
Detective George Francisco:	*Eric Pierpoint*
Susan Francisco:	*Michele Scarabelli*
Cathy Frankel:	*Terri Treas*

Based on the movie of the same name. LAPD detective Matt Sikes is teamed with George Francisco, a Newcomer, one of the alien refugees from a crashed spaceship. The Newcomers are now being assimilated into Southern California life. Matt is initially ignorant and somewhat prejudiced about Newcomers, but learns a lot and changes his attitudes while working with George. Plots involve police investigations of crimes involving Newcomers; subplots include Matt and George's developing partnership, family crises in the Francisco clan, and the potential romance between Matt and Cathy, his Newcomer neighbor. Newcomer religious and child-rearing practices are also featured. Broader-ranging than the obvious cross of science fiction and cop show, the series was canceled because Fox chose to drop its hour-long shows in favor of half-hour comedies.

Prepared by Meg Garret

THE AVENGERS
1961–1969 (UK) ITV/ABC (Created by Sydney Newman; beginning 1965, produced by Albert Fennell and Brian Clemens.)

Cast

John Steed:	Patrick Macnee
Doctor David Keel:	Ian Hendry (1st season)
Mrs. Catherine Gale:	Honor Blackman (2nd-3rd seasons)
Mrs. Emma Peel:	Diana Rigg (4th-5th seasons)
Tara King:	Linda Thorson (6th season)

Beginning in the first season (never aired in the US) as Dr. Keel's attempt to avenge the death of his fiancee, *The Avengers* became a tongue-in-cheek romp through British eccentricity and the conventions of the spy genre. In Cathy Gale and Emma Peel, television gained its first liberated heroines, able to defend themselves with gun and karate while dressed in cutting-edge designer fashions of leather and knit. Steed is the total gentleman, with bowler hat, brolly, and Edwardian-influenced suits. Its style made the series extraordinary on all levels. Plots in the Cathy Gale episodes are fairly generic spy stories; under Fennell and Clemens the Emma Peel episodes deftly combine spy plots with wit, fantasy, science fiction, and parody. The last season goes further out into broader farce and fantastical plots.

BATMAN
1966–1968 (USA) AB

Cast

Bruce Wayne (Batman):	Adam West
Dick Grayson (Robin):	Burt Ward
Alfred Pennyworth, the butler:	Alan Napier
Commissioner Gordon:	Neil Hamilton
Barbara Gordon (Batgirl):	Yvonne Craig (2nd season)

Deliberately campy version of the comic book hero's defense of Gotham City against various arch-villains. The silly plots, visual "POWs" and "BANGs," overdone or deadpan acting, sight gags, verbal running gags ("Holy—, Batman!"), and two-part cliff-hanger

stories made the show a smash success, with well-known actors chewing the scenery as guest villains like The Penguin, Catwoman, and The Joker. But the novelty wore off, and the show went from top-ten to cancelation in two seasons. Batgirl was added as a character in the series' second season and it was reduced from one hour to half-an-hour per week; these changes proved disappointing to program fans and may have contributed to its decline.

BATTLESTAR GALACTICA
1978–1980 (USA) ABC (Created and produced by Glen Larson)

Cast
Commander Adama:	Lorne Greene
Captain Apollo:	Richard Hatch
Lieutenant Starbuck:	Dirk Benedict
Lieutenant Boomer:	Herb Jefferson, Jr.

Highly publicized, high-budget, special-effects-laden attempt to duplicate on television the success of *Star Wars*, this series follows the flight of a rag-tag convoy of spaceships attempting to evade the enemy Cylon war fleet and reach refuge on the legendary home of their people, Earth. Fatherly Adama commands the only surviving warship, the Galactica; Apollo, Starbuck, and Boomer are the dashing young hotshot pilots. The special effects are marvelous, created by John Dykstra who created effects for *Star Wars*, but the scripts are second-rate, never fully utilizing the potential of the concept.

BEAUTY AND THE BEAST
1987–1990 (USA) CBS (Created by George R. R. Martin)

Cast
Catherine Chandler:	Linda Hamilton
Vincent:	Ron Perlman
Father:	Roy Dotrice
Mouse:	David Greenlee

An unusual attempt to blend romantic fantasy with action-adventure. Catherine is attacked and injured by criminals in New York. Vincent finds and rescues her, carrying her to the tunnel world, a secret community of refugees beneath the streets of the city. Band-

aged, she doesn't know that the man caring for her has the look of a beast—all she knows is the beautiful voice reading poetry as she recuperates. They fall in love, but cannot be together; Vincent must stay below, unseen, and she must return to her life above ground as a lawyer, then as an assistant D.A. Their love is expressed in a psychic bond and despite separation, their lives become more and more entwined. Episodes deal with the tunnel world and the lives of the below-ground residents, Catherine's job, her relationship with her father, and various perils Catherine faces.

BLAKE'S 7
1978–1981 (UK) BBC (Created by Terry Nation; script editor, Chris Boucher)

Cast

Kerr Avon:	Paul Darrow
Roj Blake:	Gareth Thomas
Vila Restal:	Michael Keating
Cally:	Jan Chappell (1st-3rd season)
Dayna Mellanby:	Josette Simon (3rd-4th season)
Oleg Gan:	David Jackson (1st-2nd season)
Jenna Stannis:	Sally Knyvette (1st-2nd season)
Servalan:	Jacqueline Pearce
Soolin:	Glynis Barber (4th season)
Del Tarrant:	Steven Pacey (3rd-4th season)
Travis:	Stephen Grief (1st season)
	Brian Croucher (2nd season)

This science fiction-adventure series set in a dystopic future follows the attempts of a band of rebels led by Roj Blake to overthrow the repressive Federation. The series is unusual because of the failure of many of the rebel's plots, the deaths of some rebels, and the generally darker universe, exemplified by the antagonism between Blake and Avon (nominally comrades-in-arms, but philosophically at odds.) Blake is an idealist, devoted to his cause; Avon is cynical, looking out for himself first; Vila is a Delta grade, used to being pushed around. Escaping a Federation prison ship, they gain control of a non-Federation spaceship, which they name the Liberator. Cally, Jenna, Dayna, and Soolin are all defined as tough, independent, and capable women, but their parts in the scripts don't always

follow through. Overall, it can be viewed as an inversion of *Star Trek*, where the government is tyrannical, where individuals in power are corrupt, where the 'heroes' are deluded, perhaps mad, and events thoughout the series degrade from bad to worse, with betrayal and failure at every turn. It is an interesting contrast to *The Prisoner*, where the individual is similarly brainwashed and manipulated by the authorities, but survives undaunted.

DARK SHADOWS
1966–1971 (USA) ABC (Created by Dan Curtis)

Cast

Barnabas Collins:	Jonathan Frid
Angelique:	Lara Parker
Maggie Evans/Josette DuPres:	Kathryn Leigh Scott
Quentin Collins:	David Selby
Victoria Winters:	Alexandra Moltke/
	Kate Jackson
Elizabeth Collins Stoddard:	Joan Bennett
Dr. Julia Hoffman:	Grayson Hall

This gothic soap opera follows the efforts of the vampire, Barnabas Collins, to escape his curse and find love. Plots are borrowed from classics such as *Frankenstein, Doctor Jekyll and Mr. Hyde*, and *Rebecca*. Initially having no supernatural elements, the soap had poor ratings until they were added. With Barnabas' arrival in the second season, ratings picked up even more, and the wilder the plots got, the better the series did. Many high school and college students rushed to get home in time to see it and *Dark Shadows* was also part of the elementary school experience of many fans. The show broke new ground for daytime television, not only for its gothic concept, but for its realistic, atmospheric sets, the use of special effects, and the introduction of dual roles for characters. (Flashback stories—the first to 1795—involve how Barnabas became a vampire, and the past lives of the modern characters' ancestors.) *Dark Shadows* was revived and recast for a short-lived 1991 series.

DOCTOR WHO
1963–1989? (UK) BBC

Cast

The Doctor: *William Hartnell (1st–4th season)*
Patrick Troughton (4th–6th season)
Jon Pertwee (7th–11th season)
Tom Baker (12th–18th season)
Peter Davison (19th–21st season)
Colin Baker (21st–23rd season)
Sylvester McCoy (24th–26th season)

And innumerable companions

This science fiction-adventure show first became a massive hit with the introduction of the villainous Daleks, created by Terry Nation. The Daleks were mechanical creatures that for the first time in television SF, actually looked alien and not like men in rubber suits. The Doctor is a time-traveling native of Gallifrey with a fondness for Earth ("quite my favorite planet") and a crusading spirit coupled with endless curiosity that lands him and his various companions in a great deal of trouble. A Time Lord, he 'regenerates' (into a new actor) every few years, but his time-space ship, the TARDIS, always looks like an old-style police call box, due to a faulty chameleon circuit. Mainly thought of as a children's or family show in the UK, US showings helped many a PBS station's finances with its appeal to older viewers as well. The Doctor's relationships with his traveling companions are paternal or avuncular, his moral stance rarely dubious, his conquests never romantic ones, and unlike most science fiction shows, this one doesn't always take itself too seriously. The show is presently on hiatus, with its future undecided by the BBC.

THE EQUALIZER
1985–1989 (USA) CBS

Cast

Robert McCall: *Edward Woodward*
Control: *Robert Lansing*
Scott McCall: *William Zabke*

In Manhattan, a retired secret agent, known as "The Equalizer," places ads so people in trouble can find him when they need help. Most shows involve him as a loner acting as detective or bodyguard for his clients, but some involve his son. Disillusionment with his past career leads him to try to do some good on a personal level with his one-man security force, even for those that can't afford to pay.

FROM EROICA WITH LOVE
(Japan) Shojo Manga (comic books)
(Created, written, and drawn by Yasuko Aoike)

Comic book stories involving the run-ins of Major Klaus von dem Eberbach, a rigid and authoritarian NATO officer, with the flamboyant, frivolous, and gay Earl Dorian Red Gloria. A British art thief, Dorian operates under the name "Eroica" and would love to know the major better, despite the major's protests at the idea. These comics are delightful, using the tension between the two to great effect against spy and action plots. Though in Japanese, fan-circulated translations are available. This series is very popular with women and girls in Japan, as are other comics involving gay characters.

INDIANA JONES
1981: RAIDERS OF THE LOST ARK
1984: INDIANA JONES AND THE TEMPLE OF DOOM
1989: INDIANA JONES AND THE LAST CRUSADE
(Stories by George Lucas; directed by Steven Spielberg; produced by George Lucas)

<div align="center">Cast</div>

Indiana Jones:	*Harrison Ford*
Marion Ravenwood:	*Karen Allen (1981)*
Willie Scott:	*Kate Capshaw (1984)*
Professor Henry Jones:	*Sean Connery (1989)*

Inspired by the Saturday afternoon matinee serials of Lucas' childhood, this trilogy set in the 1930s details the action-filled exploits of Indiana Jones, archeologist and adventurer. In the first film, Indy locates and recovers the Ark of the Covenant, also being sought in Egypt by the Nazis. In the second, Indy retrieves a sacred stone

from the worshippers of Kali. The third is the quest for the Holy Grail. Marion, his companion in *Raiders*, is a competent and feisty heroine. Willie, in *Temple of Doom*, is less likeable, hampered by a script that often has her screaming and hysterical. Indy's father is a fine foil, and the father and son relationship is explored both personally and professionally in *The Last Crusade*. All three films are technical marvels, with special effects that outdo and parody old B adventure films with flash, slime, and speed as the occasion demands.

MAGNUM, P.I.
1980–1988 (USA) CBS
(Created by Glen Larson and Donald P. Bellisario)

Cast

Thomas Magnum:	*Tom Selleck*
Jonathan Higgins:	*John Hillerman*
T.C.:	*Roger E. Mosley*
Rick:	*Larry Manetti*

Thomas Magnum is a private investigator in Hawaii. He lives an idyllic life on a wealthy (and absent) writer's estate as his security consultant, in return for rent-free residence on the estate and the use of a Ferrari. This job allows him plenty of time to help beautiful women, hang out with his friends, swim, jog, and keep up his tan. Many plots are standard detective fare, enlivened by recurring characters. T.C. and Rick are old buddies who provide information and assistance on cases; Higgins is a military-minded Englishman that runs the estate and finds Magnum's laid back and sloppy lifestyle a continuous affront. A distinct air of stern father and wayward excuse-making adolescent pervades their encounters.

THE MAN FROM UNCLE
1964–1968 (USA) NBC

Cast

Napoleon Solo:	*Robert Vaughn*
Illya Kuryakin:	*David McCallum*
Alexander Waverly:	*Leo G. Carroll*

Solo and Kuryakin are the top agents of the United Command for Law and Enforcement, dedicated to saving the world from a variety of evil masterminds, and especially from the agents of THRUSH. They work out of UNCLE's North American headquarters in New York City, under Mr. Waverly. Solo is the suave American who usually gets the girl, and Kuryakin is the quiet Russian with the blond hair and shy demeanor. Beginning as a spy spoof in the manner of James Bond, later plots become almost comic-book fantastic, with an attempt to be more realistic in the last season. Kuryakin's character was originally secondary, a sidekick, not a partner, to Solo, but audience response to him was so favorable that his part was improved.

MIAMI VICE
1984–1988 (USA) NBC

Cast

Detective Sonny Crockett:	*Don Johnson*
Detective Ricardo Tubbs:	*Philip Michael Thomas*
Lieutenant Martin Castillo:	*Edward James Olmos*

Two vice cops working the underworld for their boss, Castillo—sounds like many other cop shows. But the look and sound of *Miami Vice* made it stand out. Don Johnson wears pastel T-shirts with white pants and beard stubble, becoming a sex symbol and fashion trend-setter for the late eighties. The show features MTV-style musical interludes, and lots of turquoise and pink. Its hipness includes guest stars and cameos drawn from rock music (Little Richard, Phil Collins, James Brown), politics (G. Gordon Liddy), business (Lee Iacocca), and sports (Robert Duran). The show has ensemble aspects, with many of the other police officers used regularly as recurring characters; also, Crockett and Tubbs interact with Castillo as individuals as well as a partnership. Castillo's character is fascinating and enigmatic; he says little but is powerful when he does, and mysterious hints are given of his background in the DEA.

THE PRISONER
1968 (UK) ITC/CBS (Created and produced by Patrick McGoohan)

Cast

The Prisoner (Number 6): *Patrick McGoohan*

What happens to a spy that resigns? He wakes up in the Village, to find that They have given him a number and taken away his name. Filmed in Portmeirion, Wales, the show follows Number 6's attempts to discern truth from traps and to resist brainwashing in various forms. The strength of the individual triumphs, though he cannot escape the state, and it is left unclear whether the Prisoner really escapes the Village in the final episode. Very surreal and enigmatic, each episode involves the attempts of a new Number 2 to break Number 6. The ultimate loner, Number 6 has no partner, no agency to call on, and can trust no one that offers assistance.

THE PROFESSIONALS
1977–1983 (UK) LWT (Created by Brian Clemens and Albert Fennell)

Cast

Ray Doyle:	*Martin Shaw*
William Andrew Philip Bodie:	*Lewis Collins*
George Cowley, Head of CI5:	*Gordon Jackson*

Wildly successful in the UK, this series never sold well in the US, getting only sporadic syndicated airing. Not, as is sometimes stated, a British version of *Starsky and Hutch*, though there are superficial similarities. Bodie (ex-SAS) and Doyle (ex-CID) are George Cowley's top team in Criminal Investigation 5, an elite organization set up to handle the problems of urban terrorism, the special cases that are outside the jurisdiction of MI5 and outside the expertise of the police. Plots come from the headlines and have a darker cast and harder edge than the American shows of the period. The look of the show is grittily realistic, due to location filming on the streets. Writers were directed to keep the character relationships in the foreground, combined with lots of action, resulting in a show that works on many levels.

QUANTUM LEAP
1989-current (USA) NBC (Created by Donald P. Bellisario)

Cast

Doctor Sam Beckett:	*Scott Bakula*
Al Calavicci:	*Dean Stockwell*

Dr. Sam Beckett devises a way to time-travel within his own life-time, by "leaping" into the bodies of other people. Stepping into the Project Quantum Leap accelerator before it was tested (because funding will be cut without evidence of success), the Nobel Prize-winning quantum physicist proves his theory works, but has a few problems. He has partial amnesia, doesn't remember the project or even his own name at first, and soon finds that he can't jump back home. The leaps are being controlled by "God, or Time, or some-thing" to make changes for the better in people's lives. Al is the project observer who can appear to Sam as a hologram and give him information and assistance on his missions, through the project supercomputer, Ziggy. This intricate premise allows the writers to do an anthology show with different characters from the '50's to the '80's each week, yet have a regular cast. Exceptional episodes deal with leaps that put Sam into people from his own and Al's pasts, with wonderfully emotional results. Sam and Al's partnership is invoked as that of knight and squire on a quest. Episodes deal with civil rights issues, the mentally handicapped, sexual harassment, and the war in Vietnam. The people Sam jumps into have jobs ranging from mundane to very exotic: rock stars, housewives, bounty hunters, secretaries, boxers, test pilots, and so on.

RED DWARF
1987-current (UK) BBC (Written and produced by Rob Grant and Doug Naylor)

Cast

David Lister:	*Craig Charles*
Arnold Rimmer:	*Chris Barrie*
Cat:	*Danny John-Jules*
Holly:	*Norman Lovett (1st and 2nd season)*
Hilly:	*Hattie Hayridge (3rd–4th season)*

A wonderful and bizarre blend of science fiction and comedy. Red Dwarf is a huge space-going mining ship, and Lister and Rimmer are its two lowest-ranking technicians. Lister is placed in stasis for violation of the no pets rule, and wakes to find three million years have passed. He is the only person left on the ship, perhaps in the universe. Holly, the ship's computer, supplies a hologram of his dead roommate, Rimmer, as companionship, but the two get along no better than before, since Lister is a hedonistic slob and Rimmer a spit-and-polish idiot. The only other living crew member is Cat, a human-appearing but feline-behaving descendant of Lister's illegal pet cat. The three survive a number of science-fiction adventures, including a time rift, an alien polymorph, and addictive video games, but the emphasis is on the comedy and conflict between the characters.

REMINGTON STEELE
1982–1987 (USA) NBC

Cast

Laura Holt:	Stephanie Zimbalist
"Remington Steele":	Pierce Brosnan
Murphy Michaels:	James Read (1st season)
Bernice Foxe:	Janet Demay (1st season)
Mildred Krebs:	Doris Roberts (2nd-5th season)

Laura Holt is unsuccessful running a detective agency under her own name, but when she invents Remington Steele, her mysterious supersleuth boss, business picks up, though she can never introduce clients to the imaginary Mr. Steele. Then an attractive British con-man crosses her path, and compels her to let him assume the role of Steele. He uses his encyclopedic knowledge of old movies to make up for his lack of training as a detective. Stephanie's father, Efram Zimbalist Jr., plays con-man Daniel Chalmers, a recurring guest character who may hold secrets to Steele's past. Banter, teamwork, style, humor, and sexual tension makes this blend of romance and mystery work well.

ROBIN OF SHERWOOD (USA title: ROBIN HOOD)
1984–1986 (UK) HTV (USA: Showtime Cable, PBS)
Primarily written by Richard Carpenter)

Cast

Robin Hood (Robin of Loxley):	*Michael Praed (1st–2nd season)*
Robin Hood (Robert of Huntingdon):	*Jason Connery (3rd season)*
Marion:	*Judi Trott*
Sheriff of Nottingham:	*Nickolas Grace*
Guy of Gisburne:	*Robert Addie*
Little John:	*Clive Mantle*
Will Scarlet:	*Ray Winstone*
Nasir:	*Mark Ryan*

This version of the classic tale adds sorcery, magic, prophecies, and the ancient religion of Herne the Hunter to the usual adventures of Robin Hood as he defends the people against the Sheriff of Nottingham and Prince John. The eighties versions of the characters include the sheriff portrayed as an opportunist and wily politician, Guy as a "public school fascist," and Will Scarlet as a troubled veteran. The magical atmosphere is aided by location filming in West Country forests and castles, and by the haunting music of Clannad. Robin is portrayed as a Summer King, who dies for his people and is reborn—necessitated by the departure of Michael Praed, but fitting the woodland mysticism of Herne, Lord of the Trees.

THE SANDBAGGERS
1978–1980 (UK) Yorkshire TV (Primarily written by Ian Mackintosh)

Cast

Neil Burnside:	*Roy Marsden*
Willie Caine:	*Ray Lonnen*
Jeff Ross:	*Bob Sherman*
Matthew Peele:	*Jerome Willis*
Laura Dickens:	*Diane Keen*
Mike Wallace:	*Michael Cashman*

Neil Burnside heads the three-man Special Operations Section of the British Secret Intelligence Service. This unit, known as the Sand-baggers, handles politically sensitive operations, and those that agents in the field cannot handle. Burnside's often stormy personal and working relationships with his bosses, his agents, and Jeff Ross, head of the London CIA station, are interwoven with secret agent and political plots. Tightly written, it relies more on dialogue than action. Double-think features prominently, and with the convoluted political manipulations, creates a densely structured, sophisticated and intense series.

SCARECROW AND MRS. KING
1983–1987 (USA) CBS

Cast

Lee Stetson ("Scarecrow"):	*Bruce Boxleitner*
Amanda King:	*Kate Jackson*
Dotty West, Amanda's mother:	*Beverly Garland*
Billy Melrose:	*Mel Stewart*

Amanda, a suburban divorced mother of two, accidently becomes involved in a spy caper, when "Scarecrow," a top agent for the US government, passes her a package. She was such a help defeating the spies that she ends up working for the "Agency" full time. She eventually trains as an agent, becoming Lee's partner; all the while keeping her work secret from her mother, sons, and ex-husband. Romance grows between the two, and they marry in the last season, still in secret. Initial episodes show that Amanda's housewife experience and skills are just as valuable as Lee's, and she often provides the correct insight or observation to solve the problem at hand, even before she becomes an agent.

SIMON & SIMON
1981–1988 (USA) CBS

Cast

A.J. Simon:	*Jameson Parker*
Rick Simon:	*Gerald McRaney*

A.J. and Rick are an odd pair of brothers: A.J. clean-cut and conservative, Rick casual, lazy, and a bit of a slob. Sibling rivalry char-

acterizes their working relationship as partners in a small and struggling detective agency in San Diego.

STAR COPS
1987 (UK) BBC (Created by Chris Boucher)

Cast

Commander Nathan Spring:	David Calder
Chief Superintendent David Theroux:	Erick Ray Evans
Colin Devis:	Trevor Cooper
Pal Kenzy:	Linda Newton
Alexander Krivenco:	Jonathan Adams
Anna Shoun:	Sayo Inaba

This six-part mini-series centered around Nathan Spring, the gruff, middle-aged head of the security force on a multinational moonbase. Set in 2027, the program tried for a gritty and realistic representation of space travel and international politics, offering a cynical account of the possibilities for cooperation within the newly united European community. While Spring and his staff ostensibly solve crimes, they often spend most of their time solving diplomatic problems, dodging bureaucratic barriers and confronting ideological differences. Spring's "Star Cops" include his black second-in-command, David Theroux; a ethically dubious Australian, Pal Kenzy; an overweight retired cop, Colin Davis; a cagy Russian supervisor, Alexander Krivenco and a young Japanese scientist, Anna Shoun.

STAR TREK
1966–1969 (USA) NBC (Created by Gene Roddenberry)

Cast

Captain James T. Kirk:	William Shatner
Mr. Spock:	Leonard Nimoy
Doctor Leonard "Bones" McCoy:	DeForest Kelley
Engineer Montgomery Scott:	James Doohan
Lieutenant Sulu:	George Takei
Lieutenant Uhura:	Nichelle Nichols
Nurse Christine Chapel:	Majel Barrett
Ensign Pavel Chekov:	Walter Koenig

The first series to do science fiction seriously with continuing characters, *Star Trek* was not a ratings success, appealing to the then-unattractive audience of young adults and children. The adventures of the starship Enterprise and her crew made a place for itself in syndication, a series of movies, and many original novels (which automatically garner top places on the national paperback bestseller lists). The heroic captain Kirk is supported by Spock's logic and McCoy's compassion in his difficult decisions. The ship's multicultural crew includes Montgomery Scott, chief engineer, from Scotland; Lt. Uhura, communications officer, of African descent; Lt. Sulu, helmsman, of Oriental heritage; and Ensign Chekov, very proud of his Russian background. The show portrays a positive future in space that includes women and minorities as working members of the crew—even though white men still have the top jobs, and the women have traditional positions as the nurse and secretary. Spock gains viewer's interest and sympathy at the difficulty he faces attempting to reconcile the emotional heritage of his human mother with his Vulcan father's training in self control, and at his feelings of being a perpetual outsider.

STAR TREK: THE NEXT GENERATION
1987-current (USA) Syndicated (Created by Gene Roddenberry)

Cast

Captain Jean-Luc Picard:	*Patrick Stewart*
Commander Will Riker:	*Jonathan Frakes*
Lieutenant Cmdr. Data:	*Brent Spiner*
Lieutenant Geordi LaForge:	*LaVar Burton*
Lieutenant Worf:	*Michael Dorn*
Tasha Yar:	*Denise Crosby (1st season)*
Counsellor Deanna Troi:	*Marina Sirtis*
Doctor Beverly Crusher:	*Gates McFadden (1st, 3rd season–present)*
Wesley Crusher:	*Will Wheaton*
Doctor Pulaski:	*Diana Muldaur (2nd season)*
Q:	*John de Lancie*

Set 80 years after the original *Star Trek* series, this new version has

done well in the ratings. It continues the voyages of the Enterprise with new captain and crew, and more expensive sets and effects. The show has gotten mixed ratings from fans of the original; some enjoy it whole-heartedly, some consider the scripts to be less powerful. Relationships between the characters are more amiable, and this ship is more a ship of peace, with fewer battles and armed confrontations than the original show. Picard is an older, experienced captain, less involved in the physical action than Kirk; Riker takes that aspect of Kirk, but has not yet risen to command his own ship. Data is the android first officer who wants to become human, or at least learn as much as he can about the whys and wherefores of human behavior. Worf is the first Klingon to serve in Star Fleet, since the recent Klingon/Federation peace treaty. Yar was briefly the security chief, but the other women's roles are noncommand ones; Troi is a psychologist, Crusher and Pulaski are medical officers.

STAR WARS
1977: STAR WARS
1980: THE EMPIRE STRIKES BACK
1983: RETURN OF THE JEDI
(Created by George Lucas)

Cast

Luke Skywalker:	*Mark Hamill*
Princess Leia Organa:	*Carrie Fisher*
Han Solo:	*Harrison Ford*
Ben (Obi-Wan) Kenobi:	*Alec Guinness*
Darth Vader:	*David Prowse, voice by James Earl Jones*
C3PO:	*Anthony Daniels*
Lando Calrissian:	*Billy Dee Williams*

George Lucas' box-office record-breaking trilogy blends myth, fairy-tale, and the story of a boy growing up with the trappings of westerns, air-ace movies, and science fiction. The climax of the story is Luke Skywalker's difficult moral choice—to save his evil father, or to kill him and give in to his own dark side. With more and better special effects than ever seen before, still it is Luke and his companions, fearless Princess Leia and seemingly mercenary Han Solo,

and his nemesis, evil Lord Darth Vader (redeemed at death), that make this trilogy classic.

STARSKY AND HUTCH
1975–1979 (USA) ABC

Cast

Detective Dave Starsky:	Paul Michael Glaser
Detective Ken Hutchinson:	David Soul
Captain Harold Dobey:	Bernie Hamilton
Huggy Bear:	Antonio Fargas

A touchy-feely '70s version of the basic cop-partner show, distinguished by the open expression—verbal, physical, and emotional—of the affection and loyalty between streetwise New Yorker Starsky and white-bread Midwestern Hutch. Never before have cops cried or hugged so much. They zoom around L.A. in Starsky's red Torino arguing about junk food vs. health food and solving the usual range of cop-show crimes, with the help of their informant Huggy.

TWIN PEAKS
1990–1991 (USA) ABC (Created by David Lynch and Mark Frost)

Cast

Special Agent Dale Cooper:	Kyle MacLachlin
Sheriff Harry S. Truman:	Michael Ontkean
Audrey Horne:	Sherilyn Fenn
Laura Palmer/	
Madeline Palmer:	Sheryl Lee
Benjamin Horne:	Richard Beymer
Donna Hayward:	Lara Flyn Boyle
Pete Martell:	Jack Nance
Josie Packard:	Joan Chen
Catherine Martell:	Piper Laurie

Twin Peaks' inventive blend of soap opera and mystery, its eccentric and ever-expanding cast of characters and its complex and compelling plotlines attracted strong critical interest when it first appeared as a mid-season entry at ABC. FBI agent Dale Cooper comes

to the small northwestern town of Twin Peaks to solve the murder of Laura Palmer, who was found washed ashore beside the Packard saw mill wrapped in plastic, with a letter embedded under her fingernail. Cooper finds the world's best cherry pie, a close friendship with the local sheriff, and a quirky and sometimes sinister group of local residents. Critics and some viewers became frustrated when Lynch delayed revealing the identity of Laura's killer until well into the second season and lost interest as it introduced supernatural story elements. The second season's final episodes, involving Cooper's deranged former partner Windom Earle, held their own grim fascination and its final episode left much room for fan speculation.

WAR OF THE WORLDS
1988–1990 (USA) Syndicated (Created by Greg Strangis)

Cast

Doctor Harrison Blackwood:	Jared Martin
Lieutenant Colonel Paul Ironhorse:	Richard Chaves
Norton Drake:	Philip Akin
Doctor Suzanne McCullough:	Lynda Mason Green
Debi McCullough:	Rachel Blanchard
John Kincaid:	Adrian Paul (2nd Season)

A follow-up to the classic movie, this series assumes that the Martian invaders were not defeated in the 1950s, but are still here, dormant. Now they are awake and taking over the bodies of humans to prepare the way for total subjugation of Earth. Though much of humanity has forgotten the Martian invasion, Blackwood remembers, and keeps looking for evidence. When dormant Martians are revived by radiation and take over a military base, he intercepts alien transmissions and goes to investigate with his associates, Drake, a computer whiz, and McCullough, a microbiologist. There they meet Ironhorse, and shortly the four become a secret team to study and detect the presence of the Martians, reporting to a Pentagon general. Ironhorse and Drake are killed and Kincaid joins the team, now fighting an occupation force, as the first wave of the invasion succeeded.

Sources

Adams, Fanny (n.d.). "Noises at Dawn." Circuit Story.

Adorno, Theodor W. (1978). "On the Fetish Character in Music and the Regression of Listening." In *The Essential Frankfurt School Reader*, edited by Andrew Arato and Eike Gabhardt. New York: Urizen.

Airey, Jean and Laurie Haldeman (1988). *The Totally Imaginary Cheeseboard*. Aura, Il: Fanfun Publications.

Allen, Robert (1985). *Speaking of Soap Operas*. Chapel Hill: University of North Carolina Press.

Almedina, Patricia (1989). Letter. *The Whispering Gallery* 8: Unnumbered.

Altman, Rick (1986). "Television/Sound." In *Studies in Entertainment: Critical Approaches to Mass Culture*, edited by Tania Modleski. Bloomington: Indiana University Press.

―――. (1987). *The American Musical*. Bloomington: Indiana University Press.

Amesley, Cassandra (1989). "How to Watch *Star Trek*," *Cultural Studies* 3 no. 3.

Andrew, Dudley (1987). *Concepts in Film Theory*. Oxford: Oxford University Press.

Ang, Ien (1985). *Watching Dallas: Soap Opera and the Melodramatic Imagination*. London: Methuen.

―――. (1990). "Wanted: Audiences. On the Politics of Empirical Audience Research." In *Remote Control: Television, Audiences, and Cultural Power*, edited by Ellen Seiter, Hans Borchers, Gabriele Kreutzner, and Eva-Maria Warth. London: Routledge.

Arat, Andrea (1988). "Tranquilized Dreams," *Resistance* 2, edited by Wendy Rathbone. Poway, CA: Self-Published.

Arellanes, Denetia (1989). *U.N.C.L.E. Affairs.* Alhambra, CA: Self-Published.

Auster, Albert (1989). *Actresses and Suffragists: Women in the American Theatre, 1890–1920.* New York: Praeger.

Bacon-Smith, Camille (1986). "Spock among the Women." *New York Times Book Review,* November 16 1986.

Bakhtin, Mikhail (1981). *The Dialogic Imagination.* Austin: University of Texas Press.

Barry, Natasha (1989). "A Suspicious Commodity," *Dyad* 2, edited by Doyna Blacque. Poway, CA: MKASHEF Enterprises.

Barthes, Roland (1957). *Mythologies.* New York: Jonathon Cape.

———. (1975). *S/Z.* New York: Hill and Wang.

Bates, London (1986). "Nearly Beloved/Rogue," *Southern Lights* 2.5. Altamonte Springs: Ashton Press.

"The Beastie Girls," *Gentleman's Quarterly,* December 1989.

Beckett, Terri (n.d.). "Consequences." Circuit Story.

Becker, Howard (1982). *Art Worlds.* Berkeley: University of California Press.

Belle (1988). "He Who Loves." In *Exposures,* II, edited by Kandi Clarke. Traverse City, MI: Otter Limits Press.

Benjamin, Walter (1969). "The Work of Art in the Age of Mechanical Reproduction." In *Illuminations,* edited by Hannah Arendt. New York: Schocken.

Bennett, Tony (1983). "The Bond Phenomenon: Theorizing a Popular Hero." *Southern Review* 16 no. 2.

Bennett, Tony and Janet Woolacott (1986). *Bond and Beyond: The Political Career of a Popular Hero.* London: Routledge, Chapman and Hall.

Berman, Ruth (1976). "Visit to a Weird Planet Revisited." In *Star Trek: The New Voyages,* edited by Sondra Marshak and Myrna Culbreath. New York: Bantam.

Bianco, Margery Williams (1983). *The Velveteen Rabbit or How Toys Become Real.* New York: Holt, Rinehart and Winston.

Bishop, Jeff and Paul Hoggett (1986). *Organizing around Enthusiasms: Mutual Aid in Leisure.* London: Comedia.

Blaes, Tim and Bill Hupe (1989). *The Hellguard Social Register.* Hendersonville, NC: Rihannsu Press.

Bleich, David (1986). "Gender Interests in Reading and Language." In *Gender and Reading: Essays on Readers, Texts, and Contexts,* edited by Elizabeth A. Flynn and P. P. Schweickart. Baltimore: Johns Hopkins University Press.

Bordwell, David (1989). *Making Meaning: Inference and Rhetoric in the Interpretation of Cinema.* Cambridge: Harvard University Press.

Bourdieu, Pierre (1979). *Distinction: A Social Critique of the Judgement of Taste.* Cambridge: Harvard.

――――. (1980). "The Aristocracy of Culture," *Media, Culture, and Society* 2.

Boylan, Susan (1989). "Deliverance." In *Southern Seven* 5, edited by Ann Wortham. Altamonte Springs: Ashton Press.

Bradley, Marion Zimmer (1983). *The Mists of Avalon.* New York: Knopf.

――――. (1985). "Fandom: Its Value to the Professional." In *Inside Outer Space: Science Fiction Professionals Look At Their Craft,* edited by Sharon Jarvis. New York: Frederick Ungar.

Bright, Lynna (1983). "A Place to Hide." In *Who You Know, What You Know, and How You Know It,* edited by Elaine Hauptmann and Lucy Cribb. Self-Published.

――――. (1986). *Murder on San Carmelitas.* Baltimore: Amapola Press.

Brown, Mary Ellen and Linda Barwick (1986). "Fables and Endless Genealogies: Soap Opera and Women's Culture." Paper delivered at the Australian Screen Studies Association Conference, Sydney, December 1986.

Brown, Roberta (1978). Letter. *Alderaan* 3 (September 15, 1978): 7.

Brunsdon, Charlotte (1981). "*Crossroads*: Notes on Soap Opera." *Screen* 22 no. 4.

Brunsdon, Charlotte and David Morley (1978). *Everyday Television: Nationwide.* London: British Film Institute.

Bryant, Danni (1989). Letter. *Interstat* 144 (October): 7.

Buckingham, David (1987). *Public Secrets: EastEnders and Its Audience.* London: British Film Institute.

Budd, Mike (1990). *The Cabinet of Dr. Caligari: Texts, Contexts, Histories.* New Brunswick: Rutgers University Press.

Budd, Mike, Robert M. Entman, and Clay Steinman (1990). "The Affirmative Character of U.S. Cultural Studies." *Critical Studies in Mass Communication* 7.

Burchill, Julie (1986). *Damaged Gods: Cults and Heroes Reappraised.* London: Century.

Burke, Vicki (1988a). "Chamber Music." *The Whispering Gallery* 5: Unnumbered.

———. (1988b). "What's Missing." *The Whispering Gallery* 6: Unumbered.

———. (1989). "Notes from the Editor." *The Whispering Gallery* 10: 1–7.

Burke, Vicki and Janet Dunadee (1990). *A Collection of Memories: The Beauty and the Beast Phenomenon.* Grand Rapids: Whispering Gallery Press.

Burns, Anne (1988). Letter. *Interstat* 131–132 (September-October): 8.

———. (1989). Letter. *Interstat* 141–142 (July/August): 9.

C.P. (n.d.). "The Janus." Circuit Story.

Carlson, Timothy (1990). "*Beauty and the Beast*: The Show that Wouldn't Die . . . and the Fans Who Wouldn't Let It." *TV Guide* (January 13): 2–4.

Carnall, Jane (1987a). "Mental Health." *Southern Lights Special 3.5.* Altamonte Springs: Ashton Press.

Carnall, Jane (1987b). "Civilized Terror." *Southern Lights Special 3.75.* Altamonte Springs: Ashton Press.

Carr, Anne (n.d.). "Wine Dark Nexus." Circuit Story.

Carter, Paul A. (1978). *The Creation of Tommorow: Fifty Years of Magazine Science Fiction.* New York: Columbia University Press.

Caruthers-Montgomery, P. L. (1987). Letter. *Comlink* 28: 8.

Cesari, Julie (1989). Letter. *Interstat* 137 (March): 4.

Chalbram, Andie (1990). "Chicana/o Studies as Oppositional Ethnography." *Cultural Studies* 4 no. 3: 228–47.

Chartier, Roger (1984). "Culture as Appropriation: Popular Cultural Uses in Early Modern France." In *Understanding Popular Culture: Europe from the Middle Ages to the Nineteenth Century*, edited by Steven L. Kaplan. New York: Mouton.

Childs-Helton, Barry (1987a). "Mundania." In *Escape from Mundania!* Indianapolis: Space Opera House, available through Wail Songs.

Childs-Helton, Barry (1987b). "Flying Island Farewell." In *Escape From Mundania!* Indianapolis: Space Opera House, available through Wail Songs.

Childs-Helton, Sally (1987). "Con Man Blues." In *Escape From Mundania!* Indianapolis: Space Opera House, available through Wail Songs.

Christy, Jo Ann (1985). "Dear Mr. Lucas." In *Return of Massteria!: Star Wars and Other Filk Songs*. Los Angeles: L.A. Filkharmonics: 67.

Clapp, T.J. Burnside (1988). "Robin Hood." In *Station Break*. Wakefield, MA: Fesarius Publications, available from Wail Songs.

Clemens, Brian (1986). "The A Squad." In *The Complete Professionals: The Cast, The Characters and the 57 Episodes*, edited by Dave Rogers. London: Queen Anne Press.

Clifford, James (1983). "On Ethnographic Authority." *Representations* 1: 118–46.

Clifford, James and George Marcus, eds. (1986). *Writing Culture: The Poetics and Politics of Ethnography*. Berkeley: University of California Press.

Cox, Carol (1990). Letter. *Newcomer News* 1 (May): 6.

Cranny-Francis, Anne (1985). "Sexuality and Sex-Role Stereotyping in *Star Trek*." *Science Fiction Studies* 12: 274–83.

Cubitt, Sean (1988). "Time Shift: Reflections on Video Viewing." *Screen* 29 no. 2 (spring): 74–81.

D'Acci, Julie (1988). *Women, "Woman" and Television: The Case of Cagney And Lacey*. Ph.D. dissertation, University of Wisconsin-Madison.

Davis, Anne and Meg Garrett (1989). "Video Lust." In *Hip Deep in Heroes: A* Blake's 7 *Filk Song Book*, edited by Meg Garrett. Los Angeles: Meg Garrett: 80.

De Certeau, Michel (1984). *The Practice of Everyday Life*. Berkeley: University of California Press.

Del Rey, Lester (1979). *The World of Science Fiction*. New York: Ballantine.

DeLeon, Gloria M. (1990). Letter. *Once Upon a Time ... Is Now* 18: 3.

Diane (1990). "Teddy Bears' Picnic." In *Dyad* 5, edited by Doyna Blacque. Poway, CA: MKASHEF Enterprises.

Dickholtz, Daniel (1990). "April in Turtleland." *Starlog* 154, (May): 17–19.

D'neese (1990). "If I Reach Out, Will You Still Be There?" *To Boldly Go* 1. Canoga Park, CA: Starlite Press.

Doane, Mary Ann (1987). *The Desire to Desire: The Woman's Film of the 1940s*. Bloomington: Indiana University Press.

Drew, Dennis (n.d.). "Smurf Song." *The Final Reality*. Joplin, MO: Self-Recorded, distributed by Wail Songs.

Dyar, Allyson (1987). Editor's Introduction. *Comlink* 28: 2.

Dyer, Richard (1985). "Entertainment and Utopia." In *Movies and Methods, Volume II*, edited by Bill Nichols. Berkeley: University of California Press.

Ecklar, Julia (1984a). "Born Again *Trek*." *Genesis* (El Cerrito, CA: Off Centaur.

———. (1984b). "One Final Lesson." *Genesis* (El Cerrito, CA: Off Centaur.

Eco, Umberto (1986). *Travels in Hyperreality*. London: Picador.

Ellis, John (1982). *Visible Fictions*. London: Routledge and Kegan-Paul.

Elms, Duane (1985). "Take This Book and Shove It." *Mister Author*. Oakland, CA: Wail Songs.

Enzensberger, Hans Magnus (1974). "Constituents of a Theory of the Media." *The Consciousness Industry*. New York: Seabury.

E. T. (n.d.). "They Don't All Wear Green on Thursdays." Circuit Story.

F. J. (n.d.). "Starlight, Starbright." Circuit Story.

Faiola, Ray (1989). Director, Audience Services, CBS. "Dear Viewer" Letter (July). Reprinted in Vicki Burke and Janet Dunadee (1990). *A Collection of Memories: The Beauty and the Beast Phenomenon.* Grand Rapids: Whispering Gallery Press.

Fetterly, Judith (1978). *The Resisting Reader: A Feminist Approach to American Fiction.* Bloomington: Indiana University Press.

———. (1986). "Reading about Reading: 'A Jury of Her Peers,' 'Murders in the Rue Morgue,' and 'The Yellow Wallpaper'." In *Gender and Reading: Essays on Readers, Texts, and Contexts,* edited by Elizabeth A. Flynn and P. P. Schweickart. Baltimore: Johns Hopkins University Press.

Feuer, Jane (1983). "The Concept of Live Television: Ontology vs. Ideology." In *Regarding Television,* edited by E. Ann Kaplan. Los Angeles: American Film Institute.

Feyrer, Gayle (1986). *The Cosmic Collected.* Self-Published.

Fiedler, Leslie (1975). *Love and Death in the American Novel.* New York: Stein and Day.

Finch, Mark (1986). "Sex and Address in *Dynasty*." *Screen* 27: 24–42.

Finity's End: Songs of the Station Trade (1985). El Cerrito, CA: Off-Centaur, available from Firebird.

Fish, Leslie (1977). "Warped Communications." *Warped Space* 25 (May): 13–14.

———. (1983a). "Toast for Unknown Heroes." In *Minus Ten and Counting.* El Cerrito, CA: Off Centaur.

———. (1983b). "Hope Eyrie." In *Minus Ten and Counting.* El Cerrito, CA: Off Centaur.

———. (1984). Letter. *Not Tonight Spock* 2: 5–6.

———. (1988). *The Weight.* Lansing, MI: T'Kuhtian Press.

Fish, Leslie and Joanne Agostino (1977). "Poses." In *Obsc'zine* 1, edited by Lori Chapek-Carleton. East Lansing: T'Kuhtian Press: 78–100.

Fish, Leslie and the DeHorn Crew (1977). "Banned from Argo." In *Solar Sailors.* El Cerrito, CA: Firebird Arts and Music.

Fish, Stanley (1980). *Is There a Text in This Class?: The Authority of Interpretive Communities*. Cambridge: Harvard University Press.

Fiske, John (1987). *Television Culture*. London: Methuen.

———. (1989). *Understanding Popular Culture*. Boston: Unwin Hyman.

———. (1990). "Ethnosemiotics: Some Personal and Theoretical Reflections." *Cultural Studies* 4 no. 1: 85–99.

———. (1991). "The Cultural Economy of Fandom." In *The Adoring Audience*, edited by Lisa Lewis. New York: Routledge, Chapman and Hall.

Fletcher, Robin, Doris Robin, and Karen Trimble (1985). "Science Wonks, Wimps, and Nerds." In *Return to Massteria!: Star Wars and Other Filksongs*. Los Angeles: L.A. Filkharmonics: 4.

Fluery, Gail P. (1988). Letter. *Interstat* 131–132 (September-October): 9.

Flynn, Elizabeth (1986). "Gender and Reading." In *Gender and Reading: Essays on Readers, Texts, and Contexts*, edited by Elizabeth A. Flynn and P. P. Schweickart. Baltimore: Johns Hopkins University Press.

Flynn, Elizabeth A. and P. P. Schweickart, eds. (1986). *Gender and Reading: Essays on Readers, Texts, and Contexts*. Baltimore: Johns Hopkins University Press.

Formaini, Peter J. (1990). The Beauty and the Beast *Companion*. Ithaca: Loving Companion Enterprises.

Fox, William (1980). "Folklore and Fakelore: Some Sociological Considerations." *Journal of the Folklore Institute* 17: 244–61.

Frayser, Tim (1989). Letter. *Interstat* 144 (October): 2.

Freeman, Camila W. (1990). Letter. *Once Upon a Time . . . Is Now* 18: 3.

Gallagher, Diana (1984). "Monsters in the Night." In *Bayfilk II Concert 1*. El Cerrito, CA: Off Centaur.

Gaines, Jane (1990). "Superman and the Protective Strength of the Trademark." In *Logics of Television: Essays in Cultural Crit-*

icism, edited by Patricia Mellencamp. Bloomington: Indiana University Press.

Garrett, Maureen (1981). "Open Letter to *Star Wars* Zine Publishers." August, Informally Circulated.

Garrett, Meg (1985). "VCR Song." In *Return to Massteria!: Star Wars and Other Filksongs*. Los Angeles: L.A. Filkharmonics: 19.

Garrett, Susan M. (1989). *The Fantastically Fundamentally Functional Guide to Fandom for Fanzine Readers and Contributors*. Toms River, NJ: Self-Published.

Genovese, Eugene D. (1976). *Roll Jordan Roll: The World the Slaves Made*. New York: Random.

Germer, Alicia (1989a). Letter. *Interstat* 135 (January): 14.

———. (1989b). Letter. *Interstat* 144 (October): 2.

Gerrold, David (1973). *The World of Star Trek*. New York: Ballantine.

Gilbert, Debbie (1989). Letter. *Interstat* 136 (February): 7–8.

Gitlin, Todd (1983). *Inside Prime Time*. New York: Pantheon Books.

Glasgow, M. Fae (1988). "The Things We Do for Love." *Oblaque*. Los Angeles: GBH Productions.

———. (1989). "There Is None So Blind . . ." In *Different Destinies 1*, edited by Brendon O'Cullane. Chicago: Xenon Press.

Goodwin, Joseph P. (1989). *More Man than You'll Ever Be: Gay Folklore and Acculturation in Middle America*. Bloomington: Indiana University Press.

Gold, Lee (1986). "Reporters Don't Listen to Trufen." In *Filker Up*. Oakland: Wail Songs.

Gordon, Howard (1988). "In the Belly of the Beast." *Starlog* (June): 26.

Gray, Ann (1987). "Behind Closed Doors: Video Recorders in the Home," In *Boxed In: Women and Television*, edited by Helen Baeher and Gillian Dyer. New York: Pandora.

Great Broads of the Galaxy (n.d.). "Trekker." In *The Cosmic Connection*. Lawrence, Kansas: Audio House, currently distributed by Wail Songs.

———. (n.d.). "Born of Your Son." In *The Cosmic Connection.* Lawrence, Kansas: Audio House, currently distributed by Wail Songs.

Grossberg, Lawrence (1987). "The Indifference of Television." *Screen* 28 no. 2: 28–45.

———. (1988). "Putting the Pop Back into Postmodernism." In *Universal Abandon?: The Politics of Postmodernism*, edited by Andrew Ross. Minneapolis: University of Minnesota Press.

Grosse, Edward (1990). "Season of the *Beast.*" *Starlog* (November): 53–54.

H. G. (n.d.). "Emerging from the Smoke." Circuit Story.

Hakucho (1990). "Just Say No." In *Southern Comfort 5.5*, edited by Ann Wortham. Altamonte Springs, FL: Ashton Press.

Hall, Stuart (1980). "Encoding/Decoding." In *Culture, Media, Language*, edited by Stuart Hall, Dorothy Hobson, Andrew Lowe, and Paul Willis. London: Hutchinson.

———. (1981). "Notes on Deconstructing 'The Popular'." In *People's History and Socialist Theory*, edited by Robert Samuel. London: Routledge and Kegan-Paul.

———. (1986). "Introduction." In *Family Television: Cultural Power and Domestic Leisure*, by David Morley. London: Routledge, Chapman and Hall.

Hall, Stuart and Tony Jefferson, eds. (1976). *Resistance through Rituals.* London: Hutchinson.

Hartley, John (1985). "Invisible Fictions: Television Audiences and Regimes of Pleasure." Paper quoted in John Fiske (1987). *Television Culture.* London: Methuen.

Hartwick, Sue-Anne (1990). Letter. *Newcomer News* 1 (May): 16.

Hebdidge, Dick (1987). *Subculture: The Meaning of Style.* London: Methuen.

Heilbrun, Carolyn (1979). *Reinventing Womanhood.* New York: W. W. Norton.

Herbert, Marguerete S. (1990). Letter. *Once Upon a Time . . . Is Now* 18: 5.

Hillyard, Denise (1990). Letter. *Newcomer News* 1 (May): 11.

Hobson, Dorothy (1982). *"Crossroads": The Drama of a Soap Opera*. London: Methuen.

———. (1989). "Soap Operas at Work." In *Remote Control: Televiison, Audiences and Cultural Power*, edited by Ellen Seiter, Hans Borchers, Gabriele Kreutzner, and Eva-Maria Warth. London: Routledge, Chapman and Hall.

Hodge, Robert and David Tripp (1986). *Children and Television*. Cambridge: Polity.

Holland, Norman (1977). "Transactive Teaching: Cordelia's Death." *College English* 39: 276–85.

Huff, Laurel (1990). Letter. *Newcomer News* 1 (May): 13.

Hughes, Karene (1989). "Letters to the Editor." *The Whispering Gallery* 6 (January): 3.

Hunt, Berkeley (1989). Letter. *Interstat* 135 (January): 2–3.

Hunter, Kendra (1977). "Characterization Rape." In *The Best of Trek 2*, edited by Wauren Irwin and G. B. Love. New York: New American Library.

Issacs, D. M. (1988). Letter. *Interstat* 133 (November): 6.

Jackson, Sourdough (1986). *Starship Troupers: A Filkzine*. Denver: Virtuous Particle Press.

———. (1987). *Filk Index*. Fairlawn, NJ: Other World Books.

Jameson, Frederic (1979). "Reification and Utopia in Mass Culture." *Social Text* (winter): 130–48.

Jane (n.d.). "The Hunting." Serialized Circuit Story.

Jenkins, Henry (1988). "Going Bonkers!: Children, Play, and *Pee-Wee*." *Camera Obscura* 7 (May): 168–93.

———. (1991a). "*Star Trek* Rerun, Reread, Rewritten: Fan Writing as Textual Poaching." In *Close Encounters: Film, Feminism, and Science Fiction*, edited by Constance Penley, Elisabeth Lyon, Lynn Spigel, and Janet Bergstrom. Minneapolis: University of Minnesota Press.

———. (1991b). " 'If I Could Speak with Your Sound': Textual Proximity, Liminal Identification, and the Music of the Science Fiction Fan Community." *Camera Obscura* 23 (May): 149–76.

Jewett, Robert and John S. Lawrence (1977). *The American Monomyth*. Garden City, NY: Anchor Press.

Jones, Deborah (1980). "Gossip: Notes on Women's Oral Culture." *Women's Studies International Quarterly* 3: 193–98.

Junius, Kimberley (1989). Letter. *Interstat* 135 (January): 9.

Kaplan, E. Ann (1985). "A Post-Modern Play of the Signifier?: Advertising, Pastiche, and Schizophrenia in Music Television." In *Television in Transition*, edited by Phillip Drummond and Richard Patterson. London: British Film Institute.

———. (1987). *Rocking around the Clock: Music Television, Postmodernism, and Consumer Culture.* New York: Methuen.

Kirkland, Lee (1990). *Quantum Beast: All's Well that Ends Well.* Commerce City, CO: Self-Published.

Kloer, Phil. "*Beauty and the Beast.*" *Atlanta Constitution* (November 22–28, 1987): 4.

Knight, Sylvia (1988). "Descending Horizon." In *Resistance* 2, edited by Wendy Rathbone. Poway, CA: Self-Published.

Kopmanis, Gretchen (1990). Letter. *The Whispering Gallery* 18–19: unnumbered.

Kulikauskas, Jane (1988). Letter. *Interstat* 134: 5.

L. H. (n.d.). "A Momentary Aberration." Circuit Story.

Lacey, Jenny (1989). "The Ultimate Avon Drool Song." In *Hip Deep in Heroes: A Blake's 7 Filk Song Book*, edited by Meg Garrett. Los Angeles: Self-Published.

Lamb, Patricia Frazer and Dianna L. Veith (1986). "Romantic Myth, Transcendence, and *Star Trek* Zines." In *Erotic Universe: Sexuality and Fantastic Literature*, edited by Donald Palumbo. New York: Greenwood.

Land, Jane (1986). *Kista.* Larchmont, NY: Self-Published.

———. (1987). *Demeter.* Larchmont, NY: Self-Published.

Landers, Randall (1989). Letter. *Comlink* 38: 8.

Landman, Elaine (1990). Letter. *The Whispering Gallery* 18–19: unnumbered.

Larkin, Katrina and Susanne Tilley (1988). *Log of the Hellhound,* Book I. Altamonte Springs, FL: Ashton Press.

Leerhsen, Charles (1986). "*Star Trek*'s Nine Lives." *Newsweek* (December 22, 1986).

Lefanu, Sarah (1988). *Feminism and Science Fiction.* Bloomington: Indiana University Press.

Levine, Lawrence W. (1977). *Black Culture and Black Consciousness: Afro-American Folk Thought from Slavery to Freedom.* Oxford: Oxford University Press.

————. (1988). *Highbrow/Lowbrow: The Emergence of Cultural Hierarchy in America.* Cambridge: Harvard University Press.

Lewis, Lisa (1987). "Consumer Girl Culture: How Music Video Appeals to Women." *OneTwoThreeFour: A Rock 'N' Roll Quarterly* 5: 5–15.

Lewis, Lisa A. (1990). *Gender, Politics and MTV: Voicing the Difference.* Philadelphia: Temple University Press.

Lichtenberg, Jacqueline (1976). *Kraith Collected.* Detroit: Ceiling Press.

Lichtenberg, Jacqueline, Sondra Marshak, and Joan Winston (1975). *Star Trek Lives!* New York: Bantam.

Limon, Jose E. (1983). "Western Marxism and Folklore: A Critical Introduction." *Journal of American Folklore* 96 no. 379: 34–52.

Lipsitz, George (1988). "Mardi Gras Indians: Carnival and Counter Narrative in Black New Orleans." *Cultural Critique* (fall): 99–122.

————. (1990). *Time Passages: Collective Memory and American Popular Culture.* Minneapolis: University of Minnesota Press.

Lombardi-Satriani, Luigi (1974). "Folklore as Culture of Contestation." *Journal of the Folklore Institute* 2: 99–121.

Long, Elisabeth (1989). "Feminism and Cultural Studies." *Critical Studies in Mass Communications* 6 no. 4: 427–35.

Lorrah, Jean (1976a). *Night of Twin Moons.* Murray, KY: Self-Published.

————. (1976b). *Full Moon Rising.* Bronx: Self-Published.

————. (1978). *NTM Collected,* Vol. I. Murray, KY: Self-Published.

————. (1979). *NTM Collected,* Vol. II. Murray, KY: Self-Published.

————. (1984). *The Vulcan Academy Murders.* New York: Pocket.

————. (1988). *Trust, Like the Soul.* Murray, KY: Empire Books.

Lorrah, Jean and Willard F. Hunt (1968). "Visit to a Weird Planet." In *Spocknalia* 3, edited by Devra Langsam and Sherna Burley. Brooklyn: Self-Published.

Marc, David. *Demographic Vistas: Television in American Culture.* Philadelphia: University of Pennsylvania Press, 1984.

Marcus, George and Michael Fischer (1986). *Anthropology as Cultural Critique.* Chicago: University of Chicago Press.

Marnie, ed. (n.d.). *Vila, Please.* St. Louis: 4-M Press.

———. (n.d.). *Avon, Anyone.* St. Louis: 4-M Press.

Martin, Joan (n.d.). "Slash (Read This First)." Informally circulated introduction to slash fiction.

Matthews, Susan R. (1983). *The Mind of a Man Is a Double-Edged Sword.* New York: Strelsau Press.

———. (1985). *Mascarada.* New York: Strelsau Press.

———. (1988). *Shadowplay.* Rochester, NY: P. I. Press.

Meehan, Eileen R. (1990). "Why We Don't Count: The Commodity Audience." In *Logics of Television: Essays in Cultural Criticism*, edited by Patricia Mellencamp. Bloomington: Indiana University Press.

Mellor, Adrian (1984). "Science Fiction and the Crisis of the Educated Middle Class." In *Science Fiction and Social Change*, edited by Colin Pawling. London: Macmillan.

Menefee, Christine (1989). *Meet Spotlight Starman.* Self-Published.

Metz, Christian (1977). "Trucage and the Film." *Critical Inquiry* (summer): 656–75.

McEwan, Emily (1989). *Power.* Wheaton, IL: Green Cheese Press.

McManus, Vickie (1989). "An Irate Fan Speaks." In *Hip Deep in Heroes: A* Blake's 7 *Filk Song Book*, edited by Meg Garrett. Los Angeles: Self-Published.

McManus, Vickie (1989). "Do Not Forsake Me." In *Hip Deep in Heroes: A* Blake's 7 *Filk Song Book*, edited by Meg Garrett. Los Angeles: Self-Published.

McRobbie, Angela (1980). "Settling Accounts with Subcultures: A Feminist Critique." *Screen Education* 34.

———. (1982). "The Politics of Feminist Research: Between Talk, Text, and Action." *Feminist Review* 12: 45–57.

_____. (1984). "Dance and Social Fantasy." In *Gender and Generation*, edited by Angela McRobbie and Mica Nava. London: Macmillan.

_____. (1991). *Feminism and Youth Culture: From Jackie to Just Seventeen*. London: Macmillan.

McRobbie, Angela and Mica Nava, *Gender and Generation*. London: Macmillan.

Mike, Jan M. (1989). Letter. *Interstat* 143 (September): 6.

Modleski, Tania. (1982) *Loving with a Vengeance: Mass-Produced Fantasies for Women*. Hamden, CT: Archon Books.

_____. (1983). "The Rhythms of Reception: Daytime Television and Women's Work." In *Regarding Television*, edited by E. Ann Kaplan. Los Angeles: American Film Institute.

Moore, Henrietta L. (1988). *Feminism and Anthropology*. Minneapolis: University of Minnesota Press.

Morley, David (1980). *The Nationwide Audience: Structure and Decoding*. London: British Film Institute.

_____. (1986). *Family Television: Cultural Power and Domestic Leisure*. London: Routledge, Chapman and Hall.

Moscowitz, Sam (1954). *The Immortal Storm*. New York: ASFO Press.

Nava, Mica (1981). "Drawing the Line." In *Gender and Generation*, edited by Angela McRobbie and Mica Nava. London: Macmillan.

Nelson, Jenny L. (1990). "The Dislocation of Time: A Phenomenology of Television Reruns." *Quarterly Review of Film and Video* 12 no. 3: 79–92.

Nolan, Khrys (1984). "The K/S Completist." *Not Tonight Spock* 3: 15–18.

Oney, Steve (1987). "Is Prime Time Ready for Fable?" *New York Times* (September 20): 37.

Osman, Karen (1982). *Knight of Shadows*. Brooklyn: Poison Pen Press.

Ostrow, Joanne (1989). "Will *Beauty and the Beast* Survive Retooling by CBS?" *Denver Post* (July 25). Reprinted in Vicki Burke and Janet Dunadee (1990). *A Collection of Memories:*

The Beauty and the Beast *Phenomenon*. Grand Rapids: Whispering Gallery Press.

Palmer, Sharon M., L. C. Wells and A. Nea Dodson, eds. (1990). *CrosSignals* 2. Beltsville, MD: Self-Published.

Palmer, Patricia (1986). *The Lively Audience: A Study of Children around the TV Set*. Sydney: Allen and Unwyn.

Paredes, Americo (1977). "On Ethnographic Work among Minority Groups." *New Scholar* 6: 1–32.

"Paula" (1990). "Comfort." In *Southern Comfort 5.5*, edited by Ann Wortham. Altamonte Springs, FL: Ashton Press.

Penley, Constance (1989). "The Female Spectatrix." *Camera Obscura* 20–21: 256–59.

———. (1991). "Brownian Motion: Women, Tactics, and Technology." In *Technoculture*, edited by Constance Penley and Andrew Ross. Minneapolis: University of Minnesota Press.

———. (forthcoming). "Feminism, Psychoanalysis, and the Study of Popular Culture." In *Cultural Studies: Now and in the Future*, edited by Lawrence Grossberg, Cary Nelson, and Paula Treichler. New York: Routledge, Chapman and Hall.

Prather, Anne (n.d.). "Editorial Soapbox." *Denver Filk Anon-y-mouse*: 4–5.

Rabinovitz, Lauren (1989). "Animation, Postmodernism, and MTV." *The Velvet Light Trap* 24 (fall): 99–112.

Rabinowitz, Peter J. (1985). "The Turn of the Glass Key: Popular Fiction as Reading Strategy." *Critical Inquiry* (March): 418–31.

Rache (n.d.). "A Reasonable Man." In *Bright Forests: Songs about Robin of Sherwood*. Albion.

Radway, Janice (1984). *Reading the Romance: Women, Patriarchy, and Popular Literature*. Chapel Hill: University of North Carolina Press.

———. (1988). "Reception Study: Ethnography and the Problem of Dispersed Audiences and Nomadic Subjects." *Cultural Studies* 2 no. 3: 359–76.

Raymond, Eunice (1989). Letter. *Interstat* 138 (April): 3–4.

Reece, J. D. (1990). "A Friendly Drink." In *Southern Comfort 5.5*: 39–47, edited by Ann Wortham. Altamonte Springs, FL: Ashton Press.

Resch, Kathleen (n.d.). Flier, *The Dark Shadows Storyline.* Temple City, CA: Self-Published.

Rhodes, Karen (1989). Letter. *Interstat* 143: 4.

Roberts, Helen, ed. (1981). *Doing Feminist Research.* London: Routledge, Chapman and Hall.

Robin, Doris (1985). "Rise Up, You Challenger." In *Return of Massteria!: Star Wars and Other Filksongs.* Los Angeles: L.A. Filkharmonics, 5.

Rogow, Roberta. (n.d.) "I've Got Fanzines." *Rogow and Company.* Self-Published, currently available through Wail Songs and New World Books.

_____. (n.d.). "Lament to the Station Manager." *Rogow and Company.* Self-Published, currently available through Wail Songs and New World Books.

_____. (1987). "A Use For Argo." *Rec-Room Rhymes* 5: 39.

Roman, Linda, Linda Christian-Smith, and Elizabeth Ellsworth, eds. (1988). *Becoming Feminine: The Politics of Popular Culture.* London: Falmer Press.

Roper, Bill (1986). "Wind from Rainbow's End." *Liftoff to Landing.* Milwaukee, WI: STI Studios, currently distributed by Wail Songs.

Rosaldo, Renato (1989). *Culture and Truth: The Remaking of Social Analysis.* Boston: Beacon Press.

Ross, Andrew (1989). *No Respect: Intellectuals and Popular Culture.* New York: Routledge, Chapman and Hall.

_____. (1991). "Getting Out of the Gernsback Continuum." *Critical Inquiry* (winter): 411–33.

Ross, Jessica. "Roddenberry." *Rec-Room Rhymes* 6: 7.

Rosenthal, Leah and Ann Wortham (1986). "Season of Lies." *Southern Seven,1:* 161–89, edited by Ann Wortham. Altamonte Springs, FL: Ashton Press.

Russ, Joanna (1985). *Magic Mommas, Trembling Sisters, Puritans, and Perverts: Feminist Essays.* Trumansberg, N.Y.: Crossing.

Russell, W. M. S. (1982). "Folktales and Science Fiction." *Folklore* 93 no. 1: 3–30.

Saiid, Kami (1988). "Lover's Quarrel." In *Resistance* 2, edited by Wendy Rathbone. Poway, CA: Self-Published.

Sankek, David (1990). "Fans' Notes: The Horror Film Fanzine." *Literature/Film Quarterly* 18 no. 3: 150–59.

Schatz, Thomas (1981). *Hollywood Film Genres*. New York: MacGraw-Hill.

———. (1986). "The Structural Influence: New Directions in Film Genre Study." In *Film Genre Reader*, edited by Barry Keith Grant. Austin: University of Texas Press.

Schnuelle, Shari (1987). Letter. *Sociotrek* 4: 8–9.

Schweickart, Patrocinio P. (1986). "Reading Ourselves: Towards a Feminist Theory of Reading." In *Gender and Reading: Essays on Readers, Texts, and Contexts*, edited by Elizabeth A. Flynn and P. P. Schweickart. Baltimore: Johns Hopkins University Press.

Schwictenberg, Cathy (1989). "Feminist Cultural Studies." *Critical Studies in Mass Communications* 6 no. 2: 202–08.

Sconce, Jeffrey Alan (1989). *Colonizing Cinematic History: The Cult of "Bad" Cinema and the Textuality of the "Badfilm."* Master's thesis, University of Texas-Austin.

Sebastian (n.d.). "On Heat." Circuit Story.

Sedgwick, Eve Kosofsky (1985). *Between Men: English Literature and Male Homosocial Desire*. New York: Columbia University Press.

Segal, Howard P. (1984). "The Technological Utopians." In *Imagining Tommorow*, edited by Joseph E. Corn. Cambridge: MIT Press.

Segel, Elizabeth (1985). "As the Twig Is Bent . . .': Gender and Childhood Reading." In *Gender and Reading: Essays on Readers, Texts, and Contexts*, edited by Elizabeth A. Flynn and P. P. Schweickart. Baltimore: Johns Hopkins University Press.

Seiter, Ellen (1990). "Making Distinctions in Television Audience Research: Case Study of a Troubling Interview." *Cultural Studies* 4 no. 1: 61–84.

Seiter, Ellen, Hans Borchers, Gabriele Kreutzner, and Eva-Maria Warth (1990). " 'Don't Treat Us Like We're So Stupid and Naive': Toward an Ethnography of Soap Opera Viewers." In *Remote Control: Television, Audiences, and Cultural Power*, edited by Ellen Seiter, Hans Borchers, Gabriele Kreutzner

and Eva-Marie Warth. London: Routledge, Chapman and Hall.

Selley, April (1986). " 'I Have Been, and Ever Shall Be, Your Friend': *Star Trek, The Deerslayer* and the American Romance." *Journal of Popular Culture* 20 no. 1: 89–104.

Sharratt, Bernard (1980). "The Politics of the Popular? From Melodrama to Television." In *Performance and Politics in Popular Drama*, by David Bradby, Louis James, and Bernard Sharratt. Cambridge: Cambridge University Press.

Sholle, David (1991). "Reading the Audience, Reading Resistance: Prospects and Problems." *Journal of Film and Video* 43 no. 1–2: 80–89.

Siebert, Catherine A. (1982). "By Any Other Name." *Slaysu* 4: 44.

Sobchack, Vivian (1990). "The Virginity of Astronauts: Sex and Science Fiction Film." In *Alien Zone: Cultural Theory and Contemporary Science Fiction Cinema*, edited by Annette Kuhn. London: Verso.

Solten, Natasha (1988). "The Conquering Touch." In *Resistance* 2, edited by Wendy Rathbone. Poway, CA: Self-Published.

Spacks, Patricia Meyer (1983). *Gossip.* New York: Alfred A. Knopf.

Spelling, Ian, Robert Lofficer, and Jean-Marie Lofficer (1987). "William Shatner, Captain's Log: *Star Trek V.*" *Starlog*, May: .

Spigel, Lynn (1991). "Communicating with the Dead: Elvis as Medium." *Camera Obscura* 23: 177–205.

Spigel, Lynn and Henry Jenkins (1991). "Same Bat Channel, Different Bat Times: Mass Culture and Popular Memory." In *The Many Faces of the Batman: Critical Approaches to a Superhero and His Media*, edited by William Urrichio and Roberta Pearson. New York: Routledge, Chapman and Hall.

Stein, Mike (1989). "The Final Lesson," as performed at Philcon 1989.

Stevens, Suzanne and S. J. Nasea (1986). *Baker's Dozen.* Taylor, MI: Self-Published.

Stewart, Mary (1970). *The Crystal Cave.* New York: Morrow.

Stoltenberg, John (1989). *Refusing to Be a Man: Essays on Sex and Justice.* Portland: Breitenbush Books.

Strathern, Marilyn (1987). "An Awkward Relationship: The Case of Feminism and Anthropology." *Signs* 12 no. 2: 276–92.

———. (1987). "Out of Context: The Persuasive Fictions of Anthropology." *Current Anthropology* 28 no. 3: 1–77.

Streeter, Thomas (1988). "Beyond the Free Market: The Corporate Liberal Character of U.S. Commercial Broadcasting." *Wide Angle* 11 no. 1: 4–17.

Sutton, Brenda Sinclair (1989). "Strangers No More." *Strangers No More.* Santa Monica, CA; DAG. Available through Wailsongs.

Taylor, Helen (1989). *Scarlett's Women:* Gone With the Wind and Its Female *Fans.* New Brunswick: Rutgers University Press.

Taylor, Karla (1989). Letter. *Interstat* 143 (September): 7.

Tennison, Barbara (1990). "Strange Tongues." *Terra Nostra Underground.*

———. (n.d.). "Masque For Three: Night's Masque." Privately circulated story.

Terhaar, Rita (1988). "What They Didn't Tell Us." *The Whispering Gallery* 2 :5.

Tetzlaff, David (1986). "MTV and the Politics of Postmodern Pop." *Journal of Communication Inquiry* 10 no. 1: 80–91.

Thompson, Leslie (1974). "*Star Trek* Mysteries—Solved!" In *The Best of Trek*, edited by Wauren Irwin and G. B. Love. New York: New American Library.

Thorburn, David (1987). "Television Melodrama." In *Television: The Critical View*, edited by Horace Newcomb. New York: Oxford University Press.

Trimble, Karen (1985). "Harrison, Harrison or Revenge of the Harrison Ford Slobber Song." In *Return to Massteria!: Star Wars and Other Filksongs.* Los Angeles: L.A. Filkharmonics.

Tulloch, John (1990). *Television Drama: Agency, Audience, and Myth.* London: Routledge, Chapman and Hall.

Tulloch, John and Henry Jenkins (forthcoming). *The Science Fiction Audience:* Dr. Who, Star Trek *and Their Fans.* London: Routledge, Chapman and Hall.

Turkle, Sherry (1984). *The Second Self: Computers and the Human Spirit.* New York: Touchstone.

Uricchio, William and Roberta E. Pearson (1991). "I'm Not Fooled by That Cheap Disguise." In *The Many Faces of the Batman: Critical Approaches to a Superhero and His Media*, edited by William Uricchio and Roberta A. Pearson. New York: Routledge, Chapman and Hall.

Urhausen, Mary G. (1990). Letter. *Newcomer News* 1 (May): 9.

Verba, Joan Marie (1989a). Letter. *Interstat* 141–142 (July/August): 1.

———. (1989b). Letter. *Interstat* 143 (September): 11–12.

———. (1990). Letter. *Interstat* 147 (January): 7–8.

Vermorel, Fred and Judy (1985). *Starlust: The Secret Fantasies of Fans*. London: W. H. Allen.

Vitti, Bonnie (1990). "Editorial." *Children of the Federation*. Self-Published.

Walkerdine, Valerie (1986). "Video Replay: Families, Films, and Fantasy." In *Formations of Fantasy*, edited by Victor Burgin, James Donald and Cora Kaplan. London: Methuen.

Warner, Henry (1969). *All Our Yesterdays*. New York: Advent.

Warren, Jr., William (1983). "Ballad of Apollo XIII." *Minus Ten and Counting*. El Cerrito, CA: Off Centaur.

Watts, Eric (1988). Letter. *Interstat* 131–132 (September-October): 15.

Weber, Chris (1982). "All You Get Is Drek." *Fan-Tastic: Filk Songs and Other Fannish Delights* 1 no. 1.

———. (1985). "What Does a Dorsai Do?" *I Filk: The Science Fiction Folk Music of Chris Weber*. Santa Monica, CA: DAG.

Werkley, Vicki Hassel (1989). "Making History—The Spotlight Starman Way." *Blue Lights* (fall).

Wenk, Barbara (1980). *One-Way Mirror*. Brooklyn: Poison Pen Press.

Weiskind, Ron (1989). "*Beauty*ful Surprises." *Pittsburgh Post-Gazette* (May 29). White, T. H. (1939). *The Once and Future King*. New York: G. P. Putnam's Sons.

Williams, Linda (1990). *Hardcore: Power, Pleasure, and the 'Frenzy of the Visible'*. Berkeley: University of California Press.

Williams, Raymond (1974). *Television: Technology and Cultural Form*. London: Fontana.

Williams, Rosalind (1990). *Notes on the Underground: An Essay on Technology, Society, and the Imagination.* Cambridge: MIT Press.

Wilson, Alison (1990). Letter. *Newcomer News* 1 (May): 8.

Woman's Studies Group, eds. (1978). *Women Take Issue: Aspects of Women's Subordination.* London: Hutchinson.

Wood, Robin (1986). *Hollywood: From Vietnam to Reagan.* New York: Columbia University Press.

Wortham, Ann (1988). *Southern Lights* 4. Altamonte Springs, FL: Ashton Press.

Yardley, O. (n.d.). "Stand and Deliver." Circuit Story.

Zdrojewski, Ed (1988). "The Sixth Year" In *The Weight, Collected* edited by Lori Chapek-Carleton. Lansing, MI: T'kuhtian Press.

Index

ABC, 28, 78
Abortion, 83–84
Adams, Fanny, 205
Adderly, 41
Adorno, Theodor, 51
Adventures of Huckleberry Finn,
203
Aesthetics, 60–61, 223–249, 268–
273
Agency, 63
Agostino, Joanne, 199
AIDS, 220
Air Supply, 235, 237
Airey, Jean, 173
Airwolf, 157, 170
Alias Smith and Jones, 158
Alien Nation, 38, 56–57, 60, 75,
82, 92 (Pic.), 92–95, 164, 233–
234, 237 (*See also* George
Francisco, Cathy Frankel, Matt
Sikes)
Alien Relations, 92
Aliens, 196
Allen, Robert, 111
Almedina, Patricia, 137
Alternatives, 188, 216
Altman, Rick, 55, 123
Alt.tv.twinpeaks, 77–79, 109–112
Amadeus, 41
Amanda (*Star Trek*), 82, 94, 162–
163
Amazing Stories, 46
American Chronicles, 77
Amesley, C.E., 19, 65–66, 76
Anarchists, 178–183
Andorian (*Star Trek*), 180, 186
Andrew, Dudley, 123
Androgyny, 193–194, 196–198,
215–216, 218
Ang, Ien, 21–22, 65, 107, 286

Anglofans, Unlimited, 41, 43
(Pic.), 44
"Anais," 200
Animazine, 41
APA-Filk, 47
APA-VCR, 71
Arat, Andrea, 194
Are You Lonesome Tonight?, 252
Arellanes, Denetia, 170
Aristotle, 61
Art Forum, 47, 161
Art Worlds, 46–49, 253
Arthur, King, 37
Authorship, 24–26, 110–111, 248
Avengers, The, 17, 37, 69, 196 (*See
also* Emma Peel, John Steed)
Avon, Kerr (*Blake's 7*), 95, 163,
165, 168, 169, 171, 173, 174,
175, 194, 200, 202–203, 207–
208, 210–212, 213, 214, 215–
216, 218, 226–227, 258, 261
Avon, Anyone?, 176

Bad Film Cult, 63
Bacon-Smith, Camille, 157, 191
Baker, Colin, 176
Baker, Tom, 176
Baker's Dozen, 176
Bakhtin, Mikhail, 224
Balzac, Honore de, 53, 67
Barney Miller, 207
Barry, Natasha, 207
Barthes, Roland, 11, 67–68
Barwick, Linda, 81
Bates, London, 210–211, 220
Batman (Movie), 30
Batman (TV), 35, 37, 72, 158 (*See
also* Catwoman)
Battlestar Galactica, 252

Bayfilk, 274
BBC, 72, 173
Beast Master, The, 38
Beatles, The, 13, 15
Beauty and the Beast, 17–18, 28, 34, 38, 41, 53, 58, 60, 70, 72, 76–77, 82, 89–90, 93–94, 120 (Pic.), 131 (Pic.), 139 (Pic.), 147 (Pic.), 121, 123, 125–151, 155, 157, 164, 167, 170, 176, 219, 231, 258, 278, 282, 284 Episodes: "Alchemist, The," 126, "Ashes, Ashes," 137, "Beast Within," 126, "Brothers," 137, "Chamber Music," 136, 137, "Children's Story, A," 126, 127, "China Moon" 127, "Dark Spirit," 126, 135, "Dead of Winter," 126, "Everything Is Everything," 126–127, "Fair and Perfect Knight, A," 134, "Fever," 127, "Happy Life, A," 127, 134, 142, 144, "Hollow Men, The," 135, "Impossible Silence, An," 127, "Masques," 126, 134, "No Iron Bars a Cage," 126, "No Way Down," 126, "Once Upon a Time . . .," 134, 143, "Orphans," 127, 134, "Outsiders, The," 135, "Promises of Someday," 134, "Remember Love," 137, "Shades of Grey," 127, "Siege," 126, "Song of Orpheus," 126, "Temptation," 126, "Terrible Savior," 126, 135, 143, "Though Lovers Be Lost . . .," 145, "To Reign in Hell," 126, Names: "Beastie Girls" 36, 129, Burch, Elliott, 134, Diana, 149–150, Father, 126, 146, 150 (*See also* Catherine Chandler, Paracelsus, Vincent)
Becker, Howard, 46
Beckett, Sam (*Quantum Leap*), 152, 153 (Pic.), 163, 170, 174, 202
Belle, 209
Bennett, Harve, 118

Bennett, Tony, 68
Berman, Ruth, 173
Bernstein, Leonard, 263
Betina Sheets, 200
Bianco, Margery Williams, 50, 51
Biem, Michael, 14
Big Valley, The, 157
Bishop, Jeff, 280
Black Adder, 157
Black, Alexis Fagin, 49
Blackman, Mark, 259–260
Blaes, Tim, 165
Blake, Roj (*Blake's 7*), 163, 165, 168–169, 174–175, 191, 194, 196–197, 200, 203, 207–208, 210–212, 214, 216, 218, 226–227, 258
Blake's 7, 28, 38, 43, 44, 48, 64 (Pic.), 70, 72, 90–91, 156–157, 163–165, 167, 169, 170, 173, 176, 188, 191, 196, 201, 206, 209, 213, 220, 226–227, 230, 237, 246, 252, 253, 258, 261, Episodes: "Animals," 95, "Blake," 244, "Orbit," 211, "Ultraworld," 169, Terms: Alpha, 212–213, Delta, 212–213 (*See also* Kerr Avon, Roj Blake, Cally, Federation, Oleg Gan, Anna Grant, Liberator, Dayna Mellanby, Vila Restal, Servalan, Soolin, Jenna Stannis, Del Tarrant, Travis)
Bleich, David, 108–109, 112–113
Bloch, Robert, 22
Blood-Orgy of the She-Devils, 63
Boardman, Mark, 255
Bodie, William Andrew Philip (*The Professionals*), 163, 171, 173, 174, 176, 192, 194, 195 (Pic.), 199–200, 203, 206–210, 215–216, 218, 228–229
Bonanza, 175
Boorman, John, 38
Bordan, Lizzie, 284
Bordwell, David, 89
Born In Flames, 284
Bourdieu, Pierre, 16–18, 60–62
Boylan, Susan, 165

Bradley, Marion Zimmer, 37–38, 47, 258
Brecht, Bertholt, 61–62, 73
Bright, Lynna, 192, 208–209, 216
Brown, Mary Ellen, 81
Brown, Roberta, 73
Brunsdon, Charlotte, 39, 81
Bryant, Danni, 100
Buck Rogers, 167, 251 (*See also* Col. Wilma Deering)
Buckaroo Bonzai, 90, 157
Buckingham, David, 65
Budd, Michael, 27, 67
Buffet, Jimmy, 225, 237
Bunnies From Hell, 230, 246–247
Burchill, Julie, 13–14
Burke, Vicki, 120, 127, 130, 132, 136–137, 146
Burns, Anne, 84, 97
Burton, Tim, 30
Butch Cassidy and the Sundance Kid, 236

Cabinet of Dr. Caligari, 67
Cagney and Lacey, 13, 28, 129
California Crew, 229, 234–236, 238, 246, 248
Callan, 236
Calavicci, Al (*Quantum Leap*), 152
Cally (*Blake's 7*), 163, 165, 167, 169, 175, 197–198, 200, 227
Campbell, Joseph, 13
Cannell Files, 41
Cannell, Stephen J., 229
Canon Formation, 94–98, 134–135
Carmen Miranda's Ghost, 275
Carnall, Jane, 212–213, 214
Carr, Anne, 171
Caruthers-Montgomery, P. L., 52, 69
Cascade of Dreams (Zine), 146
Castillo, Martin (*Miami Vice*), 175
Catwoman (*Batman*), 35, 37
CBS, 28, 121, 127, 129, 231
C. C., 227, 228
Challenger, 258, 266
Chalmers, Daniel (*Remington Steele*), 163

Chandler, Catherine, (*Beauty and the Beast*), 94, 121, 125–127, 129, 134–138, 139 (Pic.), 140–146, 147 (Pic.), 148–150, 151, 164, 167, 175, 196, 231
Chapel, Christine (*Star Trek*), 83, 167, 169, 174, 181–182, 196, 252, 264
Chapman, Dwight, 13
Chartier, Roger, 271–272
Cheers, 170
Chekov, Pavel (*Star Trek*), 82, 103–104, 264
Cherryh, C. J., 258
"Child Is Being Beaten, A," 200
Childhood, 35, 55, 163, 264–265
Children of the Federation, 163
Childs-Helton, Barry, 254, 262–263
Childs-Helton, Sally, 262, 268
Christy, Jo Ann, 261
CI-5 (*The Professionals*), 43, 44, 156, 208, 216
Clapp, T. J. Burnsides, 265, 277, 280–281
Class, 212–213
Clemens, Brian, 203
Clifford, James, 4
Cocteau, Jean, 125
Cold Fish and Stale Chips, 161
Collins, Barnabas (*Dark Shadows*), 42
Collins, Joan, 76
Collins, Phil, 232
Colors of Love, 275
Comlink, 41, 95
Communications Console, The, 159
Community, 2–3, 160–161, 237–238, 246–248, 255–260, 280–283
Compuserve, 77
Computer Nets, 41, 77–79, 109–112, 128, 278
Constructed Reality Videos, 228–229, 234, 252
Conventions, 41, 46–49, 237–239, 247, 253–260, 262
COOP, 28
Cooper, Dale (*Twin Peaks*), 112, 174, 214

Copyright Law, 30–32, 158, 276
Cosmic Fuck Collected, 185–186, 194
Cousteau, Jacques, 226
Cowley, George (*The Professionals*), 171, 199
Cox, Carol, 56, 94
Creation Cons, 92
Crockett, Sonny (*Miami Vice*), 170, 175, 235
Criticism, 86–119, 134–138
CrosSignals, 170
Cruise, Julee, 77, 110
Crusher, Dr. Beverly (*Star Trek: The Next Generation*), 37–38, 82, 96, 98, 103, 106, 169, 174
Crusher, Wesley (*Star Trek: The Next Generation*), 95, 103
Crystal Cave, The, 38
Crystal Visions, 146
Cubitt, Sean, 73
Culture, 2–3

Dallas, 21–22, 107
Danger Mouse, 156
Danler, Signe Landon, 42 (Pic.)
Darkover, 258
Dark Shadows, 69, 138, 167 (*See also* Barnabas Collins, Dr. Julia Hoffman)
Dark Shadows Storyline, The, 69
Darrow, Paul, 239, 252
Data (*Star Trek: The Next Generation*), 37–38, 84, 95, 98, 103, 105 (Pic.), 169, 230–231
Datazine, 47, 156, 159
Davis, Anne, 261
Davis, Diane, 141
D. C. B., 228
De Certeau, Michel, 3, 23–27, 32–34, 36, 44, 49, 51–52, 61–62, 63, 86, 152, 154–155, 223
Deering, Col. Wilma (*Buck Rogers*), 167
Deerslayer, The, 203
DeLeon, Gloria M., 149
Demeter, 167
Dempsey and Makepeace, 41
Denver, John, 226

Devlin Connection, The, 157
Diane, 214
Dickens, Charles, 27
Dickson, Gordon, 258, 263–264
Dire Straits, 237
Distance, 6, 18, 60–66, 115, 285
D'neese, 197
Doane, Mary Ann, 61
Doctor, The (*Doctor Who*), 42, 163, 170
Doctor Who, 28, 43, 69, 87, 91, 95, 157, 163, 166 (Pic.), 167, 170, 176 (*See also* The Doctor, The Master, Sarah Jane Smith, TARDIS, Time Lords)
Dorsai, 258, 263–264
Double Viewing, 66
Doyle, Ray (*The Professionals*), 171, 172 (Pic.), 174, 176, 190, 194, 195 (Pic.), 199–200, 203, 206–208, 210, 215, 218, 228, 231
Downs, Gerry, 216
Dragnet, 63, 68
Drew, Dennis, 262
Dune, 38
Dunadee, Janet, 120, 127, 130, 132, 146
Dyar, Allyson, 75
Dyer, Richard, 281
Dynasty, 76

E. T., 192
Eagles, The, 237
Ecklar, Julia, 250–252, 260
Eco, Umberto, 50
Ellis, John, 54–55
Ellison, Harlan, 22
Elms, Duane, 262
Emotional Intensification, 174–175
Emotional Realism, 107, 115–116
Empire Strikes Back, The, 227
"Encoding and Decoding," 33–35
Ender's Game, 251
Enterprise (*Star Trek*), 164, 170, 171, 173, 175, 178–179, 182, 185, 245, 264, 282
Entman, Robert, 27
Enzensberger, Hans Magnus, 281
Equalizer, The, 170, 236

Eros, 200
Escape from New York, 157, 251
Ethnographic Authority, 3–4, 6–7
*Everything But . . . the Kitchen
Sink*, 41, 157
Excalibur, 38
Excalibur, 230, 246

Fade To Black, 14, 19
Faded Roses, 41, 146
Fagin (*Oliver!*), 226
Fame, 39
Famous Monsters of Filmland, 4
Fan, The, 14
Fanaticus, 12–13
Fanzines, 30–33, 41, 45, 47, 91,
 92–93, 102, 104, 112, 146, 151–
 184, 185–222, 230–232, 247,
 259, 262, 279, 280, 286, Terms:
 Alternative Universes, 176,
 Bootlegging, 160, Crossover
 Stories, 170–171, 228, 252, Fifth
 Season Stories, 165, 176, First
 Time Stories, 206–219, Hurt-
 Comfort Stories, 174–175, 209,
 Letters of Comment, 161–162,
 Letterzines, 41, 95–107, 151,
 161, Mary Sue Stories, 171, Plot,
 What Plot? Stories, 191, Post
 Gaude Prime Stories, 164–165,
 174, 210–211, 230,
 Professionalism, 159,
 Pseudonyms, 200, Story
 Circuits, 158, 201, 280, Stories:
 "Visit to a Weird Planet," 173,
 "Visit to a Weird Planet
 Revisited," 173
Faulkner, William, 251
Fawlty Towers, 43, 170
Federation (*Star Trek*), 96–97, 107,
 168, 177–178, 182–183, 185
Federation (*Blake's 7*), 211, 214,
 218
Fenn, Sherilyn, 77
Fetterly, Judith, 108, 113
Feuer, Jane, 55
Feyrer, Gayle, 185–186, 194
Fiedler, Leslie, 203

Filk, 152, 156, 250–276, 280,
 Songs: "Ballad of Apollo XIII,"
 266, "Banned From Argo," 264,
 "Blake Bunch, The," 253, "Born
 Again *Trek*," 250–251, 260,
 "Born of Your Sun," 252, "Con
 Man Blues," 262, "Dear Mr.
 Lucas," 261, "Do Not Forsake
 Me," 261, "Final Lesson, The,"
 266, "Flying Island," 254,
 "Gilligan's Liberator," 253,
 "Hope Eyrie," 266–267, "Irate
 Fan Speaks, A," 261, "I've Got
 Fanzines," 261, 263, "Lament to
 the Station Manager," 262,
 "Living Down Below," 258,
 "Making Wookie," 252,
 "Mundania," 263, 264, "One
 Final Lesson," 252, "People in
 the Tunnel World, The," 258,
 "Reasonable Man, A," 252,
 "Reporters Don't Listen to
 Trufen," 263, "Revenge of the
 Harrison Ford Slobber Song,"
 261, "Roddenberry," 261, "Rose
 For Emily, A," 251, "Science
 Wonks, Wimps and Nerds,"
 260–261, 265–266, "Smurf
 Song," 262, "Sound of Cylons,"
 252, "Strangers No More," 255,
 "Take This Book and Shove It,"
 262, "Toast For Unknown
 Heroes," 266, "Trekker," 261,
 263, "Ultimate Avon Drool
 Song, The," 261, "Use For Argo,
 A," 263, "Video Lust," 261,
 "Weekend Only World," 277,
 280–281, "What Does a Dorsai
 Do," 264, "Wind From
 Rainbow's End," 265, Terms:
 Bardic Circles, 256, 269, Choir
 Practice, 256, 269, Filk
 Hymnals, 257, 269, Midwest
 Chaos, 256, Ose, 255, Pick, Pass
 or Perform, 256
Filkcon, 274
Filkers Anonymous, 259
Firebird Arts, 275–276
Fireside Tails, 41

Firestarter, 251
Firestorm, 267
Fish, Leslie, 49, 177–184, 193, 199, 251, 264, 265–266, 267, 272, 273, 274–276
Fish, Stanley, 88
Fiske, John, 5, 55, 124, 232–233, 234, 270–271, 273, 278
Fister-Liltz, Barbara, 49
Flashdance, 39
Fletcher, Robin, 260
Fleury, Gail P., 98
Fly, The, 258
Flynn, Elizabeth, 108, 115
Folk Culture, 268–273
Folk Music, 257, 268–269
Folksongs For Folks Who Ain't Even Been Yet, 274, 275
Ford, Harrison, 41, 261
Foster, Jodie, 13
Fox, William, 271
Fox Network, 92, 94
Fraggle Rock, 170
Francisco, George (*Alien Nation*), 92, 93
Frankel, Cathy (*Alien Nation*), 82, 94, 233, 234
Frank's Place, 128
Frayser, Tim, 101
Freeman, Camila W., 148
Fresh Beaver Tails, 92
Freud, Sigmund, 200
Frisky Business, 157
From Eroica With Love, 90, 218
Frost, Mark, 77

G.A.L. Club, 19, 20 (Pic.)
Gan, Oleg (*Blake's 7*), 191
Garland, Beverley, 170
Garrett, Maureen, 31
Garrett, Meg, 70, 97, 260–261, 269
Garrett, Susan M., 40, 160–162
Gender and Reading, 108
Gendered Reading, 108–116
Generic Ad Zine, 159
Generic Contract, 123–124
Genesis, 251
Genre Theory, 123–125, 127, 132–134, 137–138

Genre Shifting, 169–170
Germer, Alicia, 84
Gernsback, Hugo, 46, 161
Ghostbusters, The, 157, 170
Gibson, Mel, 41
Gilbert, Debbie, 98
Girl From UNCLE, The, 37
Gitlin, Todd, 68, 124
Glasgow, M. Fae, 200, 205, 213
Glass Key, The, 133
Glen or Glenda, 63
Gless, Sharon, 13
Gold, Lee, 263
Gordon, Howard, 126
Gossip, 80–85, 155
Grant, Anna (*Blake's 7*), 165, 211, 220
Gray, Ann, 55–56
Great Bird of the Galaxy, 251
Great Broads of the Galaxy, 252, 261
Greatest American Hero, The, 17
Green, Shoshanna, 210
Green Hills of Earth, 258
Grossberg, Lawrence, 54–55, 57, 283–284
Group Viewing, 76–77

H. G., 194, 207
Hakucho, 212
Haldeman, Laurie, 173
Hall, Stuart, 33–35, 39, 56
Hamilton, Linda, 121, 145
Hammett, Dashiel, 133
Hardcastle and McCormick, 93–94, 244
Hartley, John, 124
Hartwick, Sue-Anne, 93
Hawaii 5-O, 157
Heathers, 110
Hebdidge, Dick, 39
Heilbrun, Carolyn G., 196
Heinlein, Robert, 258
Hellguard Social Register, The, 165
Hellhound, 165
Helper's Network, 121, 128–129
He-Man and the Masters of the Universe, 156

Henry V, 37
Herbert, Marguerete S., 121
Hetroglossia, 224–227, 253
Hillyard, Denise, 75
Hinkley, John, 13
Hobson, Dorothy, 39, 81
Hodge, Robert, 55
Hoffman, Dr. Julia (*Dark Shadows*), 167
Hoggett, Paul, 280
Holland, Norman, 108
Holly, Ann (*The Professionals*), 220
Holmes, Sherlock, 27
Holt, Laura (*Remington Steele*), 174, 229, 238
Homosocial Desire, 186, 202–219
Homophobia, 205, 213
Houston Knights, 93
Huff, Laurel, 56–57
Hughes, Karene, 146
Hunt, Berkeley, 107
Hunt, Willard F., 173
Hunter, Kendra, 89, 187
Hunter, 41, 229
I Spy, 41
IDIC (*Star Trek*), 116, 251
Indifference, 54–55, 57–58
Incredible Hulk, The, 127
Interstat, 95
Interpretive Community, 88–89
Intertextuality, 37–39, 67–68
Invaders, The, 17
Issacs, D. M., 107
It Takes a Thief, 157

Jackson, Sourdough, 259
Jameson, Fredric, 281
Jane, 171
Jane Eyre, 138
Japanese Animation, 53, 76–77, 90, 157, 254
J. E., 226, 236
Jean, 172 (Pic.)
Jefferson, Tony, 39
Jenkins, Henry, 35, 55, 157, 187, 252, 279
Jewett, Robert, 13
Joel, Billy, 237

Jones, Deborah, 80, 84
Jones, Henry "Indiana" (*Raiders of the Lost Ark*), 170, 258
Junius, Kimberley, 87

Kaplan, E. Ann, 232, 237
Katz, Aya, 253
K. S., 226
K/S, 185–186, 193–194, 198, 206, 216 (*See also* Slash)
Keaton, Buster, 14
Keaton, Michael, 30
Keeler, Edith (*Star Trek*), 175
Keeler, Garrison, 258
Kelly, DeForest, 9, 173
Kenobi, Obi-Wan (*Star Wars*), 168–169
Key, Francis Scott, 269
K. F., 225, 228
Khan Noonian Singh (*Star Trek*), 104, 250–251
Kill The Dead, 170
King, Amanda (*Scarecrow and Mrs. King*), 174, 235
King, Carole, 230
King of Comedy, The, 14
Kipling, Rudyard, 251
Kirk, James T. (*Star Trek*), 9–10, 13, 42, 52, 85, 96, 99, 101, 104, 106, 168, 169–170, 171, 173–175, 177–183, 185–186, 193–194, 196, 198–199, 203, 206, 209–210, 216, 218, 221, 226, 232, 240–243 (Pics.), 244–246, 251, 264
Kirkland, Lee, 170
Kista, 169
K. L., 228
Klingons (*Star Trek*), 11, 19, 97–98, 101, 104, 168–169, 179
Kluge, Jean, 37–39, 49, 171, 251
Knight, Sylvia, 211–212
Knight of Shadows, 168
Kopmanis, Gretchen, 121
Koslow, Ron, 125, 127, 129
Kraith, 169–170
Kuryakin, Illya (*Man From UNCLE*), 170, 174, 187, 203, 206, 209, 227

L. A. Filkharmonic, 260–261, 269
L. A. Law, 90, 102
Lacey, Jenny, 261
Ladyhawke, 251
LaForge, Geordi (Star Trek: The
 Next Generation), 98, 103
Lamb, Patricia F., 157, 190, 193–
 194, 196–198, 215–216, 218
Land, Jane, 167, 169, 176
Landers, Randall, 104
Landman, Elaine, 34, 122
Land of the Giants, 17
Larkin, Katrina, 165
Late Spring, 74
Laugh-In, 37
Lauper, Cyndi, 40
Lawrence, John Shelton, 13
L. B., 234–236, 244
Lee, Tanith, 170
Legend of Robin Hood, The, 239
LeGuin, Ursula, 37, 182
Lehrer, Tom, 258
LeMasters, Kim, 125, 129
Lennon, John, 13
Lesbian, 167, 197–198, 204–205,
 220
Lester, Janice (Star Trek), 175, 180
Lethal Weapon, 41, 236
Letter From an Unknown Woman,
 74
Lewis, Lisa, 40, 233
L. H., 199
Liberation Television (LTV), 246
Liberator (Blake's 7), 165, 171, 282
Lichtenberg, Jacqueline, 49, 169–
 170
Life Without Limits, A, 146
Limon, Jose, 271
Lipsitz, George, 271–272
Living-Room Videos, 238–239,
 244–246
Lombardi-Satriani, Luigi, 271
Lorrah, Jean, 45, 49, 162–163, 169,
 173
Lost in Space, 17, 37, 158
Lotta Sleaze, 200
Lovett, Suzan, 49, 171, 187 (Pic.),
 195 (Pic.), 217 (Pic.)
Lucas, George, 164

Lucasfilm, 30–31
Lynch, David, 77, 110–111

Mad Magazine, 4, 37
Madame Bovary, 15
Madonna, 40–41
Magic Flute, The, 110
Magnum, P.I., 157, 229
Maiewski, Shirley, 11
Man From UNCLE, 157, 170, 174,
 187 (Pic.), 188, 227 (See also
 Illya Kuryakin, Napoleon Solo,
 THRUSH)

Manga, 90, 218
Manilow, Barry, 15
Manson, Charles, 13
Marc, David, 124
Mardi Gras Indians, 272
Mar, Kathy, 275
Martin, George R. R., 127
Martin, Joan, 188, 201–202
M*A*S*H, 69, 157
Master, The, 157
Master, The (Doctor Who), 168
Master of the Revels, 217 (Pic.)
"Matinee Girls," 12
Matthews, Susan R., 165
Max Headroom, 157, 158
M. B., 228
M'Benga, Dr. (Star Trek), 102, 183
McCaffrey, Anne, 258
McAuliffe, Christa, 266
McCall, Robert (The Equalizer),
 170, 236
McCoy, Joanna (Star Trek), 102–
 103
McCoy, Leonard (Star Trek), 52,
 84, 96, 99, 103–104, 169, 173–
 174, 178, 182–183, 186, 216, 232
McManus, Vickie, 261
McRobbie, Angela, 39
MediaWest, 28, 41, 47, 92, 94, 128,
 159, 247–248
Meehan, Eileen, 29–30
Mellanby, Dayna (Blake's 7), 167,
 196, 230
Mellor, Adrian, 87
Memory, 35

Meta-Text, 98–107, 137–138, 146, 151, 155, 162, 278
Methodology, 4–8, 285–287
Metz, Christian, 65
McEwan, Emily, 165, 254
Miami Verse, 156
Miami Vice, 156, 165, 170, 188, 234–235 (*See also* Martin Castillo, Sonny Crockett, Ricardo Tubbs)
Middleton, Margaret, 274
Mike, Jan M., 97
(The Mind of Man Is A) Double-Edged Sword, 165
Misery, 14, 19
Misreading, 33
Mists of Avalon, The, 38
Moby Dick, 203
Mod Squad, The, 69
Modleski, Tania, 55, 207, 218
Moonlighting, 138, 157, 229
Moral Realignment, 168–169
Morley, David, 33, 55
MTV, 40, 232–233, 234, 237
Muldaur, Diane, 102
Mundanes, 154, 191, 255, 262–264, 282
Murder on San Carmelitas, 208–209
MVD, 225, 228, 230–231, 232, 238–246, 240–243 (Pics.)

NASA, 37, 258, 266–268
Nathan-Turner, John, 176
Nationwide, 33
Nava, Mica, 39
NBC, 28, 41, 106
Neilson Ratings, 29–30, 94, 127–128
Nelson, Jenny L., 68–69
Newcomer News, 92
Newsweek, 11–12, 19
Nightbeat, 41
Night of The Twin Moons, 162–163
Nimoy, Leonard, 11, 173
Nomadic Reading, 27, 36–44, 223, 251–252, 259, 283

Not the MediaWest Program, 29 (Pic.)
Nowakowska, Maggie, 177
Nuernberg, Kate, 92 (Pic.), 153 (Pic.)

Off Centaur Publications, 274
Oliver!, 226
Omicron Ceti Five, 275
On the Double, 47, 220
Once and Future King, The, 38
Once Upon a Time . . . Is Now, 130
One Way Mirror, 173
Organa, Leia (*Star Wars*), 227
Osman, Karen, 168–169
Outer Limits, The, 17

Packard, Josie (*Twin Peaks*), 174
Palmer, Laura (*Twin Peaks*), 78, 110, 214
Palmer, Patricia, 55
Paracelsus (*Beauty and the Beast*), 126, 134, 168
Paradise, 157
Paramount, 28, 98
"Paula," 196–197
Pedagogy, 25–26
Peel, Emma (*The Avengers*), 37, 175
Penley, Constance, 85, 157, 159, 190, 198, 218
Pern, 258
Personalization, 171, 173
P. F. L., 227
Phantom of the Opera, 41
Philcon, 255–260
Picard, Jean-Luc (*Star Trek: The Next Generation*), 37–38, 82–83, 96, 98–101, 103, 106–107, 169, 174–175, 226
Pike, Christopher (*Star Trek*), 84, 163, 226, 244
Pipeline, 130
P. K., 227, 234, 244
Planet of the Apes, 170
Playboy, 77
Play It Again, Sam, 14

Poaching, 23–27, 32–34, 36, 49,
 62, 223–224, 252–253, 268, 283
Poltrack, David, 129
Pon Farr (*Star Trek*), 118, 174,
 185–186, 191
Popular Expertise, 86–88
Pornography, 190–193
Postmodernism, 54–55, 232–234,
 238, 283
Power, 165
Presley, Elvis, 15, 252
Prime Time, 41, 157
Prisoner, The, 17, 69, 77, 170
Proctor, Martin F., 166 (Pic.)
Professionals, The, 43, 70, 90–91,
 156, 158, 161, 163, 170–171, 172
 (Pic.), 188, 190, 195 (Pic.), 199,
 201, 203, 208, 217 (Pic.), 220,
 228, 231, 237, 246, Episodes:
 "Discovered in a Graveyard,"
 174 (*See also* William Andrew
 Philip Bodie, CI-5, George
 Cowley, Ray Doyle, Ann Holly)
Program Guides, 69–70, 92–93
Program Selection, 89–94
Promise of Eternity, A, 146
Proximity, 6, 60–66, 115, 155,
 277–278, 285
"PTL Club, The," 200
Dr. Pulaski (*Star Trek: The Next
 Generation*), 84, 101–102
Punks, 39

*Quantum Beast: All's Well That
 Ends Well*, 170
Quantum Leap, 28, 152–154, 153
 (Pic.), 163, 170, 237, 258 (*See
 also* Sam Beckett, Al Calavicci)
"Quest, The," 37–39
Queen, 230

Rabinowitz, Peter J., 132–133, 138
Rache, 252
Rachid (*Seventh Voyage of
 Sinbad*), 228–229
Radway, Janice, 6, 36, 60, 68, 138,
 142–144, 149, 218
Raiders of the Lost Ark, 234
Rambo, 236

Rand, Janice (*Star Trek*), 9
Rat Patrol, 157
Raymond, Eunice, 118
Reading vs. Writing, 44–46
Reading the Romance, 6
Real Ghostbusters, The, 157
Recombination, 124–128
Recontextualization, 162–163
Red Dwarf, 70
Refocalization, 165–167
Refusing to Be a Man, 185
Remington Steele, 41, 138, 157,
 163, 170, 174, 229, 238 (*See also*
 Daniel Chalmers, Laura Holt,
 Remington Steele)
Reece, J. D., 197
Renault, Mary, 196
Rereading, 67–75, 278
Rerun, 41, 42 (Pic.)
Reruns, 68–69
Resch, Kathleen, 69
Resistance Through Rituals, 39
Restal, Vila (*Blake's 7*), 163, 165,
 169, 200, 212–213, 218, 226–227
Rhodes, Karen, 83
Riker, William (*Star Trek: The
 Next Generation*), 83, 85, 96,
 101, 103, 106–107, 116, 117
 (Pic.), 169, 175
Riley, Kevin (*Star Trek*), 102
Riptide, 41, 152, 229
River, Karen, 49
Roantree, Jenneth (*The Weight*),
 180–181
Road Warrior, The, 41
Robin, Doris, 260, 266
Robin of Sherwood, 168, 252, 282
Robinson, Ann, 230
Robot Monster, 63
Rocky and Bullwinkle, 170
Roddenberry, Gene, 106, 109, 173,
 176, 178, 182, 261
Rogow, Roberta, 92, 258, 261–263,
 274–275
Role-Playing Games, 254
Romance, 126–127, 133–134, 137–
 151, 193–194, 196, 218–219
Romulan Commander (*Star Trek*),
 175

644446

Romulans (*Star Trek*), 101, 106, 165, 168–169, 179
Ronstadt, Linda, 237
Roper, Bill, 265
Rosaldo, Renato, 3
Rosenthal, Leah, 64 (Pic.), 100 (Pic.), 165
Rosenzweig, Barney, 28
Ross, Andrew, 190
Ross, Jessica, 261
Roving Reporter, 166 (Pic.), 167
Russ, Joanna, 37, 157, 182, 190, 192–193
Russell, Mark, 258

Saavik (*Star Trek*), 82, 116, 118, 165, 252
Saiid, Kami, 207–208
Sandbaggers, The, 70, 90–91, 157, 171
Sappho, 200
"Sarrasine," 67
Sarek (*Star Trek*), 82, 94, 162–163
Saturday Night Live, 9 (Pic.), 10–12, 19, 21
Scarecrow and Mrs. King, 138, 157, 170, 235 (*See also* Amanda King, Lee Stetson)
Schatz, Thomas, 123
Schweickert, Patricia, 108
Science Fiction Fandom, 46–49
Sconce, Jeff, 63
Scorpio, 173
Scott, Montgomery "Scotty" (*Star Trek*), 52, 104, 183, 264
Scriptural Economy, 24, 62, 86
Sebastian, 200
Secret Life of Walter Mitty, The, 14
Sedgwick, Eve Kosofsky, 202–203, 205
Segal, Elizabeth, 113
Seiter, Ellen, 81
Selley, April, 203
Servalan (*Blake's 7*), 165, 167–169, 175, 230
Sesame Street, 239
Seven Year Itch, The, 14

Seventh Voyage of Sinbad, The, 228–229
Shakespeare, William, 16, 53, 202
Sharratt, Bernard, 86–87
Shatner, William, 9–10, 12, 30, 173, 277
Shaw, Martin, 228–229
Sherlock Junior, 14
Sherman, Allan, 258
Sheriff of Nottingham, 168, 239
Sholle, David, 6
Siebert, C. A., 31
Sikes, Matt (*Alien Nation*), 82, 93–94, 233–234
Silverado, 157
Simon and Garfunkel, 237
Simon and Simon, 93, 174–175, 188, 229
Simpsons, The, 77
"Sixth Year, The," 178
Skywalker, Anakin (*Star Wars*), 163
Skywalker, Luke (*Star Wars*), 163, 227, 244
Slaggs Are People, Too, 92
Slash, 156, 175–176, 185–222, 223, 225–228, 254, Stories: "As Night Closes In," 208, "Breaking Point," 210, "Civilized Terror," 212–213, "Comfort," 196–197, "Consequences," 220, "Descending Horizon," 211, "Friendly Drink, A," 197, "He Who Loves," 209, "Hunting, The," 171, "If I Reach Out, Will You Still Be There?," 197, "Just Say No," 212, "Lover's Quarrel," 207, "Masque For Three—Night's Masque," 218, "Mental Health," 213–214, "Midnight Snack," 215, "Momentary Aberration, A," 199, "Nearly Beloved/Rogue," 210–211, 220, "On Heat," 200, "Poses," 199, "Stormy Weather," 215, "Stand and Deliver," 171, "Teddy Bears' Picnic," 214, "There Is None So Blind . . .," 213, "Wine Dark Nexus," 171 (*See also* K/S)

SLAYSU, 31
Smith, M. A., 105 (Pic.), 117 (Pic.)
Smith, Sarah Jane (*Doctor Who*), 166 (Pic.), 167
Smothers Brothers, The, 258
Soap Operas, 77, 81
Soap Opera Digest, 81–82
Solar Sailors, 274
Solo, Han (*Star Wars*), 73
Solo, Napoleon (*Man From UNCLE*), 170, 175, 187 (Pic.), 203, 206, 209, 227
Solten, Natasha, 215
Song Tapes, 239, 244
Sonic Screwdriver, The, 41
Sonnets and Roses, 146
Soolin (*Blake's 7*), 167, 196–197
Southern Lights, 157
Southern Seven, 176
Spacks, Patricia Meyer, 81–82
Special Effects, 65–66
Spigel, Lynn, 35
Spinrad, Norman, 22
Spock (*Star Trek*), 9, 13, 52, 83, 93, 95–96, 99, 103–104, 105 (Pic.), 107, 162–163, 169–171, 173–175, 178, 183, 185–186, 191, 193–194, 196, 198–199, 202–203, 206, 209–210, 216–218, 221, 240–243 (Pics.), 244–246, 250–251, 252, 262, 264
Spotlight Starman, 28–29, 32
Stannis, Jenna (*Blake's 7*), 167, 169, 196–198, 227
Starbase Houston, 11
Star Cops, 70, 91
Star Fleet (*Star Trek*), 101, 104, 164, 175, 179, 181, 183, 216, 245
Starlite Press, 93
Starlog, 65
Starlust, 15
Starman, 28–29, 90, 170
Starsky and Hutch, 82, 96, 158, 171, 174, 188, 192, 203, 206, 208–209, 216, 218, 225–226, 228, 246
Star Trek, 9, 17, 19–21, 22–23, 28, 30, 36–39, 41, 45, 48, 52–53, 57, 66, 69, 75–76, 77, 82–83, 84, 86, 89, 91, 93–99, 101–105, 106–107, 109–110, 111, 115–116, 118, 157–158, 162, 163–164, 167–170, 173, 174, 177, 181, 184, 187, 203, 206, 216, 237, 240–243 (Pics.), 244–246, 250, 254, 258, 261, 277, Episodes: "Amok Time," 95, 162, 174, 191, 244–245, 262, "City on the Edge of Forever," 76, 95, 262, "Empath, The," 245 "Journey to Babel," 162, "Menagerie, The," 244, "Mirror, Mirror," 156, 168, 173, "Requiem for Methuselah," 245, "Space Seed," 104, "Spock's Brain," 95, 262, "This Side of Paradise," 179, "Turnabout Intruder," 180, "Yesteryear," 162 (*See also* Amanda, Andorian, Christine Chapel, Pavel Chekov, Enterprise, Federation, IDIC, Edith Keeler, Khan Noonian Singh, James T. Kirk, Klingons, Janice Lester, Dr. M'Benga, Joanna McCoy, Leonard McCoy, Christopher Pike, Pon Farr, Prime Directive, Janice Rand, Kevin Riley, Romulan Commander, Romulans, Saavik, Sarek, Montgomery "Scotty" Scott, Spock, Star Fleet, Sulu, Surak, Sybok, Penda Uhura, Vulcans)
Star Trek: The Motion Picture, 96, 245
Star Trek II: The Wrath of Khan, 96, 104, 116, 245, 250, 252
Star Trek III: The Search For Spock, 96, 116, 118, 245
Star Trek IV: The Journey Home, 96, 226, 245
Star Trek V: The Final Frontier, 95, 96, 103
Star Trek Lives!, 22
Star Trek: The Next Generation, 37–39, 71, 82, 87, 93, 95, 97, 99, 100 (Pic.), 101–103, 105 (Pic.),

106, 107, 117 (Pic.), 167, 226, 230, Episodes: "Arsenal of Freedom," 98, "Conspiracy," 97, "Heart of Glory," 98, "Hollow Pursuits," 102, "Justice," 95, "Measure of a Man," 95, 98, 230, "Naked Now, The," 230, "Pen Pal," 100, "Sarek," 174, "Yesterday's Enterprise," 95 (*See also* Dr. Beverley Crusher, Wesley Crusher, Data, Geordi LaForge, Jean-Luc Picard, Dr. Pulaski, William Riker, Deanna Troi, Lt. Worf, Tasha Yar)
Star Wars, 4, 30–32, 73–74, 91, 157–158, 163–164, 168–169, 177, 227, 251–252, 258, Terms: Alliance of Jedi Knights, 73, 164, 168, 251, Death Star, 227 (*See also* Obi-Wan Kenobi, Lea Organa, Anakin Skywalker, Luke Skywalker, Han Solo, Darth Vader)
Steed, John (*The Avengers*), 42, 175
Steele, Remington (*Remington Steele*), 163, 170, 174, 229, 238
Stein, Mike, 266
Steinman, Clay, 22
Stereotypes, 9–22
Stetson, Lee "Scarecrow" (*Scarecrow and Mrs. King*), 174, 235
Stewart, Mary, 38
Stewart, Patrick, 38, 99
Stoltenberg, John, 185, 189, 190, 192
Stoogemania, 14
Strategies and Tactics, 44–45, 223
Stringer, Howard, 121
Streeter, Thomas, 30
Sturgeon, Theodore, 22
Subcultures, 39
Subculture: The Meaning of Style, 39
Sulu (*Star Trek*), 82, 102–104
Superman, 72
Surak (*Star Trek*), 251

Sutton, Brenda Sinclair, 255
Sybok (*Star Trek V*), 103, 104

TACS, 171
Tales of the Gold Monkey, 90
Tales of Hoffman, 167
TARDIS (*Doctor Who*), 170–171
Tarrant, Del (*Blake's 7*), 95, 169, 213, 226, 230
Taste, Politics of, 16–17
Taxi, 157
Taylor, Helen, 68
Taylor, Karla, 104
Technological Utopians, 264, 266–267
Teenage Mutant Ninja Turtles, 65–66
Telepics, 152
Temporal Times, The, 41
Tenctonese Guide to the Universe, A, 92
Tennison, Barbara, 32, 90, 91, 204–205, 218
Tequila Sunrise, 41
Terhaar, Rita, 136
Terra Nostra Underground, The, 220
Terrell, Rita, 131 (Pic.), 139 (Pic.), 147 (Pic.)
Tetzlaff, David, 232
Thorburn, David, 124
Thousandworlds, 177
THRUSH (*Man from UNCLE*), 209
Thundercats, 156
Tilley, Susanne, 165
Tim, 41
Time Tunnel, 170
Totally Imaginary Cheese Board, The, 173
Travis (*Blake's 7*), 227
"Trekkies," 9–13, 19, 21, 36, 53
Treklink, 47
Trimble, Karen, 260, 261
Tripp, David, 55
Troi, Deanna (*Star Trek: The Next Generation*), 83, 103, 169, 197–198
Tron, 157

342 INDEX

Trucage, 65
Truman, Harry S. (*Twin Peaks*), 112, 174, 214
Trust, Like the Soul, 169
Tubbs, Ricardo (*Miami Vice*), 170, 235
Tuesday Night, 41
Tulloch, John, 87, 125, 279
Tunnels of Love, 146
Turkle, Sherry, 110
TV Guide, 58, 102, 120–122, 129, 145
Twilight Zone, The, 17, 69
Twin Peaks, 19, 28, 72, 77–79, 109–112, 164, 174, 278, Names: "Bob," 78, Briggs, Major, 79, Deputy Andy, 78, 112, Earle, Windom, 79, Hayward, Doc, 112 (*See also* Dale Cooper, Josie Packard, Laura Palmer, Harry Truman)
Two-Feathers, Quannechota (*The Weight*), 180, 183
Tyler, Bonnie, 234

Uhura, Penda (*Star Trek*), 82–83, 102, 104, 167, 169, 181–182, 196, 252, 264
U.N.C.L.E. Affairs, 170
Undercover, 41
Underground Utopias, 126
Universal Sheriton Hotel, 229
Urhausen, Mary, 93
Usenet, 77
Utopian Entertainment, 281–282

Vader, Darth (*Star Wars*), 168–169, 227, 244
Van Buren, Sylvia (*War of the Worlds*), 230
V. B., 231
Veith, Diane, 157, 190, 193–194, 196–198, 215–216, 218
Velveteen Rabbit, The, 50–52
Verba, Joan Marie, 86, 95–96, 104
Vermorel, Fred and Judy, 15
Videomaking, 154, 156, 225–249, 253, 254, 279, 280, Videos: "Another One Bites The Dust,"

230, "Big Bad Leroy Brown," 227, 234, "Calypso," 226, "Can't Hurry Love," 244, "Can't Keep From Loving You," 233, 234, "Holding Out For A Hero," 234, 236, "Hungarian Rhapsody," 229, "I Am A Rock," 231, "I Needed You," 240–246, "Last Time I Felt Like This, The," 235, "Leaving the Straight Life Behind," 225, 228, "Lonely Is The Night," 234–235, "Long Long Way To Go," 231–232, "Peter Rabbit," 227, "Reviewing the Situation," 226, "Rubber Ducky," 239, "Send In the Clowns," 244, "So Happy Together," 227, 228, "Stripper, The," 231, "Tapestry," 230–231, "Tattered Photograph," 230, "This Man Alone," 236, "We're Going to Score Tonight," 228
Video Cassette Recorder (VCR), 56–57, 70–73, 78, 225–249, 278, Terms: Clone, 71
Viewer Activism, 28–30, 118–119, 121–122, 128–130
Viewers vs. Fans, 54–60
Vila, Please, 176
Vincent (*Beauty and the Beast*), 94–95, 125–127, 129, 131 (Pic.), 132, 134–138, 139 (Pic.), 140–146, 147 (Pic.), 148–151, 164, 170, 174–175, 231
Vitti, Bonnie, 163
Voyage to the Bottom of the Sea, 157
Vulcans (*Star Trek*), 9, 11, 97, 99, 101, 107, 170, 173–174, 178, 180, 194, 199, 206, 216, 245, 252, 264

Wail Songs, 275
Walkabout, 41
War of the Worlds, 28, 170, 230, 282 (*See also* Sylvia Van Buren)
Warped Space, 178
Warren Jr., William, 266
Watts, Eric, 103

Weber, Chris, 262–264
Weight, The, 177–184
Wenk, Barbara, 173
West Side Story, 263
What You Fancy, 41, 157
Wheel of Fortune, 170
Whispering Gallery, The, 130, 135, 137
White, T. H., 38
Wild at Heart, 77
Williams, Linda, 190
Williams, Raymond, 55
Williams, Rosalind, 126
Wilson, Alison, 94
Wiltse, Stephanie A., 130
Wise Guy, 237
Witt/Thomas Productions, 125
Witt, Paul, 125
Wizards and Warriors, 157

Wollacott, Janet, 68
Wood, Robin, 74
Woodward, Edward, 236
World of Star Trek, The, 22
World Science Fiction Convention, 47
Wortham, Ann, 157, 165
Wuthering Heights, 138
Wyatt, Marrianne, 252–253

Yar, Tasha (Star Trek), 37, 103, 107, 167, 169, 196–198, 230–231, 252
Yardley, O., 171
Year of Living Dangerously, The, 41

Zdrojewski, Ed, 178
Zine Scene, The, 159